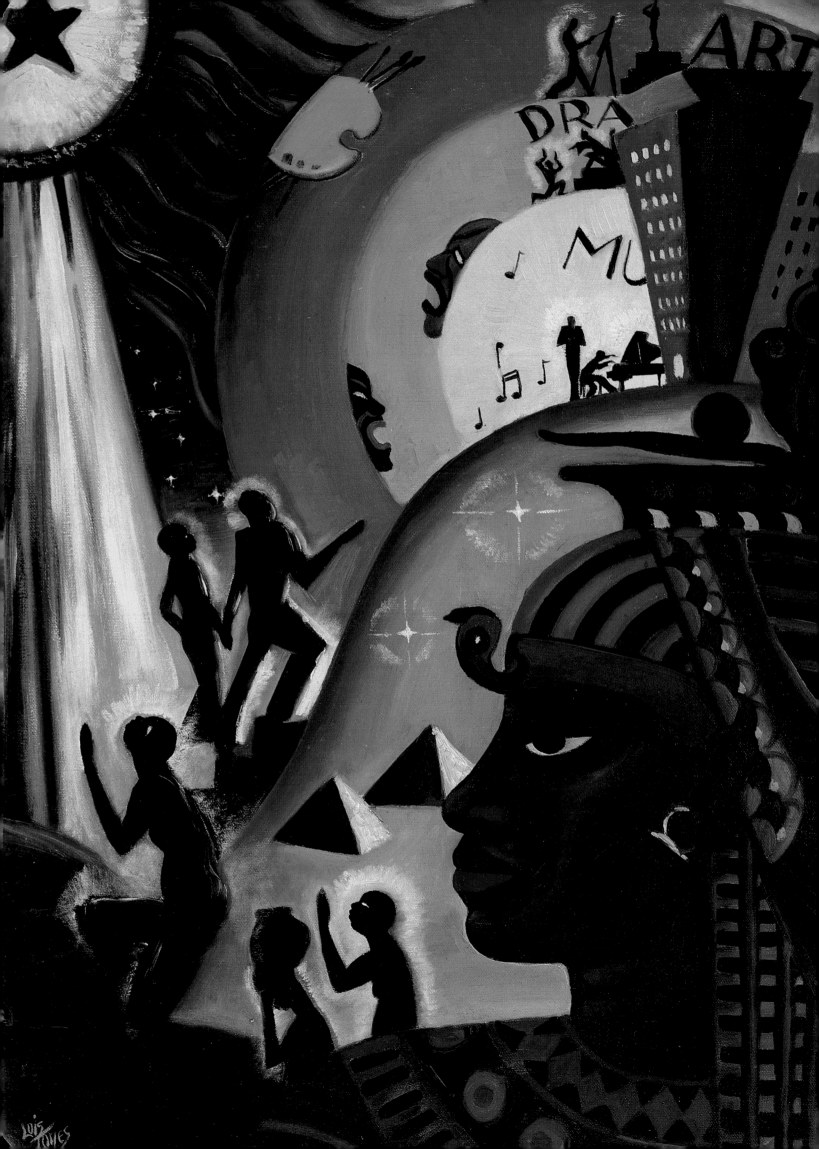

BLACK ART
ANCESTRAL LEGACY

THE AFRICAN IMPULSE IN AFRICAN-AMERICAN ART

DALLAS MUSEUM OF ART

HARRY N. ABRAMS, INC.
PUBLISHERS, NEW YORK

This catalogue is published on the occasion of the exhibition
Black Art — Ancestral Legacy: The African Impulse in African-American Art
organized by the Dallas Museum of Art.

EXHIBITION STAFF

Alvia J. Wardlaw
Chief Curator

Regenia A. Perry
Edmund Barry Gaither
Curators

Maureen A. McKenna
Project Director

David Boxer
David C. Driskell
William Ferris
Robert Farris Thompson
Exhibition Advisors

EXHIBITION ITINERARY

Dallas Museum of Art
Dallas, Texas
December 3, 1989 - February 25, 1990

High Museum of Art
Atlanta, Georgia
May 22 - August 5, 1990

Milwaukee Art Museum
Milwaukee, Wisconsin
September 14 - November 18, 1990

Virginia Museum of Fine Arts
Richmond, Virginia
January 28, 1991 - March 24, 1991

This exhibition and publication have been made possible through a generous grant from the Luce Fund for Scholarship in American Art, a program of The Henry Luce Foundation, Inc., as well as through grants from the National Endowment for the Arts and the National Endowment for the Humanities, Federal Agencies; and the Edward and Betty Marcus Fund, established in their honor by Melba Davis Whatley.

**The exhibition and its national tour are sponsored by
Philip Morris Companies Inc.**

Second Printing, 1990

Editors: **Robert V. Rozelle, Alvia Wardlaw and Maureen A. McKenna**

Index and manuscript preparation: **Linda Ledford**

Photo editor and checklist preparation: **Maureen A. McKenna**

Assistance with photos and credits: **Elizabeth Simon**

Object photography, except where otherwise noted: **Tom Jenkins**

Designed by **Carol Haralson.**

Published by the Dallas Museum of Art and Harry N. Abrams, Incorporated, New York, a Times Mirror Company.
No part of the contents of this book may be reproduced without the written permission of the publisher.

Printed and bound in Japan

Library of Congress Cataloging in Publication Data

Black art — ancestral legacy.

"Exhibition itinerary: Dallas Museum of Art, Dallas, Texas, December 3, 1989 - February 25, 1990; High Museum of Art, Atlanta, Georgia, May 22 - August 5, 1990; Milwaukee Art Museum, Milwaukee, Wisconsin, September 14 - November 18, 1990; Virginia Museum of Fine Arts, Richmond, Virginia, January 28, 1991 - March 24, 1991" —T.p. verso.
Includes bibliographical references.
1. Afro-American art — Exhibitions. 2. Art, Modern — 20th century — United States — Exhibitions. I. Dallas Museum of Art.
N6538.N5B525 1989 704'.0396073'07473 89-23743

ISBN 0-936227-04-0 softcover (Dallas Museum of Art)
ISBN 0-8109-3104-4 hardcover (Abrams)

COVER: **Jean Lacy,** *Little Egypt Condo.*
FRONTISPIECE: **Lois Mailou Jones,** *Ascent of Ethiopia.*
CONTENTS PAGES: **Renée Stout,** *Fetish #2;* **Unknown artist (Mali: Dogon),** *Standing Female Figure;* **Ed Love,** *Totem for Senufo.*
PREFACE: **Murat Brierre,** *Chien de mer.*

*This publication is dedicated to all
African-American artists
in recognition of their creative vision
which has enriched the world.*

CONTENTS

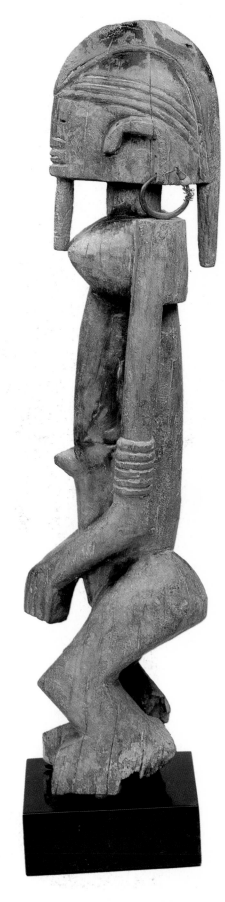

CATALOGUE

ALVIA J. WARDLAW

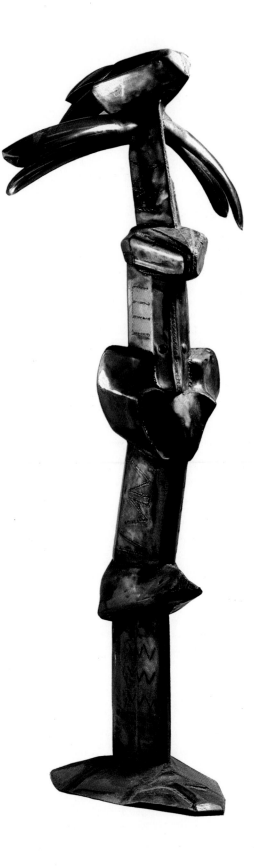

PREFACE

Most Americans know painfully little about the traditions of African-American civilization. Our museums are devoted almost exclusively to the representation of "white" culture, our libraries to the western tradition of literature, our universities to the history of the ancient Mediterranean and modern Europe. There have been inroads made in our institutional culture during the last generation, but their cumulative power has yet to be felt. We now have African-American studies programs in our major universities and are able to read books by African-American writers and to see exhibitions of art made by folk and professional artists of African descent. Yet, many of the attempts to help free American education from its racial straightjacket have been strongly attacked in recent years, and it is for that reason in particular that the Dallas Museum of Art is especially proud to present *Black Art: Ancestral Legacy*.

We at the Dallas Museum of Art have devoted considerable resources in the past three years toward educating the public about African-American art of the 20th century. We enlisted the aid of Alvia Wardlaw, a brilliant young scholar from Houston, as a curator to guide us. We have allotted thousands of hours of staff time to the process and have asked the advice and invited the collaboration of people both in our city and throughout the country. Their names can be found throughout this book. Collectively they have produced an exhibition, a catalogue, and a sophisticated program of public education that deals with African-American culture in all its depth and breadth.

From the outset, we decided not to be sectarian in our approach, focusing only on a select group of recognized African-American artists and their distinguished and well-known works of art. Instead we have given equal attention to urban and rural art, to "folk" as well as trained artists, and no part of the United States has been overlooked as we sought to cast our net widely. Even the cultures of the Caribbean are included, because they have infused African-American culture in the United States with extraordinary energy and vitality. We chose not to extend our research to the African-American cultures of South America, preferring rather to concentrate on the United States and the Caribbean and to present the rich civilizations of African Brazil in a future exhibition.

Yet, most importantly, we have emphasized the American side of the African-American equation as much as we have the African, and the many messages of this exhibition address fundamental issues concerning the meaning of America itself. The major myth of America — that of assimilation — does not apply to African-American civilization. But many others do: the adaptation of "Old World" culture to a new set of circumstances, the retention of culture and memory through literature, art, music, and pop culture, and the appropriation of "Old World" cultural elements as crucial components of a "New World" identity. Just as Greek Americans, Italian Americans, and Mexican Americans have preserved and recast their cultural heritage, so too have African-Americans.

To me, as an American male of Anglo-Saxon heritage with an Ivy League education living in a Texas city in which the majority of citizens are

called "minorities" and in a country whose capital is populated largely by Americans of African descent, *Black Art: Ancestral Legacy* is particularly important. I feel strongly, as do the trustees of the Dallas Museum of Art and members of the Cultural Arts Commission of the city of Dallas, that the exhibition is fundamentally an American exhibition, "targeted" not for a racially identified audience, but for everyone interested in a more accurate definition of American culture.

The fact that *Black Art: Ancestral Legacy* has its origins in Dallas is oddly appropriate, for although African-Americans have made a lasting contribution to our urban culture for more than a century, Dallas itself has never been considered one of the major centers of African-American culture. Yet, one of the important lessons of this exhibition is that these centers are not confined to our great capital cities of the east coast and that African-American art springs from every part of this nation.

Interestingly, the Dallas Museum of Art had the wisdom and foresight to purchase two internationally significant private collections of African art as early as 1969 and 1974. Indeed, the Stillman and the Schindler Collections represent the core of a collection of African sculpture that rivals that of the Metropolitan Museum of New York and is among the greatest collections of African art in any American art museum. When a visitor to the Dallas Museum of Art can study original, exemplary works of art from Zaire, Mali, and the Ivory Coast, his understanding of our African-American art is more meaningful because it can be rooted in African civilization itself.

To further enhance this opportunity, the museum has built an active program of exhibitions and acquisitions based on African art. Not only have we explored the question of so-called African "primitivism" through the purchase of an early Picasso and the installation in Dallas of the Museum of Modern Art's brilliant and controversial exhibition *Primitivism in 20th-Cen-*

tury Art, but we have also bought major works by African-American artists, many of which will make their "debut" in *Black Art: Ancestral Legacy.* Indeed, it is our feeling that the very finest African-American art must be unequivocally integrated as part of the larger history of American art represented in the DMA's collections, exhibitions, and public programs, and when *Black Art: Ancestral Legacy* concludes its important national tour, several of the most important works from it will return to Dallas as part of the DMA's permanent collection.

Unlike many exhibitions of western art based upon several generations of scholarship and publication, *Black Art: Ancestral Legacy* is the fruit of a new generation of scholars. As a matter of fact, much of the research that will inform readers of this catalogue is new and was undertaken as part of the process of preparing this exhibition. None of this would have been possible without generous and farsighted exhibition research grants from The Henry Luce Fund for Scholarship in American Art, the National Endowment for the Humanities, the National Endowment for the Arts, and the Edward and Betty Marcus Fund, established in their honor by Melba Davis Whatley.

After an exhibition is conceived, of course, it must be brought alive to its potential audience. We at the Dallas Museum of Art feel so strongly about the essential power and importance of African-American art that the programming and marketing of this exhibition became as vital to our mission as was its conception. A major commitment to national sponsorship on the part of the Philip Morris Companies Inc. was pivotal to this enterprise, taking the exhibition from its planning stages to a reality for all to enjoy. And from the beginning, we were aided in this task by a superb Steering Committee assembled by the Museum.

In the final analysis, though, everyone involved in *Black Art: Ancestral Legacy* — the foundations, the curators, the advisors, and museum administrators — must remember that

we are here to serve civilization and to carry the messages of artists to the audience they so richly deserve. This is the importance of America, a country in which the work of living artists, largely unrecognized outside their narrow communities, can be presented to a diverse national audience. In this larger forum, the minds and hearts of many people can be touched and broadened so that our collective idea of America can be as rich and complex as America is itself.

Richard R. Brettell
Director
Dallas Museum of Art

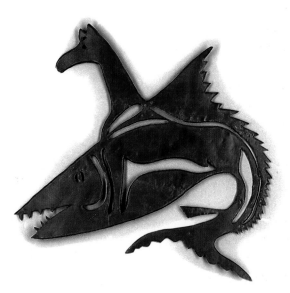

SPONSOR'S STATEMENT

As Americans, our backgrounds are so diverse and our history so varied that we are always making new discoveries about ourselves and each other and gaining new strength from what we learn.

Since we began our arts support program over thirty years ago, Philip Morris has consistently sponsored exhibitions and performances that underscore the riches of our national character and culture, in the spirit of deepening the knowledge of our collective past and enriching our common future.

Black Art: Ancestral Legacy is just such an exhibition. It explores the importance of African cultural traditions and iconography in the creative expressions of African-American artists, and through them, in our shared cultural vitality.

We are pleased to sponsor this provocative exhibition which so strongly links the old and the new, the African and the American, presenting a unique perspective from which to understand the evolution and cultural heritage of African-American art in this century.

Hamish Maxwell
Chairman and Chief Executive Officer
Philip Morris Companies Inc.

FOREWORD AND ACKNOWLEDGMENTS

This exhibition celebrates the richness and diversity of American art and culture through the exploration of the connections between 20th-century African-American artists and their African heritage. These connections between Africa and America are a particularly rich and important aspect of African-American art which has never before been the subject of a major traveling exhibition. The focus and scope of *Black Art: Ancestral Legacy* evolved during a series of meetings among the project staff that began in early 1987. In exploring the impact of Africa upon twentieth century black visual artists the curators felt it critical to demonstrate that such an awareness of their ancestral heritage exists among both formally trained and self-taught artists. Because of this, art work by both groups of creative individuals are included in the exhibition. The curators also felt it important to indicate the continuity of this "impulse." It did not emerge full-blown as a result of artistic activism during the 1960s, but is traceable among trained artists to the Harlem Renaissance and the teachings of Alain Locke, and among self-taught artists to craft traditions passed down over the generations. Nor has this impulse been restricted to particular urban centers of America. It permeates the fabric — north, south, east, and west — of this country. The exhibition thus examines this aspect of African-American art from a broad historical perspective, matched by an equally broad geographic distribution of artists. Artists from across the United States are included, as well as Jamaica, Haiti, and the Bahamas, demonstrating that expressions of the Diaspora exist throughout the western hemisphere. Common to all the artists is the expression of a cultural self which links them to the traditions of their ancestral homeland. It has been the challenge of *Black Art — Ancestral Legacy* to present this expression in all its complexity.

The support and commitment of a number of people have made possible the organization of this exhibition and publication. Among the many individuals who deserve our deepest thanks is Dr. Rick Stewart, former Curator of American Art at the DMA, now Curator of Western Paintings and Sculpture at the Amon Carter Museum. His interest in exploring American art in all its rich diversity led him to present a proposal for a major exhibition of 20th-century African-American art to the Luce Fund for Scholarship in American Art. Although he began his duties at the Amon Carter Museum before all the project staff were assembled and the final focus of the exhibition established, it was his vision that began the project. Our deepest thanks are also extended to the Luce Fund for Scholarship in American Art. The generous grant they awarded the DMA supported much of the research for this exhibition and publication and made it possible to bring together on this project a distinguished group of experts in the field of African-American art and culture.

Dr. Regenia A. Perry, Professor of Art History, Virginia Commonwealth University, and E. Barry Gaither, Director, Museum of the National Center of Afro-American Artists, Inc., who served as members of the curatorial team, contributed a wealth of knowledge to the project. Their vision helped shape and guide *Black Art: Ancestral Legacy*, and made possible a dynamic exhibition featuring both well-established and emerging artists. In addition, their catalogue essays provide information on little documented movements in African-American art and examine the impact of both political events and folk

culture upon the black artist. Their invaluable contribution deserves special recognition and appreciation.

The exhibition advisors form another key group of scholars whose expertise and support ensured the success of this project. They include: Dr. David Boxer, Director, National Gallery of Jamaica; Mr. David Driskell, Professor of Art, University of Maryland; Dr. William Ferris, Director, Center for the Study of Southern Culture, University of Mississippi; and Dr. Robert Farris Thompson, Professor of Art History, Yale University. David Boxer gave generously of his time and expertise in discussing the art and artists of his country, and facilitated the loan of key Jamaican works for the exhibition. Through every phase of the exhibition's development David Driskell offered support and guidance based on his own extensive experience in organizing exhibitions of African-American art. His introduction to the catalogue places the exhibition in proper historical context and relates it to current studies of African-American art. William Ferris provided valuable contacts among artists, scholars, and patrons interested in African-American culture in the south. His essay on black southern culture examines the importance of sense of place among African-American artists. Robert Farris Thompson's deep enthusiasm for the project resulted in a major essay based on intensive research and thoughtful reflection. Drawing upon his extensive knowledge of black culture he offers new insights and interpretations of a number of works in the exhibition and establishes important connections among them. Our thanks are also extended to Ute Stebich who shared her expertise on Haitian and Bahamian art and contributed an essay on Caribbean art to the catalogue. We acknowledge with great appreciation the contribution of these scholars to the exhibition and publication.

We also acknowledge with gratitude the cooperation of all the lenders to *Black Art: Ancestral Legacy* who generously agreed to part with their works of art for an extended period of time.

Philip Morris Companies Inc. have provided generous support for the exhibition, publication, and national tour of *Black Art: Ancestral Legacy*. We express our deepest appreciation to them for their support which has made possible the organization of such an ambitious exhibition and publication and ensured that the exhibition will be shared with museum visitors in Dallas, Atlanta, Milwaukee, and Richmond.

Our gratitude is also extended to the National Endowment for the Arts and the National Endowment for the Humanities, federal agencies, for the generous grants they awarded the DMA for the exhibition and catalogue. We extend our thanks as well to the Edward and Betty Marcus Fund, established in their honor by Melba Davis Whatley, for their support. We also acknowledge with appreciation the Metropolitan Life Foundation's generous grant which has allowed the DMA to acquire several key works from the exhibition for its permanent collection.

We are delighted that *Black Art: Ancestral Legacy* will travel to the High Museum of Art, the Milwaukee Art Museum, and the Virginia Museum of Fine Arts and extend a special word of thanks to our colleagues at these museums for their cooperation and enthusiastic support.

A number of colleagues at other institutions have been particularly helpful in providing research assistance. We thank Esme Bahne at the Moorland-Spingarn Collection, Tritobia Benjamin at Howard University, Deirdre Bibby at the Schomburg Center for Research in Black Culture, Dorothy Chapman at Texas Southern University, Floyd Coleman at Howard University, Danny Dawson at the Caribbean Cultural Center, Rebecca DuBey at The University of Mississippi, Elizabeth Howse at Fisk University, Jim Huffman at the Schomburg Center for Research in Black Culture, Mary Lou Hultgren at Hampton University, María Leyva at the Museum of Modern Art of Latin America, David Muir at the National Gallery of Jamaica, Francine Murat at Le Centre d'Art, Lester Sullivan at the Amistad

Research Center, Patrick Sweeney at the Davenport Museum of Art, Lucy Turnbull at The University of Mississippi, Jerry Waters at Fisk University, and Jeanne Zeidler at Hampton University. In addition, we acknowledge with appreciation the assistance provided by the following individuals: Gerald Alexis, Mrs. Alleyne R. Booker, Dr. Margaret Burroughs, Ronald Gray, William Watson Hines III, Larry G. Hoffman, Shari and Randall Morris, Augustus Palmer, Aaronetta Pierce, Dr. Jontyle Robinson, Luise Ross, and Virgil Young.

Without the tireless efforts of a number of DMA staff members the production of this catalogue would not have been possible. Special thanks are extended to Robert Rozelle, Director of Publications, who served as chief editor of the catalogue and oversaw the complex task of catalogue production; Elizabeth Simon, Curatorial Assistant, for her diligent and meticulous research as well as her assistance with locating artist photographs and information on photography credits; Linda Ledford, Publications Assistant, for her great patience in preparing the catalogue index and in typing and proofing countless pages of text as well as helping facilitate catalogue production; Scott Hagar, DMA Photography Assistant, for a wonderful job in printing hundreds of negatives; Eileen Coffman, Manager of Visual Resources, for her expert assistance in selecting the best transparencies for catalogue reproduction; and Amy Schaffner, DMA Librarian, for her assistance with our research efforts. We also appreciate the valuable contribution that Tom Jenkins, DMA Photographer, has made to this publication. His talent and sensitivity resulted in many of the striking object photographs that fill these pages and made it possible to produce a book of great beauty. We are also grateful for the kind cooperation of many lenders in providing information about works in the exhibition as well as photographs for the catalogue. The care and creativity which designer Carol Haralson brought to this project is evident in the beauty of this book. Her immediate sensitivity to the inherent richness, power, and complexity of the material (as expressed through both text and images) guided her imagination and yielded magnificent results. We greatly appreciate her devotion to this project and the unfailing patience and professionalism with which she worked even under the strictest time constraints. We also extend our thanks to Margaret Kaplan, Executive Editor and Senior Vice-President at Abrams, for her early belief in the importance of this project.

Many colleagues at the DMA have contributed to the success of *Black Art: Ancestral Legacy*. We thank Dr. Richard Brettell, Director of the DMA, for his enthusiastic support of the exhibition. Jody Cohen, Assistant Registrar for Loans and Exhibitions and Anna McFarland, Exhibitions Coordinator, deserve special thanks for their ongoing assistance with the complex arrangements necessary to organize an exhibition of this magnitude. For their support and assistance during various phases of the project we also thank Phil Angell, Connie Cullum, Barney Delabano, Lynn Jones, Manuel Mauricio, Gay McNair, David Miller, Ron Moody, Judy Nix, Jack Rutland, Emily Sano, Mark Snedegar, Russell Sublette, Pam Wendland, Debra Wittrup, and Melanie Wright. For their invaluable assistance with the extensive public programs being presented in conjunction with the exhibition we thank Melissa Berry, Nancy Berry, Julie Cochran, Phillip Collins, Gail Davitt, Tracy Harris, Aileen Horan, and Kathy Windrow.

We wish to express a special thank you to our families and friends whose love and support have made our work possible. Finally, we wish to extend our warmest thanks to the artists in the exhibition for sharing their creative vision and energy in these magnificent works of art.

Alvia J. Wardlaw
*Adjunct Curator of
African-American Art
Dallas Museum of Art*

Maureen McKenna
*Assistant Chief Curator
Dallas Museum of Art*

LENDERS

Aaron Douglas Collection,
Amistad Research Center, New Orleans

Xenobia Bailey

Banks Enterprise, New York City

Ivy Beckles

John and Hazel Biggers

Wallace Campbell

Cavin-Morris Gallery, New York City

Dr. and Mrs. Maurice C. Clifford

Houston Conwill

Dallas Museum of Art, Dallas

Estate of David Miller, Jr.

Evans-Tibbs Collection, Washington, D.C.

Fine Arts Museums of San Francisco, San Francisco

The Flagg Collection, Milwaukee

Gallery Light Center, Cambridge

David and Bobbye Goldburg

Grinnell Gallery, New York City

Mr. & Mrs. Robert L. Gwinn

Carl Hammer Gallery, Chicago

Michael D. Harris

Bessie Harvey

Dr. and Mrs. William R. Harvey

Ellen Maria Hill

William Watson Hines, III

Geoffrey Holder

Mr. Imagination

Clarencetta Jelks

Lois Mailou Jones

Kofi Kayiga

Jean Lacy

Ed Love

Vusumuzi Maduna

Marie Martin Gallery, Washington, D.C.

Mr. & Mrs. Robert A. McGaw

McIntosh Gallery, Atlanta

The Museum of Fine Arts, Houston

Museum of International Folk Art, Sante Fe

Museum of the National Center
of Afro-American Artists, Inc., Boston

National Gallery of Jamaica, Kingston

National Museum of American Art,
Smithsonian Institution, Washington, D.C.

The Newark Museum, Newark

New Jersey State Museum, Trenton

Olympia International Art Centre, Kingston

Regenia A. Perry

James Phillips

David R. Philpot

Private Collections

Leon Renfro

Deryck Roberts

Luise Ross Gallery, New York City

Bert Samples

San Francisco Museum of Modern Art, San Francisco

Schomburg Center for Research in Black Culture,
The New York Public Library,
Art & Artifacts Division, New York City

Charles Searles

George Smith

Ute Stebich Gallery, Lenox

Renee Stout

Matthew Thomas

Camilla Trammell

University Museums, The University of Mississippi

Wadsworth Atheneum, Hartford

Willard Watson

Derek Webster

Anne and Allan Weiss

Sheila and Gregory Wells

Whitney Museum of American Art, New York City

Rip Woods

Virgil Young

INTRODUCTION

The cultural legacy that black Americans inherited from their African ancestors remains an active force in their art in the latter quarter of the 20th-century. This ongoing trend can be seen in the exhibition *Black Art: Ancestral Legacy*. And while this lineage of drawing on African sources for inspiration in art has not been confined to persons of African descent alone, it nonetheless has served to inform the work of many black American artists of this generation. Indeed, the properties of African art have been assimilated into the fabric of 20th-century European art and that of many of the nationals of the South American continent as well. But, in recent years, black American artists have consciously sought to redefine their cultural legacy by returning to the ancestral arts of Africa for inspiration in the visual arts, music, and dance.

Over the years, our artists have reconstructed in various media the spiritual impetuosity of the multimedia-oriented forms of a bygone African past. The results are manifested in the re-creation of dance forms that echo the spirit and rhythm of an inventive motive art in the same manner that visual artists have color-chromed and coded their creations with an explosive tonal palette akin to what jazz musicians do when staging improvisation and sound amplification in their medium. These forms speak clearly of an African sensibility in contemporary American art.

It is from this perspective of an African sensibility, one that reflects on the ancient arts of Egypt, Ife, Benin, and the various national cultures of West Africa, that black American artists have returned during the past one hundred years in search of their roots in a culture other than their adopted one here in the United States. Many artists have consciously sought to divest themselves of those forms which do not speak of their African lineage in art, and they have searched the pages of history in pursuit of their ancestral roots. Their prayerful desire is to re-create art forms that are both physically and spiritually sound in their search for a new self-determination, and the artists have shown an unending interest in those forms which survived the transplant of Africans to the New World.

Much of the art which survived the African's forced migration to the New World was not permitted to show direct lineage with the art of Africa. However, retentions can be seen in the iconography of walking canes of the South, in the adaptations of black dress, in architecture, and in the decorative arts of ceramics and furniture-making. It may be argued that an even stronger African influence survived in dance forms and in music, thereby helping to keep alive, often in disguise, African retentions in American culture in opposition to slave rule. While black American artists were often powerless to organize festivals pertaining to the carriers of their culture, such as those centering on birth, death and the harvest of crops, they managed nevertheless to keep alive those salient beliefs which communicated their displeasure in being a displaced African people. The magic of those visual forms which survived the ordeal of slavery in the United States, the Caribbean and South America, is convincingly part and parcel of an ongoing African sensibility in the Western world.

Much of what we know about our African legacy in the fine arts came to the attention of American scholars during the Harlem Renaissance. Indeed, Africa became the unifying theme among artists of the Harlem Renaissance and for many others who lived in various cities throughout the nation. One inspiration for this movement was the example of Meta Warrick Fuller, a Philadelphian whose sculpture was exhibited as early as 1902 in the celebrated exhibition at S. Bing's Gallerie L'Art Nouveau in Paris. When she returned to the United States the following year, she continued to create works whose themes reflected African folk tales and rituals, thereby setting an example for other black American artists to emulate. She was followed in the depiction of African-related subjects by Aaron Douglas, whom Alain Locke singled out as "the father of Negro art" in the New Negro Movement. Since these two pioneering artists showed their allegiance to African themes, the ancestral legacy of African art has grown measurably in creative and scholarly pursuit in the United States. In 1939, a survey of black American artists conducted by the Harmon Foundation revealed that just over four hundred were at work in the United States. Today, more than three thousand artists of African ancestry are practitioners of the visual arts in America.

Since the advent of the New Negro Movement following World War I, American art has experienced the making of a renaissance that is helping to redefine the boundaries of its vast cultural territory. Once recognized for those visual forms which drew heavily on European sources, modern American art is becoming more comprehensive in its outreach toward cultural diversity, much of which is visible in the art that has been created by persons of African descent. The result should be a more positive and holistic view of art and history, a new perspective unencumbered by the ills of racism, sexism and an adverse nationalistic temperament in the arts.

In the past two decades, we have witnessed a genuine scholarly interest in those areas of the arts which historically have omitted the visual achievements of women, blacks and other minorities as contributors to American visual culture. Our knowledge of these important areas of creativity has been greatly enhanced primarily through a series of important exhibitions which have documented the diversity of modern American visual culture.

Black Art: Ancestral Legacy joins the ranks of those exhibitions which have helped to define new horizons in American visual culture. By putting its hand on the real impulse of Africa in the Americas, this exhibition explores in a comprehensive way the ancestral bonds which still exist among African artists and their descendants in the New World. Visual patterns that are easily recognized as having African origins are readily discernible in many of the works included in this exhibition. Yet, *Black Art: Ancestral Legacy* also shows in a profound way the diversity of black American creativity in the mediums of painting and sculpture. These artists celebrate their unique gift of artistry by imposing a particular sensibility that seems closely related to the art of Black Africa, whose art forms often serve as a functional aid to living. And while these artists seldom offer solutions to cultural problems with their work, still they continue to remind us that art is man's highest form of material communication and in it the message of form often goes hand-in-hand with social and cultural aspirations.

The artists whose works comprise this exhibition have aided our move toward redefining American art, a revisionist position warranted by the breadth and depth of American visual culture as documented in shows such as *Black Art: Ancestral Legacy*. In so doing, these artists also help to reaccess and redefine our nation's cultural boundaries to include the diverse contributions of all Americans who are practicing artists.

David C. Driskell
Professor of Art
University of Maryland

HERITAGE RECLAIMED:
AN HISTORICAL PERSPECTIVE AND CHRONOLOGY

EDMUND BARRY GAITHER

Groups of slaves as well as free Africans brought to the Americas were men and women who possessed a framework — religious, mythical, political, historical, psychological, and ontological — from which they drew the meaning of their lives. This framework with its myriad components provided a profound sense of relationship to their ancestors, nature and the world as they knew it. It constituted their culture. Africans from many cultures found themselves in this hemisphere where they were confronted with the reality of having to remake themselves; they had to change from being Africans in the Americas to being Afro-Americans. Herein lie the great and catalytic forces which have left all aspects of American culture greatly impacted by Africa. Whether Africans became maroons like the Djukas of Surinam, or revolutionaries as in the case of the Haitian revolt, or achieved some other level of accommodation or even assimilation as black people in this hemisphere, they have continued for several centuries to live in essentially black communities. This fundamental condition — the continual existence of black communities — is the most salient reason why there remains an Afro-American or black experience, a black socialization, a black psychological reality. Within the immensity of this presence, black cultural expressions have become potent indicators of the inner bonding of black communities as well as of the limitations imposed on those communities by racism and institutionalized prejudice as reinforced by economic structures. It is in this context that our present examination occurs.

Black culture, here defined as African cultural elements reworked and expanded, helped to assure the survival of Afro-Americans in their new socio-political and economic conditions. The impact of

1502

First Africans arrive in the New World.

1619

Arrival in Jamestown, Virginia, of a Dutch slaveship, launching the beginning of slavery in what was to become the United States.

1776

Toussaint L'Ouverture initiates the slave rebellion in Haiti, which eventually leads, in 1804, to the establishment in Haiti of the first independent black republic in the Western Hemisphere.

1787

Absalom Jones and Richard Allen organize the Free African Society in Philadelphia, precursor of the Bethel African Methodist Episcopal Church, founded in 1794.

1816

African Methodist Episcopal Zion Church is founded in New York. The American Colonization Society is organized in U.S. House of Representatives by Bushrod Washington, Henry Clay, and other white legislators to encourage blacks to return to Africa.

1822

Denmark Vesey's slave revolt erupts in Charleston, South Carolina.

1831

Nat Turner's slave rebellion takes place in Southhampton County, Virginia.

1835

Fifth National Negro Convention meets in Philadelphia and urges blacks to drop the use of the terms "African" or "colored" in referring to themselves or their institution.

1851

Publication of *Clotel*, the first novel by a black American, William Wells Brown.

1859

Abolitionist John Brown leads a raid on the federal armory in Harper's Ferry, West Virginia.

1861-1865

U. S. Civil War.

1867

Beginning of the Reconstruction era in what were formerly "slave" states.

(Opposite) Meta Warrick Fuller, *Ethiopia Awakening*, bronze, 1914. Collection of the Schomburg Center for Research in Black Culture, The New York Public Library, Art & Artifacts Division.

black culture has been pervasive, but its more African aspects were most richly retained in those areas, mostly in a Southern matrix, where there were significant numbers of blacks living continuously in black communities. African elements have remained alive as fragments in all areas of the cultural life of blacks, but especially in speech, dance, music and religions in the rural South.

Music has always been the preeminent cultural form in Africa. While black churches in the American South served to preserve aspects of traditional music, they failed to become institutional patrons of black visual artists. An integral part of funerals and other African ceremonies, the ritual use of visual arts was discouraged by Protestantism. And other social institutions which might have sponsored development of the visual arts, such as universities or museums, were virtually absent in the rural South until the mid-19th century.

Without a significant role to play in religious or ceremonial functions, the African creative impulse of American black artists was directed into folk and utilitarian art, especially in objects for personal use, such as canes and other small decorative items. The artistic impulse to express personal, often religious visions later became objectified in paintings, sculpture and the constructed environment.

Eighteenth-century blacks in the East and mid-Atlantic areas did not live in distinctly black environments. Instead, they formed small groups which were integrated into the life of their local communities. Colonial black and white identities merged as American during the struggles against England, and following the Revolution, free and servant blacks increasingly adopted the values of the larger society.

As evidenced by the poetry of Phillis Wheatley and the artwork of Scipio Moorhead, the educational and cultural values of progressive blacks of the period were directly inspired by European aesthetics and technical models. Like other provincial artists, Afro-Americans had limited opportunities for training and, consequently, relied heavily on secondary sources for professional development. Both Afro-American and American fine arts had conservative beginnings with a limited range of acceptable subjects, treatments and aesthetic assumptions derived from other traditions, and this emphasis continued through the 18th and 19th centuries.

The Ancestral Legacy

Twentieth-century Modernism brought innovation and experimentation to the visual arts for black and white Americans. The impact of the encounter between African art and European art was

radicalizing for both, though in very different ways. European and white American artists responded to the audacity of African forms, to their emphatic *thingness*, and to their refreshing departure from "art as imitation of nature." The appeal of African art to European artists was its bold forms and its freedom from strict naturalistic canons. Out of his encounter with African art, Picasso and his circle originated Cubism, the formative movement of modern art. Although a small number of Afro-American artists produced cubistic works in the first third of the century, Afro-American artists by and large viewed African art as part of their spiritual heritage, as part of their legacy. For Afro-Americans, Africa was a recurrent theme with implications for all aspects of life — political, social, and religious.

Meta Warrick Fuller's sculpture, *Ethiopia Awakening* (1914), symbolized the complex meaning of Africa for black Americans. The work recalls the observation made by William E. B. Du Bois in *Souls of Black Folk* that race would be the dominant issue of the 20th century. It also reiterates the popular image of Africa as a sleeping giant, one that would once again come into its own and recover its ancient Egyptian/Nubian glory. Fuller depicted Ethiopia in allegorical terms — sighing deeply and beginning to stir with renewed self-awareness — a work of such African consciousness that it is an all-encompassing declaration of heritage. *Ethiopia Awakening* stands at the head of a direction in Afro-American art which was to become increasingly important: the reclamation of African themes and styles in the remaking of black American identity.

It is vital to recall that Africa is an inseparable element in black American racial consciousness. From the 18th century forward, many Afro-Americans chose to identify themselves, their institutions and organizations as African. Phillis Wheatley's poem to the black painter, Scipio Moorhead, was titled: "To S.M., An African Painter." The African Methodist Episcopal Church and the African Methodist Episcopal Zion Church, as well as many independent African Baptist churches, are testimony of the use of "African" as a proper appellation for American blacks. Pre-emancipation and post-emancipation controversies over how blacks should identify themselves — African-Americans, Afro-Americans, Africamericans, Negroes, Colored, blacks, *et al.* — underscore the centrality of Africa to black self-concepts.

Following the Civil War and during the Reconstruction period, radical changes took place in the socio-political matrix of blacks. The end of slavery brought opportunity and challenge in creating new roles for individuals and communities. Black "normal" schools, colleges, and universities appeared in the South and the mid-Atlantic. Some, such as Hampton, embraced service to Africa as

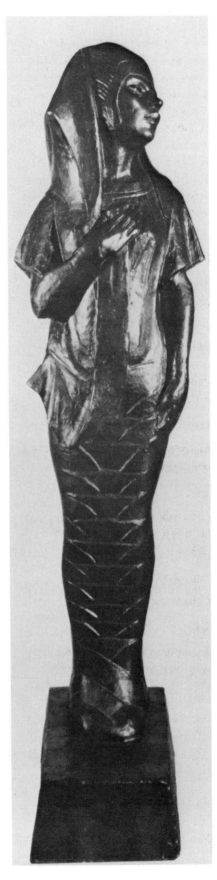

1902

William Marion Cook's musical satire, "In Dahomey," opens in New York and is among the first of a number of productions that focuses on African themes.

1903

W.E.B. Du Bois' *Souls of Black Folk* is published. This collection of essays introduces the idea that in the 20th century Africa, "the sleeping giant," will emerge as an important force in international politics.

1909

National Association for the Advancement of Colored People is organized.

1914

Ethiopia Awakening is completed by sculptor Meta Warrick Fuller. This sculpture introduces African subject matter into African-American art.

1916

Marcus Garvey arrives in New York from Jamaica and founds the Universal Negro Improvement Association, which raises the issue of a common African heritage to the general black public through the "Back to Africa" movement.

1917

United States enters World War I; 300,000 blacks serve.

1918

Beginning of the Great Migration of blacks from the South to the North.

1919

First Pan-African Congress meets in Paris. Under leadership of W.E.B. Du Bois, this convention includes African, Caribbean and African-American participants. Four subsequent congresses meet through 1945.

part of their mission. Self-help initiatives, inspired by Booker T. Washington and encouraged at Tuskegee Institute, swept the South and helped to lay the foundation for the emergence of the "new Negro" of the 1920s.

Simultaneously, a small group of black intellectuals, Du Bois paramount amongst them, began to forge closer relationships between black Americans in the United States and blacks in the Caribbean and Africa. The result was the Pan-African movement, an international vehicle for addressing the common problems and dilemmas of black people under colonialism and other modes of racial and economic oppression. This, too, helped lay the foundation for the "new Negro."

In the wake of World War I and as a consequence of the extraordinary migrations of southern black people to northern industrial centers, the Afro-American community underwent a remarkable transformation. Southern blacks, northern blacks, West Indians and even a few Africans crowded into newly created urban communities, shed their often rural, parochial 19th-century selves, and embraced a more aggressive and assertive, more urban and comprehensive identity. At the center of this new identity was the acceptance of African heritage as a shared legacy.

In this setting, Marcus Garvey's nationalistic Universal Negro Improvement Association declared: "Africa for Africans: At Home and Abroad." Theatre productions, such as "Dahomey," became possible and everywhere Harlem Renaissance writers and poets were asking, in the words of Countee Cullen, "What is Africa to me?"[1] This new identity unleashed a cultural explosion in blues and jazz, literature, dance, film and theatre. It called forth new institutional forms which have become associated with black urban communities such as storefront churches and gospel music. These changes were aided by the broader American cultural movement known as the "Jazz Age," and by the appearance of the record industry and the radio.

For artists, the twenties validated the use of African themes and stylistic elements as well as southern "folk" themes. These themes and the traditions which they implied became the reservoirs of black culture, the raw materials for sophisticated and gifted fine artists.

In his watershed 1925 work, *The New Negro*,[2] the black intellectual and aesthete, Alain LeRoy Locke, gave the new identity a name — the New Negro — and related it to a larger view of African culture. An early statement of his views on Afro-American and African visual art is provided in his essay, "The Legacy of Ancestral Art." A more complete statement of his thesis appears in *Negro Art: Past and Present*,[3] published a decade later.

Dr. Locke believed in a racial artistic temperament in the Jungian

sense, and he regarded this artistic perspective as unique to each race. Locke understood African (old Negro) art to be disciplined and craft-based. He saw it as one of the grand traditions of world art. Because he observed Afro-American art as lacking a unique direction, he concluded that black American artists had become separated from their natural artistic development as a consequence of slavery.

Afro-American (new Negro) art was viewed by Locke as imitative in that it was derived from European traditions. While he did not attack Afro-American artists working with themes and in styles which he viewed as extensions of European-American art, he did feel that they were denying their own rich heritage and alienating themselves from the uniquely creative possibilities of their own natural racial heritage.

Locke concluded that Afro-Americans needed to reclaim their ancestral legacy. To re-establish continuity with their heritage, he recommended that Afro-American artists study African art, and he sought to provide opportunities for direct study by making his own collection available as well as those of others.

Locke observed that Picasso and other European artists had encountered African art and derived from it seminal ideas for the birth of modern European art. Without understanding African art on its own merit, they had used its formal properties to liberate themselves. How, then, could Afro-Americans — descendants of those Africans — ignore their birthright?

Afro-American artists who had been formally trained also shared an interest with other American artists in new directions in modern art. Cubism was one of those directions. Hale Woodruff's *Card Players* (1930) and Malvin Gray Johnson's *Negro Masks* (1932) provide examples of black participation in American cubism. Somewhat later, one notes in Romare Bearden's *Factory Workers* the use of cubistic language.

Inspired in part by collections such as those of Alain LeRoy Locke and the Barnes Foundation of Merion, Pennsylvania, and by exhibitions at the Museum of Modern Art, in black college galleries and at other institutions, a growing number of Afro-American visual artists began to make direct use of African themes, images and stylistic elements in their works. Aaron Douglas frequently interpreted African and Afro-American subjects by using stylistic language strongly influenced by African flat patterns and designs. His illustrations for James Weldon Johnson's *God's Trombones* (1927), as well as his mural *The Aspects of Negro Life* (1934), illustrate this influence. Lois Mailou Jones' *The Ascent of Ethiopia* (1932) and *Africa* (1935), as well as Palmer Hayden's *Fétiche et Fleurs* (1933), are further evidence of the interest of Afro-American artists in African subjects.

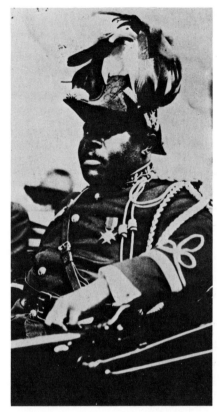

Marcus Garvey at 1924 convention parade in Harlem. Photo courtesy of the Schomburg Center for Research in Black Culture, The New York Public Library.

1925

Survey Graphic publishes a special edition on Harlem, edited by Alain Locke, in which Countee Cullen's poem "Heritage" appears with its famous line, "What is Africa to me?"

1926-1935

During this period the Harmon Foundation (established by New York philanthropist William E. Harmon) sponsors annual exhibitions for African-American artists. These are among the earliest exhibitions to feature works reflecting an exploration of the artists' ancestral heritage.

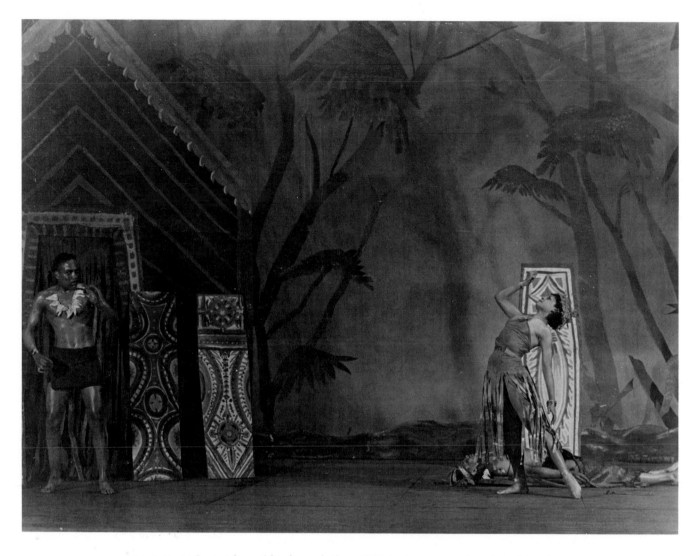

"Death Dance," scene from Richard Bruce's play *Sahdji*, 1931. Photo courtesy of the Schomburg Center for Research in Black Culture, The New York Public Library.

1930

The Black Muslims organization is founded by W.D. Ford, who is later succeeded by Elijah Muhammad in 1935. *Copper Mask* is created by sculptor Sargent Johnson. During this time, Johnson's work provides the most direct example of African-American art inspired by African art.

1935

African Negro Art, the first large exhibition of traditional African art at a major American museum, opens at The Museum of Modern Art, New York City.

Perhaps the most dramatic early use of African artistic language by an Afro-American can be seen in the works of Sargent Johnson.[4] In a remarkable series of copper masks produced in the mid-1930s, Johnson reinterpreted Baule sculptural traditions with both a profound respect for the elegant, geometrical forms of traditional Baule masks and an appreciation of the tenets of modern sculpture.

At the same time that Afro-American artists were discovering the beauty of African art, they were also embracing the acceptance of black genre, types and portraiture. Sympathetic treatment of black features and a compassionate presentation of the black experience were becoming dominant directions in Afro-American art. None of these directions had been widely present in 19th-century Afro-American art, and all of these approaches were to continue as important strains over the rest of the course of this century.

Going Home and Cultural Nationalism: The Fifties to the Seventies

Beginning in the 1950s and continuing through the 1970s, the Afro-American social, political and cultural matrix became increasingly radicalized. Major developments contributing to this included the Civil Rights movement, the rise of the Nation of Islam (popularly called Black Muslims), the emergence of post-Colonial Africa following the independence of Ghana, and the appearance of the black power movement with its cultural dimension subsumed under the battle cry, "Black is Beautiful." These socio-political events, in turn, precipitated a complex of visual, literary and performing arts expressions broadly called "black art."

In the decade following World War II, Afro-Americans increasingly relied upon the courts — especially the Supreme Court — in their efforts to gain civil rights. Several victories were achieved, including the 1954 school desegregation ruling, but the pace of change was too slow, and racial discrimination and "Jim Crow" practices continued to confront blacks on every hand. Feeling a need for greater progress in collapsing racial barriers, the southern Civil Rights movement adopted direct action as a tactic in the second half of the fifties. Buses were boycotted in Montgomery, Alabama. The SCLC (Southern Christian Leadership Conference) was formed. CORE (Congress of Racial Equality) extended its work into the South, and SNCC (Student Non-Violent Coordinating Committee), was organized. Students at black colleges and universities, as well as ordinary black people, took to the streets in a moral campaign which reached its apex in the March on Washington in 1963.

In the East and the Midwest, the teachings of Elijah Muhammad were having an impact. The Nation of Islam was growing and its most articulate minister, Malcolm X, was inspiring urban black youth by his courage and his sense and expression of black manhood. The Nation of Islam offered black Americans a counter identity as black Muslims with an Afro-Asiatic lineage.

On the international scene, Ghana achieved independence in 1957 and entered the United Nations. Forging a strong identification with Afro-Americans, Ghana and Kwame Nkrumah, its president, became symbols of the ascent of black people worldwide. In the wake of Ghana's independence, most of the remaining colonial territories in the Caribbean and in Africa also became self-governing nations. It was a period of great optimism.

In the second half of the sixties, American cities became cauldrons of ferment as the Civil Rights movement gave way to militant nationalism or to more pragmatic efforts to gain political

1936

As part of the Texas Centennial celebration, Alonzo Aden creates an exhibition for the Hall of Negro Life at Fair Park in Dallas. 93 works by 38 artists are featured.

1937

Les Fetiches is painted by Lois Mailou Jones.

Lois Mailou Jones, *Les Fetiches,* oil on canvas, 1937. Collection of the artist. Photo courtesy of the Museum of the National Center of Afro-American Artists, Inc.

1941

The exhibition *American Negro Art: 19th and 20th centuries,* organized by Alain Locke with assistance from the Harmon Foundation, is held at the Downtown Gallery in New York City.

1942

Native Son is published by Richard Wright. The Congress on Racial Equality (CORE) is organized.

1941-1945

World War II.

1945

Dancer, choreographer, and anthropologist Katherine Dunham choreographs *Carib Song* inspired by her travel and study in Haiti.

1947

Presence Africaine, a journal devoted to African culture, is established by Alioine Diop in Senegal.

1953

Following her marriage to Haitian artist, Louis Vergniaud Pierre-Noel, Lois Mailou Jones establishes a second residence on that island.

1954

Brown vs. Board of Education case is decided in favor of school integration by the U.S. Supreme Court.

1955

Rosa Parks begins the Montgomery, Alabama bus boycott.

1956

Ghana achieves independence marking the beginning of the Post-Colonial era for Africa and the Caribbean.

1957

The American Society of African Culture is organized in the wake of the First International Congress of Negro Writers and Artists. Texas artist John Biggers travels to West Africa.

1959

The first organizational meeting of The National Conference of Artists convenes at Atlanta University. Among the founders are Dr. Margaret Burroughs, Jack Jordan, Marion Perkins, and James Parks.

power (e.g., Mississippi Freedom Democratic Party). Confronted by growing poverty, injustice and disillusionment, urban ghettos exploded with riots. Defiance and confrontation replaced passive resistance, and cries of "black power," "by any means necessary," and "We are an African people" were heard. The death of Martin Luther King, Jr. in 1968 further inflamed black communities. Black issues and concerns became America's number one problem.

Another Afro-American identity was forged as a result of these events, as the label of "Negro" was replaced by the more radical term, "black." James Baldwin's name became known, and Leroi Jones changed his to Imiri Baraka. Everywhere, young black men began wearing dashikis and "Afro" haircuts, and young black women sported gèlès, African coiffures, jewelry and fabrics. As identification with post-Colonialism grew stronger, the adoption of African names became widespread and the reclamation of aspects of African heritage became ubiquitous in black communities. "Black is Beautiful" became a profoundly meaningful phrase.

Such was the matrix for three important developments in the visual arts: the appearance of works by Afro-American artists who had traveled to post-Colonial Africa; the appearance of artist groups committed to forging a militant black political art; and the appearance of a neo-African art concerned with reclaiming the symbols and features of African art.

Ghana became home for a while to several major figures in Afro-American art. Foremost amongst them was John Biggers[5] who arrived there in 1957. He had also traveled in several neighboring African countries, including the present Republic of Benin (then Dahomey) and Nigeria. A gifted narrative artist with a consummate mastery of drawing, Biggers was inspired to create a remarkable body of drawings and paintings of African life and environments. A work such as *Jubilee — Ghana Harvest Festival* (pages 248, 249) has the majesty and beauty of Paolo Uccello's *Battle of San Romano*. And his *Three Kings* (page 218) captures an intimacy and depth of character analysis which had escaped earlier efforts to depict Africans by artists who had not traveled there. A similar comment would be appropriate for the drawings and illustrations of Ghanian subjects by Thomas Feeling. Though much smaller in scale, Feeling's drawings testify to his love of the people and their acceptance of him. A third artist who was also an early visitor to post-Colonial Ghana was Herman (Kofi) Bailey, whose works frequently feature a heroic President Nkrumah with a black star in the background. At that time, Ghana provided the "home" to which Afro-American artists returned and reclaimed their spiritual heritage.

Since those early years of re-acquaintance with Africa, myriad Afro-American artists have made pilgrimages to Africa in order to

re-attach themselves to her spirit and legacy. Two world festivals have provided impetus for such travel: the First World Festival of Negro Arts, held in Dakar, Senegal in 1966, and FESTAC'77, held in Lagos, Nigeria in 1977. Indeed, the latter festival provided the largest exposure to Afro-American artists of both traditional and contemporary visual and performing arts in Africa. Many of the scores of participating Afro-American artists still reflect the impact of FESTAC'77 in their works.

Black art, as the term came to be used in the 1960s, may be described as:

> . . . didactic art form arising from a strong nationalistic base and characterized by its commitment a) to use the past and its heroes to inspire heroic and revolutionary ideals, b) to use recent political and social events to teach recognition, control and extermination of the "enemy," and c) to project the future which the nation can anticipate after the struggle (for freedom) is won.[6]

Proponents of black art were very concerned with its function and its place of location within the experiences of African peoples. Note the following from the preamble of the CONFABA convention held in Evanston, Illinois in 1970:

> Black art should be concerned with the African Heritage as much as with our contemporary reality.
>
> When we addressed ourselves to the problem of the function of art, it was explicit that the function of art is to liberate man in the spiritual sense of the word, to provide more INTERNAL space. Total culture is not only imposed upon man but it IS man in a greatly expanded sense.
>
> The heart of the Black Artist's ideology is the dedication of his art to the cultural liberation of his people. It is in this sense that Black art is decidedly functional, politically and spiritually, and it is not to be confused by the alienation concept of "art for art's sake" rather than art for people's sake.
>
> Black artists must engage themselves actively in the transformation of the environment — the buildings, the community, the streets that we walk on, the walls that enclose us, the schools that our children attend, our homes, the churches, mosques, abandoned refrigerators, abandoned cars, vacant lots, broken windows. We have to push for an explosion of colors into the black community. We must make the black communities sing and dance with colour and vitality.[7]

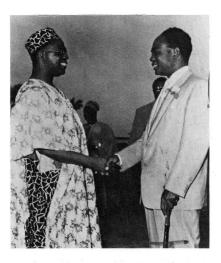

African leaders meet: Chief Awolowo Obafemi of Western Nigeria greets Prime Minister Kwame Nkrumah of Ghana, 1959. Photo courtesy of the Schomburg Center for Research in Black Culture, The New York Public Library.

1960

Student sit-ins in Greensboro, North Carolina mark the beginning of a broad range of student involvement in the Civil Rights Movement. Student Non-Violent Coordinating Committee (SNCC) is organized in Atlanta. Black Muslims flourish as their number exceeds 100,000. *West Africa Vignettes* by Elton Fax is published. This is the first book to document an African-American artist's travels to Africa.

1963

Death of W.E.B. Du Bois in Ghana. The March on Washington, D.C., at The Washington Monument, serves as the setting for Martin Luther King, Jr.'s "I Have a Dream" speech. The Museum of African Art/Frederick Douglass Institute is founded in Washington, D.C. *Black Scholar* magazine is founded.

1964

Malcolm X leaves the Nation of Islam to launch his Organization of Afro-American Unity in New York City. After converting to Islam, Cassius Clay changes his name to Muhammad Ali.

Muslims, c. 1960s. Photo courtesy of the Schomburg Center for Research in Black Culture, The New York Public Library.

These passages document an immediate and contemporary statement of the perception of leading figures in the shaping of the black art movement. It is necessary to understand the roots and objectives of this movement in order to appreciate how it spawned the AfriCobra group with its more specifically African emphasis.

The Wall of Respect, painted in Chicago in 1967, is regarded by many as the spiritual source of the black art movement in the visual arts. The Wall was the corporate concept of a group of Chicago artists who belonged to the Visual Arts Workshop of OBAC (Organization of Black American Culture). OBAC was founded in May 1967 by Gerald McWorter, a sociologist; Hoyt W. Fuller, editor of *Negro Digest* (later *Black World*); and Jeff Donaldson, an art historian and painter.[8] They were joined by several other members, including poets, musicians, dramatists, lawyers, professors and political activists. OBAC's goal was to "organize and coordinate the activities of art, dance, drama, literary and music cadres in support of the overall struggle."

The Visual Arts Workshop included: Jeff Donaldson, Eliot Hunter, Wadsworth Jarrell, Sylvia Abernathy, Barbara Jones, Carolyn Lawrence, Norman Parish, William Walker and Myrna Weaver (all printmakers); Billy Abernathy, Darrell Cowherd, Roy Lewis and Roy Sengstake (photographers); and Edward Christmas, (a mixed-media artist).

The workshop artists agreed upon the project of a mural as an expression of art consistent with the ideas in the previously cited preamble. By August of 1967, they had built a cooperative network among the merchants, gangs and neighbors in the community around the site of the proposed wall (43rd Street and Langley Avenue). They had also agreed to use "black heroes" as a general theme. And lastly, they had raised among themselves the money to finance the project. Before the completion of the Wall, the celebrated writer John O. Killens dubbed it the "Great Wall of Respect."

Following the completion of the project, differences developed among members of the Visual Arts Workshop and it splintered. Several of the original group (Donaldson, Hunter, Jarrell, Jones and Lawrence) then founded AfriCobra (African Commune of Bad Relevant Artists). Since 1968, a number of other artists have formally or informally associated themselves with AfriCobra, which still meets and exhibits works as a group.[9]

AfriCobra sought to give expression to the "Afrocentric impulse" in black art. Its announced goals were: "to impose a new visual reality on the world, and in the process, move the audience to a more profound realization of its inner possibilities."[10]

AfriCobra engaged its members in discussing and producing art

which utilized the urban black flair for "high energy" or bright colors, bold or "loud" designs, and African or non-western patterns and symbols. Its members wished to create a visual arts aesthetic which would parallel the "compelling intensity" of black music.

At the same time, AfriCobra intended that its art should contribute to black people's sense of nationhood as an African people in America. Consistent with this objective, it emphasized themes associated with family and with the protection of one's community. Frequent use was made of African or nationalist symbols, such as the "ankh" and "star and crescent" which adorn the ears of Shango's wives by Jeff Donaldson in the painting of the same title. Frequently, AfriCobra artists used words in their prints, paintings and fabricworks, and political and social phrases were artfully spelled out, their meaning impossible to miss. From the

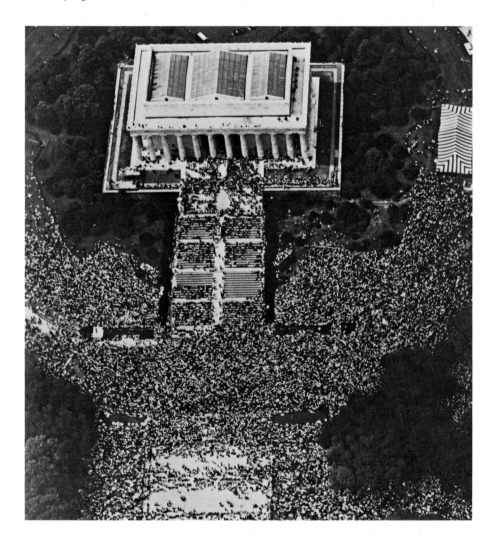

March on Washington, D.C., 1963. Photo courtesy of the Schomburg Center for Research in Black Culture, The New York Public Library.

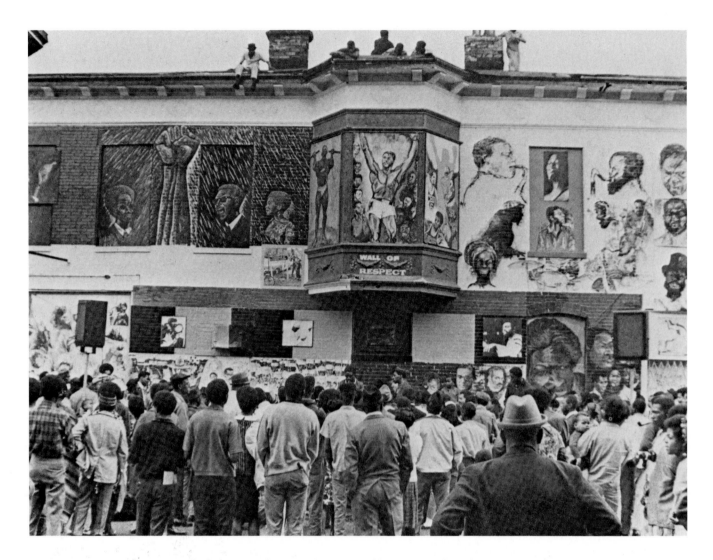

Wall of Respect and Community as One, Chicago, 1967. Photo ©1967 Roy Lewis.

beginning, AfriCobra artists sought to fuse political messages with urban black aesthetic ideas as expressed via colorful clothing, jewelry and coiffure, with African aesthetic values, such as surface lustre, irregular geometric patterns, and strongly felt rhythmic impulses. To this complex they added the use of foil and other shiny collage elements, as well as a rhetorical use of dualities such as sun/moon, male/female, or original/reflected. By integrating Afro-American and African visual elements, they created a widely recognized group style which internationally has been very influential. AfriCobra, though only one of many Afrocentric visual movements in the Americas, is nevertheless the oldest and most consistent artist group in the United States which espouses a synthesis of African and Afro-American stylistic elements in the service of an ideology of socio/political liberation.[11]

Afrocentric artist organizations also emerged in the 1960s in New York, with its rich mix of black people from the Caribbean. The most important and abiding of these is the Weusi group. Founded in Harlem in 1965, Weusi was organized as an association of artists which sought "to preserve, develop, promote and project African and African-American culture through the visual sciences,"[12] and to make available to ordinary people fine art at affordable prices. In 1969 the group expanded to become the Weusi Ya Sanaa Gallery and Academy of Fine Arts and Studies.

Weusi, whose name means black or blackness in Swahili, sought to achieve the first objective through its academy and its participation in exhibitions, public festivals and celebrations. The second objective was to be realized via its collectively held gallery which operated from 1967 until 1978. Among the artists who are/were members of Weusi are: Otto Neals, Abdullah Aziz, Kay Brown, Falcon Beazer, Taiwo DuVall, Abdul Rahman, James Phillips, Ademola Olugebefola, Bill Howell (deceased), Oko Pyatt, Jim Sepyo, Milton Martin, Rudi Irwin and Gaylord Hassan.

As an artist group, Weusi members may have shared an African heritage as a common point of reference, but their own styles were highly individual. Ademola Olugebefola, a spokesperson for Weusi, has produced a number of works which are closely akin to African art in their psychological presence (e.g. *Baba*) and which sometimes use popular African materials such as cowrie shells. His works retain a mystical, even mythic quality. By contrast, Gaylord Hassan's works are much more descriptive and narrative, drawing primarily on Africa for subject matter. James Phillips has evolved a style characterized by complex rhythmic patterns rendered in bold colors. It seems inspired not only by African design, but also by jazz. In spite of its diversity, Weusi, like AfriCobra, has provided a matrix in which artists can work independently while benefitting from the stimulation of a shared perspective on the importance of their African heritage.

Both AfriCobra and Weusi helped to establish an iconography expressive of black art and neo-African themes. Among the elements of this iconography are: the use of the colors red, black and green to express black nationalist sentiments; the clenched fist to represent defiant black power; the star and crescent to symbolize the Nation of Islam; the double axe to represent Shango, specifically, and African religious heritage in general; the ankh to recall ancient Egyptian heritage, or more generally, cultural nationalism; and the frequent use of zigzag patterns and other African derived designs. Together, this complex of symbols provided a language with which to express twin sentiments of the reclamation of African heritage and the political objectives of "black power."

1965

Malcolm X is assassinated in New York City. Civil Rights march from Selma to Montgomery, Alabama. Urban riots begin in Watts, Los Angeles, and Chicago. Weusi, an artists' group, is founded in Harlem.

1966

First World Festival of Negro Arts is held in Dakar, Senegal. The Black Panther Party is founded by Huey Newton and Bobby Seale in Oakland, California.

1967

The Nyumba Ya Sanaa Gallery is founded in New York City by 5 members of the Weusi group. *The Wall of Respect* is painted by members of the Organization of Black American Culture (OBAC) in Chicago. H. Rap Brown becomes chairman of SNCC.

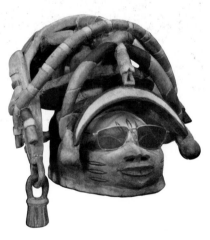

Symbol of AfriCobra (Yoruba gelede mask with sunglasses), late 1960s. Photo courtesy of the Museum of the National Center of Afro-American Artists, Inc.

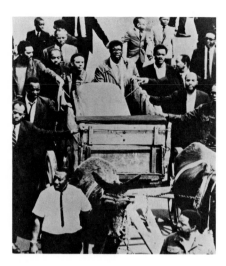

Martin Luther King, Jr. Funeral Procession, Memphis, April 3, 1968. Photo courtesy of the Schomburg Center for Research in Black Culture, The New York Public Library.

1968

CONFABA (Conference on the Functional Aspects of Black Art) is held in Evanston, Illinois under the leadership of artist Jeff Donaldson. The First National Conference of Black Museum and Museum Professionals is held in Detroit. OBAC becomes COBRA (Coalition of Black Revolutionary Artists) and later AfriCobra (African Commune of Bad Relevant Artists). Martin Luther King, Jr. is assassinated in Memphis.

1969

African Arts Magazine is established at University of California at Los Angeles (U.C.L.A.). Cinque Gallery is founded in New York City by Romare Bearden. *New Black Artists* opens at The Brooklyn Museum. *30 Contemporary Black Artists* is exhibited at the IBM Gallery in New York City. *Harlem on My Mind* is exhibited at the Metropolitan Museum of Art in New York City. *Invisible Americans: Black Artists of the Thirties* is presented at The Studio Museum in Harlem.

Beyond the Obvious

So powerful has been the sense of African heritage as a black American legacy that virtually all Afro-American artists have produced at one time or another African-inspired works. Yet these works have differed considerably in the ways in which Africa's impact has been rendered. Some artists have been content to pursue African themes as subject matter; some have sought to integrate its formal elements with their own personal styles, and still others have assigned themselves the extraordinary task of creating a new — perhaps even hybrid — art that will result from merging formal and psychological elements of black American and African cultural traditions. These artists seek transformation via their interaction and adaptation of African art.

The most obvious application of African inspiration in Afro-American art is the narrative use of themes from the "motherland." These uses often correspond to familiar — sometimes even stereotypical — images of Africa and its people. Richmond Barthe's *Wetta* and *African Dancer* of 1933 (page 158), for example, are evocative figurative sculptures which capture both the energy and grace of traditional dance. But they are also familiar and accepted characterizations of black people as a sensuous, rhythmic and primitive people. Ambiguity, as raised by such works, is a near inescapable aspect of black creative life, caught, as it often is, between its own inner motivations and racist, pejorative and social stereotypes. Over the last three decades, narrative themes have grown more diverse and complex, largely as a result of travel by Afro-American artists to the continent. *Meat Market, Nigerian Series* (1964) was inspired by Jacob Lawrence's trip to Lagos and Ibadan in 1962. It does not rely upon a romantic imagination, but rather recalls the actual frenzy of a traditional open-air market in post-Colonial Nigeria. In the painting, Lawrence captures the impression of the market as viewed from a nearby elevation, but he has rendered it in his well established and respected personal style.

Historical knowledge of Africa's artistic past has grown rapidly over the course of this century. Little was known of the treasures of the Benin Empire before the first World War, but as the bronzes of the Oba and his court emerged into the light of modern art history, they became icons for Africa's rich artistic past. These icons frequently provided materials for the collages of many black artists, including Romare Bearden whose *Guitar Executive* employs a Benin mask for a male face and who used a fragment of a Benin ivory for the mother in his *Mother and Child* (1976). Lois Mailou Jones, an extraordinary artist whose career stretches from the late 1920s to the present, has also used visual quotes from African art, such as in

Homage to Senghor (1976) where an Ife head underscores Leopold Sedar Senghor's role in vindicating historic African heritage through the Negritude movement. In all of these cases, African art has served to link black experiences across time and history by referring to its early masterpieces.

More typically, Afro-American artists concerned with asserting African heritage have incorporated its iconographies as well as its dominant formal elements into their own styles. In the process, they have freely appropriated designs, patterns, and a large body of highly abstracted symbols. *Sudanesia*, completed in 1979 by Lois Mailou Jones, features two highly stylized costumed dancers. The first wears a *kanaga* mask with its characteristic crocodile superstructure, while the second, with arms raised, wears a Bobo mask. Jones mixed symbols to give the painting a greater compositional resolution. A more dramatic juxtaposition can be seen in Jones' *Ubi Girl from the Tai Region* (1972) in which a partially painted face in trompe-l'oeil is imposed over a profile of a mask and several passages of flat African patterns. Artistic explorations of the theatrical possibilities of visual counterpoints is as much the subject of *Ubi Girl* as its numerous African references. Here, as is often the case, African-inspired elements are important, but they are subordinate to the expressive needs of the artist.

Many Afro-American artists whose careers took shape in the early seventies and who benefited from traveling to Africa in their formative years, have sought to fuse Afro-American and African traditions. Such a prospect has attracted them because they view African art in a fundamentally different way. Whereas earlier Afro-American artists tended to view African experiences as distinctly unrelated to their Afro-American experiences, younger painters and sculptors have often viewed themselves as being psychologically at one with Africans. This more intimate view of Africa and its people has resulted from several factors. Today's Afro-American artists are more likely to know Africans personally, including artists who are of the same age; Afro-Americans are generally more knowledgeable about Africa, since many have traveled there; and artists, at both ends of the continuum, feel that they share a common struggle to reclaim their selfhood and dignity and to eliminate racism and Eurocentric prejudices. In addition, Afro-Americans and Africans have discovered a mutual taste in music, dance, and other social practices. While traveling in Africa, Afro-Americans have frequently encountered gestures, expressions, and other features of folklife familiar to their own backgrounds. In short, they feel at home with Africans in a way never before possible. This "at homeness," this sense of immediate familiarity has reflected itself in the desire of many Afro-American artists to reach beyond the *symbols* of Africa in

1970

Afro-American Artists, New York and Boston is exhibited at the Museum of Fine Arts, Boston. *Black Art — International Quarterly* is founded by Samella Lewis. WSABAL (Women, Students and Artists for Black Art Liberation) is organized in New York City. AFRICOBRA I is exhibited at The Studio Museum in Harlem and at the Museum of the National Center of Afro-American Artists, Boston.

1971

Basketball star Lew Alcindor legally changes his name to Kareem Abdul-Jabbar.

First Mardi Gras Carnival is held in Brooklyn, New York by the West Indian community.

1974

Alex Haley's *Roots* airs on national television. Sixth Pan-African Congress convenes in Tanzania.

1976

Two Centuries of Black American Art, organized by David Driskell, opens at the Los Angeles County Museum of Art.

1977

FESTAC '77, The Second World Black and African Festival of Art, is held in Lagos, Nigeria. Alex Haley's *Roots* airs on national television.

1984

Primitivism in 20th Century Art/Affinity of the Tribal and the Modern is organized by The Museum of Modern Art, New York City. The National Conference of Artists, the oldest organization of African-American artists, holds its first international meeting in Dakar, Senegal. The group leaves a commemorative plaque at Goree Island, a former slave port.

order to grasp the *reality* of Africa. It has become more important to tap the African inner life than to pay homage to her facade, more urgent to know her spirit than to describe her features. Synthesis of the two experiences has become an important objective for many artists.

The psychological reclamation of Africa has required recovering an inner sense of her spirituality, her legends and myths, her love of rhythms and color. Improvisation, inventiveness, boundless variations within tradition, *àshe* (the creative power to make things happen), all of these factors have become the informants of artists as they strive to apply a more comprehensive understanding of Africa in their works. Alfred Smith, Jr., for example, looked for an artistic language that would unite urban black America and Africa. After a number of early works, such as *Beginnings, Endings, Beginnings* (1973) and *Concert In the Sky*, he painted *King and Queen of Harlem* in which the figures are black Americans. Clothed in richly patterned African fabric and backed by a gold foil sun and a silver moon, the "king" and "queen" of Harlem possess the "smarts" of city dwellers, the boldness in color and pattern of an African market, and the universality of children of the sun. The spirit that fills them is primordial, one that arises from the ancient civilization of Egypt. This quality is not incidental, for Smith spent many years studying and exploring the art of Egypt and Nubia.

In his work Charles Searles, a contemporary of Smith's, reflects his African travels differently. Seeing Africa essentially in rhythmic patterns derived from dance and marketplaces, he produced a series of paintings in the mid-1970s in which several dance themes share a reduction of figures to flat shapes against a plain ground. In *Dancer*

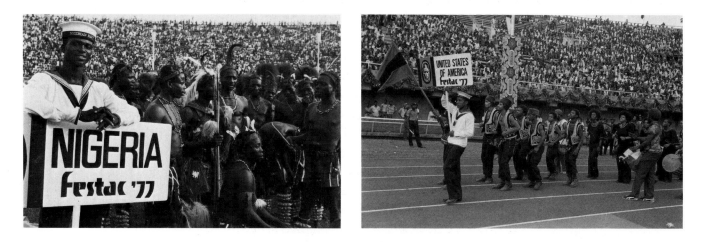

Nigeria Festac 77 (Nigerian contingent during opening ceremony), 1977. Photo ©Marilyn Nance 1989.

Festac 77 (U.S.A. contingent led by an African-American dance troupe during closing ceremony), 1977. Photo ©Marilyn Nance 1989.

Series (page 237), for example, each figure, striking a dance gesture, is fully costumed in profusely patterned fabrics. As an ensemble, the dancers create a strong rhythmic but repetitious movement across the canvas. Like Egyptian figures, their heads are in profile though their bodies are not. The top and bottom margins of the paintings are also decorated with ribbons of colorful African patterns. Friezelike, the works stand out not only for their emphatic repetition of the dancer motif, but also for their sophisticated use of bright colors. It is important to note that there are no two identical dancers in the Searles' work. Instead, the dancers exhibit the African principle of infinite variations within a tradition. James Phillips, a member of the Weusi group, also makes a provocative use of African designs. Works such as *Bazu* (1974) liberate African patterns and designs completely from representational obligations. These formal elements take on the quality of black (African or Afro-American) music with its improvisational character. By color and shape, accents, and crescendos, jazzlike percussive effects are conjured. Dematerialized, the *àshe*, the creative force that informs African and African-derived experiences, pervades the work and gives it a profound energy and presence. *Bazu* is not African art; instead, it is the essence of the "will" that creates African art: the wellspring of creative drive in the world's black people. It is a visual equivalent of the impetus behind jazz, soul, and "juju" music.

Much of African art is concerned with ritual functions associated with magico-religious presences. A requirement of this aspect of African heritage is the ability to objectify psychological realities, to give form to what is otherwise only real at the level of the intuitive. Vincent Smith and Kofi Kayiga are both artists whose works spring from a study of African art and heritage and a thorough digestion of its lessons. Their works, while generally expressionistic in character, derive strength also from a study of African philosophy. Smith began studying African art in the early 1950s at The Brooklyn Museum, while Kayiga, Jamaican by birth, studied African art and religion in Uganda in the early 1970s. Neither artist consistently uses African themes or titles in his work, but both acknowledge retaining African aspects and qualities.

Several Afro-Americans have distinguished themselves for their sculptures which, while closely related to traditional African models, are uniquely contemporary. Two such artists are Edgar Sorrells-Adewale and Vusumuzi Maduna. Born in Philadelphia and educated at Pennsylvania State University, Edgar Sorrells-Adewale participated in FESTAC'77 in Nigeria. His experiences with Africans and African art are primary sources for his remarkable, mixed media sculptures which use feathers, plaster, sand and dry straw in creating mask-like objects of great beauty. *In the Beginning was the Word* (1975) is a

1985

TransAfrica organizes protests against South Africa's policy of apartheid.

1986

Wole Soyinka of Nigeria is awarded the Nobel Prize in Literature.

1987

Toni Morrison's novel, *Beloved*, wins the Pulitzer Prize.

1988

The Reverend Jesse Jackson runs for president, wins over 6.6 million votes in the Democratic primaries. The National Conference of Artists meets in Brazil. The first National Black Arts Festival is held in Atlanta.

1989

U.S. Representative Mickey Leland, Founder and Chairman of the House Select Committee on World Hunger, dies in plane crash in Ethiopia on August 7, 1989 during mission to visit Fugnido refugee camp.

1. Countee Cullen, "Heritage," *Survey Graphic,* "Harlem, Mecca of the New Negro" March 1925, New York City, p. 674.

2. Alain Locke, *The New Negro* (New York: Albert and Boni, Inc., 1925).

3. Alain Locke, *Negro Art: Past and Present* (Albany: Albany Historical Society, 1933).

4. *Sargent Johnson: Retrospective* (Oakland: The Oakland Museum, 1971).

5. John Biggers, *Ananse: The Web of Life in Africa* (Austin: University of Texas Press, 1967).

6. Edmund Barry Gaither, *Afro-American Artists* (New York and Boston: Museum of Fine Arts, Boston, 1970), p. 191, and the Center of Afro-American Artists, Boston.

7. Program for CONFABA, Conference On the Functional Aspects of Black Art, Northwestern University, Evanston, Illinois, May 1970.

8. This information and the following comments about the Visual Arts Workshop are expanded upon in Jeff Donaldson, "Upside the Wall: An Artist's Retrospective Look at the Original 'Wall of Respect,'" *The People's Art: Black Murals, 1967-1976* (Philadelphia: Afro-American Historical and Cultural Museum, 1986), pp. 3-6.

9. Members of AfriCobra listed in the program booklet for CONFABA included: Sherman Beck, Jeff Donaldson, Napoleon Henderson, Joe Jarrell, Wadsworth Jarrell, Barbara Jones, Omar Lama, Amir Nour, Robert Paige, Nelson Stevens, Douglas Williams, and Gerald Williams.

10. *The People's Art: Black Murals, 1967-1976,* p.7

11. After the early seventies, many AfriCobra artists moved to other cities such as Boston, Washington, et al., thus spreading its influence still more widely.

12. Ademola Olugebefola, *"The Weusi: A Legacy Continues,"* a lecture presented April 18, 1989 at the International House in New York City on the occasion of the New York National Black Memorabilia Exhibition.

round disc surmounted by a feather. At the top of the disc is a small abstract mask bordered by an irregular arching band of "u" shaped lines. Surrounding this band are double sets of zigzag patterns above three smaller circles. A band of alphabet, two symbolic eyes, and an egg constitute a second face in the lower portion of the large disc. A variation on the "u" shaped patterns completes the work. Somewhat akin to a *guli* mask, this structure is oddly African in its presence. *Elder King*, another work of the 1970s, seems like a large raffia-covered bird with a feather disc for a face and a plaster tablet for a stomach. A small, circular mask appears in the location of the naval and from it hangs small Yoruba ritual bells and other devices. *Elder King* has the feeling of a cult or religious object that possesses some mystical power.

Vusumuzi Maduna, working largely with wood scraps and other mixed media, re-interprets identifiable African sculptural traditions in new ways that are post-African. Though related to traditional works, he conceptualizes his works in terms of quite different values from those of traditional sculptures. He freely mixes elements from more than one ethnic heritage in the same piece, and often he simplifies its overall construction considerably. Retaining the natural surfaces of old wood staves while painting small surface areas, he creates works, such as his *Untitled* female, which take on a very elegant, contemporary feeling. Maduna's works have a lightness and energy without seeming overproduced. The Africa which they suggest is tomorrow's Africa; it is the Africa of the quiet, reflective moment.

Although a great many other Afro-American artists belong to the discussion of the African theme in Afro-American art, a just treatment of the topic would require a great deal more space. Nevertheless, it is vital that we realize the persistence of Africa in all aspects of Afro-American life. Africa is at the foundation of black American identity, yet its relationship to that identity is always changing. Artists have reflected these changes through their works, leading us, in a broad way, from a romantic notion of Africa and Africans to an intimate grasp of Africa as another facet of ourselves.

Edmund Barry Gaither, Director of the Museum of the National Center of Afro-American Artists in Boston, currently is serving as president of the Afro-American Museums Association. Most recently he organized an exhibition of work by over forty African-American artists from Massachusetts for the Museum of Fine Arts, Boston.

AFRICAN ART AND AFRICAN-AMERICAN FOLK ART:

A STYLISTIC AND SPIRITUAL KINSHIP

REGENIA A. PERRY

The artistic and cultural heritage of Black Africa — that area south of the Sahara Desert — was formulated by its millions of inhabitants many centuries ago. From the prehistoric cave paintings of South Africa and the ancient stone architecture of Zimbabwe to contemporary examples, the artistic legacy of Black Africa has been profoundly creative and essentially spiritual in content.

More than 300 years have elapsed since the first slaves were taken from the west coast of Africa to South America, the Caribbean and the United States. Those slaves who survived the lengthy, often cruel transatlantic voyages were cast suddenly into unfamiliar environments, where every attempt was made to disassociate them from all memories of their homeland. However, an artistic heritage so rich as that of Africa is not easily obliterated, and the process of acculturation enforced by slave owners was far from successful. Evidence supports the fact that shortly after the first African slaves arrived on new shores, they began to fashion objects in styles they had known in their home countries. Some of the most tangible manifestations of African survivals in the United States can be observed in the coastal areas of the South.

Fig. 1. *South Carolina "Sweet Grass" Basket,* mid-19th century. Division of Community Life, National Museum of American History, Smithsonian Institution, Washington, D.C.

Basketweaving

The tradition of basketweaving in Africa is centuries old. Woven by men, women and children, African basketry is frequently charac-

terized by bold geometric patterns and employs a variety of weaving techniques. One of the earliest African traditions to be practiced in the New World was the weaving of "sweet grass" baskets in the Sea Island communities on the outskirts of Charleston, South Carolina.

These Sea Island baskets, produced by black female residents of John's, Sullivan's and Mt. Pleasant's Islands, are very similar to baskets still woven on the west coast of Africa. Certain regional traits characterize the South Carolina baskets, though, in particular a bold polychromy which is achieved by contrasting light and dark strips, and the use of the coil weaving technique (fig. 1). Lacking African materials, the Sea Island basketweavers employ convenient substitutes in local aromatic marsh grass (sweet grass) for the coil or body of the basket; split palmetto leaves, for the binding; needles of the long-leaf pine,

for the decorative brown bands; and, for the heavier baskets such as rice fanners, a rush for strengthening and reinforcement. A teaspoon, broken off at the bowl and with the narrow end of the handle fashioned in a wedge shape, is used to push openings in the tight coil of sweet grass and to thread the palmetto strips through it. The modified teaspoon and a pair of scissors are the only tools employed to produce these unique baskets.

The South Carolina "sweet grass" baskets have been compared with almost identical examples found in the coastal region of West Africa, from Senegal to Sierra Leone.[1] The stylistic similarities may be explained by the fact that large numbers of African slaves were taken from the Gambia-Sierra Leone area to South Carolina between 1752 and 1808.[2] African-American residents of the South Carolina Sea Islands, left until recently relatively isolated from Anglo-American cultural and aesthetic influences, have thus preserved the longest-surviving African craft still practiced in America.

Pottery-making

During the first three-quarters of the 19th century, a tradition of pottery-making was established in Georgia and South Carolina which is unique in the history of American ceramics. African slaves working in plantation potteries fashioned a number of small vessels which characteristically depict the human face. Unfortunately, these vessels have been identified for years by a variety of unflattering labels, including "voodoo pots," "monkey jugs," "plantation pottery," "slave pots," and "grotesque jugs." The most sophisticated and appropriate designation, "Afro-Georgian and Afro-Carolinian face vessels," was coined by Professor Robert F. Thompson of Yale University.[3] Thompson's nomenclature reflects the racial origin of the makers and the places in which they worked.

Made from local clay and glazed in a variety of colors ranging from light olive to dark green,

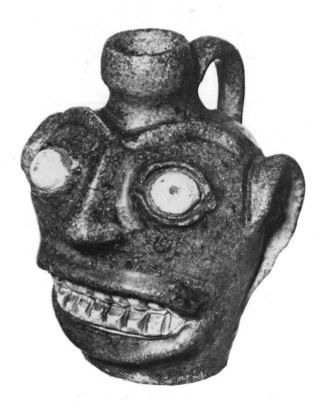

Fig. 2. *Afro-Carolinian Face Vessel*, South Carolina, mid-19th century. Division of Ceramics and Glass, National Museum of American History, Smithsonian Institution, Washington, D.C.

brown and black, these vessels vary in size from 1¼ inches to a foot in height. Their facial expressions run the gamut from laughing, smiling, and singing, to growling and gazing with a benign expression. Some of the most dramatic examples of these stoneware vessels employ kaolin, a white clay that remains white when fired, which the potters used for contrast in depicting eyes and teeth.

Several dozen of these remarkable vessels have been attributed to a talented African-American potter who worked at Louis Miles' plantation in Aiken County, South Carolina during the 1850s and 60s. Vessels made by this potter, dubbed the "Master of the Extended Eyebrows,"[4] are among the finest surviving examples. A splendid pot from this group and which features kaolin contrasts (fig. 2) may be compared with a male figure seated on an animal (fig. 3) from the Kongo tribe of Zaire to reveal several startling stylistic similarities. Both examples feature large, inlaid eyes, wide, open mouths with enormous teeth, and ferocious facial expressions. The stylistic links between African-American face vessels and African prototypes are such that it is quite possible that an African-born slave carver or potter transferred these stylistic tendencies to slave-made face vessels.

Considerable speculation has arisen concerning the function of face vessels, which are almost never signed or dated. Since their sizes and shapes vary greatly, their use as containers seems unlikely. A link with religion and the spirit world is not as easy to dismiss in view of the numerous African traditions which survived among slaves in the Deep South. Although most of the face vessels were made in Georgia and South Carolina, examples have been located as far north as upstate New York and as far west as Tennessee and Ohio. Generally, these vessels have been found in the vicinities of the Underground Railroads. Therefore, the vessels must have been important enough to escaping slaves to include among their most prized possessions.

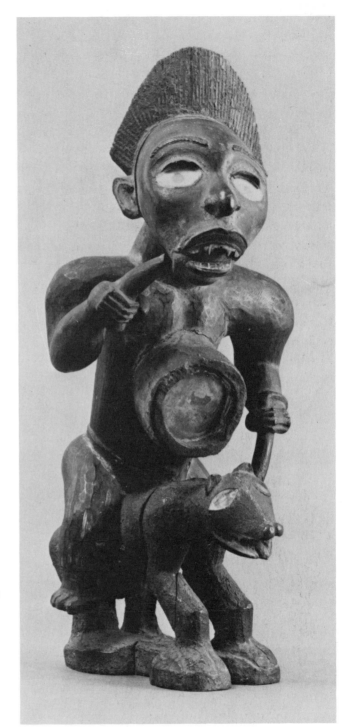

Fig. 3. *Figure, male seated on animal*, Zaire, Kongo, wood, glaze, paint, 19th-20th centuries. The Metropolitan Museum of Art, The Michael c. Rockefeller Memorial Collection, Purchase, Nelson A. Rockefeller Gift, 1966 (1978.412.531).

It is also entirely possible that these vessels were the embodiment of spirits and considered as good luck objects by their owners.

Quiltmaking

Although quiltmaking itself is not an African craft, quilts made by African-Americans bear striking stylistic similarities to certain examples of African textiles. An unusual example of a late 19th-century African-American quilt is Harriet Powers' *Pictorial Quilt* of 1895-1898 (fig. 4). The piece is one of only two surviving examples of this quiltmaker's art.[5] Harriet Powers was born a slave on October 29, 1837 near Athens, Georgia. The wife of a farmer, Armstead Powers, she apparently adopted quiltmaking as a hobby following her emancipation.

Harriet Powers' quilt is unique in its combination of 15 religious and astronomical subjects, each on a square of calico. Instead of employing the conventional quilting technique, Powers' colorful designs were appliquéd to the background squares. Legendary accounts of eclipses (Dark Day of May 19, 1780), meteors (Falling of the Stars November 13, 1833), red light nights (August 1 and 11, 1846) and extreme temperatures (Cold Thursday, February 10, 1895), were used by Powers in combination with religious scenes, apparently as a lesson of revelation and a warning to the sinful of the power of God.

The provenance of the c. 1895-1898 quilt, as well as the history of the Powers family, have been carefully researched and documented by folklorist and African-American quilt authority, Dr. Gladys-Marie Frye. Census records indicate that neither Harriet Powers nor her husband could read or write,[6] though Harriet was undeniably familiar with both the Old and New Testaments. Most of the Biblical heroes in her quilt are from the Old Testament: Noah, Moses, Jonah and Job — all of whom struggled against tremendous odds and are symbols of salvation and redemption. Powers' frequent representation of Biblical animals and characters were probably the result of her regular church attendance and the sermons she memorized.[7] It is entirely possible that Harriet Powers considered herself a prophetess who spoke of God's power through her quilt art.

There are no American prototypes for Harriet Powers' quilt designs. Her choice of subjects, the attempt to tell a complete story in each square, and the proportions of the figures are decidedly Western. However, the frequent appearance of animals and the use of appliquéd designs to illustrate a story is closely related to similar techniques practiced by the Fon tribe of the Republic of Benin (formerly Dahomey). For many centuries Fon craftsmen working at the royal palace at Abomey, Republic of Benin, have created colorful tapestries in which animals are frequently used to symbolize kings. African examples disregard formal ground lines, as in the case of the Powers quilt, but are generally not compartmentalized. A logical stylistic link between the quilt designs of Harriet Powers and royal Dahomean tapestries may be explained due to the large numbers of Dahomean slaves brought to Georgia during the first half of the 19th century.

Spirituality

The spirit world in West African societies is believed to be almost as real as the mundane one. Traditional West Africans are intensely spiritual, and religion, art and music are important and inseparable entities of that universe. Their religion is based on a triangular concept with a Supreme Being at the apex, and gods and ancestor spirits at the base points.

When African slaves were brought to the United States and indoctrinated into Christianity, the transition from polytheism to monotheism was relatively smooth. The fervor which accompanies the practice of African religions was carried over to Christianity, and manifests itself still today. It is not uncommon to observe

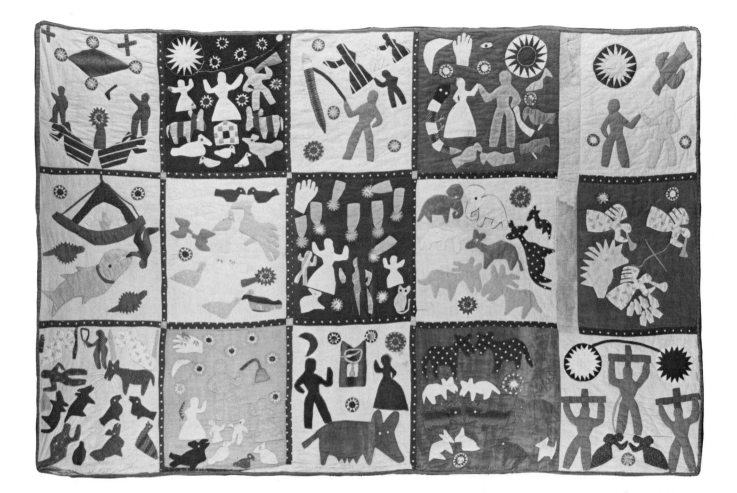

Fig. 4. Harriet Powers (1837-1911), *Pictorial Quilt*, pieced and appliquéd cotton embroidered with yarns, c. 1895-1898. M. and M. Karolik Collection, Courtesy, Museum of Fine Arts, Boston.

female members of African-American Baptist and Pentecostal churches being "struck by the spirit." These worshippers dance in frenzied movements which closely resemble the African state of being "possessed" or caught up in a trance-like state representing an apogee of religious fervor. This religiosity was also the motivation for the creation of Negro spirituals and slave work songs, which were perhaps the earliest indigenous categories of American music.

Animal imagery and walking sticks

Animals, birds, serpents and other reptiles have always figured prominently in traditional West African religions and mythology. There-

fore, it is not surprising that similar motifs appeared early on in African-American art.

The tradition of carving canes and walking sticks is a longstanding one in West Africa. In many African examples, crocodiles, tortoises and entwined serpent motifs embellish the surfaces of these objects. One of the most celebrated examples of an African-American carved walking stick was fashioned by a slave, Henry Gudgell, c. 1867, in Livingston, Missouri (fig. 5). The provenance of the Gudgell walking stick has been well-documented by Robert F. Thompson.[8] Born in Kentucky, Gudgell moved with his mother to Missouri where he assumed the surname of his master, Spence Gudgell. The Gudgell walking stick presents a lively repertory of abstract and realistic motifs carved in relief on

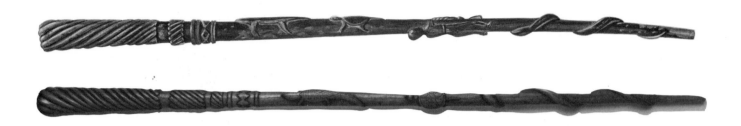

Fig. 5. Henry Gudgell (c. 1826-1895), *Carved Cane with Figural Relief, wood, c. 1867.* Yale University Art Gallery, Director's Fund.

Fig. 7. Henry Gudgell (c. 1826-1895), carved walking stick, wood, c. 1867. Collection of Allan Weiss. Photo courtesy of Allan Weiss.

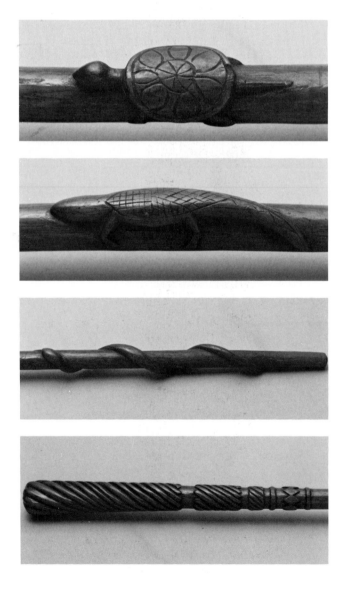

its surface. These include a slender serpent entwined near the bottom, a man with bent knees, a bent branch with a single veined leaf, a lizard and a tortoise. The man wears Western clothing and is "correctly" proportioned; however, the other motifs and their specific combination are African.

A comparison of the Gudgell walking stick with a bronze tube from the Benin tribe of Nigeria reveals striking iconographic similarities (figs. 5, 6). While the Benin tube is of metal and is a relatively isolated example, numerous examples of African carved walking sticks and certain contemporary African-American examples depict entwined serpents and reptiles. The Benin example depicts a serpent entwined around the tube and attacking a crocodile; the Gudgell walking stick probably suggests a chase. If the progression of motifs is read from bottom to top, the serpent gives chase to the man who hastily climbs a tree (suggested by the single leaf) while on the ground before the man, the lizard and tortoise flee.

Until recently, this splendid walking stick was believed to be the only extant example of Gudgell's woodcarving. However, a similar walking stick in a private collection is undoubtedly also by Gudgell. A comparison of the two (figs. 5, 7) reveals an almost identical treatment of the

handles which are expertly carved in powerful spiral grooves with a series of carved bands directly below. The walking sticks were probably carved about the same time. The recently discovered example also depicts an entwined serpent, crocodile and tortoise, but lacks the man and bent branch with a single leaf.

The combination of African and Western motifs on the documented Gudgell walking stick raises the question of influences. Kentucky, the state in which Gudgell was born, absorbed a large number of slaves from the coastal areas of the southern United States during the late 18th century.[9] Although documentary evidence does not allow a reconstruction of Gudgell's childhood, he apparently was familiar with the works of some African-American carver or carvers who had migrated to Kentucky.

Another unusual and richly carved walking stick with a Kentucky provenance probably dates from the late 19th century and is African-American (page 156). It also depicts entwined serpents, a fish, a crocodile, a leaf, boldly-projecting frogs at the branch points, and a splendid rattlesnake (with powerfully carved rattles at the end of its projecting tail) near the bottom of the stick.

The tradition of walking stick carving among African-Americans has, unfortunately, lost most of its momentum. Isolated examples may still be seen throughout the United States, but the Deep South and coastal Georgia are no longer major centers for the production of this craft. However, certain examples by a contemporary Chicago woodcarver are strikingly similar in style and spirit to African prototypes.

Born and reared in Chicago, David Philpot (b.1940) began carving decorative staffs as a hobby in 1971. Employing seasoned wood of the common ailanthus ("stink tree")[10] due to its availability, Philpot deftly carves intricate intaglio and relief designs on the surfaces of his creations, which he frequently stains in contrasting colors, or embellishes and inlays with leather, mirrors, coins, jewels and bangles

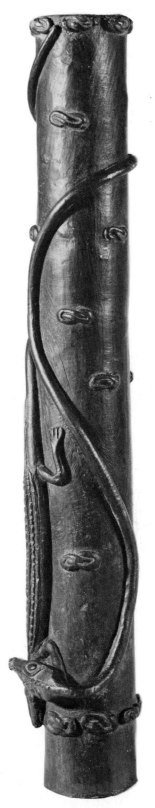

Fig. 6. *Benin Bronze tube,* West Africa (Benin tribe), 19th century. The University Museum, University of Pennsylvania (neg. 79299).

obtained from local crafts supply shops (page 247). The finished products have hand grips and are coated with polyurethane to create a gleaming crystal finish.

Since Philpot was entirely unfamiliar with African art, he initially disclaimed any stylistic association between his carved creations and similar African examples. However, after attending a local play in which actors wearing African apparel carried some of his staffs, Philpot stated that he felt an immediate spiritual connection between the content of the play, the African apparel and his staffs.[11]

There is no apparent stylistic connection between Philpot's frequent use of mirrors and other inlaid objects and the appearance of similar forms in African prototypes. Philpot has never traveled to Africa, or even to the Deep South, and he has not seen any examples similar to his works. The question arises as to whether the remarkable similarity between Philpot's staffs and the canes he began carving several years ago and African examples is coincidental, or is the African stylistic impulse so potent that it erupts, full-blown, in the works of an immensely talented woodcarver who is a continent and many generations removed from the original source.

The representation of bird, reptile and animal imagery and their relationship to spirits and the spirit world are well-documented in African cultures. Some interesting examples of this imagery can be observed in the home environment of Louisiana folk artist, David Butler (b. 1898) (fig. 8). This quiet, unassuming artist surrounded his home and filled his yard with a "fantasmagloria" of real and imaginary tin birds, animals, reptiles, humans, and whirligigs painted in vivid colors.[12] Butler believes that his tin figures possess a spiritual as well as aesthetic significance, and the numerous religious figures among his tin menagerie, including scenes depicting the *Nativity* and the *Visit of the Wise Men*, decorate window shutters which are closest to Butler's home and heart.

Like Philpot in Chicago, David Butler of

Fig. 8. Yard of David Butler, Patterson, Louisiana, 1970s.
Photo courtesy of David Butler.

Louisiana is unfamiliar with African art and its traditional representations of tortoises, serpents and birds. Similarly, Chicago folk artists, Mr. Imagination and Derek Webster, are also physically isolated from African examples, yet there are seemingly inexplicable evidences of Africanisms in their art, too.

Mr. Imagination (b. 1948) was born in Chicago and began his artistic career there by creating assemblage sculptures from objects he found in the streets and alleys. Since discovering an inexhaustible supply of sandstone molds discarded by a local foundry, Mr. Imagination has created hundreds of works from this material, which he easily carves using only a nail and file.

Fig. 9. Mr. Imagination, *Sandstone Feet*, sandstone, 1988.
Private Collection. Photo by Joel Breger.

Fig. 10. Mr. Imagination, *Self-Portrait*, mixed media, 1988.
Private Collection. Photo by Joel Breger.

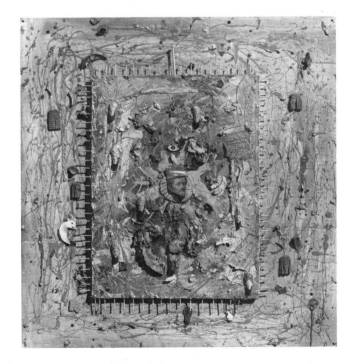

In his North Side Chicago neighborhood, Mr. Imagination is best known for his carved heads of African kings and queens, pyramids, sarcophagi, tortoises, reptiles and single eye motifs which are very Egyptian in style and spirit. There is no apparent explanation for the appearance of tortoises and coiled serpents among Mr. Imagination's carvings, nor for the existence of a group of sandstone feet which bear striking resemblance to terra cotta fragments from the ancient Nok and Owo cultures of Nigeria (fig. 9).

Though primarily a sculptor, Mr. Imagination also paints. One of his most unusual and atypical works is an engaging *Self-Portrait* of 1988 (fig. 10). In this Pollockesque assemblage-painting, Mr. Imagination depicts himself as king and crucified Christ. The central section, which is bordered with nails analogous to those used in the Crucifixion, renders the painting more personal and spiritual by virtue of the fact that they have actually been employed as tools by Mr. Imagination.

In *Self-Portrait* a small photograph of the artist wearing a silver crown confronts the observer

directly from below an all-seeing eye of the spirit. A large area of bright red paint, which serves as a foil for the central panel and photograph, represents blood shed by Mr. Imagination when he was shot and critically wounded by a Chicago gang in 1978.[13] Miniature sandstone heads of African kings are attached randomly across the painting's surface, and provide added three-dimensionality. In this powerful work, Mr. Imagination reveals his "soul," the pain and suffering he has endured, and a spiritual and biological kinship with his African ancestors. Intensely spiritual, Mr. Imagination has stated that he is fascinated by Egyptian royalty because of their belief in reincarnation.[14] The drip-painting technique, which enframes the background panel and is dominated by shades of blue, symbolizes Mr. Imagination's anxieties and his continuing struggle for physical and artistic survival.

Derek Webster (b. 1934) was born in the Republic of Honduras and grew up in Belize, Central America, in an environment completely devoid of art.[15] He came to Chicago in 1964 to visit his sister and decided to settle permanently. Webster did not begin to produce art until he purchased his present home ten years ago. Inspired to create something beautiful to decorate his home and yard, Webster is yet another example of the folk-artist environmentalist. He constructs figures and whirligigs from wood, creating complex abstract and geometric forms which he paints in bright enamel colors. The numerous sculptures which decorate Webster's yard and home (figs. 11, 12) appear to pulsate with the vibrancy of African drums and African-American jazz.

The interior of his home is also filled with wooden figures. From a small studio in a corner of his basement, Webster creates an incredible array of forms embellished with found objects, costume jewelry, his own wooden jewelry, sunglasses and a variety of appendages of wood putty. Mask-like faces appear constantly in Webster's sculptures, along with frogs, tortoises, delightful birds and acrobatic, Janus-form figures charged with tremendous vitality. Webster has also created a number of standing, life-sized figures with African mask-like faces, such as his figure with red horns of 1986 (page 181).

Another category of Webster's work is a series of abstract, free-standing pieces with flat wing-like projections embellished with costume jewelry, a pipe, sunglasses and other found objects (pages 180, 181). These sculptures project a vibrant three-dimensionality and recall West African ancestral shrines. Tortoises also appear frequently among Webster's creations (page 179), and he has recently created some examples from found stones.

Tortoises and serpents, both coiled and in motion, along with numerous animals and birds, may be observed also in the drawings of William Traylor (1854-1947). Born a slave on the George Traylor plantation near Benton, Alabama, between Selma and Montgomery, William Traylor did not begin his remarkable artistic career until 1939 when he was 85 years old. The majority of his numerous drawings were produced during a prolific four-year period. Traylor's style apparently emerged fully developed, and its consistently even quality attests to his intuitive artistic abilities. His works are simple yet powerful, as evidenced by *Serpent* (c. 1940) which is included in this exhibition and which slithers energetically across an imaginary ground line (page 154). Although Traylor was not exposed to African sculpture, nor did he have any knowledge of prehistoric cave paintings with which some of his stylized figural compositions have been compared, he did reside for many years on a southern rural plantation where birds, animals and serpents were a part of his

Fig. 11. Front yard of Derek Webster, Chicago, Illinois, 1989. Photo by Jane Stevens.

Fig. 12. Back yard of Derek Webster, Chicago, Illinois, 1989. Photo by Jane Stevens.

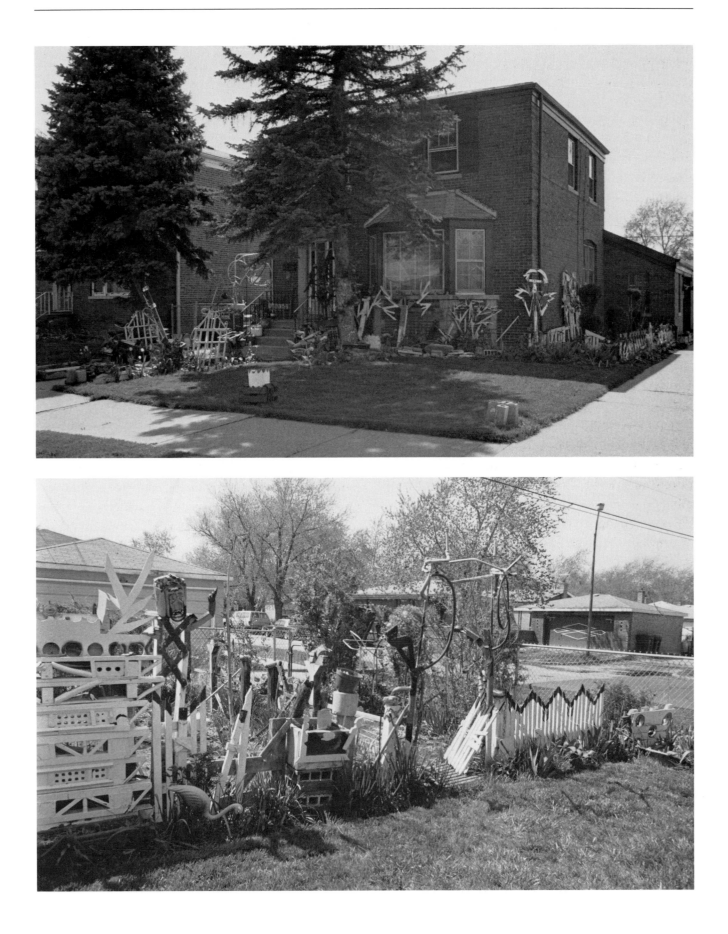

daily environment. In his art Traylor vividly recalled and depicted those plantation memories from his sidewalk studio in downtown Montgomery, Alabama, where he attempted to sell his drawings. Working with limited materials, mostly scraps of paper and discarded cardboard, Traylor created a body of work of over 2000 drawings that constitutes a collection of some of the most remarkable examples of African-American folk art.

One of the most spiritual and versatile forces among contemporary African-American self-taught artists is Bessie Harvey. Born in Dallas, Georgia in 1928, Harvey has lived in Tennessee during most of her adult life. She is intensely religious and credits the hand of God for authorship of her myriad complex creations. Employing found wooden materials, such as driftwood, roots, tree limbs and trunks, Harvey envisions figures in these abstract forms before embellishing them with paint, glitter, cowrie shells, beads, feathers, inlaid marbles, synthetic jewels and a variety of other found objects. Harvey's hauntingly beautiful figures pulsate with an intense spirituality. Birds, serpents, animals and fish figure prominently in her works. A natural piece of wood, resembling a fish with open mouth, was transformed by the artist, or re-born, to represent *Jonah and the Whale* (page 156). This small but powerful work has inset eyes for Jonah and the whale, and Jonah's bleeding body (complete with phallic symbol) is gripped tightly within the confines of the whale's prominent inlaid, razor-sharp teeth.

Harvey has completed a number of masks made of wood, foil, baskets and other found objects which are remarkably similar to African prototypes (page 185). Her masks are characterized by large staring eyes, and are liberally embellished with gold and silver glitter, shells, feathers, paint, sequins and costume jewelry. The multitalented Harvey also creates paintings, drawings, dolls, quilts, clay figures, metal sculptures and writes poetry.

Perhaps the most arresting of all Harvey's

sculptures are the large pieces created from wood which she gathers in the Tennessee hills near her home. Because she is able to visualize forms already existing in the wood, her task, she says, is merely to release them after she has meditated and contemplated their birth. Harvey believes the resulting sculptures represent a cohesive collaboration between herself, nature, and God.

To pieces of found wood Harvey incorporates additional pieces of wood, parts fashioned out of wood putty, paint, glitter, inlaid objects, and human dread-lock hair provided by a Rastafarian friend. The iconography in Harvey's large sculptures are often very complex, and entire groups are depicted in a single piece. A case in point is *The Family* (page 184) in which a mother, father and their offspring, all of whom are represented by a variety of mask-like forms, emanate from a central figure representing Mother Earth. A broader interpretation of this dramatic sculpture is that it stands for Mother Earth giving birth to all races of mankind, with her legs in an open, pulsating birthing position.[16] Of her ability to free figures from their wooden confines, Harvey says:

> You can go to a woodpile and all at once you see a face, in any piece of wood and, it looks like it's just asking for help, help to come out, you know. Take Horace. Well, when I first found him he was a big limb, but I knew he was a beautiful man, I knew that when I pulled him out . . . I said to him, "Ain't you pretty?" He said, "Granny, I ain't nobody." But I saw him and I just couldn't wait to get him home.[17]

Harvey's choice of wood as her primary material is not dictated entirely by availability, but due to her belief in the "spirit lives" of trees:

> Trees is soul people to me, maybe not to other people, but I have watched the trees when they pray, and I've watched them shout and sometimes they give thanks slowly and quietly. They praise God in this beautiful light, the flowers do, too, all these things do, everything but man.[18]

The spiritual significance which Harvey assigns to the wood used in her sculptures is an "Africanism" which is impossible to dismiss. Trees possess great spiritual powers in traditional African cultures, and sacrificial offerings are placed before certain trees which are felled for use as sculptures. The tradition of planting trees on graves in the belief that they possess a spiritual life is also a long-standing practice in Africa, and one that has been documented and traced from cemeteries in Zaire to similar practices on graves in African-American cemeteries in the southern United States.

Harvey's biological and spiritual kinship with Africa is also manifested through the African themes she assigns to her sculptures. *Blissful Blessing* and *Tribal Spirits* (pages 162, 222) are two such works. In *Blissful Blessing* Harvey deals with the African theme of *Kwanzaa* (Thanksgiving) and the difference between the rich and the poor, the "haves" and the "have-nots." A black female with Rastafarian hair, a skirt composed of draped strings of pastel beads and a straw hat, carries a basket of fruit, while several other figures bear a loaf of bread, jug of wine and additional fruit baskets. The remaining figures bear empty baskets and cooking pots, and are intended by the artist to represent the poor who will also share in the good fortunes of the rich.[19]

Tribal Spirits presents a group of large mask-like faces, each of whom has enormous inlaid teeth and eyes, attached to the base of a broad tree trunk. Each figure represents a different tribal group and the potential for internal and external strife within that group. All tribes experience some form of turmoil, but through faith they can rise above it, as indicated by the bird soaring above the group that symbolizes peace. The universal theme of *Tribal Spirits* is unity and love.[20]

Although Harvey has never traveled to Africa or studied African languages, she has read books on African history and culture, and uses an African-English dictionary for the African titles she assigns to some of her sculptures. She feels a direct linkage between herself, her art and an African ancestry:

> When I was a child I had these strange things I'd see and feel and now I'm putting them in wood . . . and just about everything I touch is Africa. I think I am of old African descent . . . I believe that when old people go on, back to where they came from for good, I think that their spirit and soul moves into a newborn baby. When momma had me, my body just received the soul and spirit, and way back then there was really a lot of African spirit here that wasn't mixed . . . I must claim some of that spirit and soul.[21]

By employing wood in an additive rather than subtractive manner, Harvey not only liberates her figures but embellishes them to accentuate their inherent spirituality. Above all, her works are powerful statements of her deeply abiding belief in the power of God.

Minnie Evans (1892-1987) first expressed her aesthetic spirit in a tangible manifestation on Good Friday 1935 when she completed two small abstract drawings with innumerable serpentine forms.[22] Evans' entire life was spent in rural Pender County and nearby Wilmington, North Carolina. For many years she was employed as a toll gate attendant at Airlie Gardens in Wilmington, where the numerous botanical specimens undoubtedly inspired her paintings. Evans' complex paintings and drawings depict foliated patterns which reveal an unaccountable presence of Caribbean color and subject matter:

> This art that I have put out has come from the nations I suppose might have been destroyed before the flood . . . No one knows anything about them, but God has given it to me to bring back into the world.[23]

The majority of Evans' paintings were executed in wax crayons, and her colors include greens shaded from light to medium deep, purples from mauve to pink, rose and royal, full ranges of reds, blues and yellows, and a sparing

use of blacks and whites. The paintings are mostly figurative and depict green dragons, white unicorns, angels, human heads, trees, rainbows, colorful flowers and other vegetation, and ubiquitous eyes which represent the omniscience of God. The genesis for many of Evans' designs is a human face surrounded by curvilinear and spiral plant, bird, angel and animal forms and multiple eyes which merge with foliate patterns (page 187).

A woman of deep religious convictions, Evans created works which are essentially spiritual and that represent a world in which God, man and nature are synonymous. They are the result of experienced visions, and the fact that they "just happened to her" confirms that they were a manifestation of an order of things unknown to anyone except the artist. Through her art, she communicated that a spiritual presence lives gloriously among nature, and in an era in which myth is virtually extinct, the art of Minnie Evans is a refreshing phenomenon - a lost world revealed through a subconscious which even Evans herself did not understand.

Festivals

Music, dancing and festivals have always been an integral part of traditional West African cultures. Indeed, the African mask is designed to be seen in motion, and is usually worn and danced to musical accompaniment.

The tradition of African festivals was established more firmly by slaves in the Caribbean and South America than in the United States. This may be explained by the fact that blacks outnumbered Caucasians in the slave colonies outside the United States, and there was far less pressure to acculturate. Hence, instead of being forced to embrace Christianity through the constant indoctrination of the plantation preacher, as was the fate of most slaves in the United States, transplanted Africans in South America and the Caribbean were left relatively free to continue practicing their native cultural and religious traditions. Many of these still survive as a part of Caribbean and black South American lifestyles.

One of the most tangible expressions of African festival themes celebrated in the United States is the Zulu float in the annual Mardi Gras parade in New Orleans, Louisiana. The practice of observing the Mardi Gras season was introduced to America by French colonists who celebrated it as early as 1702. It was not until 170 years later, however, that Mardi Gras became the well organized celebration it is today and a legal holiday in the state of Louisiana.[24] It was in 1872 that Grand Duke Alexis of Russia visited New Orleans, thus making Mardi Gras a "regal" holiday. Subsequently, a black-dominated Louisiana State legislature made it a "legal" holiday, giving rise to the black New Orleans expression: "Mardi Gras: A Russian Made It Regal; Negroes Made It Legal!"

Every year in New Orleans, the first important Mardi Gras ceremony on Shrove Tuesday is the landing of the Zulus, a group of African-Americans who parade in "black-face" makeup. Time-honored tradition dictates that King Zulu and his royal court disembark from their barge at the foot of Canal Street at the crack of dawn on Mardi Gras Day. The Zulus' arrival is scheduled to precede by one hour the parade of King Rex and his Krew, which everyone except the Zulus considers the most important parade of the Mardi Gras season. In the African-American community, King Zulu matches the regal grandeur associated with Rex; both monarchs dress in costumes which might have been inspired by a deck of playing cards, and each waves his scepter magnanimously toward his subjects. The remaining elements of the Zulu parade - Queen Zulu, the Big Shot from Africa, and the Zulu Warrior - supply decorated coconuts to the begging crowd, and a New Orleans brass band marches with them to the delight of carnival spectators.

With its growth in popularity and membership, the Zulu Club and its parade are now one of the main attractions of the New Orleans

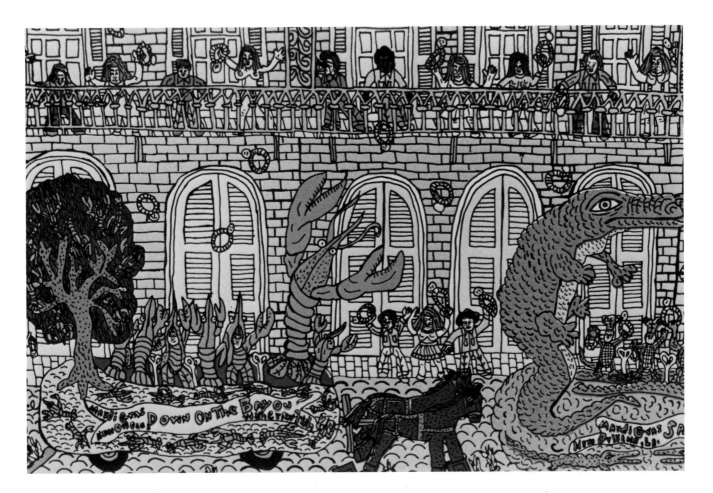

Fig. 13. Bruce Brice (b. 1942), *Mardi Gras in New Orleans*, silk screen on paper, 1978. Private Collection. Photo by Regenia Perry.

Mardi Gras. Though relegated for many years to back streets and the African-American community, King Zulu's parade was moved to Canal Street in 1969. Donning "black-face" makeup, black leotards, straw hats, grass skirts and bearing decorated coconuts, the Zulus and their friends today ride on floats which are eagerly anticipated annual attractions. Bruce Brice (b. 1942), an African-American folk artist who was born and lives in New Orleans, has effectively captured the spirit of Mardi Gras in his numerous colorful paintings and prints of Mardi Gras parades and festival-related activities (fig. 13).

The longstanding tradition of decorating coconuts, which are exchanged as gifts during Mardi Gras, still survives among New Orleanian Zulus. While the majority of these coconuts are husked, sanded and decorated with paint and glitter, special commemorative examples are created for King Zulus, Big Shots, chiefs and officers. A splendid example of this commemorative type[25] is attached to a wooden base and inlaid with two coins (fig. 14). One coin bears the inscription, "Zulu the King - 1916," an obvious reference to the year the club was incorporated, while the other coin is inscribed, "The African Elephant, Mardi Gras, New Orleans - 1969," in reference to the date of the coconut. This commemorative coconut is replete with inlaid shell eyes and teeth. The use of dramatically contrasting inlaid eyes and teeth may be compared with similar techniques found

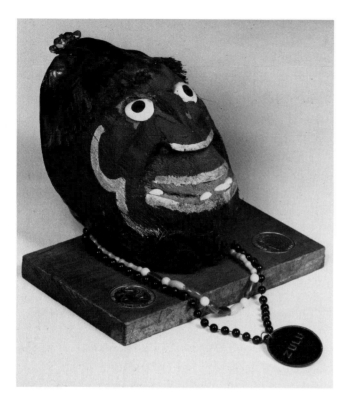

Fig. 14. Mardi Gras coconut, 1969. Private Collection.
Photo by Joel Breger.

in West and Central African artifacts, as well as
in face vessels fashioned by slave potters working
in plantation potteries in Georgia and South
Carolina during the half-century prior to the
Civil War (see figs. 2, 3).

Folk artist John Landry, Sr. (1912-1986) also
was fascinated by Mardi Gras parades during his
childhood in New Orleans. As a youth he often
competed with others for the coveted positions
of flambeaux carriers in the Mardi Gras parades.
Landry was attracted to the numerous colored
beads which are traditionally thrown during the
annual event. As a child he collected the beads
and re-strung them into necklaces for his sisters.
After he married and had a family of his own,
he converted Mardi Gras beads into playthings
for his children.

Following his retirement as a longshoreman,
Landry returned to his lifelong fascination with
Mardi Gras themes when he began creating

miniature, shoe-box size Mardi Gras floats
crafted out of colored beads and wire. Landry's
floats represent the standard Mardi Gras reper-
tory: King's Floats, Queen's Floats, Butterfly,
Heart, Riverboat, and Dragon Floats. Also
included among Landry's creations, however, are
several variations of beaded Zulu floats, one of
which replicates a square African house that
encloses a throne chair with a single black bead
representing Black Africa (page 256). Although
Landry was not an official member of the Zulu
Social Aid and Pleasure Club, he was a frequent
guest at the club's lounge, and rode on Zulu
floats in Mardi Gras parades, wearing "black-
face" makeup and full Zulu regalia (fig. 15).

Around 1976, Landry discontinued his decade-
long practice of constructing beaded Mardi Gras
floats, due to the difficulty he experienced in
obtaining plastic beads. He continued to design
floats on paper, however, and collected pictures
and articles concerning Mardi Gras floats and
other activities associated with the festival.

Following a five-year hiatus from his float-
making activities, Landry launched a renaissance
of float construction in 1981, employing corru-
gated cardboard for the body of the floats which
he painted with sign painter's enamel and embel-
lished with glitter and a multiplicity of found
objects. The second stage of Landry's float-
making career was astonishingly prolific, since
constructing cardboard floats was considerably
less time-consuming, and his imagination and
energy seemed stimulated as a result. The
miniature floats are impeccably constructed, and
are perhaps a reflection of Landry's unfulfilled
ambition to become an architect.

While there are only several examples of Zulu
floats among Landry's beaded examples, Zulu
floats were a favorite theme among his card-
board constructions. One splendid example, a
black-and-gold float, displays a bold "Z"
between two dramatic vertical arrows at the
front of its canopy (page 257). Landry's card-
board floats represent an incredible variety of
designs: houseboats, pagodas, dragons, hearts,

lotus blossoms, shoe houses, woodsmen floats with axes, floats supporting birds and Zulu coconuts, and innumerable untitled abstract designs.

Landry's earlier beaded floats, as well as his cardboard models, are constructed of coathanger wire axles and are fitted with wheels which roll. During the last two years of his life, Landry devoted most of his time to making these remarkable floats, and at the time of his death in 1986, some two dozen models of this unique category of African-American folk art were awaiting his finishing touches.

Spiritual and Stylistic Kinship

Artifacts produced by Africans in America since their arrival more than three centuries ago attest to the fact that a spiritual and stylistic kinship with African prototypes has been continuous. This African impulse is especially

prevalent in the work of African-American folk artists. Because they work outside the "mainstream" of professional or fine artists, these artists initially produce art primarily for pleasure rather than for sale or public acceptance.

The most concentrated expressions of Africanisms in African-American fine art occurred during the Harlem Renaissance of the 1920s and the Black Expressionism period of the 1960s and early 70s. Conversely, the African impulse in African-American folk art has remained remarkably constant. Although many of the self-taught artists have been acutely aware of Africanisms in their works, other African-American folk artists have produced works reflecting similar Africanisms of which they were unaware.

The fact that African stylistic impulses still appear today in the creations of African-American folk artists in culturally isolated settings gives rise to a number of interesting speculations. Art styles, in general, do not emerge without historical precedent, and art influences

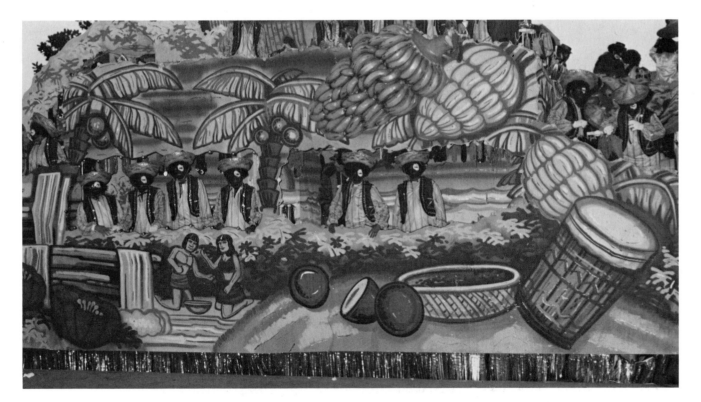

Fig. 15. John Landry with members of the Zulu Social Aid and Pleasure Club on a Zulu Float, Mardi Gras, New Orleans, 1986. Photo by Wallace Reynolds Photography.

are not believed to be genetic in origin. How, then, does one account for the stylistic similarities between walking sticks carved by Henry Gudgell in Livingston County, Missouri during the 1860s, and similar examples currently produced in Chicago by David Philpot? Why does Mr. Imagination of Chicago emphasize such a close kinship with his African ancestors, and what logical explanation exists to link his remarkable sandstone sculptures stylistically with ancient Nigerian Owo and Ife terra cotta sculptures? What are the factors which serve to unify works which are seemingly as diverse as slave-made ceramic face vessels of the 19th century and contemporary root sculptures by Bessie Harvey of Tennessee?

The common denominator that serves as a unifying element throughout African-American folk art is a deeply rooted and firmly entrenched spiritualism which has its origins in Black Africa. The spirituality of African-American folk art, its vibrant colors, pulsating rhythms, and predilection for bird, animal and serpent imagery are among the factors which clearly distinguish it from other categories of American folk art.

Regenia Perry, Professor of Art History at Virginia Commonwealth University, Richmond, is an expert and major collector in the field of African-American folk art. In 1976 she organized the exhibition *Selections in Afro-American Art* for the Metropolitan Museum of Art. She is currently preparing a major publication on African-American folk art.

1. Judith Wragg Chase, *Afro-American Art and Craft* (New York: Van Nostrand Reinhold and Company, 1971), p. 78.

2. *Ibid*

3. Robert F. Thompson, "African Influences on the Art of the United States," Armstead L. Robinson et al., eds., *Black Studies in the University* (New York: Bantam Books, 1969), p. 136.

4. Regenia A. Perry, "Spirits of Satire-African American Face Vessels of the 19th Century," Exhibition catalogue, Charleston, South Carolina, Gibbs Art Gallery, 1985. The title "Master of the Extended Eyebrows" was coined by the writer to describe the artist of certain vessels in this exhibition.

5. The other known example of a Bible quilt by Harriet Powers is in the collection of the Smithsonian Institution, National Museum of American History.

6. Gladys-Marie Frye, "Harriet Powers: Portrait of a Black Quilter," *Missing Pieces.* (Atlanta: Georgia Council for the Arts, 1976), p. 76.

7. *Ibid*, p. 73.

8. Thompson, *op. cit.,* p. 128.

9. Thompson, *op. cit.,* p. 127.

10. The ailanthus is also known as the Tree of Heaven, Paradise Tree and Chinese Sumach. It is an immigrant from China which has been extensively planted in this country. When in blossom, around June, the staminate trees emit a most disagreeable odor, and the pistillate ones bear bountiful crops of wind-borne seeds. This tree grows very rapidly and sprouts extensively from the roots making it very difficult to eradicate once it becomes firmly established. In many places it has become a nuisance which aggressively competes with more desirable trees. The tree is extremely tolerant of adverse city conditions, and very often is the only tree which can grow on certain sites.

11. Interview conducted with the artist by the writer, Chicago, Illinois, May 10, 1988.

12. Butler's yard has been completely stripped of all figures by folk art enthusiasts, and Butler has been forced to leave his home of many years, to avoid publicity, and currently resides in another town with a relative.

13. "Mr. Imagination Makes Carving in Sandstone His Life's Work" Chicago: *Lawndale News,* September 8), 1986.

14. *Ibid*

15. Interview conducted with the artist by the writer, Chicago, Illinois, May 11, 1988.

16. Telephone interview conducted with the artist by the writer, March 12, 1989.

17. Shari Cavin Morris, "Bessie Harvey: The Spirit in the Wood," *The Clarion,* Vol 12, No. 2/3, (New York: The Museum of American Folk Art, Spring/Summer, 1987), p. 45.

18. *Ibid*, p. 47.

19. Telephone interview conducted with the artist by the writer, March 12, 1989.

20. *Ibid.*

21. Morris, *op. cit.,* p. 47.

22. Nina Howell Starr, "The Lost World of Minnie Evans," *Bennington College Review,* Bennington, Vermont, Spring 1969, p. 41.

23. *Ibid*

24. Files in the office of the Zulu Social Aid and Pleasure Club, Inc., New Orleans, Louisiana.

25. This commemorative coconut was made for Milton Bienamee, who has the distinction of having reigned three times as King Zulu, in 1965, 1967, and 1970. It was acquired by the writer in New Orleans in 1988.

A SPIRITUAL LIBATION:
PROMOTING AN AFRICAN HERITAGE IN THE BLACK COLLEGE

ALVIA J. WARDLAW

The black college has been a fundamental repository for African-American culture in this century. Basic to the mission of the black institution of higher learning has been the perpetuation of those ideas which have given a distinct identity to its students. The presence of African and African-American art collections on black college campuses has served as a source of symbolic pride among the schools' larger communities. These works of art convey a sense of the historical, of the very real past to African-Americans and, through them, the history of a people has been given a more immediate sense of reality. It was not simply the collections, however, but also the teaching methods which enabled students to confront — often in painful recognition — and ultimately to embrace their heritage. The historic mandate, then, of the black college has been to re-educate students regarding the meaning of slavery and to remove the psychological scarring which it caused, replacing it with a more comprehensive knowledge of their positive heritage. As bastions of black culture, African-American educational centers became responsible for nurturing scholarship and a revised and more accurate definition of history which for so long had been ignored. Through programs, exhibitions, per-

sonal travel, and the establishment of a teaching system which emphasized Afrocentric ideas, black colleges became the private protectorate, as it were, of a legacy often maligned, rarely defended, and little understood.

Because many museums, particularly those in the South, were themselves segregated, and because black schools had quite early in their development established themselves as major cultural centers, it was important that these colleges acquire their own art collections. Organizations such as the American Missionary Association, which was instrumental in the founding of a number of private black colleges, set in motion the act of collecting African art at a time when such collecting by any American was regarded as avant-garde. As the European modernists provided validation of works from Central and West Africa, it became more common for black schools to display their African art in a formal museum setting. Later, as members of the community became active collectors, figures, masks, and textiles were received from these constituencies as gifts. How these works were incorporated into the college curriculum and used by the faculty depended upon the degree of cultural awareness of the administration, faculty and staff. Five colleges offer profiles of the development of such collections:

Hampton University, Howard University, Fisk University, Atlanta University, and Texas Southern University.

Hampton Institute in Virginia, now called Hampton University, was one of the first institutions in the country to collect African art. Works collected by former student William H. Sheppard while serving as a missionary in the Kasai Valley of Zaire between 1890 and 1910 today represent some of the most important art from Central Africa in a university collection.

Early in its history, Hampton Institute boasted a large enrollment of African and native American students, due in large part to the vision of the school's founder, Samuel Chapman Armstrong. A leader of the 8th and 9th U.S. Colored Troops during the Civil War, Armstrong was born in Hawaii on the island of Maui to missionary parents who devoted their lives to the establishment of native Polynesian schools. On the eve of his departure to command Negro troops, Armstrong wrote his mother a telling description of his own feelings regarding the impact of the end of the war upon black Americans:

> I tell you the present is the grandest time the world ever saw. The African race is before the world, unexpectedly to all, and all mankind are looking to see whether the African will show himself equal to the opportunity before him.[1]

After the war, Brevet General Armstrong was made responsible for the demobilization of Negro troops. His early vision of a school to "train selected Negro youth who should go out and teach and lead their people" received support from former abolitionists as well as funds from the American Missionary Association.[2] Founded in 1868, the school was built over the years in part by students — many of whom were ex-slaves — a fact that promoted a sense of self-worth and an awareness of cultural heritage among the academic community.

The curriculum at Hampton was based upon a threefold system of training which incorporated the hand (industrial training), the head (intellectual training), and the heart (spiritual training). This education model was inspired in part by the work of Armstrong's parents in providing public education for Polynesian children in the Hawaiian islands. Mrs. Armstrong may very likely have been influenced, in turn, by an Italian educator, J. H. Pestalozzi, who worked with poor children. Armstrong's mother had taught at Pestalozzi's school in New York early in her career. Armstrong himself was fond of saying, "Activity is a purifier; labor is perhaps the greatest moral force in civilization."[3] Booker T. Washington, one of Hampton's most famous graduates, went on to establish Tuskegee Institute based largely upon the educational approaches of Hampton.

At Hampton, the arts were inculcated into the curriculum and everyday life of the students. Since its founding, the college has experienced the singing of the Hampton Student Singers and the Hampton quartet, the oratory of Dr. W. E. B. Du Bois, and the spiritual guidance of great black religious leaders. Initially, General Armstrong had established a teaching collection using a number of mineral specimens from Hawaii and other natural history specimens from around the world. This collection of objects and artifacts allowed students to examine firsthand materials from other cultures, giving them background information at the same time on the social structure and nature of these cultures.

Although agricultural and industrial training were fundamental components of a Hampton education, the training of teachers continued to be the major focus of Hampton's curriculum. In the preparation of future teachers, the hands-on museum experience working with ethnographic materials was particularly effective. As noted by Jeanne Zeidler and Mary Lou Hultgren in their essay for the *ART/artifact* exhibition catalogue, "The museum had an indirect impact upon education throughout the south, for as early as 1880, Hampton graduates were teaching nearly

ten thousand southern black children."[4]

In discussing Hampton's African art collection in *Art/artifact*, Zeidler and Hultgren describe the cultural climate and the extraordinary individuals which together caused Hampton's collection to emerge so very early as a major center of study and connoisseurship in this country. African missions and missionary work were very much a part of the Hampton atmosphere. The first acquisition for the African collection came in the 1870s. One of its early graduates, Ackrel E. White, who worked at the Meridi Mission on Sherbro Island in Sierra Leone, contributed a number of objects to the college from Sierra Leone during the 1880s. However, it was the art collected by William Sheppard which far outshone the earlier acquisitions in size, scope, and quality and which was to form the critical nucleus of Hampton's African art collection.[5]

The story of William Sheppard reads like a screenplay. The confident and ambitious Sheppard entered Hampton Normal and Agricultural Institute when he was only fifteen. While there he was inspired to become a missionary. Although he did not graduate from Hampton, he maintained close ties with the institute as he went on to become the first black missionary sent to Africa by the Southern Presbyterian Mission Board (fig. 1). In 1890 Sheppard traveled to the Congo Free State in west central Africa with Samuel Norvell Lapsley, a white minister appointed to head the mission. In an early letter to Armstrong, Sheppard indicated his desire to send a number of weapons, tools, figures, and other functional objects to be used in what was then called the "curiosity room" at Hampton (figs. 2, 3).[6]

It is after the death of Lapsley that the story of Sheppard becomes even more intriguing. Previously denied access to the capital city of I-fuca upon penalty of death, as the Lukenga (king) of the Kuba was wary of potential social disruption by foreigners, Sheppard journeyed towards I-fuca alone. Upon his arrival, he astounded the Kuba people, first, because he was

Fig. 1. Dr. William H. Sheppard. Photographed at the induction to the Royal Geographic Society, 1893. Photo from the Collection of Arthur R. Ware.

black, and, moreover, could speak their language, which he had learned along the way. As an African-American, Sheppard was embraced in a manner not common to American missionaries. Indeed, the king and his people decided that Sheppard was a reincarnation of a member of the royal family. Because of his acceptance as "blood kin," Sheppard established a remarkable

by the king personally and given to Sheppard as a treasured gift. On another occasion, a ceremonial knife which had been kept in the royal family of the Bushongo people for many generations was given to Sheppard by Masamalinge, the favorite son of the Lukenga ruling during Sheppard's early days in the Congo. The young missionary's own description of the ceremony in which he witnessed this knife displayed gives an immediate sense of the impressive ceremony and panoply which surrounded this object:

> I have been at the great annual feast at the capital, Munsenga, when thousands of the king's subjects — Bakuba, Baketti, Basongamana, Bashalonga, and other tribes gathered to give their report of the crops, mortality, progress, etc. of their section of the country. The feast lasted for weeks. Daily the people assembled in a large square in the center of the town. The king, or Lukenga, as he was called, sat high in a pavilion with his family and chiefs around him. The master of ceremonies laid the long knife before the chief of each tribe in turn. The chief picked it up and stepping out into the circle faced the king, saluting with the knife. Then he danced as the big drums beat and the long ivory horns blew. After this he made his speech about the progress of his people.[7]

Fig. 2. Bowl, Kuba, Zaire, wood. William H. Sheppard Collection, Hampton University Museum, Hampton, Virginia. Photo courtesy of Hampton University Archives.

Fig. 3. Hoe, Kuba, Zaire, wood, iron. William H. Sheppard Collection, Hampton University Museum, Hampton, Virginia. Photo courtesy of Hampton University Archives.

relationship with the Kuba people as a young missionary. Consequently, many of the works which he later contributed to Hampton's museum have a unique contextual and historical association, as they were personal gifts to Sheppard from the king and other important members of Kuba society. For example, a portion of the burial robe of the Kuba king was cut

This kind of cultural context enabled Hampton's students not only to study the objects, but to realize their ceremonial meaning through Sheppard's words. Particularly useful were Kongo textiles which were used in home economics and design classes (fig. 4). A strong advocate of teaching African culture to the American people, Sheppard toured periodically in America from 1893 through 1910, spreading firsthand knowledge about the ancient cultures of Africa while recruiting missionaries. In many instances Sheppard used actual objects to complement his lectures. Sheppard's lectures and publications served to instill pride in African-American communities in their African heritage, and the objects in Hampton's museum allowed

students to replace stereotypical notions with knowledgeable opinions. A major purchase of nearly fifty works from the Blondiau Theatre Arts Collection in 1927 by trustee George Foster Peabody served to complement the Sheppard holdings in a significant way.[8]

It was this art collection that inspired Hampton's great educator of the 1940s, Viktor Lowenfeld, to create encounters between his students and their heritage by compelling them to look at African art and to embrace it as their own. Lowenfeld created poignant moments of recognition for many of the students. The artist John Biggers, then a student at Hampton, recalls that initially he found the work "ugly, unlike anything I had seen before."[9] What Lowenfeld

accomplished, though, was the development of self-recognition among art students like Biggers by encouraging them to acknowledge their cultural heritage and to express in their art the value of their unique black experiences. In so doing, they prepared for productive and creative lives in their communities.

Although the impact of Hampton's art collection and its educational activities upon its students was great, other arenas of new thought about Africa were also influencing young black people during the early twentieth century.

New York City from the late teens to the mid-twenties was the origin of black intellectual thought and ferment which was to underpin the aesthetic and educational philosophy of many

Fig. 4. Hampton Institute Domestic Science Class, c. 1920. Photo courtesy of Hampton University Archives.

black colleges.

In New York during the Harlem Renaissance "salons" such as those held at the Countee Cullen Library attracted leading black artists and writers, among them noted bibliophile Arthur Schomburg and self-taught historian Charles Seifert. The salons frequently explored the historical and cultural past of Africa, particularly that of Egypt. A growing awareness of the ancient culture of "Abyssinia" spread throughout Harlem intellectual circles and soon permeated the thought of black visual artists and writers alike. Black theater productions began to introduce African themes in their works, as in Richard Bruce's *Sahdji*, while the Ethiopian Art Players presented Shakespeare with jazz accompaniment. In 1916 activists including Marcus

Fig. 5. Alain L. Locke c. 1920s. Photo courtesy of the Schomburg Center for Research in Black Culture, The New York Public Library.

Garvey founded the Universal Negro Improvement Association in Harlem, and in 1918 Garvey began to produce his newspaper, *Negro World*. His approach was directed towards the re-establishment of self-esteem among blacks. Through the paper, he informed the masses that they had a history, a culture to be proud of, and that theirs was a legacy which should be reclaimed. With its highly structured organizational character and its emphasis upon heraldry and pageantry (e.g. elaborate titles and ranks, often with African names, such as "Duke of Nigeria"), the UNIA became a force in Harlem whose concept was readily graspable by the masses and whose impact was undeniable.

During the same period, W. E. B. Du Bois, in his role as editor of the NAACP journal *Crisis*, began to promote the concept of Pan-Africanism. The writer was instrumental in the organization of Pan-African Congresses in 1919, 1921, and 1923, and it was Du Bois' hope that such interaction between Africans and African-Americans would create a world view through which the issues of racism could be discussed as a problem which affected not only black people in the southern United States, but also in colonial Africa. Du Bois frequently used the NAACP journal as a platform from which to discuss the role of the arts within the black community. He considered it essential that both black artists and their support communities begin to develop their own criteria for the evaluation of art, and he stated his position unequivocally in such articles as "The Negro in Art: How Shall He Be Portrayed?" and "Criteria of Negro Art," in which he instructed his readers: "The ultimate judge has got to be you and you have got to build yourselves up into that wide judgement, that catholicity of temper which is going to enable the artist to have his widest chance for freedom."[10]

Alain LeRoy Locke, often called the father of the Harlem Renaissance, led efforts in New York to create alternative Afrocentric cultural institutions (fig. 5). In 1927, Locke sought to organize a

Museum of African Art in Harlem as a center of cultural study for artists, scholars, and the general public. A statement from its constitution declared as the purpose of the museum and its foundation "to increase and diffuse knowledge and appreciation of African history, art, and science, with special reference shown to the cultural development and background of the Negro people."[11]

Toward this end, Locke worked with a board that included Mrs. Charlotte Osgood Mason, Mrs. Edith J.R. Isaacs, Paul Kellogg, and Franklin Hopper to secure collections of African art for the Museum, the core of which was created when Locke purchased for the board a major portion of the Blondiau Theater Arts Collection of African Art. Having traveled extensively in Europe, Locke was well acquainted with African art styles and in an introductory statement which he wrote for the Blondiau collection, he summarized his attitude regarding African art:

> Painting and sculpture have felt its influence and so may the theater and decorative arts. In its own setting, African art was a vital part of life — masks and costume for the ritual dances, the festivals, the initiations, the pageants of a primitive but wholesome civilization. Most of it was regalia, accoutrement and even utensils of practical use — but all considered as fit vehicles for art — so that art was integral with life. And that was why — in spite of the crudest of implements and resources, Africa produced things imperishably beautiful.[12]

Although Locke's museum never attained an independent physical site, its collection of African art became an integral part of exhibitions held at the 135th St. Branch of the New York Public Library. Meanwhile, other art groups downtown were beginning to examine the culture of Africa through museum exhibitions. In 1935 the Museum of Modern Art held its first exhibition of African art, *African Negro Art*, which opened on March 18 to great public acclaim. Described as the first exhibition of

African art to be organized by a major museum in this country, the exhibition included 600 works from American and European museums, private collections, and dealers. In the catalogue of that exhibition, James Johnson Sweeney, MOMA director and an early scholar and lover of African art, wrote of the genius of African creativity, "The art of Negro Africa is a sculptor's art. As a sculptural tradition in the last century it has had no rival. It is as sculpture we should approach it."[13] Impressed by the positive reactions to the exhibition, the General Education Board of the Rockefeller Foundation funded the production of a portfolio of photographs of selected works from the exhibition. Photographer Walker Evans was chosen to photograph the objects. *African Negro Art-Photographs by Walker Evans* circulated in a traveling exhibition which visited fifteen black colleges as well as the 135th St. Library in New York City. It is significant to note that Locke's efforts at organizing a major collection of African art in Harlem and his subsequently organized exhibitions of African art on black campuses predated the MOMA exhibition by almost ten years.

The American Museum of Natural History was another early exhibitor of African art, but the works were presented primarily as exotic artifacts. Although the vast number of Congo works which the museum had collected since 1907 were exhibited in numerous display cases, much of it remained out of public view and in storage.

This attitude, however, did not deter artists such as Aaron Douglas, who later established Fisk's art department, from carefully studying the African works as art. In discussing this period of "self-study" of African culture, Douglas noted on one occasion how, ironically, the attitude of the Natural History museum gave him a better opportunity to examine the works. Because they were considered unimportant ethnographic works, he was given free access to examining the art in storage. "In those days, they were just curios," stated Douglas.[14] Because of the pres-

ence in Manhattan of such major cultural institutions as well as smaller galleries and cultural centers which displayed African art on a regular basis, New York during the twenties and thirties was that fertile place from which information on African culture gradually spread throughout the South.

At Howard University in Washington, D.C., the program to collect African art was organized by Dr. Alain Locke. As chairman of the Philosophy Department and the country's first black Rhodes scholar, Locke wanted to bring to Howard's campus a cultural enlightenment as expressed through an appreciation of Africa's social traditions and art. Locke's interest in African art began early in his career. While at Oxford from 1907 through 1910, he met many African students and he founded an African Union Society. During his years as a Rhodes scholar, Locke had the opportunity to study a number of collections of African art in London, Paris, and Berlin. His subsequent frequent trips to Europe enabled him to maintain an awareness of the trends of European modernists in their study of African art. Describing the impact of African art upon 20th-century modern art, Locke said:

> It is neither as exotic nor as dead as is usually imagined. Having entered so largely both in general inspiration and specific idiom into contemporary European modernist art, an appreciation of African sculpture becomes critically and historically necessary to an appreciation of some of the most representative modern artists, Picasso, Matisse, Modigliani, Epstein, Lipchitz, Lembruch, Nolde, Pechstein, Holtzer, to mention a few.[15]

Traveling between New York and Washington, D.C., Dr. Locke tried to impart to both his peers and students the importance of an appreciation of their African heritage. As early as 1912 when he first began teaching at Howard University, he conceived of that university becoming a center for research related to race, "culture contact," and colonialism. Howard, he thought, was the best place in the United States to develop a Negro cultural center — "an incubator of Negro intellectuals"[16] — and it was Locke who with his own funds began buying works of African art for Howard's permanent collection. Eventually, several hundred artifacts, including an outstanding collection of goldweights, were purchased.[17]

In 1918, Locke received his Ph.D. in philosophy from Harvard. Six years later he was granted a sabbatical leave to work with the French Oriental Archeological Society of Cairo, and was appointed the "official head of the Howard University Mission." As representative of the Negro Society for Historical Research, Locke traveled to the Sudan and Egypt, and was present at Luxor for the reopening of the tomb of Tutankhamen. His presence at such an historical moment, and his knowledge of African history and philosophy, imbued him with a view of the world that was uniquely comprehensive at that time. It was this vision which encouraged Locke in 1928 to propose the development of an African Studies Program at Howard.

It is Locke's essay "The Legacy of the Ancestral Arts" that so clearly demonstrates the philosopher's attitude towards inspiring young African-American artists to draw from their cultural heritage in order to more completely express themselves as "Negro" artists. Published in *The New Negro* in 1925, the article became a philosophical point of departure for many artists, and created much discussion among them regarding the validity of his points of view.

Lois Mailou Jones, a member of the Howard faculty from 1930 until 1981, is fond of recalling how one day on Howard's campus Dr. Locke stopped her, and gently admonished her for continuing to paint in the European mode; he encouraged her to draw upon her African heritage, instead, for inspiration in her painting. The incident stuck in her mind and, indeed, she did go on to create a number of works, beginning with *Les Fetiches*, which were inspired

by her appreciation of African art via Europe, Africa, and Haiti. Her marriage to Haitian artist Louis Vergniaud Pierre-Noel brought a personal association with Haitian culture to her work. Jones continues to encourage students to explore their African culture by organizing trips to Africa as well as through her own art and writing, including her essay on the impact of African art upon African-American artists.[18]

The creation of Howard's African art collection was a long and arduous task which involved a great deal of personal sacrifice for Locke. His records indicate painstaking attention to all aspects regarding acquisitions. Locke served as registrar, curator, and preparator, which was not uncommon on black campuses. He also took every opportunity to bring to Howard's campus exhibitions of African art. For example, Locke organized an exhibition of African art from the Harlem Museum of African Art in 1928 (fig. 6).[19] He also continued to travel and lecture widely, and he published numerous articles on African art. Upon his death, Dr. Locke gave much of his personal collection of African art to Howard University.

Alain Locke was certainly not alone at Howard in his efforts to encourage students to examine African culture. Simultaneously with Locke's efforts, there developed over the years an awareness of African culture encouraged by the faculty at Howard University. In his catalogue *Art in Washington and Its Afro-American Presence: 1940-1970* Keith Morrison gives a thorough analysis of the relationship of Locke's early philosophy to the professional developments within Howard's art department.[20] James Herring founded the art department at Howard in 1921 and opened an art gallery in Rankin Memorial Chapel in 1930. In addition to showing work by artists such as Matisse, Klee, Kandinsky, and Thomas Hart Benton, the Howard Art Gallery also displayed work by Cuban artists Wifredo Lam and Teodoro Ramos-Blanco, and Brazil's Candido Portinari. The gallery displayed African art from Alain Locke's

Fig. 6. Program Cover. *An Exhibition of African Sculpture and Handicraft from the Travelling Collection of Harlem Museum of African Art of New York City*, 1928. Alain Locke Collection, Moorland-Spingarn Research Center. Photo courtesy of Moorland-Spingarn Research Center, Howard University, Washington, D.C.

collection on a regular basis. These exhibitions continued well into the fifties and sixties.

Herring retired in 1952, and James Porter succeeded him as chairman of the Howard Art Department until 1965. Porter, who had authored the landmark book *Modern Negro Art*, was a distinguished art educator whose work in African-American art history was ground-breaking. His book quickly became the standard text on the subject and he lectured on African-American art in South America, Europe and the Caribbean. In 1963, under the sponsorship of the U.S. Department of State Culture Program, Porter traveled throughout Africa lecturing on African-

American art. As director of the gallery, Porter exhibited the work of Wilson Bigaud of Haiti in addition to that of Cuban artists. During his tenure, Porter organized a number of major shows of African art, including the 1951 exhibition of work by Ben Enwonwu, an exhibition of traditional African art in 1953, and a major exhibition of African contemporary art organized with the Harmon Foundation in 1954.

During this period a number of artists who graduated under Porter's guidance went on to express their own strengths. Artist Elizabeth Catlett and artist/art historian David Driskell, both Howard graduates, have created important work reflecting an African-American influence. Driskell's experiences as acting chairman of Howard's art department and director of the art gallery in 1945 prepared him for the monumental task of researching and organizing the watershed exhibition of 1975, *Two Centuries of Black American Art.*

Another aspect of Howard's cultural contribution to the Washington, D.C. community was the establishment by Warren Robbins of the Museum of African Art, now a part of the Smithsonian Institution. As noted by Morrison, Robbins had a major exhibition of African art at Howard during his early period of developing support to establish a museum at the Frederick Douglass house. There was an immediate interest in supporting this effort. States Morrison:

> While he was chief of the USIA cultural program in Germany, Robbins 'discovered' African art and developed the idea of establishing a permanent museum of African art in the nation's capital. Robbins' interest in German Expressionism led him to a study of African sculpture, which he learned had been a primary influence on twentieth century European art. By the time he returned to the U.S. in 1960, he had acquired a small collection of African objects. He then began to discuss his ideas about a museum of African art with many people, not the least of whom was James Porter.[21]

At Porter's invitation, Robbins displayed his collection at Howard in 1962. Thus began the broad interaction of the black and white educational and diplomatic communities to develop what is now the first major museum of African art in the country. It is certainly a fitting tribute to Locke's efforts to bring national attention to the beauty of African art and culture that almost forty years later a national museum devoted to African culture was established in his own city.

Jeff Donaldson, an active artist and art historian in Chicago and one of the founding members of AfriCobra — the African Commune of Bad Relevant Artists — succeeded James Porter as the chairman of Howard's art department in 1970. Donaldson's presence brought a renewed and revitalized sense of political and cultural purpose to the department which was characteristic of the activist atmosphere on a number of black college campuses during the period. Inspired by the philosophy of Locke, Donaldson encouraged art students to look to their African heritage for inspiration in their work. With the expression of contemporary African drama and music being presented by students on campus as well as the political climate of Washington, D.C. which fostered an awareness of African culture, there was a unique blending of the black academic and political communities on the campus. The addition of Ethiopian artist Skunder Boghassian and art historian Paul Ofori-Ansah of Ghana to Howard's art faculty added another aspect of African creativity to the campus. The strong presence of both African faculty and students is felt on Howard's campus, and a number of museums, boutiques, and gift shops offer traditional African clothing — Kente cloth, bangles, woven hats, etc. In Washington, D.C. there is also a preponderance of African hair styles which offer a particularly personal dimension of the Diaspora enabling students to express a sense of culture in their development of personal style.

Fisk University in Nashville, Tennessee was

founded in 1866. Also organized initially by the American Missionary Association, the university has graduated some of the country's most outstanding scholars, including W. E. B. Du Bois. Fisk's collection of African art was begun as early as 1876 when works were contributed by AMA missionaries to the school. These early works were housed along with a collection of Native American art in the basement of the Theology Building (Bennett Hall) on the Fisk campus.[22]

It was Aaron Douglas, founder of the Fisk Art Department, who brought a truly historical and cultural awareness of Africa to the Nashville campus. A "pioneering Africanist" cited by Alain Locke as the premiere artist of the Harlem Renaissance, Douglas's involvement with artists and writers in New York during the era of the New Negro movement provided him with an experience of dynamic study and cultural exploration which was to remain with him for the rest of his career as an artist. His murals, particularly *Aspects of Negro Life* at the 135th St. Branch of the New York Public Library, have continued to serve as a point of departure for other artists working in New York.

While in New York, Douglas often contributed his graphic skills to magazines such as *Crisis* and *Opportunity. Opportunity* was then edited by Charles Spurgeon Johnson, who came to Fisk in 1936 and later was appointed its first black president. It was at the invitation of Johnson that Douglas came to Fisk in 1929 to paint murals for its Erasto Milo Cravath Library. Later, as a member of the Fisk University faculty, Aaron Douglas instilled in his students an awareness of their cultural heritage through his own professional example.

The murals, which Douglas called his *Symbolic Negro History Series,* are located in three areas on the second floor of the university's administration building. In his own words, the artist describes this series as "the panorama of the development of black people in this hemisphere" (fig. 7)[23]. The series includes scenes

Fig. 7. Aaron Douglas at work on *Symbolic Negro History Series* murals, Fisk University, Nashville. Photo courtesy of Special Collections, Fisk University, Nashville.

dealing with African history: Egyptians at the pyramids, West Africans dancing to the sounds of traditional drumming, and Africans being led by force to a three-mast slave ship that would bring them to America. In addition, the murals relate, in other sequences, the many aspects of the humanities and sciences which serve as a source of inspiration for the creative spirit.

Beginning with the *Symbolic Negro History Series,* murals became a primary means of visual expression and historical reference on the black college campus. Douglas' murals are the first to place the painful chapter of slavery within a broader context of black history. The past, as represented by the great civilizations of Africa and the future, symbolized by the quest for achievement, places the joy and pain of black existence in its proper perspective. Using his broadly expressive style of "geometric symbol-

Fig. 8. Standing Figure with Bowl on Head, Ivory coast, West Africa, wood, 19th century. The Alfred Stieglitz Collection, The Carl Van Vechten Gallery of Fine Arts, Fisk University Museum of Art, Nashville. Photo by Larry Dixon.

ism" Douglas breaks down his mural cycle into three fundamental aspects of human activity; toil, religion, and self-entertainment. The artist once stated that by examining such basic activities, one could see patterns in life emerge. As he did for most of his murals, Douglas prepared carefully written descriptions of the various segments of the Fisk series. As a teacher and an artist, he recognized the potential which murals had to educate the public. His large scale and dynamic patterns could attract the casual viewer who would then walk away knowing more of African-American history.

In 1949, Georgia O'Keeffe gave a major gift of works from the collection of her late husband Alfred Stieglitz to Fisk University. Encouraged by Carl Van Vechten, O'Keeffe felt that Fisk students would benefit enormously from having contact with the challenging examples of creativity which her husband had assembled in large part to educate the public. In addition to works by such outstanding American artists as Arthur Dove and John Marin, the collection included several works of African art which Stieglitz had originally exhibited at his gallery, 291. It was in fact Stieglitz who had organized in 1914 the first American exhibition to deal with African art purely on its aesthetic strength. One of the works from this exhibition was contributed to Fisk (fig. 8). Before the dedication of the works in the Carl Van Vechten Gallery on November 4, 1949, Douglas and Fisk students worked directly with Ms. O'Keeffe in developing an installation of the collection which reflected her sensitivity to the objects.

Douglas used this opportunity to teach students about the history of Africa. The presence of African art of such quality on campus gave students the same opportunity for encountering the power of African art which Douglas had felt on his many visits to the American Museum of Natural History and the Brooklyn Museum. This teaching collection allowed students to not only look at and interpret the works formally, but also in the context of their cultural heritage (fig 9).

In 1952, Irene McCoy Gaines gave the university 252 pieces of African art in memory of George W. Ellis, who for twelve years had served as secretary of the American delegation in Monrovia, Liberia and who had become an authority on West African culture, in the process. The gift was part of the George W. Ellis African Collection, formerly housed in the Smithsonian Institution.

In addition to the Stieglitz Collection and the Douglas murals, Fisk also boasts a collection of paintings and drawings of African native life, the Cyrus Leroy Baldridge Paintings and Drawings Collection. The artist Cyrus Leroy Baldridge began to draw African and African-American people during World War I when he served with Colonial troops from Africa and with African-American soldiers. The Winold Reiss Collection of Portraits and Studies includes a number of the studies which were published in Alain Locke's 1925 publication, *The New Negro*. Dr. Charles Johnson, established the Afro-American Collection, which includes objects from both Africa and the South Pacific. Like Hampton's collection, the works include functional objects such as musical instruments, masks, ceremonial objects, knives, spears, paddles, etc. made of natural materials. Because of its various collections and art commissions, the Fisk campus is an especially rich environment for the study and appreciation of African-American culture.

The Atlanta University complex in Georgia has been a center of learning for African-Americans in that city. Comprised of Morehouse, Spelman and Morris Brown colleges, in addition to Atlanta University (now Clark Atlanta University), the complex has through the years had such outstanding scholars as W. E. B. Du Bois and Benjamin Mays on its faculty and as administrators.

Hale Woodruff was a nationally known black artist when he came to Atlanta University in 1931 from Paris where he had studied for over three years at the Academie Moderne and in the atelier of Henry O. Tanner. Atlanta President

John Hope had met Woodruff in 1930 during a trip to France, and he persuaded the talented artist to come to Atlanta the following fall. As an art instructor, Woodruff brought national recognition to the school. The annual Art Exhibit, which was inaugurated in 1942 under the direction of Woodruff, played an important part in the development of art appreciation in the Atlanta University Center and in the South in general. Further, it stimulated black artists working at black colleges to compete and exhibit their works nationally. Alain Locke served as keynote speaker for the first National Art Exhibition awards program on April 26, 1942.

It was while teaching at Spelman College in Atlanta during the summer of 1938 that Woodruff was invited by Buell Gallagher, then president of Talladega College in Talladega, Alabama, to teach an art history course at that college. Woodruff accepted the position and commuted to Talladega, a three-hour drive from Atlanta, on the days of his course.

During this same summer, the William Savery Library was being built to replace Talladega's first library, built in 1904. This, of course, was an important event for the black school. To commemorate such a landmark occurrence, President Gallagher, a white educator who was later to

Fig. 9. Aaron Douglas Gallery of African Art, Fisk University Museum of Art, Nashville. Photo courtesy of Fisk University Museum of Art, Nashville.

Fig. 10. William Townsend, *Marque*, pencil on paper,
1840-41. Collection of the Beinecke Rare Book and
Manuscript Library, Yale University, New Haven.

Fig. 11. William Townsend, *Little Kale*, pencil on paper,
1840-41. Collection of the Beinecke Rare Book and
Manuscript Library, Yale University, New Haven.

become president of CCNY, asked Woodruff to
paint a mural series for the new library. The
president had a specific suggestion for the
mural's subject matter; he wanted to see repre-
sented an event which ultimately led to the
establishment of black colleges like Talladega —
The Amistad Mutiny.[24]

The events which surround the Amistad
Mutiny form one of the most profound chapters
known in the history of the African-American.
In 1839 some forty Africans were kidnapped,
carried to Havana on a Portuguese slaver and
sold. While being transported to another port on
a boat ironically called the Amistad (Friendship),
the Africans mutinied, led by their Sierra
Leonese chief, Cinque. Cinque and his men
ordered the Spanish slavers to turn the ship back

east to Africa. The Spaniards obeyed their orders
— during the daylight hours. Under cover of
night, they steered the ship northwards, along
the eastern seaboard of the United States. As a
result, the ship eventually landed in New
London, Connecticut. For the next two years,
the Spaniards and Africans continued their bat-
tle, this time in the courtroom. The trial
ultimately worked its way to the Connecticut
Supreme Court where John Quincy Adams
defended the Africans' right to freedom from
slavery and from the Spaniards' charges of
murder and mutiny. By emphasizing the fact that
the United States had no jurisdiction in the
matter in the first place the defense won its case.
The Africans were allowed to return to Sierra
Leone. Abolitionists in Connecticut raised the

Fig. 12. William Townsend, *Yuang*, pencil on paper, 1840-41. Collection of the Beinecke Rare Book and Manuscript Library, Yale University, New Haven.

Fig. 13. William Townsend, *Pona*, pencil on paper, 1840-41. Collection of the Beinecke Rare Book and Manuscript Library, Yale University, New Haven.

funds for their return voyage and when the time came for them to sail in November 1841, several interested whites traveled with them, with the intention of establishing a Mendi Mission in Africa. From this core of interest emerged the American Missionary Association, an institution which is still in existence and is largely credited with the founding of several black colleges in the South, including Talladega.

In accepting this commission it thus became Woodruff's task to visually present the events of the Amistad mutiny. He began by first fully acquainting himself with the events and individuals involved. He traveled to New Haven to study drawings in the collection of the New Haven Colony Historical Society which included actual depictions of the vessel as well as repre-

sentations of costumes, weapons, and architecture of the period. At the Yale University Library Woodruff pored over thirty-two pencil drawings of the African captives, sketched by the young artist William Townsend during the Amistad trial.

An examination of four of the Townsend sketches (figs. 10 to 13) and a comparison of their interpretation by the artist demonstrates the careful attention Woodruff paid to accuracy of depiction. There is a clear connection between the Townsend likenesses and their representations in the Woodruff mural (page 161). In the midst of the group is Woodruff's own self-portrait. Seated among black men, women and children, Woodruff deliberately places himself in this chapter of African-American history, becom-

ing a very real part of this classic battle for freedom. The artist conveys to us by this gesture the need for black people to embrace emotionally the pain and struggle associated with slavery and celebrate the strength of survival.[25]

In 1950 Hale Woodruff was commissioned by Rufus Clement, then president of Atlanta University, to paint a mural series for the Atlanta University Trevor Arnett Library. Since his Paris days, Woodruff had been studying African art, and he challenged himself to incorporate this knowledge in this mural series, which he entitled *The Art of the Negro*. The murals were to occupy six lunettes, eleven feet in width and, at their highest point, eleven feet in height. The color scheme of the series was restricted largely to rich earth tones, reds and browns, with white highlights. The vibrancy and earthiness of these colors suggest the natural tones of the African savannah region as well as the wood tones of much of the continent's art.

The first panel, *Forms of African Art*, is dominated by a composite form representing several styles of African art. Its head is adorned with the double-axed symbol of Shango. Artists are depicted carving, painting, and involved in other activities. The second panel *Interchange*, reflects the early contact between African cultures and European societies such as Greece and Rome. The exchange of ideas, customs, architecture, and music are symbolized by Woodruff's depiction of personal encounters between the groups. The destruction of African civilization by the forces of European expansion are graphically depicted in the third panel, *Dissipation*. *Influences*, the fourth panel in the series, illustrates parallels in ethnic art and features symbolic motifs of African, Oceanic, and Native American cultures. The fifth panel focuses upon the impact of African art upon modern art, while the final panel, *Muses*, is Woodruff's dynamic statement regarding the continuous creativity of black artists. Woodruff gathers together for an impressive group portrait a number of black artists ranging from Igueghe,

the Benin bronze-caster credited with teaching his fellow craftsmen the high art of working in metal, to Juan de Pareja, the gifted assistant of Velazquez, to a number of Woodruff's contemporaries such as Jacob Lawrence and his personal friend Charles Alston.

It is remarkable that Woodruff in 1950 took on the task of representing in a mural series those aspects of an artistic heritage which few blacks at the time were even aware of. This project was conceived in the interim between two periods in which African heritage was emphasized: the days of Alain Locke and the New Negro Movement and the political and cultural impact of the Civil Rights movement.

The *Art of the Negro* was Woodruff's favorite mural series. He expressed genuine disappointment in a 1970 interview when he stated, "I'd hoped the work would be an inspiration to all the students who entered the AU library. I'd hoped they'd look up and wonder about what they saw. Instead I hear they just walk on and never notice."[26]

The seriousness of his purpose in creating this particular series is most effectively reflected in the powerful panel *Dissipation* (fig. 14). As a strong historical statement of cultural destruction, Woodruff depicts the sacking of Benin City during the Benin Punitive Expedition of 1897. By placing these works in the context of the library, Woodruff's hope was that the information which served as the murals' subject matter would become part of the students' cultural frame of reference. In a sense, he is warning the students that history can repeat itself, and like Benin City, there can occur another cultural holocaust in which African history can be lost forever unless the students are aware and protect it. The *trompe l'oeil* archway becomes a bottomless pit into which the sacred teachings and artifacts of the Benin have been cast. Because of the perspective, the viewer becomes involved in the art in a very direct way, causing the mural's impact to be imminent and immediately felt. The artist juxtaposed his masterful pantheon of figures of

artistic achievement against this disquieting destruction by fire and violence of the Benin culture.

Painted high upon the wall above doorways, Woodruff deliberately causes us to look up at *Muses* (fig. 15), placing the artist Igueghe, for instance, in a sacred space and allowing viewers to identify other known artists within the pantheon he has depicted. By creating a "group portrait" of famous black artists, Woodruff demonstrates that there exists a continuum not only among the so-called "anonymous" artists, but also a continuum of known artists who have created special and sacred crafts and objects, reaching back to the African continent. By

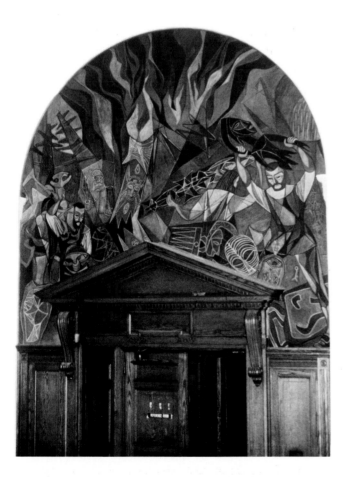

Fig. 14. Hale Woodruff, "Dissipation" from *The Art of the Negro* mural series, Trevor Arnett Library, Atlanta University, Atlanta. Reproduced by permission of Archives and Special Collections, Atlanta University. Photo by Albert N. Wardlaw.

providing the viewer with the name and the history of a very pivotal figure in West African history, Woodruff defines with an assured sense of history the past boundaries of the creative history of black people. Libation can now be poured to the name Igueghe, as Woodruff has placed his name upon that slate of artists who have contributed so much to world culture.

The climate of the community at the Atlanta University Center was one in which such expressions of black history were embraced not as alternatives to traditional Eurocentric history, but as the building blocks, the foundation of African-American history. The rich educational legacy in Atlanta was the perfect complement to Woodruff's murals. As recently as 1986, the university completed their restoration and thus acknowledged their importance as a major cultural resource within the city. The murals were a focal point for the first National Black Arts Festival held in Atlanta in the summer of 1988. The increased publication of background information regarding the iconography of the murals heightens even further its accessibility to the public.[27]

At Texas Southern University in Houston, the tradition continues of black artists serving not only as teachers of art, but teachers of culture. The distinctive nature of Texas Southern's art program is not coincidentally linked to the history of its administration and faculty. Texas Southern University's first black president, Dr. R. O'Hara Lanier, had served as an instructor in history from 1923-1925 at Tuskegee Institute. In 1940, Lanier become Dean of Hampton Institute. Soon after in 1943, Lanier was appointed acting president of Hampton, becoming the first black chief administrator of this historically black college. In 1946 Lanier accepted President Truman's appointment as United States minister to Liberia, followed by his appointment in 1947 as the first black president of Texas State University for Negroes, later to be renamed Texas Southern University.

Dr. Lanier with his strong Hampton connec-

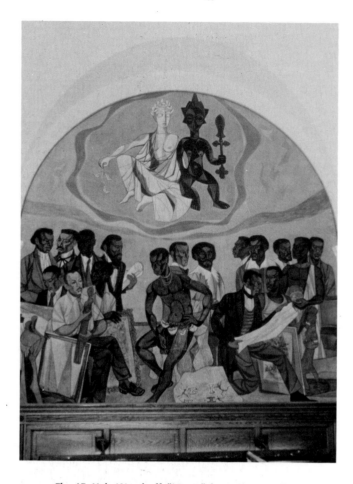

Fig. 15. Hale Woodruff, "Muses" from *The Art of the Negro* mural series, Trevor Arnett Library, Atlanta University, Atlanta. Reproduced by permission of Archives and Special Collections, Atlanta University. Photo by Albert N. Wardlaw.

tions began to develop a faculty which included a former student of Hampton's art department. Dr. Lanier wished to actively transmit the Hampton character to that of Texas Southern's academic program. Indeed in 1933, when Lanier had served as Dean of Texas Southern (then a junior college for Negroes) the scholar had established a *Ten Point Program* for the college which included a board of visitors from the community, a Little Theatre and Hobby Center and a Museum of Negro History and Arts.[28]

To this most culturally isolated of those campuses affected by the expansion of the intellectual theory of the Diaspora came artists John Biggers and Joseph Mack in 1949 and Carroll Simms in 1951, respectively. Just as Douglas left New York for Fisk to teach with a certain philosophical point of view, so too did John Biggers come to Texas Southern, at the invitation of Dr. Lanier, prepared to formulate and present a philosophy which he had developed at Hampton and Penn State.

John Thomas Biggers was born in Gastonia, North Carolina in 1925. He studied with Charles White and Viktor Lowenfeld while a student at Hampton Institute. The influence of the Hampton art department's philosophy of encouraging students to paint their own experiences of growing up in the American South can be seen quite early in the works created by students at Texas Southern. Just as he was challenged to discover the beauty of his North Carolina community while at Hampton, so did Biggers challenge his art students to discover the beauty of shotgun houses in their community. His colleague Carroll Simms had a similar outlook and together they formulated a unique art philosophy based upon their own Afrocentric expressions of culture.

In 1957, Biggers received a UNESCO grant to travel to West Africa to study. The trip was to change his life. From it emerged the book *Ananse: the Web of Life in Africa* and, more importantly, a complete philosophy of black culture which Biggers would maintain for his entire teaching career. A series of 89 drawings serve as a visual diary of that journey and include works such as *Three Kings* (page 218). A series of paintings soon followed, including works such as *Jubilee* (page 248). That such glorious celebrations of the beauty and power of African culture were executed in the heart of segregated Texas is testimony to the enormous impact Africa had on this talented artist.

The important role of the art department on campus was clearly demonstrated in the sixties during a number of events focusing on the Diaspora, including a student-organized Black Arts Festival, May 9-11, 1969. Dr. Biggers served

as an advisor to the student group who organized the celebration, entitled "Color Me Black." Among those participating in this open forum were Maya Angelou, Arna Bontemp, Ron Karenga, Leroi Jones (Imamu Baraka), and Don L. Lee (Haki Madhubuti). Art from the Texas Southern Art Department and the Menil Collection was displayed in the university library.[29]

As chairman of the art department, Biggers' goal was to inspire his students to look to their own African-American and African heritage for inspiration in their work. He initiated a mural program for art majors which resulted in each student creating a mural. To date, there are 114 murals on the campus of Texas Southern University. Biggers' own *Family Unity*, 50 feet long and located in the student center, links the African and African-American family in a visual progression of birth, death and continuity of heritage. This mural, which was painted before his retirement, demonstrates Biggers' recent synthesis of form inspired by years of study of African sculptural tradition.

Like Biggers, Carroll Simms also traveled to Nigeria where he studied traditional terra cotta sculptures, as well as ancient Benin and Yoruba

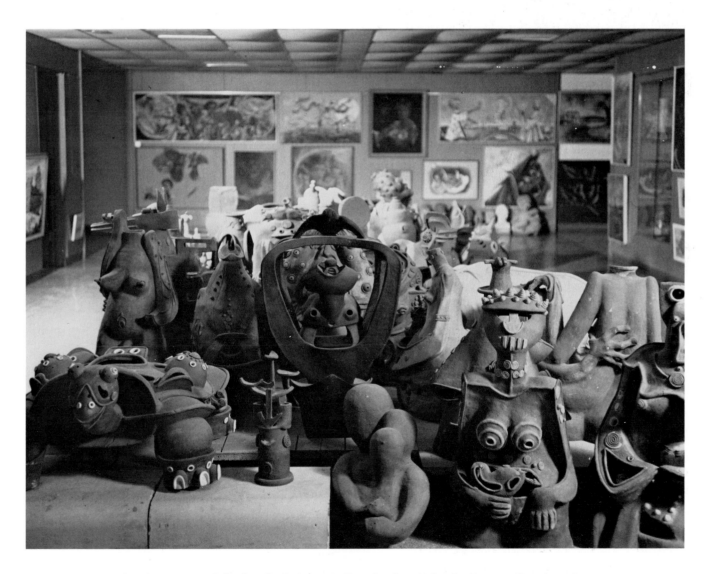

Fig. 16. Permanent Collection, Art Department, Texas Southern University, Houston. Photo by Earlie Hudnall, Jr.

sculptures with Ekpo Eyo and William Fagg. At Texas Southern, Simms imparted to his students a sense of "shrine" or holy place about their large sculpture pieces (fig. 16). In the murals created by Texas Southern University students, one sees an increasing awareness of African culture. The murals range from those without any references during the segregated fifties to a full-blown political expression during the sixties, to a seemingly more personal absorption of the emblems, history, and motifs by the artists of the seventies and eighties who seem to want to embrace the spiritual meaning of the Diaspora, but not be restricted in their manner of creativity.

One of the most successful innovations by the art department at Texas Southern has been the development with the Parsons School of Design of a travel-abroad program to the Ivory Coast, West Africa. This allows students the opportunity to study traditional art forms in West Africa under the instruction of Ivorian craftsmen and craftswomen. Both John Biggers and Carroll Simms have created major works for Texas Southern and the Houston community which are directly related to their own experiences in the Motherland. Biggers' later mural, *Family Unity*, refers to the structure of familial life, the ties to one's ancestors, and the sacred relationship between man and nature which is so revered in West African culture. In *Family Unity*, the women bear the house on their heads in much the same way as the ancient Egyptian goddess Nephthys bore the columnar headdress as a symbol of her connection to the home (fig. 17). Simms' *African Queen Mother* was inspired by his own study of traditional Nigerian sculpture, and examines the metaphor of the Motherland as a source of life and evolutionary culture (fig. 18). The long association of the Houston art patron Susan McAshan with Texas Southern resulted in the publication of *Black Art in Houston* in 1974, a valuable chronicle of the history and productivity of art on this campus.[30]

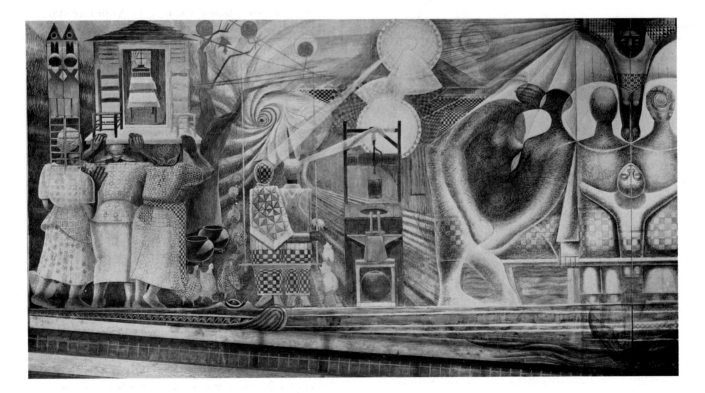

Fig. 17. John Biggers, detail of *Family Unity* mural, 1979-1984, Sterling Student Life Center, Texas Southern University, Houston. Photo by Earlie Hudnall, Jr.

The long history of African-American colleges which have preserved African culture through their collections is a little known legacy within the United States. The extensive travel by artists and scholars to Africa enabled their students and, by extension, the general public to view the African continent in a more personal way, and to assess its history and cultural contributions in a manner that was free of those African stereotypes so common in early 20th-century mass media. Such scholarship and travel established a place within the black community for African and African-American art equal in stature to that of major movements of European modernism.

The vision of faculty and administration at predominantly black colleges has promoted an atmosphere of self-awareness which continues today. African-American colleges have historically been regarded as centers of the black intelligentsia, setting the standards for intellectual pursuit in the community. By promoting African culture through writing, exhibitions, teaching, and travel, these educators have provided their students with an anchor of self-awareness. Along with their white patrons and supporters, they have truly formed a uniquely American avant-garde. In recent testimony regarding the importance of black colleges and prepared for the National Association for Equal Opportunity in Higher Education, a prominent black professor stated: "They have been menders, healers for wounded minds and restless souls. They have produced sterling talent which benefited the Republic beyond measure of calculation not only in material contributions, but intellectual, cultural, moral, and spiritual offerings."[31]

Currently there is a growing interest in African and African-American art in this country which effectively demonstrates the importance of these unique collections. However, too many Americans remain blind to the many unique histories that make up the distinct fabric of this society. At a time when many black colleges are

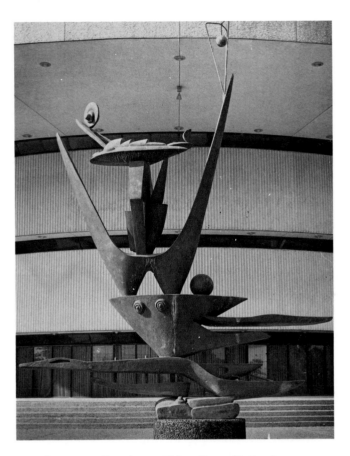

Fig. 18. Carroll H. Simms, *African Queen Mother*, bronze, 1968, Texas Southern University, Houston. Photo by Earlie Hudnall, Jr.

struggling to remain open, it becomes even more critical that these institutions receive support for the preservation, restoration and documentation of their irreplaceable collections of African and African-American art. If the story of America is to be fully told, then the strong and distinct connections between this hemisphere and the antiquity of Africa must be recognized and celebrated. One recalls the words of Alain Locke: "Nothing is more galvanizing to a people than a sense of their cultural past."

Alvia Wardlaw, Adjunct Curator of African-American Art at the Dallas Museum of Art and Assistant Professor of Art History at Texas Southern University, has organized a number of exhibitions on African and African-American art including *Roy De Carava: Photographs* for the Museum of Fine Arts, Houston. She is currently completing major research on the art of John Biggers.

1. William H. Robinson, *The History of Hampton Institute 1868-1949*, Ph.D. dissertation, New York University, 1953, p. 56.

2. Armstrong Samuel Chapman, "From the Beginning" *Twenty-Two Years' Work of the Hampton Normal and Agricultural Institute*, Hampton, Va: Hampton Institute Press, 1893, p. 2.

3. Robinson, *op. cit*, p. 77.

4. Mary Lou Hultgren and Jeanne Zeidler, "Things African Prove to Be the Favorite Theme: The African Collection at Hampton University," *ART/artifact*, The Center for African Art, New York, 1988, p. 97.

5. Zeidler and Hultgren, *op. cit.*

6. *Southern Workman*, 20 (March 1891), p. 168.

7. *Southern Workman*, Vol. LVIII, No. 89, August 1929, pp. 353-354.

8. The Blondiau-Theatre Arts Collection was purchased in part by Alain Locke to form the nucleus of the collection for the Harlem Museum of African Art. Other portions of the collection were collected by Hampton and other private institutions.

9. Conversation with the artist, Houston, October 1988.

10. W. E. B. Du Bois, "Criteria of Negro Art," *Crisis*, Vol. III, No. 3, 1925.

11. Alain LeRoy Locke. Constitution of the Harlem Museum of African Art, File: Organization of Harlem Museum of African Art, *Alain L. Locke Papers*, Moorland-Spingarı Collection, Howard University.

12. Alain Locke, Theatre Arts Monthly, February 7-March 5, c. 1920, New York.

13. James Johnson Sweeney, *African Negro Art*, Museum of Modern Art, New York City 1935, p. 8.

14. Telephone interview with the artist, October 28, 1971. Douglas dicussed at length how he and other black artists in Harlem frequently travelled to the Brooklyn Museum to study Egyptian Art and to the American Museum of Natural History to look at the Congo works. He was a voracious reader of publications on African art from the Brooklyn Museum and *Opportunity* Magazine.

15. Alain LeRoy Locke, *Alain L. Locke Papers*, File: Organization of the Harlem Museum of African Art, Moorland-Spingarn Collection, Howard University, p. W2.

16. Wilda Logan Willis, *A Guide to the Alain L. Locke Papers* Moorland-Spingarn Research Center, Howard University, Washington, D.C., p. 1.

17. Recently, an exhibition of these goldweights was featured at the O. T. Hammond house in Atlanta during the National Black Arts Festival as a tribute to Locke's contribution to the awareness of the African Diaspora.

18. Lois Mailou Jones was invited in 1976 to present her paper "The African Influence on Afro-American Art" at a conference held in conjunction with the celebration of the 72nd birthday of President Leopold Senghor in Dakar, Senegal.

19. A number of African art exhibitions were periodically scheduled for the Howard University Art Gallery. During the school year 1933-1934, for instance, the following exhibitions were included in the exhibition schedule: "Paintings of West Africa by Erick Berry," October 2-October 16 and "African Bush Paintings" (sponsored by the Carnegie Corporation (December 9-June 3).

20. Morrison, Keith. *Art in Washington and Its Afro-American Presence: 1940-1970*, Washington Project for the Arts, Washington, D. C., 1985.

21. *Ibid.*, p. 44.

22. David Driskell cites in his introductory remarks to the catalog *The Afro-American Collection, Fisk University* the linkage between the establishment of AMA missions in West Africa and the early development of an African art collection at Fisk.

23. The Fisk murals were painted directly upon the walls of the library. Douglas' assistant, Edwin Harleson transferred on charcoal the outlines of Douglas' cartoons onto the walls using a tracing technique. Four students who, according to Douglas "had never held a brush in their hands before that summer, but needed work" assisted Douglas and Harleson.

24. Information on the Amistad mural project recorded during a series of interviews with the artist in October of 1970.

25. At the dedication ceremony of the Savery Library, Owen Dodson, a young black writer presented a play based upon the events of the Amistad. The following excerpt reflects the mood of determination also conveyed in the murals:

We have been killed over and over,
We are men, Princes in our land
We were stolen, pawned, beaten.
You are right; to kill is wrong,
But it is right to keep freedom
When you have it.
It is right to fight for freedom,
When it has been taken from you.

26. Interview, *op.cit.*

27. The catalog for the National Black Arts Festival offers an excellent analysis of Woodruff's series *Art of the Negro*. See "Go Back and Retrieve it: Hale Woodruff, Afro-American Modernist" by Judith Wilson in *Selected Essays: Art & Artists from the Harlem Renaissance to the 1980's*, National Black Arts Festival, Inc., Atlanta, 1988, pp. 41-49.

28. Bryant, Ira. *Texas Southern University, Its Antecedent, Political Origins and Future*, 1975, Vanity Press, p. 10.

29. *Color Me Black*, Black Arts Festival Brochure, May 9-11, 1969, Texas Southern University, Houston.

30. Biggers, John and Carroll Simms with Edward Weems. *Black Art in Houston: The Texas Southern University Experience*, Texas A & M University Press, 1978.

31. Tollett, Kenneth S. *Black Colleges as Instruments of Affirmative Action*, Howard University Press, Washington, D.C., 1982, p. 59.

BLACK ART:
MAKING THE PICTURE FROM MEMORY

WILLIAM FERRIS

In describing the American South, Alex Haley recalls the old men who sit on porches watching life pass and relating with vivid detail events of earlier years. Ernest Gaines and Alice Walker make similar references in their writing to elders whose memories are the heart of the black community. On the front porch of a home, beside a stove in a country store, or gathered on the grounds outside a church, these elders constantly evoke memory to bridge past times with the present.

Black art presents a similarly rich and largely unexplored well of memory. Its images are shaped both by traditional folk artists and by artists within the academy. African sculpture, metalwork, and textiles offer a rich background for understanding contemporary black artists in the Caribbean, Central and South America, and the United States. A growing body of research on black art in each of these geographic areas helps us understand black culture in the New World. Black adaptation to the New World is reflected in aesthetic choices by artists whose images describe their experiences with vivid detail. A Haitian painter, a designer of carnival costumes in Trinidad, and a Mississippi quilt-maker -each chooses bold primary colors to express familiar, distinctive art forms.

Concurrent with important surveys of black art in Africa and in the New World, there is also exciting information on individual artists and their perspectives. These latter studies encourage artists to reflect on their work and to explain how they conceive and execute pieces. Artists' voices are especially important in shaping a more complete understanding of black art. By presenting artists' views of their work, we experience their creative vision through their narrative. Critics often impose their theories on works of art without exploring ideas with the artists themselves. Through conversations with individual artists, we see through their eyes and encounter the vision that shapes their art.

Black artists work in a culture that is shaped by both Africa and the New World. Their art must be understood in a context of three creative streams — Africa, the New World, and the artist's creative vision. The black artist has always shared an important relationship with musicians, singers and storytellers, creating visual images of the imaginary worlds described by singer and storyteller. Through sculpture, painting and textiles, the artist offers a visual counterpart to black oral tradition. Just as the singer and storyteller describe the trickster in song and tale, the artist renders the trickster with paint on a canvas or on the head of a sculpted wooden cane. Storyteller, singer, and artist should each be viewed within the context of the black verbal tradition that in many ways parallels and shares images of its oral lore with

visual forms of art.

When we compare traditional folk artists with those trained in the academy, we find a strong affinity between them. Like black writers, the formally trained visual artist draws heavily on folk expression for inspiration. Romare Bearden's collages have obvious parallels with techniques used by traditional quiltmakers, and he consciously borrows images like the cock which are common in both African and New World folklore. Bearden's preference for primary colors such as reds and yellows is also an aesthetic common in Africa and in the New World.

Sam Gilliam compares his abstract paintings to the shimmering light he saw on the Ohio River as he returned to his home in Louisville, Kentucky. Artists relate to their childhood homes as central places on which to draw in shaping their art. Home resides permanently in the artist's imagination as a source for his or her work.

While black music and folk tales have been recorded and carefully studied for well over a century, folk art has only recently been embraced by academic institutions, museums, and art galleries. Significant research and exhibitions of black folk art date from the late sixties and have become increasingly important in the eighties.

While 20th-century artists like Picasso reached to African art for artistic inspiration, black artists find both artistic and cultural roots in their ancestral traditions. Lois Mailou Jones, John Biggers, and Romare Bearden celebrate black memory by linking their work with African and Afro-Caribbean forms.

Black Art: Ancestral Legacy builds on a series of important presentations of black art that major institutions have presented in recent years. Each of these exhibitions explored significant new areas of black art. David Driskell's *Two Centuries of Black American Art* at the Los Angeles County Museum of Art in 1976 was a landmark exhibition that explored black art from the 18th through 20th centuries. It included a study of

black artists and crafts people from 1750-1920 as well as an exploration of the evolution of the black aesthetic from 1920 to 1950 in artists such as Jacob Lawrence, Charles White, and Horace Pippin.

John Vlach's *The Afro-American Tradition in Decorative Arts*, presented at The Cleveland Museum of Art in 1978, explored the work of folk artists in important traditions like quiltmaking, wood sculpture, basketry, and pottery. Vlach also presented important architectural parallels between the southern shotgun home and African and Afro-Caribbean homes.

Vlach's pioneering work was followed by Jane Livingston and John Beardsley's *Black Folk Art in America, 1930-1980*, which opened at the Corcoran Gallery of Art in Washington, D.C. in 1982. The exhibition included a rich selection of work by black folk artists whose work had never before been featured in major American museums.

Robert Farris Thompson has pioneered the study of African art and its relationship to black art in this hemisphere. His *The Four Moments of the Sun: Kongo Art in Two Worlds*, which opened at the National Gallery of Art in 1981, drew exciting parallels between Kongo art and grave decorations and face jugs in the American South. Thompson also incorporated dramatic film footage of black dance in the exhibit so as to highlight the integration of art with music and dance.

Rick Stewart developed a major study of black painters in the American South that was featured in the *Painting in the South* exhibition which opened at the Virginia Museum of Fine Arts in Richmond, Virginia in 1983. Stewart's research on artists such as Romare Bearden, Sam Gilliam, and Benny Andrews showed how each draws on regional roots in his art.

All of these exhibitions were accompanied by catalogues that explored black art through its relationship to African roots, its folk heritage, and its aesthetic. Such work is long overdue in establishing a serious study of black art and its

contributions to the American experience.

Black Art: Ancestral Legacy builds on this important earlier work and, in the tradition of black philosopher Alain Locke, seeks to explore ancestral arts. The exhibition links artists of the United States with Africa and with other areas of the New World. It stresses the reason why we must visualize the Deep South and black culture as part of the Caribbean.

Southern writers, artists, and musicians have long recognized important links between their own culture and those to the south. William Faulkner's complex portrait in *Absalom! Absalom!* of Thomas Sutpen, who journeyed to Haiti and from there to the mythic Yoknapatawpha County, suggests that the writer understood these ties. Sutpen's dramatic arrival in Jefferson with his Haitian-born slaves is permanently etched on the memory of local townspeople who recall the "man who rode into town out of nowhere with a horse and two pistols and a herd of wild beasts that he had hunted down single-handed because he was stronger in fear than even they were in whatever heathen place he had fled from."[1] Sutpen's past life in Haiti follows him to his new home in the presence of Charles Bon, a son by his first wife who enrolls as a student at the university and is described "crossing the campus on foot in the slightly Frenchified cloak and hat which he wore."[2] The dramatic contrast Faulkner draws between Bon's elegance and the animal-like world of Sutpen's Haitian slaves suggests the different but equally powerful Haitian influences Faulkner felt in his own Mississippi world.

For centuries artists and educators have migrated between Haiti and New Orleans, and many prominent black American intellectuals, such as St. Clair Drake, trace their ancestry to "the islands." The study of this cultural bridge between the American South and the Caribbean culture, long overdue, will enrich our understanding of black art in the United States and its relation to other nations in this hemisphere. Artists always pioneer movements in our society,

and for many years black American artists have been drawn to cultures "down under." The popularity of Haitian art suggests the potential for a broader public appreciation of Caribbean artists.

Caribbean artists are similarly influenced by traditions in the United States. Patterns of migration between the islands and the United States have made black American influences at least as important as those from other islands in the region. And many black artists in the Caribbean have studied and traveled in the United States. Similar exchanges exist in the musical world where calypso and reggae performers have developed a growing following among blues and jazz performers in the United States.

Black Art: Ancestral Legacy draws important new resources together through the work of artists like Bill Traylor, Bessie Harvey, and Charles Searles. Through their eyes we can better appreciate the long memory of black art and how it shapes each of our lives.

Black folk art explores 20th-century themes such as racism and civil rights, and also draws on rural images of animals, birds, and foliage. The black worlds of family, religion, and the blues all emerge in folk art through dramatic, brightly colored images. This folk art challenges us to explore new worlds of art and to study these worlds within the context of their culture.

To appreciate black folk art, we must first understand the community from which it emerges. Like the preacher and the blues singer, the artist is a spokesperson for his or her community. The artist's visual statement is closely linked with the black experience and repeatedly evokes the long memory of elders and their remembered worlds.

We may wonder about the place in which this memory resides; where is it anchored? There are geographic locations in which memory is especially rich. Each artist has a unique attachment to the place in which he or she is born and grows up. Childhood attaches itself to these

places with deep emotion and feeling. These places are internalized and later shape the artist's work with both direct and oblique influences.

While artists bear the personal memories of a home place in their work, there are several geographical areas that have shaped folk artists with special power. Blues, for example, is closely associated with such places as the Mississippi Delta, Beale Street in Memphis, and Maxwell Street in Chicago. Performers such as B. B. King, Muddy Waters, and Robert Johnson are among the many blues names associated with the Mississippi Delta, while W. C. Handy celebrated Beale Street in his compositions, and Willie Dixon and Ko Ko Taylor sing of Chicago in their blues. In his powerful "Why I Sing the Blues," B. B. King recalls memories of slavery through the blues. These memories and King's music are poetically introduced to radio listeners by disc jockey Joe "Big Daddy" Louis on Jackson, Mississippi station WOKJ. As King plays, Louis chants:

> This is B. B. King,
> Making a statement,
> And a natural fact.
> All you got to do is sit back,
> And dig where it's coming from.
> Listen,
> Not only with your ear, but with your heart.
> Everybody wants to know,
> "Why I Sing the Blues."

As Louis suggests, the blues artist expresses a truth that is instinctively understood by his or her audience. The performer soothes the pain of poverty and lost love through his music, and the song becomes an anthem of the black experience. B. B. King and Bessie Smith carry their audience on a musical journey through time and space as they reach deep levels of memory through their music. Their verses are both an inspiration for and a parallel to black visual arts.

Geographic places that nurture black art forms also provide a landscape for the literary artist's memory. The rural South and the urban North present important landscapes for artists, writers, and musicians. Richard Wright, Ralph Ellison, and Alice Walker, interestingly, draw on both rural and urban worlds in establishing their fiction. Wright and Ellison describe black flight from the rural South to the urban North. Wright's Chicago and Ellison's Harlem are landscapes with important associations of memory for thousands of blacks who made the journey northward. Alice Walker interestingly shifts the flight of her protagonist in *The Color Purple* from the South to Africa.

Memory is repeatedly preserved by artists whose work keeps the past alive. This process is most dramatically demonstrated by the African griot who carries the history of an entire culture within his memory. Griot singers and storytellers are compared to kings and princes because their memory is a sacred trust that touches every person in their culture. Alex Haley traveled to The Gambia in search of such a griot to trace the history of his ancestor, Kunta Kente.

The griot's memory lives within the black storyteller, singer, and artist. A trickster tale, blues, or a quilt reaches beyond individual memory and achieves a collective power through its art. Each of these art forms bears the imprint of African artistic ancestry while also responding to influences of the New World. African trickster tales, for example, evolve into rhymed black toasts celebrating New World characters such as Shine and Stackolee; work chants and sacred music are restated in the late 19th century as blues; and African textile designs featuring narrow strips influence the string quilt.

Artists often learn their craft through apprenticeship or "fireplace training," and they acknowledge their teachers through their work. Bluesmen B. B. King and James "Son" Thomas frequently mention performers such as Lonnie Johnson and Elmore James who strongly influenced their own work. For every influence acknowledged, many others remain anonymous.

Through memory, black art mediates between the individual and his or her history. Through

story, song and visual image, black art forms embody and restate the history of a culture. In *The Shape of Time,* art historian George Kubler compares a work of art to a star burning in the night whose source has long since disappeared, but whose light continues to move through space and time before our eyes.[3] Black art bears a similar message of memory carried through space and time. As black artists tell the tale, sing the song, and paint the image, they restate an old story. Like the griot, they preserve memory with their voice and hands, and tend ancestral fires with their creative gifts.

Artistic memory is deepened by dreams that instruct the black artist. Through these dreams the artist discovers new images that he or she then incorporates into art. Some artists find their primary inspiration in dreams rather than in life. They draw on internal sources to shape their art, and the similarity of dreams recalled by different artists is striking. Images of water, of the journey to a lonely crossroads, and of visual designs frequently recur in these dreams.

Delta artist James "Son" Thomas draws on such images in his sculpture, folk tales, and blues. In each of his repertoires he shapes images that he first discovers in dreams and later articulates as art. Thomas' clay figures of catfish, for example, are an image he also uses in his "Catfish Blues:"

> I wish I was a catfish swimming in the deep blue sea.
> I would have all you Mississippi women swimming after me.

Folk sculptors like Thomas have a recurring dream of creating a life-sized man from mediums such as clay and wood. Thomas once explained to me, "If I could git to a mountain where they have this clay like I uses, I believe I could put a whole statue of a man in the mountain standing up."[4]

An artist in Trinidad is haunted by a dream in which he floats in space among planets and then

falls into brightly colored streams of paint. The dream is recorded in a brilliantly colored costume he designs for Carnival in which streams of color swirl around the face of the person wearing the costume. Such dreams offer artists a special link with imagination and memory that instructs them in their work.

Sultan Rogers occupies an interesting position in this artistic tradition (fig. 1). He was born near Oxford in Lafayette County, Mississippi, in 1922, and both of his parents were gifted artists. His mother was a quiltmaker, and his father a carpenter who carved animals from wood scraps in his spare time. While his sister, Allean Pearson, followed her mother's talent as a quiltmaker, Rogers pursued wood sculpture with determination. He learned first to conceive "futures" or imagined shapes before actually carving the image from wood. The following are comments he made at his sister's home in Oxford in December of 1988:

> I started following my father making carpentry work. I would get little end pieces of wood, borrow his knife, and I'd start to whittling. I got to where I could make futures of different kinds of dogs and horses and things. I could go along and see an animal out in the field, and I'd try to make it.

Rogers acknowledges that he learned his craft from his father, but he is quick to point out how his versions of animals are different from those of his father. He compares his father's striking sculpture of a cat (fig. 2) with a similar version of the animal he recently carved (fig. 3). Like his father, he chose to carve the cat with its back bowed, as if the animal is confronting a dog.

> This is a cat my father made when I was about twelve years old. He made it look in the eyes and face like a human. Course he's broke up now. But that's the way a cat draws up when he see a dog. His head was supposed to be round. But he didn't have it exactly round. When I made this cat, I was thinking about my father

Fig. 1. Sultan Rogers and his sister, Allean Pearson, 1988. Photo by William Ferris. Courtesy of The University of Mississippi Archives and Special Collections.

and how he made his. And so mine come in the face just a little bit different from the way he got his. His, I would say, was too narrow in here. Mine was wider and more rounder. Mine is all humped up in his back. His waddn't quite drawed up exactly right, didn't have the curl up under his stomach.

Rogers' first carvings were inspired by both domestic and wild animals he saw in rural Lafayette County. Like many other Afro-American folk artists, his creations frequently appeared in dreams. He would awake during the night and sketch an outline of the image. Then he would complete the carving the next day when he awoke.

The snake is perhaps the most common image in Afro-American folk art. Familiar in voodoo tradition as the god Damballah, the snake recurs as a central figure in music, folk tales, and folk art throughout the Caribbean and the American South. Sultan Rogers has carved many images of snakes (page 176) and clearly has thought often about how they inject poison into their victims. He inserts glass diamonds as eyes and wire as teeth and fangs to give the snake's mouth a particularly menacing expression (fig. 4).

I've made thousands of them in my lifetime. I made this one with his mouth open. A snake's jaw runs like on a track. They don't just bite you. They strikes. His mouth fly open and then come down. The teeth hooks back. They don't go straight in. They hooks back. And you snatch it in yourself when they hit you. And when the

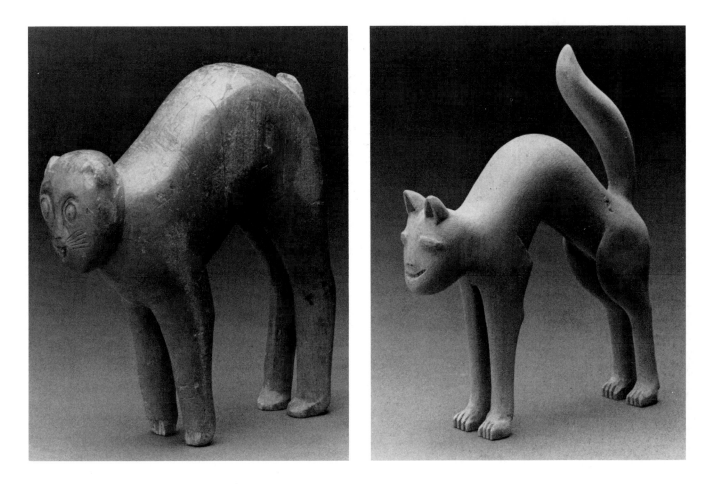

Fig. 2. Will Rogers, *Cat*, wood. Collection of Allean Pearson. Photo by William Martin. Courtesy of University Museums, The University of Mississippi.

Fig. 3. Sultan Rogers, *Untitled* (cat with back arched), wood, 1986. University Museums, The University of Mississippi. Photo by William Martin. Courtesy of University Museums, The University of Mississippi.

Fig. 4. Sultan Rogers, detail of *Snake*, wood, paint, mixed media, 1987. University Museums, The University of Mississippi. Photo by Tom Jenkins.

teeth hit, the poison shoots out its tongue. I seen a lot of them during my lifetime. I am afraid of them. Sometime I dream about them and say it's the devil after me, but I go on and make it.

Once Rogers mastered his sculpture of animals, he began to focus on human images, which now occupy a central place in his overall work.

First I make them up in the future of a human being. I say I'm going to make a statue of a man or a woman. Well I have in mind how he's

supposed to be built. That's the way I do. I can carve it right in the wood. Put a suit on him or a coat on him, shirt, necktie.

Like many black southerners, Sultan Rogers left his home and moved to the North in search of better opportunities. As a gifted mechanic he found a job in Syracuse, New York, with Allied Chemical Company, overseeing equipment that monitored the processing of soda ash. In this position he often found himself with time when he could sculpt wood. Fortunately, his foreman approved of his hobby and never criticized Rogers for carving on the job.

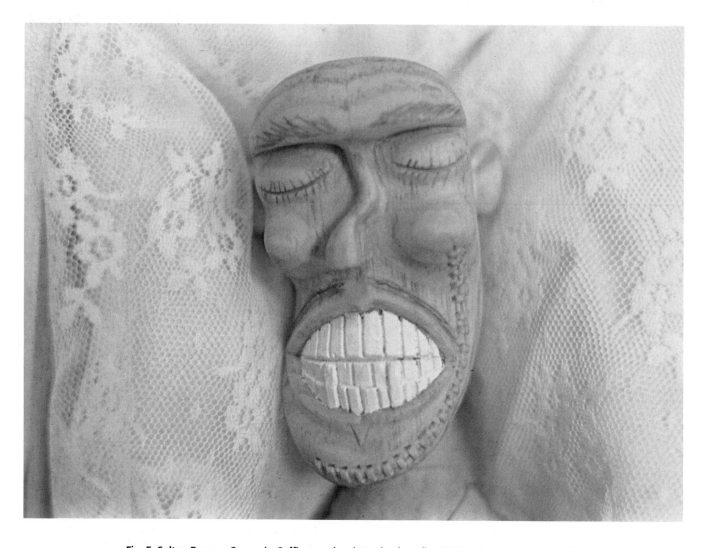

Fig. 5. Sultan Rogers, *Corpse in Coffin*, wood, paint, mixed media, 1988. University Museums, The University of Mississippi. Photo by William Ferris. Courtesy of The University of Mississippi Archives and Special Collections.

When I first met Sultan Rogers in 1987, I gave him a copy of my book on folk art, *Local Color*, and suggested he might enjoy reading about other Mississippi artists. As he read the book, he was impressed by its photographs of corpses in coffins sculpted by James Thomas and painted by Luster Willis. After seeing these photographs, he decided to carve similar images of his own in wood. Like James Thomas' clay skulls that can serve functionally as ash trays or containers, Rogers made his coffins with an eye toward practical use (fig. 5). The corpse in his coffin is carved only from the waist up, thus leaving space at the bottom of the coffin where valuables such as jewelry and cash can be stored. His coffins have become a popular item among friends in Syracuse. They are elaborately carved with handles on each of the four sides. Some are left as natural wood with a clear varnish seal, while others are painted black.

> Well what make me think of putting dead people in a coffin, I got a book from you . . . I looked at it, and I said, 'I can do that, too.' And so I tried it. A lot of people . . . wants them for jewelry boxes. They leave home, and they put money down under there. If any burglar come in, they don't fool with that. . . . They hit the other stuff, and the money and jewelry will be there. It's a space in the back end. You can take him [the corpse] out, put what you want under there, then tuck him back in. Nobody gonner fool with that who break in your home. . . . Some peoples is scared of them, and some is not. I have a friend, he won't come to the house no more. He don't like dead peoples. I'll say 'Come by the house.' 'No, you got them old dead peoples in there.' He'll come in the front room, but he won't go in the cellar. He asked me, 'How do you work down there with them old coffins around you and all that junk?' I say, 'It don't bother me. Don't be nothing but wood.' It's the live ones you better watch. They the ones that can hurt you.

Many of Rogers' human figures have accentuated expressions that give them a cartoonlike quality. Images inspired by actual people he meets also have highly dramatic expressions (fig. 6).

> I seen a guy one time making faces, you know. He was at a bar making all kind of faces. I said, 'I'm gonner make that joker's picture.' And I did. I first had his tongue way down here, but I cut it off. That guy could take his tongue out and run his tongue up around his eye, all up there. I ain't never seen a guy like that before.

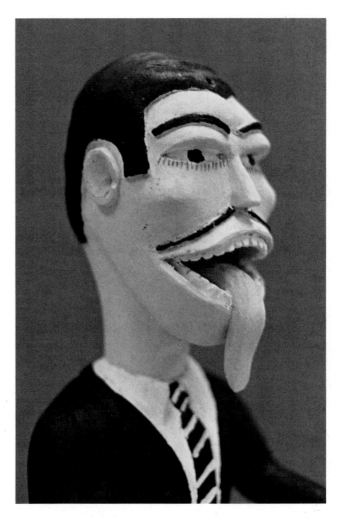

Fig. 6. Sultan Rogers, *Untitled* (man with long tongue), wood, paint, 1988. University Museums, The University of Mississippi. Photo by William Ferris. Courtesy of The University of Mississippi Archives and Special Collections.

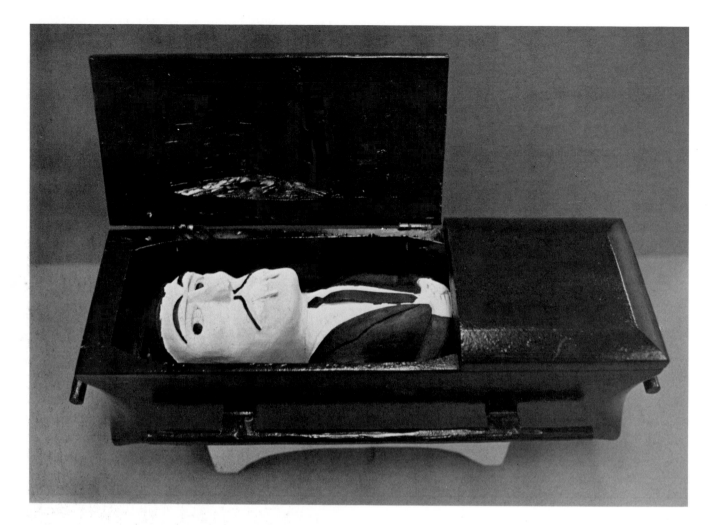

Fig. 7. Sultan Rogers, *Vampire in Coffin*, wood, paint, 1988. University Museums, The University of Mississippi. Photo by William Ferris. Courtesy of The University of Mississippi Archives and Special Collections.

Perhaps the most frightening image Rogers has conceived is a vampire in a coffin whose eyes follow the viewer (fig. 7). Like his corpses, Rogers keeps the vampires in his basement workshop where they are safely out of sight from visitors. As with many other creations, his inspiration to create a vampire first appeared in a dream.

> This man here, that's what they call a vampire. See his teeth. They bite people, you know. I laid him up there on a shelf, and I told my friend he was on the cooling board. It's awful fun when people come to see me. . . . He's supposed to be cutting his eyes round at you. He's watching you. . . . I had a dream about seeing one of them people like that. So I said, 'I think I'll make me a vampire.' . . . And when I first tried to learn to make his tie, a guy laughed at me and said, 'You'll never get that tied up under there.' I say, 'Yeah, it'll go in there.' So I got me another piece of wood and practiced on it. Then I got it. It's hard to do that.

Rogers loves the blues (fig. 8):

> I seed a girl on the TV singing at some kind of
> music awards. I didn't get her name. . . . I liked
> the way her shoes were made. I tried to make
> her high heels and the mike in her hand. She
> was singing a blues song. . . . My favorite
> singers are B. B. King, John Lee Hooker, and
> Muddy Waters. I listen to their words, and it
> give me a good thought, look like.

Sultan Rogers views his art as a hobby that he
does both for his own pleasure and to entertain
his friends. On one occasion he approached a
museum in Syracuse to see if they might be
interested in his sculpture. "They didn't seem to
pay much attention to my work so I never did
go back." Rogers also taught art at a boy's club
in Syracuse for a short time, but discipline
problems forced him to terminate the class. His
interest in teaching his art to young people,
however, reflects the important training he
received from his father.

One of the projects Sultan Rogers plans to
execute is the Lord's Supper. His proposed work
will underscore an important connection
between religion and civil rights:

> I am thinking about making the Lord's Supper.
> I'll carve it out of wood. I'll have the chairs and
> the men sitting in the chairs. I don't know how
> it's gonner come out, but . . . I'm gonner try to
> change it around a little bit. I'll have all the big
> men like President Kennedy, President Johnson,
> and Martin Luther King, all of them with their
> pictures in there in their chairs. I'm gonner try
> to draw that. I got to see the Lord's Supper to
> see how many is it in there and how it's built in
> the top and all like that. They'll all be black,
> except for President Kennedy and President
> Johnson.

Sultan Rogers drives several times each year
from his home in Syracuse to visit his family in
Oxford. Now retired, he is considering moving
back to Mississippi where he can be closer to
family.

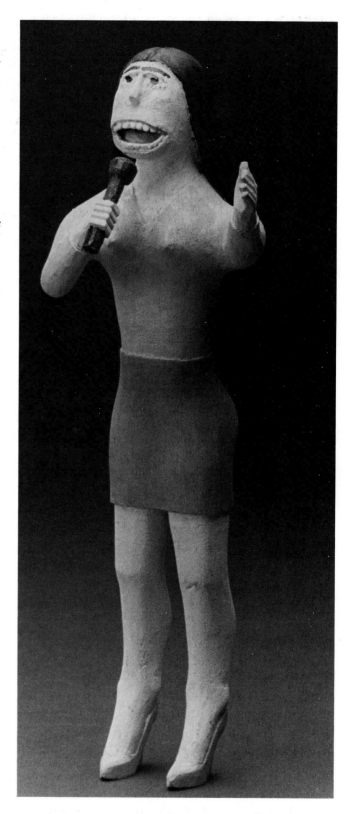

Fig. 8. Sultan Rogers, *Female Blues Singer,* **wood, paint,
1988.** University Museums, The University of Mississippi.
Photo by William Martin. Courtesy of University
Museums, The University of Mississippi.

I thinks about my home back in Mississippi all the time. I think that I might come back and stay. I've reached the age of an old man. I ain't got any peoples up there, and I think I should be around my peoples more. My childrens are all down here. I didn't think so much about that until I had a couple of operations.

As Sultan dreams of returning home, it is fitting that his works and those of other black artists are celebrated in *Black Art: Ancestral Legacy*. The exhibition is a homecoming for artists who are national treasures. Their work is a beacon through which we can explore both black and American culture, and through this journey, better understand ourselves.

Author's Note: An earlier draft of this paper was presented at a meeting of the Working Group on History and Memory in Afro-American Culture, organized by Melvin Dixon and Genevieve Fabre at the W.E.B. Du Bois Institute, Harvard University, and I am grateful to the members of that group for their comments and suggestions on the work.

William Ferris, Professor of Anthropology and Director of The Center for the Study of Southern Culture at the University of Mississippi, has contributed major studies to the field of African-American folklore and produced numerous documentary films on southern artists. He served as co-editor of the recently published *Encyclopedia of Southern Culture*.

1. William Faulkner, *Absalom! Absalom!*, Random House Modern Library, New York, 1936, p. 16.

2. Faulkner, p. 95.

3. George Kubler, *The Shape of Time*, Yale University Press, New Haven, p. 19.

4. James Thomas, "Catfish Blues" *Highway 61 Blues*, Southern Culture Records SC 1701 (Oxford: 1983).

BLACK ART IN THE CARIBBEAN

UTE STEBICH

Jamaica, Haiti, and The Bahamas are the Caribbean nations represented in the exhibition, *Black Art: Ancestral Legacy*. They are not the only islands, however, where the spirit of Africa is alive. Varying factors have prevented the art of other islands from becoming known. Political circumstances, as in the case of Cuba, have made certain countries and their art inaccessible, and a lack of research has contributed to our ignorance about art on the other islands. Granada, for example, has vodun temples decorated in a similar fashion to their counterparts in Haiti, and the ambience of St. Martin inspired artist Romare Bearden to produce works imbued with that island's local culture, such as *High Priestess,* 1985 (fig. 1). Trinidad is home to Geoffrey Holder who has designed costumes and stage sets which are a tribute to his birthplace. His famous ballet, *Banda,* is a powerful testimony to his roots, as are his paintings of black women and mysterious landscapes, as in *Forest,* 1989 (fig. 2) for example. Third-generation Haitians who live in the Dominican Republic continue to uphold their customs, though they have taken on new forms influenced by local culture. In addition, there is Carnival which is celebrated all over the islands and which brings out the splendor of Afro-Caribbean creativity.

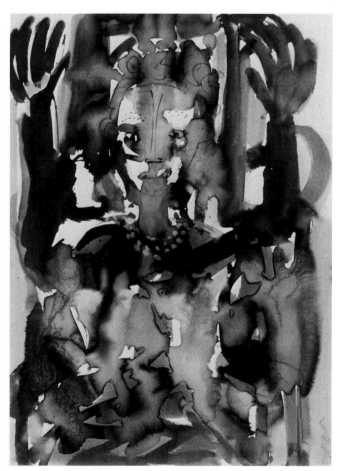

Fig. 1. Romare Bearden, *High Priestess,* watercolor on paper, 1985. Collection of Linda and Pearson C. Cummin III. Photo by Hansen Studio, Chesire, Massachusetts.

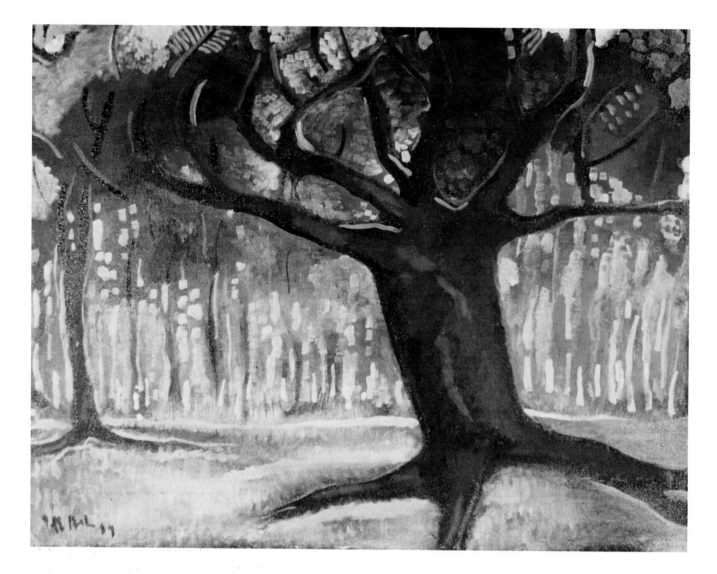

Fig. 2. Geoffrey Holder, *Forest*, oil on canvas board, 1989. Collection of Geoffrey Holder. Photo by
Hansen Studio, Chesire, Massachusetts.

New artistic forms and ideas evolve every year, and the exhibition, *Caribbean Festival Arts*, organized by The Saint Louis Art Museum in 1988, began to explore the wealth of such material.[2]

Often, however, there is a lack of support on the islands for local art. There are no galleries or museums in which artists can sell or show their work and, sometimes, it takes an outsider to recognize and promote such work. Amos Ferguson from The Bahamas is such a case. Sukie Miller, a New York psychotherapist, discovered his magnificent paintings and her devotion to his work led to the organization of a traveling exhibition, *Paint by Mr. Amos Ferguson*, which opened in 1985 at the Wadsworth Atheneum in Hartford, Connecticut.[3] The Bahamian Government supported the project financially, but still there exists no museum anywhere in that country. Amos Ferguson remains a national treasure without a showcase at home, thus limiting his influence on other talents.

The lack of support and recognition in the islands touches upon other problems as well. Artists like Amos Ferguson are uneducated, in the formal sense, and their art, unfortunately, is often labeled naive or primitive. These artists

remain close to their African heritage, a past that evokes memories of slavery and bondage, and the elite of these island nations often wish not to be associated with such nomenclature and would gladly forget the past. It will take time for the Caribbean elite, so badly hurt by history and prejudice, to mock such labels and recognize that their heritage can be a repository of strength, pride and identity.

Haiti and Jamaica, in fact, have recognized this potential for a long time. Their governments celebrate artists as ambassadors of culture and fine collections have been assembled and are displayed in their museums.[4] There is an ongoing dialogue between the artists and the community, discussing the art and trying to understand the contributions of self-taught artists or "intuitives." Rex Nettleford beautifully demonstrates this point in his introduction for the exhibition catalogue, *The Intuitive Eye*, organized by Dr. David Boxer, Director of the National Gallery of Jamaica in Kingston. Nettleford writes:

> For the works not only summon us to serious reflection on the state of the arts in a society which is on the move — and therefore in crisis — they also challenge us to deep, if not painful reassessment of much of our received aesthetic perceptions about the arts in general . . . in that realm of excellence there is no hierarchy and . . . trained artists had better be good to be respected as intuitive artists are, indeed, respected when they are good . . . these intuitive painters and carvers must be closely observed and keenly studied as guides to that aesthetic certitude which must be rooted in our own potential if the world is to take us seriously as creators rather than imitators . . . Those intuitive artists have indeed found what to paint with and what to paint on . . . by drawing on their own resources which include the diverse dimensions of everyday living, the deep and poignant inspiration of the Jamaican religious experience, the mythology and love of a transplanted and creolized people, and the dynamic recall of suppressed cultural memories.[5]

It is interesting to note that it is mostly the art of intuitives that was chosen for the exhibition, *Black Art: Ancestral Legacy*. Kofi Kayiga and Osmond Watson, both from Jamaica, are the only trained artists included. Kofi Kayiga traveled to Africa to find his roots, and through that experience he also discovered his creative certainty. Although educated at London's St. Martin's School of Art, Osmond Watson, a loner by nature, protected his unique sense of aesthetics by later distancing himself from the influence of formal training.

Since art is a reflection of time, place and society, it becomes obvious how different Haiti and Jamaica are historically and culturally. Jamaica, as a nation, did not achieve its independence until 1962. The many differing political, philosophical, and religious currents which led to Jamaica's independence are still evolving, and are indicative of a people struggling to find their identity. And the sources of inspiration and the levels of meaning behind that country's art are as diverse as the forces pulling at this young nation.

The magnificent carved *Heads* of the 1960s by David Miller, Jr. (pages 148, 149) display a proud consciousness of self and negritude, and, in that sense, they are symbols of independence. As portraits they convey at once the self-confidence of the subjects and the self-assured talent of the sculptor.

The meaning behind the statue, *Talisman*, 1940 by David Miller, Sr., (page 170) is not known, but the following interpretation is suggested. A talisman, from the Arabian *tilams*, is a magical image engraved with characters which are believed to possess occult powers. A talisman, therefore, is a charmed object whose purpose is to help deter disaster and to attract good luck. This statue, featuring four faces, stands ready to confront the future. The stance of the legs is that of a sailor prepared to brave a storm; the arms are stretched out to further support the figure's balance. Fingers, symbolically enlarged, seem to feel the direction of the wind, and growing out of the head is a knob resembling

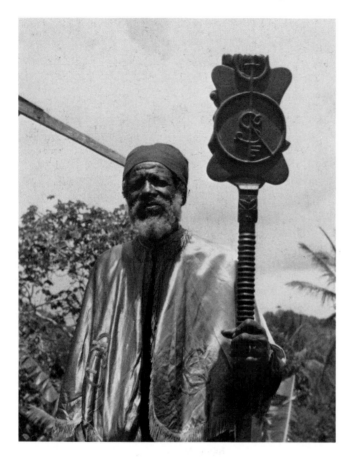

Fig. 3. Everald Brown, Murray Mountain, Jamaica. Photo courtesy of the Museum of Modern Art of Latin America, Washington, D.C.

the palette of his paintings, *Ethiopian Apple*, 1970 (page 217) and *Spiritualism*, 1979 (page 182). At the center of both paintings stands the tree that bears the national fruit of Jamaica, the ackee. This image of political awareness is combined with iconography — pumpkin, rooster, drums — derived from *obeah*, the Jamaican equivalent of vodun. His two musical instruments, *Dove Harp*, c. 1976 and *Instrument for Four People*, 1986 (page 242) are covered with religious imagery, such as sacred birds. They are of personal invention and clearly are meant for ritual usage. A number of these instruments are played by members of the artist's family during the religious ceremonies which he conducts.

Brother William, 1981 (page 155) by William "Woody" Joseph is reminiscent of African sculpture. The head is disproportionately large compared to the body, the face a type rather than a portrait. The artist's repertoire includes animals and masks, carved from one block of wood, the shape and size dictated by the inherent form of the medium. Woody's talent springs from his subconscious, but it definitely is connected to the strong national artistic tradition of woodcarving in Jamaica, a tradition which in turn can trace its roots to West Africa.

Revival Kingdom, 1969 (page 245) and *Hallelujah*, 1969 (page 246), two very fine relief carvings by Osmond Watson, were inspired by the Revivalist movement and stand for the religious nature of Jamaican people. *Hallelujah* brings associations of gospel singers to mind, while the expressive gestures and rhythmic movements of a people totally absorbed by their spiritual experience in *Revival Kingdom* elevate this image to a religious icon.

Kofi Kayiga's paintings represent Jamaicans who, through intellectual experimentation and travel abroad, learn to recognize the value of their roots. Kayiga's work expresses both confidence in and love for the culture into which he was born. *Rolling Calf*, 1979 (page 216) depicts a vampire-like being that plays an important role in Jamaican folklore. Fearful of blinding car

the hub of a wheel, the steadying force of movement. The *Talisman* can also be seen as a crown, an icon of power, thus becoming an image of human possibilities, when body and mind are in balance with the powers of nature. The art of father and son Miller seems to spring from a personal, shared philosophy.

Everald Brown's images come from a different source. A self-ordained priest, Brown creates art and musical instruments as an extension of his philosophical and religious beliefs (fig. 3). Colors and titles reveal his closeness to the Rastafarian movement and its concern with political and spiritual matters. Red, green, and yellow are Rastafarian colors (derived from the colors of the flag of Ethiopia) and they dominate

lights, it prefers to roam the countryside, and the red color of its body symbolizes its aggressive nature. Like other folk tales in the Caribbean, details about the Rolling Calf may vary from one locale to the next. *Moonlight*, 1987 (page 215), on the other hand, is a personal interpretation of ritual ceremonies witnessed by the artist in Africa. The mystical nature of this nighttime experience is rendered as an abstraction meant by Kayiga to reflect feelings rather than literal observations.

Haitian art, by contrast, derives from a more

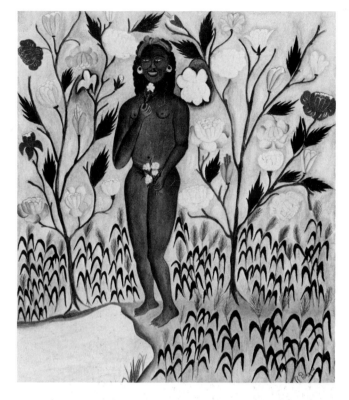

Fig. 5. Rigaud Benoit, *Nude, oil on masonite, 1948.* Private Collection. Photo by Hansen Studio, Chesire, Massachusetts

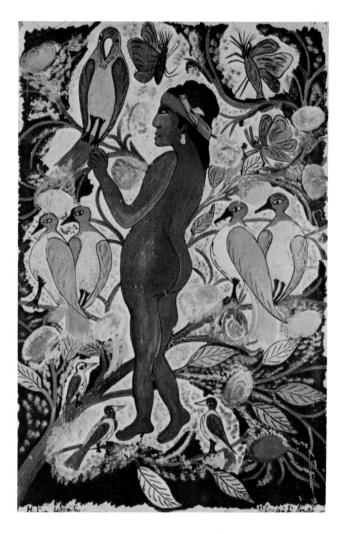

Fig. 4. Hector Hyppolite, *Maitresse Ezilie,* oil on masonite, **1948.** Collection of the Musée d'Art Haitien du College St. Pierre, Port-au-Prince, Haiti. Photo by Hansen Studio, Chesire, Massachusetts.

homogeneous culture. Unlike Jamaica, Haiti achieved her independence much earlier, through a slave uprising in 1804. Fearing that fierce spirit of revolt, the Western world decided to ignore the newborn island nation. Forced into isolation, the Haitians developed a culture that had much in common with that of Africa, still very much alive in their memory. Vodun, a creolized version of various African belief systems, became the fabric of Haitian life. It is also at the basis of Haitian art. With the founding of Le Centre d'Art in 1944 by the American DeWitt Peters, Haitian art began to flourish. An art school as well as a commercial gallery, the Art Center served as a meeting place for the intuitives. Seeing each others' work inspired and influenced them, not so much in style, but in subject matter, as the three paintings by Hector Hyppolite (fig. 4), Rigaud Benoit (fig. 5), and

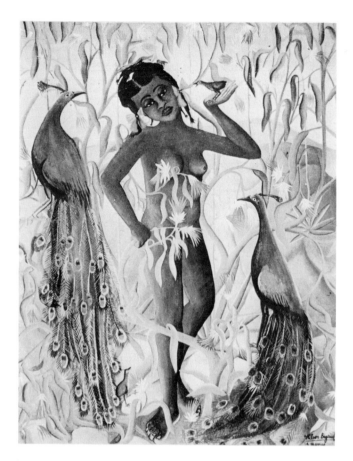

Fig. 6. Wilson Bigaud, *La Negresse***, oil on masonite, c. 1948.** Private Collection. Photo by Hansen Studio, Chesire, Massachusetts.

Wilson Bigaud (fig. 6) clearly show. As was the case with Jamaican art, it has been mainly the art of the intuitives which has achieved recognition abroad. The artists were admired for the uniqueness of their work, which is a combination of "aesthetic and cultural certainty."

The Haitian art presented in this exhibition consists of metal sculpture, paintings, and ceremonial objects. The artists who work in metal live in the village of Croix-des-Bouquets, with the exception of Murat Brierre. Georges Liautaud is the originator of Haitian metal art and his early pieces, such as *Male Spirit* (page 241), were created mostly of forged iron. Later, his use of metal from oil drums became the standard material for artists (fig. 7). Liautaud's *Male Spirit* is typical of the level of spiritualism in Haitian art. The prominent figure represents the spirit rising above the sacrificial food container. Two smaller figures are making the offering. The dominant figure is vertical, while the line of the bowl is horizontal. In vodun, vertical images represent the world of the spirits, while horizontal ones represent the human world. Together the two lines represent the four directions of the sky. The fifth point is where the two worlds

converge, and where the vodun ceremony must occur.

Inspired by Haitian folklore, Edgar Brierre's *Three Female Figures in a Stream*, c. 1968 (page 238) depicts water spirits who take on female forms at night to enjoy themselves. Some Haitians believe that sprinkling salt on discarded fish skins will prevent the spirits from returning to the sea, thereby forcing them to live among humans to help with their problems. *La Sirène*, c. 1950s (page 243) by Robert St. Brice shows the goddess of the sea in the mythical boat which brought her from Africa to the shores of Haiti. St. Brice was a vodun priest, and all of his paintings are concerned with the world of magic and spiritual matters (fig. 8). *La Sirène and Damballah*, 1973 (page 239) by Gabriel Bien-Aimé, and *La Sirène Conveyed by Two-Headed Goat*, 1970 (page 239) by Murat Brierre are all inspired by vodun. *La Sirène* is the goddess of the sea in the form of a mermaid. *Damballah* is the god of life depicted by a snake. *Chien de mer*, 1974 (page 173), by Murat Brierre, is an imaginative portrayal of that fabled being, literally the dog of the sea, who attacks swimmers. Because of the power and prevalence of vodun and the

Haitian preference for imaginative solutions, the artist and his audience are not satisfied with the logical explanation of a possible shark attack, preferring, instead, to connect their human existence with that of the supernatural.

Carnival Participants in Demonic Guise, 1973 (page 258) by Rigaud Benoit not only depicts creative and festive disguises, but also explores the origin of this festivity, a ritual for welcoming the arrival of spring and/or exorcising the demons of winter. The flowering plants, with demonic heads at their roots, symbolize this practice. Carnival, of course, remains a favorite subject matter among Haitian intuitives, possibly because of their cultural memory of Africa, where masks are of great importance. As some paintings have been seen to focus upon the power of the spirits of water, so in this work and others are the renewing spirits of the earth emphasized.

Fig. 7. Georges Liautaud at work on a medium-sized *La Sirène,* **mid-1960s, Croix-des-Bouquets, Haiti.** Photos by William Grigsby. Courtesy of Cavin-Morris Gallery, New York City.

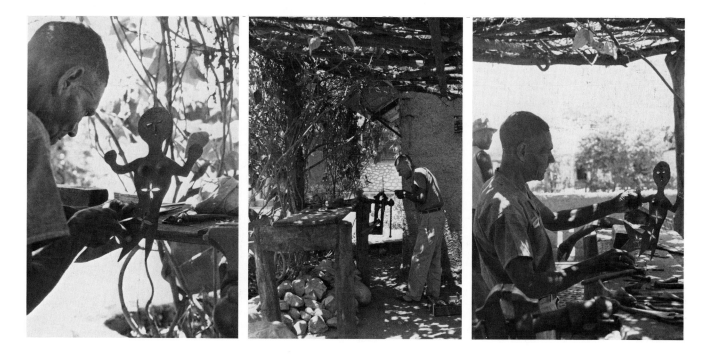

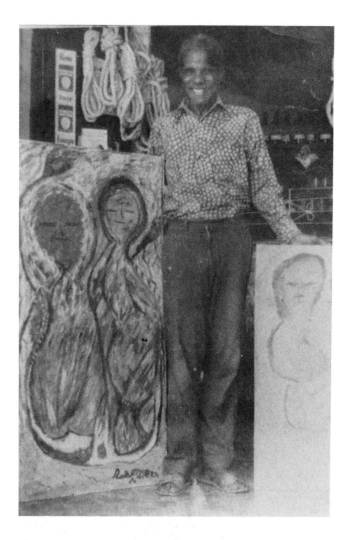

Fig. 8. Robert St. Brice, Haiti. Photo courtesy of Le Centre d'Art, Port-au-Prince, Haiti.

Ceremonial objects are of great importance in vodun. If a community can afford to do so, it commissions artists to produce elaborate flags and decorated drums such as those shown in this exhibition. They are objects of pride for the temple and essential for ritual purposes. Each spirit of the vodun pantheon has a special symbol, which explains the number and variety of images. In the flag *Damballah et Aida Woedo* (page 251), intertwining snakes represent Damballah, the god of life, and Aida Woedo, his consort. Their bodies embrace a royal palm tree which symbolizes freedom in Haiti. This combination, often seen on murals in vodun

temples, signifies that there is no freedom without the spiritual world. On one side is an *asson* (rattle) and bell and other paraphernalia for the vodun priest. On the other side is a govi clay pot used as a container for the spirit of the deceased. Stars may be found in the corners of the flag, serving as guardians of the four directions of the sky. At the same time, they represent the points which serve as extra forces. The image is set against a white ground, the color which is associated with Damballah and his wife.

Amos Ferguson is the only painter included in the exhibition to represent The Bahamas. He is also the only Bahamian painter who demonstrates that "aesthetic certitude" which is rooted in his own culture. His images are derived from Junkanoo,[6] a typically Bahamian festival, as can be seen in his works *Beeded Hair*, 1984 (page 232), *Polka Dot Junkanoo*, 1984 (page 236), and *The Star of Cow Face*, 1985 (page 235). The latter work also relates in its imagery of the cow or bull in Caribbean art to the frequent portrayal of this animal as having particular powers as in *Rolling Calf* (page 216), *Carnival Participants in Demonic Guise* (page 258), and the Haitian vodun bull flag (page 250). Mermaids are an obvious choice of subject matter for an artist from an island nation, but Amos Ferguson is also a religious man and many of his paintings attest to his religious convictions. He paints the beautiful fauna and flora of the Bahamian Islands, typical tourist activities, and family life, and his paintings reflect his surroundings and personal experiences. It is interesting that the imagery and symbolism of water, which so dominate Haitian painting, can also be seen in the work of Ferguson. His "mermaid" (page 172) shows its presence in another part of the Caribbean, the association once again of water with female spirits, ultimately traceable to Oshu, the goddess of water among the Yoruba of West Africa.

Haiti remains the Caribbean country with the richest and most active art tradition. There is no doubt that Le Centre d'Art and the way it

functioned served as a catalyst for the develop-
ment and promotion of art and patronage. In
addition, the historical circumstances of Haiti
have surely helped to foster a spirit of Haitian
creativity. Jamaica's art scene is also alive and
vibrant, but it started so much earlier than in
Haiti. The year 1922 is generally regarded as the
beginning of Jamaican art, since it is associated
with Edna Manley's arrival in Kingston and the
creation of the Institute of Jamaica. As an artist,
Manley supported the activities of the Institute
and endorsed its traditional structure which left
the intuitives in relative isolation. Jamaica, at
that time, was still a colony of England and the
Jamaican spirit lay dormant. With its recent
independence in 1962, much can now be
expected of this country's creative energy. The
Bahamas is a still younger nation, having
achieved its independence only in 1973. It is
quite possible that Amos Ferguson will be
admired by future generations as the father of
Bahamian art, at which time other Caribbean
countries will have found their cultural identity
through the arts.

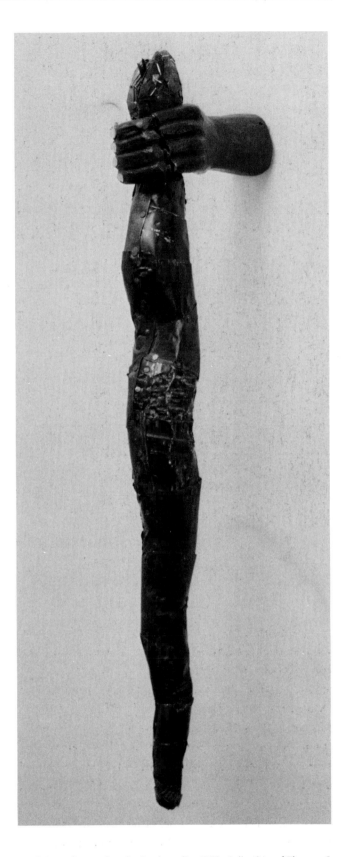

Fig. 9. Alison Saar, *King Snake of the 88's,* **wood and mixed media, 1982.** Collection of Thomas S. Schultz. Photo by Hansen Studio, Chesire, Massachusetts.

Several major images seem to recur in black art within the Caribbean. Among the most frequently represented is that of the snake. Though not included in *Black Art: Ancestral Legacy*, Alison Saar's *King Snake of the 88's*, 1982 (fig. 9) seems especially significant when related to the issues of this exhibition. Throughout religious history, the snake has been regarded as a carrier of magic, the guardian of the temple, a protector against demonic powers, and a harbinger of good luck. It is a symbol of temptation as well as of wisdom. In vodun, the snake represents the spirit of life. Saar's snake, held by a black hand, seems therefore to be an appropriate symbol for the future of African-American art, and like the snakes of Sultan Rogers, Willard Watson and the unknown African-American cane carver (pages 176, 179, 156), the serpent continues in the 20th century to express the goodness of Damballah and the shrewd cunning of the ancient Nubian cobra. Similarly, the symbolism of water as a spiritual force personified as a female spirit; the image of the tree as a central force of life; the bull as a powerful, energized animistic presence; and the stars themselves as cosmic indices of the powers of the universe are all symbols which permeate much of black art of the Caribbean and have their parallel references in African-American art within the United States.

Ute Stebich curated the groundbreaking exhibition *Haitian Art,* organized by the Brooklyn Museum in 1978, as well as the more recent exhibition *Paint by Mr. Amos Ferguson,* organized by the Wadsworth Atheneum in Hartford, Connecticut. She serves as a trustee of the Musee d'Art Haitien in Port-au-Prince, Haiti.

1. The spelling of *vodun* in this catalogue reflects the Yoruba pronunciation of the word and is currently being widely used by scholars (Courlander, R. F. Thompson and Stebich) replacing the more popular *voodoo* or *voudoun.*

2. St. Louis: The Saint Louis Art Museum in association with University of Washington Press, *Caribbean Festival Arts,* 1988.

3. Hartford, Connecticut: Wadsworth Atheneum, *Paint by Mr. Amos Ferguson,* 1985.

4. Major collections are included in the National Gallery of Jamaica, Kingston and Musée d'Art Haitien du College St. Pierre, Port-au-Prince.

5. Kingston, Jamaica: National Gallery of Jamaica, *Intuitive Eye,* 1979, Introduction by Rex Nettleford.

6. Junkanoo is a carnival-like celebration in the Bahamas which takes place from midnight to sunrise on Christmas and New Year's Day. For further information on costumes, music, and African cultural roots see Edward Clement Bethel's *Music in the Bahamas, It's Roots, Development, and Personality* thesis for the degree of Master of Art in music, UCLA, 1978, pp. 186-256.

THE SONG THAT NAMED THE LAND

THE VISIONARY PRESENCE OF AFRICAN-AMERICAN ART

ROBERT FARRIS THOMPSON

If you go there and stand in the place
where it was, it will happen again; it
will be there for you, waiting . . .

— Toni Morrison, *Beloved*.[1]

His eye is always on the line of the diaspora,
from Africa, across . . . the deep rural South and
on into the Northern cities. And he weights
and scales his perceptions so that the older
strata of culture and experience are always
the heavier. *His* South, like Toomer's, is
dense African. His North is African still,
following the presence of Black folks.

— Clyde Taylor, "Henry Dumas," *Black World*
(September 1975).[2]

The Dawn of The Black Image

The Yodel, a chest/head, high/low snap across
an octave is one of the hallmarks of the singing
of rainforest pygmies in Central Africa.[3] Dispersed across vast spaces from Gabon and the
southern Central African Republic, to Haut-Zaïre, the importance of yodeling as a central
trait remains consistent in every pygmy hunting
band.[4]

Some pygmies use the yodel as vocal signature. This they do to combat loneliness in the
forest and also to signify location when they are
lost. The textlessness of their yodeling, unshackling sound from words, unlocks extraordinary
freedom in the voice.

Ecstatic pygmy yodeling influenced Kongo
music. And then, via Kongo impact on North
American black culture, yodel-influenced street
cries turned up in Charleston, South Carolina;
yodel-like "field hollers" emerged in the Mississippi Delta blues. Moreover, Bessie Jones,
performer of black folklore, tells how, in the old
days, if a Sea Island Georgia black fisherman
wandered into a strange creek and lost his way,
he had only to shout out his yodel-like, bluesy

special cry. Then, from afar, his family would hear the sound and say, "Jet lost! Let's go find him."[5]

Earlier, in 1835, a train stopped in South Carolina in the night. Black workers shouted field cries by the railroad tracks. Frederick Olmsted, a writer for the New York *Daily Times*, heard them and was impressed. He called it "Negro jodling." He called it "the Carolina yell."[6]

The Carolina yell continued the formal strength and freedom of the Central African yodel in America. It made the presence of the black person known. It vocalized his deepest feelings. It traveled the railroads with the workers.

At some point, noting a similarity between the haunting wails of the locomotive whistle, and the soulful oscillations of the field cry, blacks combined both sounds in certain blues.

By the 1940s, if your ear were culturally prepared, you could hear a lonesome train whistle in the night and immediately think of black people, on the move. From Memphis to Mobile. Goin' to Chicago, sorry that I can't take you. Albert Murray, the novelist, put these sounds, with all their originating forest/swamp implications, right into the pages of *Train Whistle Guitar*:[7]

> Mama always used to say he was whooping and hollering like somebody back on the old plantations and back in the old turpentine woods, and one time Papa said maybe so but it was more like one of them old Luzana swamp hollers the Cajuns did in the shrimp bayous. But I myself always thought of it as being something else that was like a train, a bad express train saying look out this me and here I come . . .

These were the sounds that named the land for African-Americans. The poet, Daniel G. Hoffman, has called the train whistle, in fact, a quintessential symbol of black yearning.[8]

That fundamental voice has its visual dimensions. If African-Americans appropriated the locomotive wail, and made it theirs, then they also intuited freedom and the beauty of travel and transcendence in revolving, shining hubcaps, in the darker turning of a rubber tire, and even, sometimes, in the hard and resistant curving of a 55-gallon oil drum. Some of these basic themes, particularly hubcaps and tires, seemingly roll space and time across numerous yards in traditional Black America.[9]

Ed Love, African-American sculptor of Miami, intuits this communal aesthetic. He blends the back-home love of motion-implying objects with the technical arguments of the studio. In 1972, he interestingly mounted two chrome-plated hubcaps inside two gear-rings (fig. 1). He hung them in the wind, as chimes. No delicate-sounding slender blocks of wood for this bear of an African-American. He wanted metal. He wanted gears and wheels. Like Ancient Egyptians, he was also playing with an analog to the sun's own flash, as transcendent point. What he chose to work with, mirror-like

Fig. 1. *Chimes,* hubcaps fit in gear-rings, Ed Love, 1972 (this work originally hung outside the artist's studio). Photo by Robert Farris Thompson.

chrome from automobiles, and how he combined such materials in sculpture, intuited the strengths of black vernacular imagery.[10]

As an example of this imagery, in 1985 and 1988, oil drums became icons in the hands of two yard artists of Black Detroit, respectively Rosetta Burke and Tyree Guyton.[11] Earlier, blacks in Trinidad, during World War II, had transformed the same objects into percussion instruments, capable of playing notes.[12] They call it "pan." We call it "steel band music." In the process, oil drums, associated with car fuel, became the fuel of dance.

Similar qualities of visual propulsion informed the instrument of a black musician I saw sauntering down the streets of Port-au-Prince, capital of Haiti, in the spring of 1978. He was walking with his homemade banjo, a banjo

made from a hubcap. In 1988, Charlie Lucas, African-American sculptor extraordinaire of Alabama, stood several metal human figures within the rims of wheels abstracted from automobiles, and explained: "I'm trying to *roll* them."[13] Automotive roll and automotive flash become visual equivalents to the train whistle in the blues. Train holler. Chrome circling. Black quest.

Ed Love responds to this tradition. Automotive bumpers have provided the significantly selected raw material for his sculptures of the seventies and eighties. They emerged from his private store of auto chrome (fig. 2), itself reading like a veritable arsenal.

In 1974 Ed Love shaped out of bumper chrome a torso in honor of the jazz master, Charles Mingus. He called the work *Mask for Mingus* (page 193). As the materials coalesced,

Fig. 2. Collected automobile bumper chrome, backyard of Ed Love, summer 1986, Washington, D.C.
Photo by Robert Farris Thompson.

the chest began to read as eyes, the abdominals began to read as a mouth. Love turned industrial luminosity into muscle, commanding trapezius and deltoids, plus abdominals until the entire composition resembled the shield of a running warrior.

If chrome seizes the reflective power of the sun, and modern vehicles suggest its motion, then Love deeply praised Charles Mingus by relating this signal avatar of modern jazz to God's own moving point of illumination, to the sweetest of chariots.

Why the pull towards transcendence, towards spiritual and private symbols? Because of The Old Time Religion. Henry Dumas was right; North *is* dense African. California, too. Wherever blacks transmute modern media with their lyric voices, you sense the stress of the spirit. You hail a vision, flowing from Kongo and Angola, to Charleston and New Orleans, and from Congo Square, to everywhere. That big-hearted power that Stanley Crouch traces from back-home blues to the jazz of Albert Ayler the consciousness he says filtered through the Delta to Black America at large, parallels the vital rise of transcendence and spirit-possession as elements in African-American art.[14]

Alphabets of the Spirit

Painters and sculptors surveyed in this exhibition are moral artists. They speak to the spiritual concerns of their communities and these values can be very ancient indeed. To witness art among the San of southern Africa, who, with pygmies, probably constitute the ultimate ancestors of all black artists, elicits a certain recognition:

> Many (San) paintings have otherwise inexplicable features that may readily be understood in terms of trance, which occupied an important role in the lives of the southern San.

Paintings of human figures in the Cape and Natal provinces often show lines descending from the nostrils: trance among the San is frequently accompanied by nose-bleeding.

A strange, forward-leaning, half-crouching stance, not infrequently represented in the paintings, is identical to that adopted by San dancing while entering trance.

San emerging from trance have described their experience as feeling like riding on the back of a serpent; and paintings in the Matopo Hills of Zimbabwe show an enormous serpent, sometimes double-headed, with numbers of people standing on its back.[15]

The cultures of Kongo and Angola were respectively influenced by pygmy and San musical styles. Hence, the yodelized field-holler, emerging among descendants of Bakongo in North America, hence, the influence of a classic hunting-and-gathering musical instrument, the musical bow, in the rise of the Delta one-stringed instrument, the "diddly-bow."[16] But such African-influenced art as we have relating to spirit-possession would appear to have come from Kongo.

No images of persons dancing on the backs of serpents have yet appeared in North American black vernacular art, in insofar as we know. But we do find numerous serpent motifs. Compare Bill Traylor (page 154) and Willard Watson (page 179). Their art recalls the use of serpents (as well as other reptiles) as mediating signs on staffs held by black deacons in the old South.

In Kongo, a snake communicates danger. But the dreaded reptile also symbolically binds persons in the town to the woods and to the river, to realms where cures are hidden and wisdom concealed among the ancestors.[17]

When a Kongo ritual expert chalked the image of a python from chest to abdomen on a person's body, this bound him, his heart, to what was always known, his navel. It will be interesting to learn, with further research, which creole

meanings are attached to the snake Traylor painted and the snakes Watson carved.

In any event, Kongo ritual experts have always worked with visionary objects. They call such objects *minkisi* (*nkisi*, in the singular). An *nkisi* embeds spirit in packaged earths. The powers of that spirit seethe within inserted material signs, concealed usually in the bag or modern glass container. The spirit of a given *nkisi* might possess the owner of the charm, causing that person to utter prophecy, to reveal the location of healing herbs and how to use them.

The powers of such experts also resided in the ability to read and write the *nkisi* ideographic language of visual astonishment.[18] Such signs *(bidimbu)* include chalked ideographs, plus myriad symbolic objects linked to mystic actions, through puns, on the name of the object and the sound of a verb. For example, a priest might place a grain (*luzibu*) in an *nkisi* so that it might spiritually open (*zibula*) up an affair. But Kongo writing also sometimes included mysterious ciphers, received by a person in a state of spiritual possession. This was "writing in the spirit," sometimes referred to as "visual glossolalia," this was writing as if copied from "a billboard in the sky."[19]

Modern Kongo prophets, restructuring Christianity with the tenets of their classical religion also use such mystic writing. The prophet submits to trance, and in the spirit, he taps unseen potencies, deriving from The Holy Spirit. He communicates such contact in the strangeness of the ciphers:

> In some prophetic writing we find . . . glossolalia in print, a transitory non-communication which, like the diviner's . . . interjections, asserts the superior validity of the part of the message that is transmitted in (the) clear. Some prophets go a stage further, covering (entire) pages . . .[20]

The shapes of the individual ciphers or "letters" are unique to each prophet. Each time

the spirit descends, it brings a new alphabet. This recalls, amongst numerous New World black examples, possession writing on the Caribbean island of St. Vincent. There, "each pointer (of souls) has a different alphabet."[21]

Kongo spirit-script from Kingoyi, collected in 1934, exerts a subtle fascination (fig. 3).[22] The message combines a complex of five mysterious letter-resembling shapes: a sign resembling a *l* joined to a looping *c*; a kind of *J*, the bottom curve of which seems to turn into a snake; an undulating horizontal line; and a boldly shaded backwards *C* that also resembles a coiling snake, with head and tongue revealed. Vibrations of the spirit blur the letters into undulating hints of powers streaming from the ancestors, from the woods or from the water.

On October 14, 1970 in the city of Matadi, Bas-Zaïre, the Kongo prophet, Solomon Lumuka Kundu, wrote in the spirit. Wyatt MacGaffey, an anthropologist of religion, was present. He collected the writing from which we excerpt a sample "sentence"[23] (fig. 4).

Again, the coming of the spirit explodes the quiet order of Western left-to-right writing. Each "letter" dissolves into circling vibrations. Contact

Fig. 3. Detail, Kongo spirit-script, ink on paper, sewn with twine onto chest of *niombo* figure, Kingoyi, northern Kongo, 1934.

Fig. 4. Detail, Kongo visual glossolalia, by Solomon Lumuka Kundu, collected by Matadi, Bas-Zaïre, by Wyatt MacGaffey, October 14, 1970.

with an unknown force shakes every cipher. The "letter" or "word" at far left boils up from the page like a person emerging from a circling storm. Each utterance is unique. Shifting combinations of overlapping loops and overlapping circles make them so.

This is not writing as the secular world understands such things. This is spiritual oscillography. These texts themselves embody *mayembo*[24] (spiritual ecstasy) or *zakama*[25] (spiritual happiness). In actual Kongo spirit-possession, ecstasy trembles the shoulder-blades of the ritual authority.[26] Here, they ripple the body in a similar fashion, only miniaturized to the compass of a single writing hand.

The spirit enters into the shaping of every single utterance. It leaves unique impress, like the fated twistings of forest lianas,[27] like strangely shaped river stones[28] or forest branches, all of which are seen in Kongo as the mysterious workings of God's own hand. Surely, if forest yodelling had a script, this is what that ecstasy might read like in transcription.[29]

Cut to the rural house of an African-American mystic, southeastern Georgia, on the night of December 22, 1985. The late and great artist, J. B. Murray, whose gift as a writer-in-the-spirit has become legendary in the world of art, took from my hand a black felt pen and a piece of white paper and waited (fig. 5):

Suddenly, the spirit. The single (meandering) line that had initiated the work (visible in the upper left-hand portion of the page) was overwritten with bursts of figuration (fig. 6) sometimes connected and flowing, and sometimes not.[30]

Constantly changing combinations of loops, accents, and angles made most of the written utterances unique, with a cumulative effect not unlike the hand of Kundu in Kongo. Murray's eyes narrowed when he wrote, suggesting trance. Later, he said explicitly: "I ain't moving it, it's moving itself."

Around 1985/86 Murray completed another specimen of spirit-script (fig. 7). Here, judi-

Fig. 5. The late J. B. Murray, starting to write in the spirit, in his home, southeastern Georgia, December 22, 1985. Photo by Robert Farris Thompson.

ciously placed and weighted, colors appear, tints of blue-green wash, the spirit-script in black ballpoint, and sixteen red dots, representing eyes. Over a field of spirit-utterances written in black rise eight blue-green heads, with tiny dotted eyes in red: "bad folk, what don't respect the Lord."[31] The Lord confronts them, in this painting. Just as back-home architects papered the walls of their cabins with newsprint to confuse jealous spirits with an excess of information,[32] so negative beings here are surrounded by God-given calligraphs.

Renée Stout can date when she came in contact with protective print in the African-American manner, and it is recent: Christmas Day, 1986.[33] On that occasion she noted newspapers papering the walls of the house of a black woman in Sacramento, California. It was like a vindication of matters of cultural preparation coalescing in her own work. For Stout intuits, independently but splendidly, Murray's use of mystic writing as a shield in the making of her sculpture, *Instructions and Provisions: Wake Me Up On Judgment Day* (page 188).

With this work she has transformed a cigarbox into an *nkisi*, filling the container with her own versions of *nkisi*-bags and placing them on a bed of her own hair. The instructions are rendered in a mystic script, carried out in glittering jewel-like letters: "what to do, how to

Fig. 6. *Spirit-Writing, J. B. Murray, felt pen on paper, dated December 22, 1985.* Private Collection. Photo by Robert Farris Thompson.

Fig. 7. *Spirit-Writing, J. B. Murray, colored markers and ballpoint, c. 1985.* Private Collection. Photo by Robert Farris Thompson.

use the spirit-bags in the box, when times get so bad I need to escape."

Hear the resonance with the arts of black yearning, here called upon as medicines to propel a person from a point of depression to a point of exaltation. As a matter of fact, the artist was feeling blue when suddenly a friend brought her a curving piece of white metal which he had found while jogging. "And that was the key, the vehicle to start me working again." She affixed the bird- or snake-like element to the front side of the box. A person had thought of her. His token broke depression. His gift became the first medicine of a complex *nkisi* of regained composure.

Music brings down the spirit upon a prepared point in traditional Kongo culture. Similarly, in Washington, D.C., Renée Stout discovered Steve Winwood's rock song of 1987, *Wake Me Up On Judgment Day*: I heard the exact meaning of my piece within that song." It became part of the *Instructions*.

With her remarkable secret form of writing, Stout combines something like the reflective chrome African-Americans sometimes use, suggesting mediation, and something of the protective baffle which Murray and other seers fashion with their scripts.

Brilliant triangles in different flashing colors (red, gold, green, magenta, pink) start or end many of Stout's lines or utterances. This suggests equivalence to punctuation. They take their brilliance from the fact that each has been cut out of a postcard which bore a holographic image, hence these geometric commas or full stops communicate, at the same time, matters of transformation, and the capturing of important images.

Unsurprisingly, a black woman once regarded these ciphers and asked, "Who speaks to you?" Answer: the cultural tastes of Renée Stout's ancestors, causing her to turn equivalents to tiny mirrors, the fragments from a holograph, into part of the ink of The Holy Spirit. After she elaborated this portion of her code, the triangle

writing on the box, she found herself making a triangular shrine to honor a departed relative. In the altar she combined a tiny clock, an old lipstick, and a mirror, with the mirror appearing at the apex.

The use of the mirror in her altar recalls the evil-repelling mirrors embedded in the belly of figurated *minkisi* in ancient Kongo, even as certain African-American homes — for instance the residence of "The Texas Kid" in Dallas (fig. 8) — sometimes place mirrors on the facade or on the porch to throw back evil, thus making a Kongo mirror-image of the entire structure. For his Dallas home, Willard Watson has installed a mirror-map of Texas on the door and placed a full-length mirror under the bedroom window to the right of the entrance.

Stout deepens the tradition with the latest technologies. Here, letters read like colored mirrors, like the protective flash of the *nkisi*. If the box is moved, the fragments from a hologram scintillate and shift in color. Stout's text, therefore, stops all evil with a rainbow alphabet from heaven.

Spiritualized form-making reappears in the astonishing work of Kofi Kayiga, a painter who now resides in Boston. He was born December 27, 1943 in Kingston, Jamaica. His very name is Afro-Atlantic. *Kofi*: an Akan/Jamaican 'day name' meaning "born on Friday." *Kayiga*, an heroic appellation from the Ki-Ganda language in Uganda, signifying 'lord of the hunters.'

As a young man growing up in Kingston, Kayiga experienced multiple African-influenced arts and letters, — Kongo Kumina, maroon Akan retentions from the hills, Zion chanting, Rasta trance painting, skanking (dancing to the reggae beat). This would have been impetus enough for most African-Caribbean artists, but Kayiga strove for even deeper immersion in world black culture.

In 1970, in 1971-73, and then again in 1980, he voyaged to Uganda. There he taught art at Makerere University in Kampala. He also registered for a post-doctorate degree in traditional

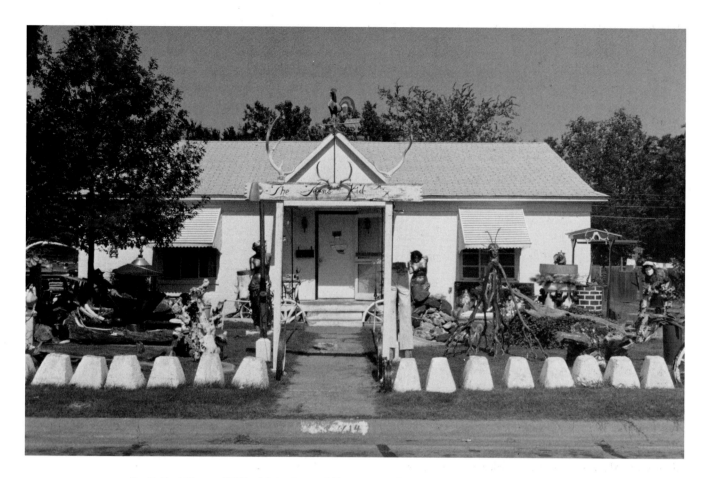

Fig. 8. Yard-Show of Willard "The Texas Kid" Watson, Dallas, 1989. Photo by Maureen McKenna.

Ganda religion and came in contact with John S. Mbiti, one of the richest minds in the study of African spiritual systems.

An intricately unfolding odyssey, Jamaican, East African, and Black North American, explains why his work stands in spiritual affinity with African–United States traditions of visual enactment.

For instance, in Jamaica there is a traditional dance (possibly derived from a Kongo dance game called *dingo-dingo*) wherein the players bend down and move stones in a circle while they dance. There are also African-Christian ceremonies in which tables, set as altars with symbolic foods and objects, are arranged and viewed from above, by standing, swaying participants. And Rasta painters, like Everald Brown

(page 182), sometimes work in trance, seeking to document, in line and color, the places where the spirit sings the world into existence.[34]

These marvels spiritually bind Kayiga to the way he makes his art. Not unlike priests who trace ground-blazons for their ancestors and for God in Kongo, or priestesses chalking sacred ground-signatures for the deity, Olokun, in the ancient city of Benin,[35] Kayiga places paper on the floor and then begins to paint.

He works, in other words, from an eagle-like fullness of perspective, gazing down upon the play of his forms. Even when he sketches, the pad is in his lap, the view is from above.

In painting from above, as opposed to on a wall or easel, Kayiga recalls the Haitian vodun master, Hector Hyppolite, at work in 1948:

First he would draw four or five pictures in pencil. Then he would mix a certain color and apply it successfully to the various cardboards he had to paint. Next he would repeat the process with some other color, and so on. He used to hold the board almost horizontal on the palm of his left hand.[36]

Hyppolite, therefore, was painting "from above," from the perspective of a vodun priest, making divine signatures on the sanctuary floor.

Kayiga cannot imagine any other way of working: "Things read better to my vision from above." In addition, again akin to the Haitian master and to Pollock[37], Kayiga works multi-compositionally: "I never work on one work by itself." There are usually two or more compositions emerging in simultaneous gestation on the floor. In this regard Kayiga also reminds me of the late master potter, Abatan of Egbado Yoruba, who used to make two sculptures for her deity, Eyinle, each time she worked. It was insurance against bad fortune in the firing — if one image cracked, there was always another one at the ready.

Kayiga argues that making several paintings at the same time deepens the accomplishment of their form and meaning. Pointing to works around his studio recently, the artist observed, "*That* painting brought forth *this* one" and "*This* one vibrates *that* one."

In his *African Religions and Philosophy*, John S. Mbiti notes that "the spiritual world of African peoples is very densely populated . . . their insight of spiritual realities, whether absolute or apparent, is extremely sharp."[38] This truth illuminates the visual imagination of Kayiga. What he learned in study of the classical religions of Uganda comes alive in an uncanny pastel about spirits moving in the moonlight. This work, called *Moonlight* (page 215), relates to its twin, *Light Dance* (fig. 9), which Kayiga completed simultaneously in 1987. Among the Nkole people of the extreme Southwest of

Fig. 9. Kofi Kayiga, *Light Dance*, pastel, 1987. Private Collection. Photo by Robert Farris Thompson.

Uganda, Kayiga had learned about the famous *night dancers* - persons moving naked in the light of the moon, possessed by ancestral spirits. Their images fired his imagination and later they reappeared to him, filling the paper on the floor of his Boston studio.

In both pastels the ancestors are intimated in a blue colonnaded structure at the bottom of the composition. The rising of their spirit, into the body of the dancers, is concretized into a single arrow, pink in one version, white lined with olive in the other. An arc-like form, tinted blue, the color of moonlight, crowns the arrow of the spirits. Lush ochre and olive areas, set above the arrow with its lunar crown, suggest the richness of the practice of the night.

After these basic forms had been completed by the artist, chalked visual glossolalia occurred

around the arrow and certain other forms: parallel lines, zigzags, circles and ovals. "I didn't plan these signs; they spoke their way into the work." Only the ovals left a trace of meaning: "microcosms, worlds to come." And so, at the end, a buzz of hieroglyphs, reading like subtitles supplied by the spirits, translate powers and presences into their proper mystery.

A proper sense of mystery, nobly accomplished, also characterizes the subtly ideographic painting of Matthew Thomas of Los Angeles. This genial artist subtly embodies his traditional sources. Consider his *Symbol of Earth Soul I* (fig. 10), the very title of which betrays semiotic intent or drive. *Symbol* which dates from 1987, consists of four pylon-like paintings, spaced as a unit across the wall. Their effect is at first lightly minimalist, like a Don Judd series. On the other hand, one detects a Longo-like cherishing of contrasting sections within a unified whole.

Still and all, like Henry Dumas, one senses a vernacular weighting, in the core of Thomas'

Fig. 10. Matthew Thomas, *Symbol of Earth Soul I*, unfired clay, soil and acrylic on plywood, 1987. Collection of the artist. Photo by J. Felgar.

visual proceedings. First of all, a migratory history, quintessentially American, begins an explanation of his art. He was born in San Antonio, Texas, on June 12, 1943. At the age of nine, in 1951, his family moved to Los Angeles. They moved again that same year to a small valley community, Pacoime, northeast of Los Angeles. There, orange trees shaded the streets and life was relatively pleasant.

But backhome, memories persisted. Thomas never forgot the altar of his grandparents in Gonzales, Texas, northeast of San Antonio:

> "It was an African Methodist altar, built in the corner of a room. Four shelves traveled out from the point where the two walls met. Homemade white lace covered each shelf. The shelves were laden with porcelain figures. I remember an image of Jesus on the highest shelf. Everything white."

In Kongo, the lines of a corner are believed to extend, communicatively, out to infinity. In addition, white porcelain icons recall images daubed with porcelain clay on altars for the ancestors in Kongo. These equivalents were probably reinforced by Christian belief, in the descending purity of the white dove of the Holy Spirit.

There were other recollections. In Texas, Thomas' paternal grandfather showed him how to put white ashes around plants to make them grow. He also let young Thomas watch him prepare stones to mark the boundary around his house. He dipped the stones in a white powder with water, whitewashing them all. This recalls the white stone boundary that marks the house of the mystic/artist Ralph Griffin of Girard, Georgia, as well as numerous other instances across the whole of Black America.

It is interesting that Thomas has worked white ashes into pigment in his recent *Essential Ground*, 1989 (fig. 11), and has executed drawings with ashes on paper with black oil, the design cut through with a nail. The artist's intent is to

Fig. 11. Matthew Thomas, *Essential Ground*, ash, dry pigment, acrylic, 1989. Collection of the artist. Photo by Scott Lindgren.

Fig. 12. Matthew Thomas, *Inner Plane Landscape*, porcelain clay, acrylic, pencil, 1989. Collection of the artist. Photo by Scott Lindgren.

work through each of the elements: earth, fire, and water. And some of his recent work is carried out, in part, in porcelain clay (fig. 12), creolizing contemporary media with natural elements, with purity and spirit. But whether there are direct links between these media and his African-Texan origins should be left open as a question. What is true, however, is that Thomas has built on a solidly African-American spiritual upbringing, an ecumenical study of Zen Amerind shamanism, and Sufism. And yet the master icons-and possibly the use of ash as medium-are touched with the Africanizing spirit.

This is evident when we return to *Symbol*. The painting second from right bears a distinctive outline: an inverted pyramid of Ancient Egypt, a circular motif of Ra, the spirit of the sun, and a crisscross motif which the artist intends as a symbol of another pyramid, viewed from above, as a point of meditation.

Paintings at either end of the progression are rendered in a rich black, nuanced with indigo, and represent, according to the artist, the black of outer space. But the void is animated, however not with stars, but with palm fronds, wrapped in silk. The Santa Anna wind, of April and May, blows palm fronds into the streets of Los Angeles. There the artist collects them, brings them into his studio. In this instance he wrapped the fronds in dark rich silk for contrastive texture, and applied them to the paintings in order to suggest spatial darkness. There is in

Symbol a hint of Christ and Palm Sunday, in utter space. Similarly, because the paintings stand as four strong verticals, they suggest ladders, lifting towards the spirit, towards Jesus on the highest shelf.

The painting second from left exerts a subtle fascination on the viewer. There are areas of bluish tint bracketing a mosaic-like field of tiny golden squares. The color gold equals "essence, refinement of the light." Savor the mirroring, for gold from the earth is like light from the sun. The paintings thus turn, at the end, into *writing*, less obviously perhaps than Kayiga, Stout, and Phillips, but just as compelling in their last effect. For what we have here are paired ideographic rectangles, disguised as paintings, whose equation reads: dark versus light equals light versus dark —

Sun and earth, ciphers of clarity, join slices of dark, ciphers of mystery. The four standing rectangles together build a tacit altar. They summon grace from Egypt to America across an inky void.

In this regard, *Symbol* recalls Houston Conwill's *JuJu Installation*, 1978 (fig. 13). In Conwill's uncanny composition, elegance and mind from ancient Africa, symbolized by an Akan royal stool, cross blood and brine in the Middle Passage, and find containment in a back-home gutbucket, icon of black renaissance. Thomas and Conwill, in the depth of their differing symbolic writing, bring art and heritage from Africa right on home to Black America.

Charles Searles suggests a similar achievement in the theory and history of Black American art. His very powerful vibrations of line and form and color are reminiscent of his friend, James Phillips, but stem from Searles' own rich imagination.

Searles does not set out consciously to spirit-write nor to suggest a given style of subSaharan art. To be sure, he acknowledges African classical sculpture, known since childhood, as a vital portion of his cultural memory. A voyage to the Yoruba in Nigeria in the early seventies had an immense impact. But he broke those memories down into a wholly personal signature.

Therefore, to include Searles with the straightforwardly mystical Kayiga, the consciously Afro-ideographic Phillips, and Conwill who created *Easter Shout*, has to be handled with care. By this I mean working within the artist's own declarations of intent.

Searles, in the treatment of his patterning, has evolved what might be characterized as the self-script of a strong creative person. This means that he relies essentially on his own visual reserves to carry him through.

Yet if we examine his delightfully contoured sculpture, *Fantasy Animal I* (page 197), based on sketches of goats readied for sale in a Yoruba market in Nigeria, we are led to a point of spiritual intersection with some of the artists just mentioned.

Searles activates the animals with flowing contours. He opens up their forms. This is done not only so that they link up and can stand, literally and figuratively, as a unified piece of sculpture, but also because he wants the animals completely seen, from the outside to their inner spirit, via myriad openings in the surface of their forms.

Searles has painted vibrating lines of strong color over the bodies of the goats — black against red against white against blue against black against red, and all over again, so that "you will keep glancing over, to see if they are moving." He has reshaped their contours as interlocking loops, like the stylistic shift that announces the transformation of ordinary writing into spiritual code. Everything is interconnected. Things flow in and things flow out. Fusion to a larger spirit whole. In the process, Searles vibrates form with undulating

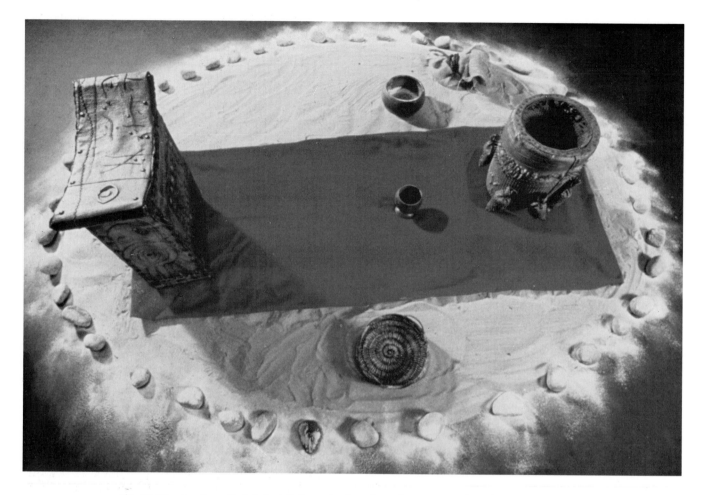

Fig. 13. Houston Conwill, *JuJu Installation*, mixed media sculpture, 1978. Photo by Stan Gainsforth.

colors, recalling the primal combinations which rain down through the compositions of Phillips, that sing, as we shall see, across the walls of Conwill's *Easter Shout*.

Remarkably, Searles' playful, interrelating, schematic animals carry the observer into their forms, into their spirit, not unlike the interconnected lines of Kundu or Murray which carry you into the letter of the Lord.

James Phillips was born in Brooklyn on April 29, 1945. His childhood was spent in the Piedmont village of Gretna, between Lynchburg and Danville, in western Virginia. There, around 1955, his uncle taught him how to draw Hausa knots on paper. Phillips has no idea where his uncle learned that patterning, but he now remarks: "Little did I know it would fall into place, later, in my life."

Phillips' first art teacher was A.B. Spellman, the jazz critic and poet, who taught him to turn around images of blacks from caricature to ones of dignity. Both Spellman and Phillips' uncle taught him something critical: that there were ancient and honorable alternative visual traditions to those which surrounded him.

He lived in Philadelphia from 1955-1965, then in New York City from 1965-1973. He was artist-in-residence at Howard University, 1973-1977. He continued to live in Washington, D.C. until he went to Japan on an exchange fellowship in 1980-81, and then moved to Berkeley from Washington, D.C. in 1983-84 where he has remained ever since.

The sixties and seventies were exciting years, both politically and culturally. Black Power. Coltrane. Amiri. Afri-Cobra. Phillips was to

serve these influences well. Contact at Howard with Adémola Olugebéfolá and Skunder Boghassian, painters respectively from the Virgin Islands and Ethiopia, had a lasting impact. African ideography especially fascinated Phillips and his peers: dotted lines of continuity or increase; undulating lines of moisture and the cool; zigzag mediations of powers from above. At the same time, Phillips was reading classics of Africanist scholarship, like Griaule's conversations with the great Dogon sage, Ogotemmeli. As Phillips recalls, "It all fit right in."

I shall never forget the day, in the summer of 1974, when I first saw a painting by Phillips. I had entered the Ile-Ife Museum in Philadelphia with a painter, Pheoris West. There, on the wall, was *Bazu*, 1973 (fig. 14), the colors of which struck me with a clangor recalling the decorated paddles of the Djuka maroons of Suriname.

Phillips says he named the painting after a Dogon spirit, Bazu. I was amazed by the overall zigzag patterning. He had started painting in that style with a work called *Mystic* in 1970. By 1973 this signature mode had evolved to cascading curves: "layer on layer, curve on curve, to give a sense of *expanding*."

Phillips seemed to be questing for an ultimate black strength. And the name of that power was *àshe*,[39] the force-to-make-things-happen, coded in zigzags, coded in lightening, coded even in slow-motion lightening, as in the movement of a royal python zigzagging confidently across the earth. He had seen such motifs in the work of Olugebefola, and it is fair to say that part of its meaning, within his own work, remained creole Yoruba. Nevertheless, at the same time, one heard in the color clashing and in all the cascading, echoes of black music of the period: Cecil Taylor, Pharoah Saunders, McCoy Tyner, Sun Ra, plus earlier work by Dolphy and Coltrane.

Around 1974 African-American musicians were "coloring the energy," as Cecil Taylor phrased the phenomenon.[40] They were improvising "silent screams" in the terms of Albert

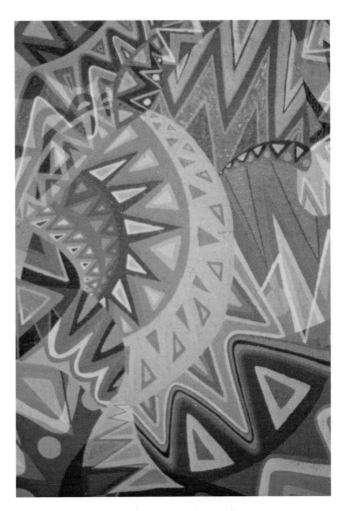

Fig. 14. James Phillips, *Bazu*, 1973 (detail). Collection of the artist. Photo by Robert Farris Thompson.

Ayler.[41] *Bazu* and other paintings in a series called *Nommo* (another reference to Dogon cosmology) linked all that musical brilliance to originating mind in Africa. *Bazu* signed the heritage in lightening, in rainbows, in power-fragments which reminded us from Whom the creativity first descended. But it was not just the energy. Phillips seemed at that time to be studying the very *machinery* of force, the meshing of the gears of heaven.

To explore color and meaning through a single motif took courage, but Phillips persevered. Even in this early era he was subliminally influencing — and being influenced by — his colleagues. Charles Searles' *Continuations of the Kings* (1974) zigzagged the teeth, and

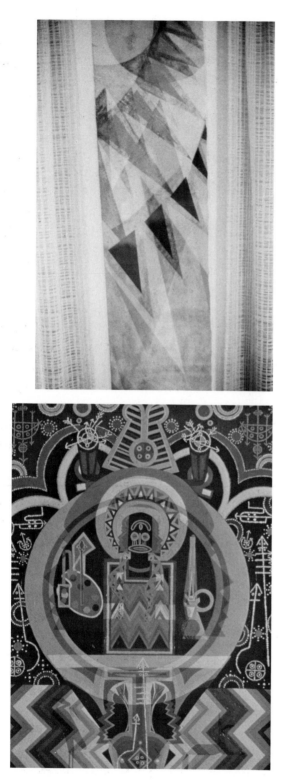

Fig. 15. James Phillips, *Untitled*, 1974. Collection of Ed Love. Photo by Robert Farris Thompson.

Fig. 16. James Phillips, *Lotus on the Nile #2*, acrylic on paper, 1984. Private Collection. Photo by Christie Cooper.

rhythmically linked the eyebrows, of several faces in a Phillips-like manner.

Al Smith, another fellow painter at Howard, spoke recently of his own work, *The King and Queen of Harlem*, in terms that are analogous: "What you're going to get are patterns and rhythm, zigzags, stating that we are heavy into jazz, Dolphy, Coltrane. We want to fill space to make the energy move."[42]

Phillips makes the energy move instructively. Thus, a composition dating from 1974 (fig. 15), now in the collection of Ed Love, was an attempt to isolate the lines of power streaming down from heaven, a crimson path of lightening and an azure path of lighting, on a single piece of paper, with nothing to distract the viewer.

In the ensuing years Phillips has created work which suggests what is most worth seeing comes from the potencies of the sky. His style has opened up. Zigzags have been formalized. Parallel energies from the stars and the sun appeared. Most wondrous has been his development of a fluent usage of the hieroglyphs of traditional African writing systems, ancient to modern, Egyptian to Yoruba to Akan to Ejagham.

Mojo, dating from 1984, is a good example (page 213). The work is ten feet by five, acrylic on canvas. Zigzags carry the persuasive force of Phillips' reverence in all directions. Their development no longer curves and collides. They have turned to grids. Their tonalities have shifted from clashing primaries to elegant gradations. Equally elegant transmissions of the word of God are carried out in two African writing systems, ancient Egyptian and modern Akan.

At the top of the painting Phillips rephrases slightly an Akan *adinkra* pattern, the *Gye Name* (None except God) motif.[43] *Gye Name* symbolizes the power of the Almighty.

Under this sign he has tucked another adinkra pattern, two crocodiles joined at the belly, a sign of the imperative of cooperation. The sign of

God's power is repeated below within a mandala, guarded by horns hidden in subtle tonalities. The setting of *Gye Name* in a protective square effects a hymn to the staying power of the Almighty.

At the center of the painting stands the mojo spirit.[44] Its head is guarded by the double cobra of the crown of the ancient pharaohs. Stars and galaxies compose his body and his weapons. There is mystery here. But there is also direct allusion to actual constellations. Yet some of the patterns write *odun ifá*, in the sky, Yoruba divination permutation signs. The latter are identifiable in star patterns of parallel lines, like the favorable permutation, *eji ogbe*[45]:

$$\begin{matrix} \bullet & \bullet \\ \bullet & \bullet \\ \bullet & \bullet \end{matrix}$$

We find the Ancient Egyptian sky goddess,[46] Nut, at the moment of the world's creation, also rendered within the sky-body of the mojo figure.

The artist explains that the blending of ancient Egyptian and Yoruba materials signals that, in the last analysis, the force behind these systems of belief is one. Phillips has creolized the skies with an Afro-Atlantic search for the truth. And he proves, with all the complexities of this painting, that he is a theoretician, as well as a painter, in African-American aesthetics.

The theoretical side to his creativity carries over into another composition, *Lotus on the Nile #2*, dating from 1984 (fig. 16). With this painting Phillips pays homage to the late Hale Woodruff, a "direct and pragmatic"[47] African-American painter, printmaker, muralist, and educator. Here, the glowing geometries of the sky, Phillips' signature zigzags, announce the importance of the departed artist. Luminous interstellar vapor surround his body like a halo. Woodruff, with his sense of beauty, his landscapes that quietly discovered qualities noble and direct in the streets of southern towns, liberated people and helped them find their worth. We sense that special gift in the pairing of palette with rifle.

One of Woodruff's most famous works, *Celestial Gate*, fills the eye with a rich play of African-looking ideographic patterns rendered in green. It is almost as if Phillips is honoring the interest of the artist in signs and symbols by surrounding his image with a play of emblems from three different African writing systems, Yoruba and Dogon (the zigzags), hieroglyphs from Ancient Egypt, and Ejagham-Cuban *ereniyó* signs.

The zigzags of course are everywhere, but hidden in the vibrations of their patterning at the bottom appear two phoenixes, symbols of resurrection, a way of saying that Woodruff is gone but comes back in his name, and comes back in his work.

There is a highly appropriate citation of the properties of funereal writing borrowed from the leave-taking hieroglyphs of the Abakuá Society in Cuba. Abakuá is founded on a creole black tradition of writing and initiation, fusing Ejagham and Kongo themes. The name of Abakuá script is *ereniyó* or *anaforuana*. Phillips borrows from their signs to write a glowing page of honor and commemoration. Note the "arrow of farewell," pointing towards heaven, and parallel horizontal arrows (four in number) shooting through this arrow pointing at the sky:

This is the sign of Anamangui, spirit of death in the dramatis personae of the Abakuá.[48] Phillips also includes the Abakuá signature of God,

a cosmic circle quartered and animated with the luminous eyes of God and the eyes of Sikan,[49] a princess of the Efut people in Cameroon who figures prominently in the lore of the Abakuá. It is a way of saying that God and his retinue of noble subSaharan spirits welcome Woodruff to their realm.

113

Similarly the art of Houston Conwill recaptures elements of the ideographs of ancient Africa. With the publication in English of the classic text on Dogon ideography, *The Pale Fox*,[50] plus Gerhard Kubik's important monograph on traditional Bantu writing,[51] and similar contributions by David Dalby[52] and Lydia Cabrera,[53] we are now, more than ever, in a position to savor the existence of immense Afro-Atlantic graphic systems, numbering several thousands of signs among the Dogon alone.

Houston Conwill works by analogy with these traditions. With latex scrolls (fig. 17), crypts in the earth, ritual settings (fig. 13) and religious glossolalic painting (fig. 18), he turns spirit into matter with calligraphic flair and braille-like textures.

Lucy Lippard includes Conwill in her *Overlay: Contemporary Art and The Art of Prehistory*, as part of a trend towards studying sites and nature.[54] Lippard finds that the hermetic quality of "awesome stones and mounds was compatible with Minimalism's obdurate silence."[55] She argues that the minimalist/conceptualist obsession with repetition, modules, and mapping, prepared the way for "primitivising" artists in the seventies, who sought deeper soundings of myth and history.[56]

Conwill was in touch with all this, particularly when he lived in Los Angeles in the middle seventies. There he "caught the contagious fascination of artists, ceramicists, who were working with the earth."

But he did not have to wait until the seventies to witness ritual landscape. As we shall see, it was right beside him in the black west end of Louisville when he was a child. Moreover, like other artists in this exhibition, he has continuously known black religiosity, the ultimate style, whilst secular art modes rose and fell.

The point can be made by comparing Conwill's *Passages AN-1* (fig. 17), 1980, with Robert Smithson's *Double Nonsite, California and Nevada*, 1968.[57] The Judd-like repeated trays, in which Smithson displays stones from different sites, are

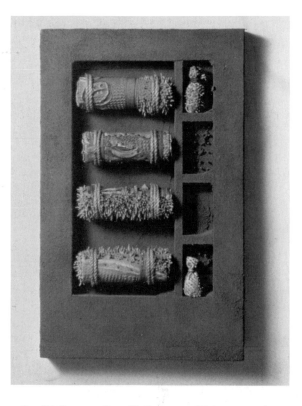

Fig. 17. Houston Conwill, *Passages: AN-1*, construction painting, 1980. Private collection. Photo by Stan Gainsforth.

not unlike the minimalist niches Conwill cuts four times into *Passages*, like a scale model of a wall cut into one of his crypt-like spaces beneath the surface of the earth. But Conwill does not put stones from distant sites into these quarried-out small spaces. Instead, he inserts textured scroll-like capsules, in latex stamped with a personal black ideography, of his own devisement.

He certainly does not share Michael Heizer's apocalypticism. He is not drawing in the earth,[58] like Heizer, to make a monument to survive a nuclear blast. He is materially writing, and embedding, convictions of his ancestors, messages making connections, between their world and ours. All this communicative vitality stems from a life that has crisscrossed the nation, from Kentucky to Howard to Los Angeles to New York.

Conwill was born on April 2, 1947 in Louisville, Kentucky. Houston was his maternal grandmother's maiden name, and so his name

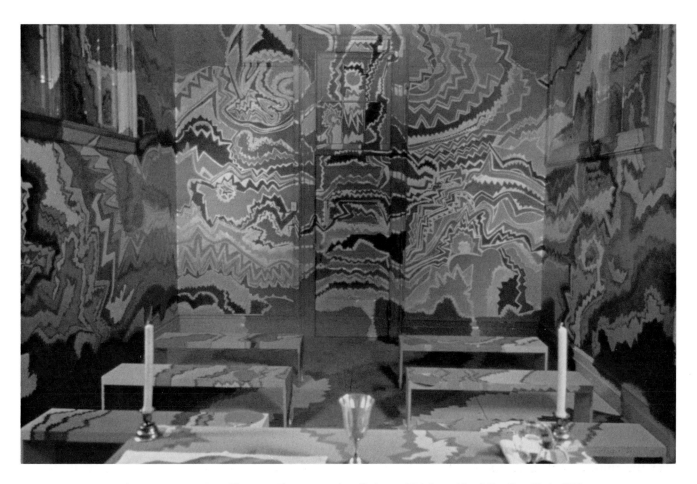

Fig. 18. Houston Conwill, *Easter Shout*, room installation at P.S.1, Long Island City, New York, 1981.
Photo by Frank Stewart.

balances the two sides of his family. He lived in the west end of the city, corner of 34th and Dumesnil, within four blocks of the house of Muhammad Ali. There he saw black yards bounded with white stones. Compare the circle of white stones that surrounds *JuJu Installation* (fig. 13).

Conwill was impressed by "tire sculptures" painted white — "pretty prevalent" — in the yards of Black Louisville. In 1963-66 he studied in a Benedictine monastery, St. Meinrad, some sixty miles from Louisville. During 1966-70 he was in the United States Air Force, where he "spent a lot of time in planes" as part of an air-ground communication team. Time in the sky, in an odd way, was not unlike time in the monastery, where he was fascinated with light, crypts, and "learning to ground yourself, so that

you could really experience rising." Although he was drawing all those years, he says, "I never thought I could *be* an artist until around 1970." The creative example of his people had always been with him, particularly in the store-front churches of Louisville where he had heard "some of the deepest expressions of the spirit in those halls of life."

Between 1970 and 1973 Conwill attended Howard as an undergraduate. The Ethiopian painter Skunder Boghassian was his teacher (Ed Love, too) and the former influenced Conwill's early acrylic paintings which he executed on the roughened side of leather strips: "Beardenesque, zigzags and triangular patterning." Conwill in his art was already "making connections," linking up people geneologically. He was inventing ideographs to register names and generations.

115

He moved his schoolwork to U.S.C. in California in 1974, and there started tracing ideographic marks on the ground. Over the signs he poured a synthetic palomar material mixed with latex to register the marks. Then he refined the process by making ideography in clay, and taking the palomar/latex impression off that.

Maps by this time had become media for landscape artists across the country, but Conwill was not recording, like Robert Smithson, "a sense of the earth as a map undergoing disruption."[59] He was developing a genealogical impetus, tracing ties from Africa to the U.S.A. Consider a sample latex scroll of the late seventies: flies in squares, suggesting "flight and danger"; tiny dolls, "spirits of children, before they're born, emerging into the continuum, coming to our realm"; the image of Jesus Christ under the sun; a river; a fish of Jesus over three arrows, perhaps alluding to the Trinity; a woman in a triangle; a Dogonizing figure with helmet-like head standing beside a fish, like an African deity in tandem with the Saviour; three further Dogonizing spirits, translating perhaps, The Trinity into African terms.

By 1980 Conwill was fluently executing latex maps of the spirit. He had mastered communication in terms of cartographic expression that could be read when the latex scrolls were unfurled — or when the images could be walked through, as in his recent commission for the Hirshhorn Museum in Washington, D.C. But he also left it to the viewer simply to sense what the scrolls contained, when he rolled them up into a capsule like rolling up words in Dogon ideography.

Unrolling and rolling up are essential gestures in the Conwill idiom. The words are rolled up, in *Passages*. The words are unrolled, from Ghana to Black America, in *JuJu Installation*. His passion to communicate extends across the surface of the earth and becomes heroic. In the year 2000, Conwill will mark out, at Tuscumbia, Alabama, "the crossroad city," the intersection of two lines, one running from Memphis to Atlanta, the other from Detroit to New Orleans. He will, at the millennium, make a Kongo cosmogram of virtually the entire southeastern portion of our nation.

Pointing, in its own way, towards this distant climax is Conwill's *Easter Shout*, completed Easter Day, 1981 (fig. 18) in New York City. All parts of his life herein came together: store-front churches, Black Atlantic writing, and the monastery Chalice of Jesus Christ Our Lord.

Conwill worked six months continuously on this epic: "Everyday I did portions until I ached, slept, ate, and came right back." He had come to the commission from earthworks in Georgia, and so it was "a way of bursting out of the ground, of breaking free."

In the process, he has given us an all-time monument in African-Atlantic visual glossolalia. The intent was to sing this space back into existence with metaphoric store-front shouts and tremblings of the spirit. The artist wanted to evoke "free cultural space, the store-front shouts, space in which everything could happen."

Starting with a brilliant patch of crimson in the upper left hand corner of the wall opposite the camera (fig. 18), he covered all surfaces, floors, walls, ceiling, with electric "unit-utterances" in the manner of Phillips' transcriptions of the dynamism of the Lord. These patterns seem spirit-written; they oscillate like the hand of J.B. Murray; they expand and contract, like the colors in Kayiga; they register ecstasy.

Red, blue and pastel-like vocalizations galactically carry us, round and round. They travel the walls and down to the floor and over the pews and back to the floor to reach, at length, the altar, where two candles burn. Bread and wine are present, the blood and the flesh of Jesus reborn, brought back to existence by sanctified train-whistling ring-shouting gestures, written in tongues across the room.

Astonished by an Ancient Savour: Intelligence and Taste in the Theme of Black Textiles and Tectonics.

The traditional textiles of classical Africa are often texts raised to the highest power of social communication. The proverbs of the Akan, stamped ideographically on *adinkra* cloth, illustrate the textual basis of many subSaharan textiles. The same point richly applies to signs of prowess, intuited in *nsibidi* signs, resist-dyed on cottons of the leopard spirit (*ukara ngbe*) among Ejagham and Ejagham-influenced cultures of eastern Nigeria and southwestern Cameroon.[60] Among the Dogon of Mali, "It remained only to speak of the Word, on which the whole revelation of the art of weaving was based."[61]

And so we begin to comprehend how the arts of subSaharan weavers is a situation richly paralleling recent criticism in the West. In English, Harold Bloom reminds us, "Text goes back to the root *teks*, meaning 'to weave'."[62]

Charles Searles' painting *Dancer Series* in 1975 (page 237) wondrously intuits the text = textile equation. In this work Searles was, as he tells us, thinking back to a voyage he made to Nigeria in the early seventies, where he was especially impressed by "women in the Yoruba markets, all dressed in blue." The color of their blouses (*buba*) and wrappers (*iborun*) was indigo blue, emblazoned with resist-type patterning called *adire*. Adire cloth may include motifs referring to proverbs, thus deepening the embellishment of dress with allusions to the classical oral literature of the Yoruba.[63]

Yet, at the same time, Searles was praising African-American dancer colleagues, at the Ile-Ife cultural center in Philadelphia. In the *Dancer Series*, he shows four black women of that North American city, caught in the patterns of the dance. They lift hands above heads, communicating ecstasy and joy. Ecstatic motion is further nuanced by the gesture of their fingers, deliberately shown wide-spread. The artist

remarks, "A symbol, to me, of the radiating lines of illumination from the sun." Consistent with this private symbolism, the sky turns gold precisely at the level of the dancers' hands.

When we return to the dress of the dancers we see that over adire blue the artist has inscribed a private love script. Part of their bodies face the light, while the other half embodies darkness. This leads to the basic opposition signalled by the signs upon their dresses.

Two of the women wear concentric motifs, which represents a woman's sex. The other two wear male motifs. Among many allusions, Searles suggests that pleasure and responsibility are all caught up in the dress of African-Americans, not only in the positive blaze of their colors, but also in the strength of their patterns.

The artist's own wardrobe includes samples of political T-shirts worn across Black Africa today. With *Dancer Series* and other works of that period, for example, *Nigerian Impressions #9: Material Traders* (1974), Searles documents the Afro-Atlantic phenomenon of dress worn as literature, dress worn to make a philosophic point.

John Biggers of Houston brilliantly rises to the challenges of this special tradition wherein words and admonitions are written into cloth. Consider his *Starry Crown* of 1987 (page 190). In the center of the painting appear three black quilters, their work in their laps. The number of the quilters alludes to the Trinity. This signals Biggers' perception of black women as makers of sacraments, of continuity and moral erudition.

The allusion is deepened by a circle of black cooking kettles which surround the women mysteriously like a ritual earthwork. The artist explains: "In these iron vessels our mothers turned dirt into purity, washed our clothing clean. They made soap in these vessels, too, combining hog fat and ashes. The soap that they made would bring out a pristine whiteness to our sheets and other linen. In these kettles they also changed hogs into lard, ham, chitlins."

Echoing their handiwork, heaven above turns into a textile. The vault of the night becomes a gauze-like tissue, punctuated by points of starry light. It is as if God Himself had awarded the mothers head-ties of star-emblazoned cloth to deepen the nobility of their role in protecting the continuity of the black nation within the nation.

These quilters are clearly avatars of African antiquity and knowledge. In their shadowed silhouettes are found, the artist says, "a deepness, the golden bronze quality of the past." The woman in the middle makes the pattern of a star with intersecting lines of thread, which she holds in either hand and pulls taut from her mouth as well. "She is making the world," the artist reveals.

Another world of moral allusion unfolds beneath their feet. There, red geometric patterning extends the textilizing accent of the painting. Redness is its key. "It is righteous fire, the verses in *Revelation* we sang every Sunday."

Balanced between the starry rewards of heaven and the hints of punishment below, the women work on. Biggers is saying directly and unambiguously, that the African-American quilt is one of the most precious and continuous of the art experiences of the persons of African descent in North America.

The artist expands on this point: "It was important how the women selected which materials would work together, which colors would work together. They used old, worn-out clothes, bringing out their marvelous pastel shades. The patterning I remember often included stars and human figures. Some of these wonderful motifs we were covered up with in the night I bring out in this painting."

That portion of the quilts which covers the women's laps is hard and geometric, meant to suggest the clapboards that made up the walls of the shotgun houses of the old Black South. But the portion which falls from lap to earth becomes mysteriously transparent, revealing, to the left of the woman depicted at far right, a cow — "The Great Mother" — and a goat from the manger of Jesus Christ Our Lord. The latter animal symbolizes the Nativity "on the first great morning that put the Universe together." Biggers sees the quilts in two ways: he reports the textile not only as a practical shelter, as solid as a shotgun wall, but also as a metaphysical mirror of spiritual concealment and protection, mysteriously transparent, like a vapor or a piece of glass.

The starry crown, the star the central quilter conjures with several lengths of thread, and the eight-pointed star motifs on the quilts themselves link up, at the end, to invoke the spiritual authority of heaven.

"The quilt was a prayer of poor women," Biggers says. "They didn't have anything else to cover their children with." But just as Sea Island black architects painted their windows and door frames blue, the color of heaven, to protect their homes from the intrusion of evil,[64] Biggers sees the analogous protective power of key motifs, that covered and sheltered children in the night, in terms well-nigh Miltonic:[65]

> Attir'd with Stars, we shall forever sit
> Triumphing over Death, and Chance, and Thee
> O Time.

Architectural allusions in *Starry Crown* lead to Biggers' masterpiece, *Shotguns* of 1987 (page 200). What is a shotgun house? John Vlach provides a working definition: "The shotgun house is a one-room wide, one-story high building with two or more rooms, oriented perpendicularly to the road with its front door in the gable end."[66]

Henry Glassie, the distinguished folklorist, as early as the period of his graduate study, noted the strange divergence of the shotgun house from the ordinary patterns of architectural diffusion in North America.[67] Thus, the East Anglican frame house, in becoming the New England frame house, traveled east to west. Likewise the Swedish log cabin.

But the shotgun, Glassie noted, moved from *south* to *north*, the path of the black migrants.

Glassie suspected black (and ultimately African) influence in the rise and dispersion of this intriguing house type. Later as a professor, Glassie turned the problem over to a graduate student, John Vlach who eventually completed a two-volume doctoral study, *Sources of the Shotgun House*, in 1975.

Vlach argues that the shotgun house derived ultimately from the narrow one-room unit of the Yoruba compound in West Africa.[68] In so doing, he abstracted this basic narrow room pattern from a gestalt of living units, which form compounds and are centered on an inner court. He argued that this narrow, socially intimate style of space came to Haiti with the slave trade. There it was creolized in contact with French ideas about architecture before coming to the United States in the 19th century:[69] "African slaves in Haiti maintained their own house form by making one morphological change (shifting the doorway from the side of the house to the gabled end), adapting one secondary feature (a front porch) and learning a new technology (making individual panels between posts, reminiscent of European half-timber buildings).

Kongo is equally a source for the shotgun house. If we study a traditional Beembe house, which I photographed in North Kongo in the village of Musonda in the summer of 1987 (fig. 19), we note that there is no need to shift the door from side to front — it is already there. The narrow door (fig. 20) emphasizes the verticality of the facade and the space of the building, narrow and tall. One can well imagine how women and men, coming from such structures, would be naturally attracted to the tall and narrow paired French doors of Colonial Cap Haitien and the Vieux Carre in New Orleans, like a doubling of what they prized in doorways.[70] In addition the handsome aesthetic of the Beembe facade decorations (fig. 20) opens and oscillates, at each point of phrasing, with a logic which predicts the 'flexible patterning' of the African-American quilt-top.[71] We can read change in Haiti quite clearly by comparison to a

Fig. 19. *Traditional Beembe House*, **northern Kongo, Musonda village, summer 1987.** Photo by Robert Farris Thompson.

Fig. 20. Detail, door and decorated facade, Beembe House, Musonda village. Photo by Robert Farris Thompson.

Fig. 21. Traditional Haitian rural habitation, near Léogane, southern peninsula, spring 1975. Photo by Robert Farris Thompson.

Fig. 22. Shrine House for a ritual expert (*nganga*), Yema, Bas-Zaïre (western Kongo), summer 1985. Photo by Robert Farris Thompson.

rural house photographed near Léogane in 1975 (fig. 21). A porch has been added, and the technology of wall construction has changed. But the compact spatial envelope beyond the door more or less remains.

If we juxtapose a photograph of a shrine house built in 1985 by an *nganga* (ritual expert) at Yema among the Woyo Kongo just south of the Cabinda border in Bas-Zaïre (fig. 22) with the legendary tomb of Marie Laveau (fig. 23), renowned priestess of vodun in 19th century New Orleans, similarities come alive. It would appear that the family and followers of the famous woman laid her to rest in a kind of shotgun, echoing the narrow compact plan and elevation of the Kongo structure, as well as a house illustrated in John Janzen's *Quest for Therapy in Lower Zaire* (plate 16).[72]

Examination of a Chokwe dwelling from northeast Angola, published by Baumann in 1935 (fig. 24), in relation to the Léogane area house in Haiti (fig. 21) brings out further matters of cognation. Compare the Angola veranda[73] to the Haitian porch, the basic windowlessness of both structures, with doors as major apertures, high gable roofs and so forth. I could adduce many

more links between Kongo/Angola and the shotgun type. The roots of the style seem at least as much Kongo/Angola as Fon/Yoruba, probably more so.

Vlach traces the coming of Africanizing architecture from Haiti to the USA: "the shotgun house seems to develop in New Orleans about the same time that there is a massive infusion of free blacks from Haiti."[74] Documents support this: "In 1839 one Francois Ducoing (of the city of New Orleans) requested that Laurent Cordier build a *maison basse*."[75] *Maison basse* (little house) is a phrase Haitians use to describe the narrow shotgun type.

The documentation continues: "the (Ducoing) house was built on Elysian Fields, a major street in the Third municipality, at that time a black Creole neighborhood. The connection between Haiti and New Orleans building traditions is more pronounced in the case of Martial Le Boeuf who in 1840 stated in a contract that his house was to be built after the example of buildings in (Haiti)."[76]

And now the form has spread far and wide from New Orleans, to the black and white South at large, generating new issues of intricate blending yet to be worked out. Take Louisville, Kentucky, long connected to New Orleans via river trade. There, the Preservation Alliance of Louisville and Jefferson Counties published in 1980 a study called *The Shotgun House* in which it was estimated that *ten percent* of the buildings of the entire city of Louisville was composed of shotgun houses. Clearly the shotgun is a force in American vernacular history.[77]

John Biggers knows the tradition of shotgun houses from the ground up. He was *born* in a shotgun, built by his father before 1924, in Gastonia, North Carolina. The door centered the porch. All doors within the house canonically followed that pattern. And two additional rooms were stacked behind the original two-room structure to accommodate the birth of more children.

The porch is of capital importance in the

Fig. 23. The alleged tomb of Marie Laveau, renowned priestess of *vodon*, St. Louis Cemetery (Number One), New Orleans, Louisiana. Photographed in 1979 by Robert Farris Thompson.

history of the shotgun. Biggers remembers the back porch and front porches as "talking places, because the breeze was there." Men sat on these porches, he adds, to discuss the meaning of the Bible.

Virginia and Lee McAlester in *Field Guide to American Houses* find that porches in the American sense are rare in Europe. But porches are strong in former French and English colonies. There may be a relation between the porches and verandas of Kongo and Angola architecture (as well as other subSaharan civilizations strategic in the diaspora) and the noble verandas which are such a distinctive trait of certain white plantations in the South. After all, who built these verandas and where did they come from?

John Blassingame has shared with me relevant findings, 18th century documents indicating the complaints of white builders in Georgia and South Carolina about black laborers undercutting them at the same job. Many of these black laborers were born in Africa.

If African influence explains the rise of the porch as an important element in American vernacular architecture, then part of the story will be found in the family history of John

Fig. 24. Chokwe House with verandah, Saiyongo village, Angola, 1935. Photo courtesy of Robert Farris Thompson.

Biggers: "I had a first cousin who built all the houses in Bellamy, Alabama (a village of some 750 people in Sumter County, east of Meridian, Mississippi). He built houses for both whites and blacks and porches were a part of it." Today, Labelle Prussin reports, when blacks move into an urban neighborhood where the houses were built by European-Americans before them, one of the things the African-Americans do is add on front porches: "This turns the street into a wholly different cultural situation, with dialogues crossing streets, porch to porch."

To Biggers, the shotgun is a scented precinct, with its own secret pleasures: "The floors were so carefully scrubbed with homemade lye soap that when you slept on them they smelt sweet." Porches, too, were scrubbed and scrubbed until the wood virtually turned white: "When you stepped out of the street, into the clean little shotgun, you were safe."

We come now to John Biggers' evocation of the shotgun heritage (page 200). Although he has long since moved from North Carolina to Texas, shotguns are still with him: "I see them as I walk the Fourth Ward of Houston, the rhythm of their light and shadow, the triangle of their gables, the square of the porch, three over four, like the

beat of a visual gospel."

In the painting Biggers bathes all the buildings in intensely bright light, as if set upon a stage. He repeats their temple-like facades in a mirroring effect. The brilliant solids of the gables and the darks of the voids below generate a quilt-like vividness, deliberate and controlled. By these means, Biggers establishes that here, before us, stands classical black architecture.

Memories and collective outlook enliven the handling of detail. He remembers small circular openings, cut in the gables of the shotgun in Gastonia for ventilation. He repeats this element across the composition. He remembers the white, well-scrubbed porches. He honors their role as centers of black speech and culture with quilt-patterned walls that telepathically recall the decorated facades of the Beembe. A Gothic window hints of black religiosity. The clapboards pun on washboards, icons of washings.

Black women defend that life and purity. They guard the doorways to the three houses in the foreground. In their hands they hold as lamps miniature shotgun houses. And in these lamps, light emanates from minute standing figures: "The spirits of black women who have passed away, who kept and guarded families in the Fourth Ward in Houston, which is full of shotguns."

The cooking vessels depicted on the porch, return us to themes of purity and renaissance. Washboards, placed upright in cooking vessels, suggest a Jacob-like ascension on a ladder to the firmament.

Railroad tracks, laid over black and red quilt-like patterning, resonate with allusion. This is classical architecture on the wrong side of the tracks, a way of saying matters of class and economics mask to this day the importance of these buildings.

A biographic glint is also present here. "I went to bed and got up in Gastonia by train sounds," says Biggers. "What we called 'The Bob Train' came in, like clockwork, early every morning, on the Southern Line, at 4:12 or 4:15,

Fig. 25. Detail of David Hammons' installation, *Blue Train*, EXIT ART, New York City, May 1989. Photo courtesy of EXIT ART.

and woke us up. And we'd play ball with homeplate on the tracks, getting off only to let a train pass through. And we'd swim at Long Creek, north of Gastonia, where the trestle was our diving board. The railroad tracks belonged to us."

Thinking parallel thoughts, David Hammons, black artist of New York, painted a model train bright blue, in the summer of 1989, and caused it to snake along a deliberately curving track, entering and exiting a mound of coal, over and over again. He was punning on the name of John Coltrane, avatar of modal jazz, and the name of one of Coltrane's early albums, *Blue Train* (fig. 25). John Biggers, to whom the long, narrow rooms of the shotgun house read "just like railroad cars," sees these buildings on the move, on the track, led by an unseen locomotive, of freedom and the spirit:[78]

> Ain't but one train on this line
> Run to heaven and back again.

Yard-shows and Bottle-Trees: Arts of Defense and Affirmation

A black family in tidewater Virginia, breaking up the space between their house and the road with found icons and other emblems, calls the design a "yard-show." Under this rubric and other appellations (black yard art, black yard design) has emerged an independent African-American aesthetic of immense consequence and influence.

Yard-shows assimilate the artistic and philosophic values of classical Kongo culture. This lies manifest in the recurrence and assuredness of the major themes: [1] rock boundaries [2] mirrors on the porch, "to keep certain forces at a distance"[79] [3] jars or vessels, placed by the main door on the porch, "to send back evil to its sources"[80] [4] motion-emblems, like wheels, tires, hubcaps, hoops, pinwheels [5] cosmograms, sometimes rendered as a diamond, sometimes as a circle [6] planting flowers or herbs within the

protective circle of a tire, sometimes white-washed, sometimes turned inside out and decorated with knife-cut sawtooth edges, creating what is called in Alabama a "crown"[81] [7] root sculptures, found images, dolls, plaster sculptures of persons or animals and, in one instance, stuffed animals [8] trees hung with shiny bottles, light-bulbs, or tinfoil, shiny metal disks, and sometimes the bones of animals [9] swept-earth yards with every blade of grass removed [10] graveyard-like decoration, including shells, pipes, rock piles, and sometimes even head-markers [11] plantings of protective herbs.

To repeat, the makers of yard-show art in North America work from formal principles of selectivity and emphasis, recalling rationales of classical Kongo bearing. In fact, the language and discourse of the yard-show makes of house and property virtually one vast *nkisi* charm, especially where there is a mirror on the porch, like the mirror in the belly of the *nkisi n'kondi*.

Recall that the *nkisi* tradition, brought to the United States from Kongo and Angola by Gullah Jack and other legendary healers, was a matter of embedding spirit in earths, keeping the spirit in a container to concentrate its power, and including within the earth material signs which told the spirit what to do.

The gist of those expressions is seemingly regained in a creole art wherein the house guards the spirit of the owner, and the icons in the yard guard or enhance that spirit with gestures of protection and enrichment.

There is a logic to the main visual principles of the yard-show: *motion* (wheels, tires, hubcaps, pinwheels); *containment* (jars, jugs, flasks, bottles, especially on trees and porches); *figuration* (plaster icons, dolls, root sculptures, metal images); and *medicine* (special plantings of healing herbs by the door or along the sides of the house).

These "decorations" may seem casual to persons passing by, but the sheer repetition of these themes, from coast to coast in Black America, strongly hint of conscious principles of communication.

Icons in the yard-show may variously command the spirit to move, come in, be kept at bay, be entertained with a richness of images or be baffled with their density, to savor sunlight flashing in a colored bottle or be arrested within its contours, and, above all, to be healed or entertained by the order and beauty inherent in the improvised arrangements of icon and object.

Yard-shows, as I have indicated, are everywhere in the Black USA, not just the South. They are in Detroit, Louisville, New Haven, Kansas City, Dallas, and Los Angeles.

A recent catalogue, *Home and Yard: Black Folk Life Expressions in Los Angeles*, establishes that "a large number of Black residents migrated to Los Angeles from Louisiana, Texas, and Arkansas and settled in neighborhoods around Central Avenue . . . (there they retained their culture) in yard decorations."[82]

In light of documents from the 17th and 19th centuries it is possible to suggest the influence of the classical religion of Kongo on these African-American art works. Let us review the sources. First, we know from Dapper's text of 1670 that mystically protective objects guarded houses in the northern Kongo city of Loango in the 17th century:

> *Boessi-Batta* was another *nkisi* of major importance focussed on bringing into one's homestead objects acquired in long-distance trade, thus especially pertinent to merchants. It consisted of several parts: a large lion-skin sack filled with all sorts of shells, iron bits, herbs, tree bark, feathers, ore resin, roots, seeds, rags, fishbones, claws, horns, teeth, hair and nails of albinos . . . to this satchel were added two calabashes, covered with shells and topped with a bush of feathers.
>
> The whole set of objects, satchel and (the two) calabashes was placed atop a table-like construction outside the door of the house.[83]

Naturally yard-shows in the South and in Los Angeles could not exactly duplicate this distant

Kongo house-charm complex, being as they are based on creole paraphrases of such traditions. Still and all, we note themes persisting today, shells, roots, rags, and above all, the placement of two containers by the door.

The possibility of Kongo/U.S. influence would appear strengthened by another description, this one by John F. Weeks in a book on Kongo life published in 1914:

> Some anxious mothers, after the birth of a child send for (a ritual expert, an *nganga*) who brings with him a number of small conical basket traps. These he carefully places all round the doors of the house to catch any evil spirits that may try to get into the house.[84]

The mysterious guarding of a house could be visually phrased by additions of certain kinds of cloths as well: "a pad (*munkata*) of old native cloth is twisted and placed on the article to be guarded, and the thief who then takes anything thus protected will suffer.[85] In Kongo, colored rags, hoisted on a tree, symbolized a problem within the community. A rag, cloth subtracted from entirety, visualized a social problem or division. Thus to deck a house with rag emblems called on God to mend a broken situation, sending an invading felon to his doom.[86] Trees with bones, tied to their branches or to their trunks, warned viewers that should they rob the premises they would soon become skeletons.[87]

In fact, trees are frequent media of moral intimidation in Kongo vernacular symbolism. From Weeks' 1914 text:

> An old basket hung in a fruit tree, or against a door, will give backache to the thief, or cause him or her to become sterile. A stone hung in a little palm-basket with some creepers twisted round it and suspended from (an African plum tree) will give the person who steals from it, or even attempts to climb the tree, a severe form of hernia.[88]

Within the contours of this tradition appear also hoops or circular constructions which the Bakongo translated, when placed before a house, as "an empty world," "a dead world," meaning a kind of empty window through which an aggressing thief mystically would fall down to his death.[89]

Broken pottery also was a sign of death, an emblem of the graveyard. Proyart, writing in 1776 apropos of the Vili areas around Loango, North Kongo, made it clear that this dread sign of the end of life was suspended not only from (fruit-bearing) trees, but before the houses of persons who for one reason or another had to absent themselves for a long time, "for the most determined thief would not dare to cross the threshold when he saw it protected by these mysterious signs."[90] And this was the beginning of mixing the visual languages of tomb and home.

But all was not a matter of spiritual defense in these classical expressions. We also perceive emphasized qualities of healing and affirmation, too. For instance, making a ritual circle around a tree before a house in Kongo specially protects the plant and helps it bloom and grow. And this leads to larger dimensions of positive herbalism in which healers surround their houses with myriad herbs, like an emerald aura. Consider the house of the traditional healer, Nzoamambu of Manselele in North Kongo. His residence is surrounded by some 77 specially planted trees and herbs. Most provide medicine. Some, however, protect the boundary or ward off lightning.[91] Dotting the perimeter of a house with plants for healing is not unlike nailing blades of iron into a Kongo *nkisi* as signs of the healing of problems of social discord and displeasure.

Now, Kongo medicated yards and doorways may seem impossibly distant from the modern United States, relics of a bygone pastoral level of simplicity, utterly without relevance for our times. But classical traditions often start at deceptive levels of outward simplicity and plain-

ness. Odysseus, after all, surprised Princess Nausicaa doing her laundry in a stream. The infant Moses was concealed in bullrushes, not babywear from Christian Dior or Neiman Marcus. Christ was born in a manger, not the Holiday Inn. Yet Moses and Christ arose to redirect the course of Western consciousness. And when the best of the teachings of Moses and Jesus were fused with the best of the classical religion of Kongo in North America, the result was The Old Time Religion.

All three religions are one in hailing God as the ultimate moral arbiter. This is the rationale that illuminates the protective medication of the Kongo house and yard, for it is written that: "(God) gave rise to all the *minkisi* in order to help the people."[92]

In the summer of 1987 I photographed an *nkisi* (fig. 26) which one Mayolo Pandi had fashioned around the trunk of a tree in order to protect his orchard from thieves. The charm consisted of a miniature double-ended spear on the prongs of which were impaled a palm nut, left, and an eggplant, right. Pandi suspended an *nkisi* sachet, a *futu*, on a string beneath the

Fig. 26. *Nkisi Nkandu*, also known as *Nkisi Mabibiri*, anti-theft tree medicine made by Mayolo Pandi Maurice of Ndingui village, near Mouyondzi, Bouentza Region, R. P. du Congo, July 10, 1987. Photo by Robert Farris Thompson.

fruits, themselves material ideographs of punishment and retribution.

The generic name of such a charm is *nkandu*, which means prohibition. This means the law. This makes it criminal in God's name to steal from this tree. The *futu* is seen as a package wrapt by God, Who calls upon the soul in the sachet to follow the thief and destroy him with disease or death.

Massive numbers of captives came from Kongo to New Orleans, Charleston and the Caribbean, and they brought with them memories of the medicines of God as an irreducible fundament of their culture and way of life. In spite of slavery and other problems, they managed to reinstate the material commandments of God. In 1791 on the island of Dominica, between Guadeloupe and Martinique, it was reported that the blacks had "confidence in . . . sticks, stones, and earth from graves hung in bottles in their gardens."[93] This is one of our earliest attestations of New World Kongo house-protecting charms.

It is significant that it mixes the world of the dead, cemetery earth, and the world of the living, the household garden, to achieve its proper intimidating pitch. We can read the ideography of this New World *nkisi* fluently: earth embedded with ancestral spirit, commanded to use sticks, as mystic arrows, and stones, as mystic bullets, against all thieves or enemies. The sachets have changed from cloth to glass. The bottle tree had emerged in the Americas.

A later attestation from Trinidad builds another conceptual bridge from Kongo, via the Black Caribbean, to North America:

more to prevent the pilfering of small boys than the ravaging of animals and birds (the black owner of a small farm) had scattered her plot with a miscellany of broken bottles, old tin pans, dirty colored rags, animal bones, barrel hoops and various constructions of the sign of the cross.[94]

The range of Kongo discourse is amazing. It simultaneously points towards the reinstatement of many of these themes in U.S. yard-shows, like protecting flowers within a rubber circle:

> The next day she placed a rusty barrel hoop around the (mango) tree, satisfying a belief . . . that it would thrive better.[95]

The same rationale appeared in Cuba where Esteban Montejo reported that teams of Kongo magic-men used to compete, planting a plantain tree, in the middle of a circle drawn on the ground, and casting spells on that tree to make it bear fruit.[96]

New Orleans was a point of entry for such beliefs, direct from Kongo and indirectly from creole Caribbean sources. Thus the folklore of Louisiana now includes the following: "If a tree bears wormy fruit, chop a piece from the trunk and tie a bottle of water somewhere around the tree. Next year you will have solid fruit."[97] Louisiana, furthermore, is no stranger to the concept of the medicated house which is protected cosmographically: "hide (roots and herbs) in the four corners of your house to keep things in your favour"[98]; "plant gourd vines around the house to keep snakes away."[99] Winslow Homer may have unwittingly documented this last-mentioned creole pattern in his painting, *Near Andersonville*, dated 1865/1866.[100] In this work we see a black woman, in apron and vivid head-tie, standing in a doorway. To the left of the door are gourd vines, perhaps house-protective, and to the right of the door is a basket, recalling protective baskets placed by doors in Kongo.

In tidewater Virginia today, one is astonished to pass black house after black house and note two ceramic containers — jars or pots or jugs — guarding the door on either side. The custom is also present in Georgia and North and South Carolina. John Biggers was taught this tradition in Gastonia, North Carolina and given the rationale: mystic traps or baffles, coded as pottery decorations, palisade the house, causing

Fig. 27. Tree-Charm by Rachael Presha, "The Purple Lady," Suffolk, Virginia, winter 1987. Photo by Tom Meredith Crockett.

"evil to go back to where it came from." Adds Biggers: "I remember the jars on the porch, they often contained objects considered to have power. It was a very individualistic form of phrasing, these medicines, actual or implied within the jars; knowledge of them was not necessarily shared. In any event, you didn't mess with it." And he further comments that it is not just a Kongo heritage, because on a trip to Ghana he noted an Akan person leaving jars around his house, when he left town on business, "and, of course, we knew exactly what he was saying."

The classical qualities of the medicines of God are perceived in the work of the remarkable "Purple Lady" of Suffolk, Virginia, as described by Tom and Meredith Crockett:

> There is a quarter mile stretch of Route 17 in Suffolk, Virginia near the Portsmouth County line where the telephone poles are all painted purple. There is a sense of joy and purpose in

127

her activity. There are purple trees, purple shoes, purple chairs, purple brooms, purple wash drums, and a purple baby carriage.[101]

Her works recognizably fall under yard-show rubrics of motion and containment, but uniquely are unified by a single color. Her most arresting approach to the style of Kongo material writing is a bundle of sticks, bound tightly in purple cloth and tied to the crook of a tree (fig. 27). This amazing assemblage, dating from the winter of 1987, seemingly announces that intruders of mal intent will be mystically swept or forced to deal with a unified army of spirits, bound in wood and ready to be released. This Afro-Virginian composition recalls, as well, black Cuba where Kongo men played a game of the same origin, *quimbumbia*, in which they "got handfuls of magic sticks from the forest and tied them in bundles of five, to give each man strength."[102] Whatever she meant, her work bears witness to a powerful expression of the theme of the medicated tree.

As to Mississippi and Alabama developments of this mode, the famous Southern writers, Eudora Welty and Truman Capote, did not have to study Picasso in order to appreciate African influence on the modern world. Such power was right beside them in Africanizing bottle trees. Thus, the aunt of Truman Capote recalls the bottle trees made in the thirties by Corrie Wolf, a black woman of Monroeville, Alabama, who worked for the family of Truman Capote. She would take a blooming crepe myrtle and insert the ends of its branches into brightly colored bottles, explaining that evil was "attracted to bright colours and the first thing you know they are trapped inside the bottles and can't get outside."[103] The same rationale, based on the ancient Kongo metaphysical equation, — flash equals spirit and spirit equals flash, — gave rise to tinfoil trees and tin plate trees and mirrors on the porch.

In a marvelous, personal variant on this tradition, the grandmother of Willie Collins of Los Angeles strung light bulbs on a line within her yard. She explained that when she died they would all light up.[104] In Kongo it is believed that what is incomplete in the living world is complete in the world of the dead.[105] Hence, bulbs now empty of light would light up in the other world. But only the mystically prepared could see them.

James Seay's poem, "The Bluebottle Tree," documents a portable style of arboreal *nkisi* seen in Mississippi and other portions of the South:[106]

> The bottle pile beside your shotgun house
> grows bigger — empty bottles; the beers are brown,
> The whiskeys clear, and milk of magnesia
> comes in bottles of translucent blue.
> But on this summer day you've cut a green bay tree
> Sheared the leaves away, stubbed the branches
> Stuck it upright in your yard . . .
> And slipped bottles over the stubs
> . . .
> Your bluebottle tree, a hard-won
> Stay against confusion.

Greg Stringfellow photographed in February 1985 two prepared bottle-trees not unlike the one described in Seay's poem, i.e. cut, embottled, and set up in the yard. The trees guarded the yard of a black family along Route 7 at the Holly Springs/Benton County line in northern Mississippi (fig. 28).[107] The trees were the main accents of a yard-show. In front of each tree the owners had placed open metal hoops, painted red, with red buckets suspended in their center, reading like the Kongo ideograph of life. In the early eighties I photographed a white-made bottle-tree, further south in Mississippi, at Sarepta (fig. 29). This structure was more or less disguised to look like a Christmas tree, with a metal Star of Bethlehem mounted at the top. Its tightly-clustered logic of expression, exactly miming the feel of a richly caparisoned Christmas tree, is quite different in feeling from the stark "bottle-and-branch" black bottle-trees pho-

Fig. 28. Bottle-Tree and yard-show, near Holly Springs/Benton County Line, northern Mississippi, February 1985. Photo by Greg Stringfellow.

Fig. 29. Bottle-Tree by Hubert Glenn, Sarepta, Mississippi, c. 1969. Photo by Robert Farris Thompson.

tographed by Welty and Stringfellow.

The maker of the Sarepta tree, Hubert Glenn, says that he completed the work c. 1969 and that it replaced a bottle-tree that was larger and taller. He says he got the idea from southern Louisiana and put it up for luck.

Cornelius Lee, an African-American who lives in tidewater Virginia, responds to this classical tradition in an innovative way. Acting on a kind of inspiration — "a mind tell me" — around 1959 he tied two soda bottles together on a single strand of cord and hurled them up on a branch of a tree. They stayed on the branch. "I kept on doin' that til I filled the tree out" (fig.

30). Lee says he makes bottle-trees primarily for aesthetic reasons. He savors the randomness of the patterns formed by hurled double bottles: "when you throw them up, they fall where they may, that's the beauty of it." His sister has made a similar bottle-tree of her own on a nearby property.

The sister's house is guarded by a canonical rock-pile (fig. 31), bristling with seashells and two disks of red glass "that shine on somebody coming, that reflect." The brother's decorated front yard (fig. 32) flows symphonically from the front door, guarded with two vessels at the entrance, two vessels on the bottom step, past

Fig. 30. Bottle-Tree, by Cornelius Lee, tidewater Virginia,
c. 1959. Photo by Robert Farris Thompson.

however, "The Texas Kid" placed a mirror under the right-hand window of his house, explaining, "I can tell what you are doing by mirror reflection."[108] This recalls the rationale of Lonnie Holley, African-American artist of Birmingham, Alabama: "with . . . mirror eyes this piece know what you intend to do before you do it."[109]

The glitter of the bottle-tree rhymes conceptually with the flash of the mirror by the house. They are the obverse and reverse of the same coin of Central African influence. Bottle-trees are believed, variously, to bring rain, make trees bloom, bring luck, and ensnare all evil. It is premature to draw firm conclusions but I have the impression that what distinguishes the North American bottle tree from the more Kongo-looking bottle trees of Suriname, Trinidad, and Eleuthera [110] in the Bahamas, is a conflation of the tradition of catching spirits in vessels or baskets placed by doors with the tradition of hanging anti-theft devices from the branches of a tree. This would explain the different emphasis on trapping beings in bright glass. In addition, the custom of hanging bright baubles on Christmas trees may well have stimulated the decking out of trees with multiple bottles, leading to outright mimesis, as in the case of the art of Hubert Glenn of Sarepta.

Yet, even as they were changing, the tree-*nkisi* were constantly interrelated in the black imagination with the decoration of the yard. Yard and tree as unit created a joint exuberance that danced the icons from door to street. That interrelationship is emphasized for one more time by William Eiland, who witnessed the tradition at Sprott in Alabama northwest of Selma:

> the practice (of making bottle-trees) went hand-in-hand with having a grass-free yard (except where it was bounded quite carefully with old tires or bricks). The devil could hide himself in the blades of grass; if the yard was gravel or dirt, there was no place to hide . . . Likewise, a

two whitewashed stumps tied with red ribbon, two circular gardens lined with red bricks, two tire planters painted white each enclosing a red staff, ending at a little bridge leading to the road. The Cornelius Lee yard-show also includes a piece of sculpture in white, balanced by a miniature lighthouse and two more motion icons, a propeller painted red, and a toy car.

Similar principles of selectivity and emphasis influence the yard-show of "The Texas Kid" in Dallas (fig. 8), made famous by a cameo appearance in David Byrne's film, *True Stories*. Here we meet the same balanced wheel-motifs, balanced sculptures, and a rock-pile. Instead of suggesting a protective boundary with red glass,

Fig. 31. Detail, rock pile with inserted seashells and two red glass reflectors, tidewater Virginia, winter 1988. Photo by Beverly McGaw.

mirror on the front porch would frighten the devil out of the front yard, since his reflection is even horrifying to himself.[111]

The indelibility of the spirit lies implicit in the resonance linking yard-shows to the grave-yard in terms of carefully selected emblems of permanence — rockpiles, shells, pipes. "The Texas Kid" has a mock grave on his lawn, as did Henry Dorsey of Brownsboro, Kentucky.[112] Saul Hill, who moved to Los Angeles from Louisiana in 1920, has so intensely decorated his yard with a cross (with diamond motif) and hypnotically repeated arrangements of pipes and tiles and tomb-like slabs that it strongly resembles an African-American traditional graveyard.[113]

Regardless of the varying covert messages coded in such objects, we must not lose sight of the fact that, for many of the makers of yard-shows, the main purpose is to communicate with and give visual pleasure to their communities. As Lizetta LeFalle-Collins remarks in her essay in the recent catalog, *Home and Yard: Black Folk Life Expressions in Los Angeles*, cut tire planters and other characteristic objects of the tradition are "meant to be viewed by a larger audience."[114]

That larger audience now includes the world. For many of the most famous traditional African-American artists of our time — Lonnie Holley, Mary T. Smith, Hawkins Bolden, Joe Light, Mose Tolliver, Henry Dorsey, Ralph Griffin, Nellie Mae Rowe, Sam Doyle, David Butler, and many more — caught the attention of art historians with their public yard-shows. For instance, Butler "created a rich outdoor (yard-show) around his small house in Patterson, Louisiana, a pageant-like garden filled with colorful metal cut-outs in the form of real and fantastical animals, elaborate whirligigs, trains, Biblical scenes, and Santa and his reindeer."[115] And Sam Doyle displayed his paintings under the large oak trees in his yard: "They face the road, inviting people to stop."[116] Even J. B. Murray pasted some of his spirit-script protectively around his door.[117]

Yard-shows are not only here. They act upon black artists like an invisible academy, reminding them who they are and where they come from, an alternative classical tradition. Let Ed Love, Renée Stout, Griffin Manning (of New Haven, Connecticut) and John Biggers complete and illustrate this point.

Ed Love grew up in black Los Angeles where he absorbed the images of whitewashed tires in

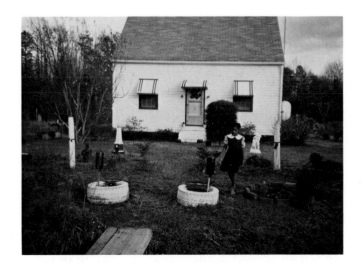

Fig. 32. The Cornelius Lee yard-show, tidewater Virginia, winter 1988. Photo by Beverly McGaw.

yards, and protective boundaries marked in whitewashed stones, which he himself helped his father tend when he was a child. Later, tough automotive chrome became the protective armor of his own identity. In the early seventies Love made a remarkable sculpture called *Talisman* (fig. 33). With this work in automotive chrome he built himself a kind of bottle-tree; he set it upright under a canopy of shrubs at the left of his door. There it guarded his house in Washington, D.C. for as long as he lived in it. "It was set so that you had to look up, stopping you from aggressing right into the house. It must have worked, because I had a lot of valuable art inside and no one ever touched a thing."

Talisman blocked all evil with its flash, its strong horns of metal, its outspread arms or wings, and its receiving concave space beneath the horns and outspread arms. Love mounted it on a contrastingly black staff. This he did so it would seem "to float across the ground."

When Renée Stout was a child, she lived near a house (now torn down) on Renfrew Street in

Fig. 33. *Talisman*, house-protective sculpture, by Ed Love, steel, early 1970s (now removed to Miami, Florida). Photo by Ed Love.

the East Liberty section of Pittsburgh. In that house lived a visionary black woman who peopled her yard with multiple doll images mounted on staffs, multiple stuffed animals mounted on staffs, and a spectral scarecrow made of an overcoat and a hat mounted on a pole. This was the directly Africanizing, directly visual dimension to her past. But part of her inspiration was purely literary: "another thing that really stimulated my imagination was a book called *Voodoo In New Orleans* by Robert Tallant."[118] She was moved by the story of Marie Laveau and her practices in New Orleans vodun and later made a pilgrimage to her tomb. She also read voraciously on African and African-American art.

With her masterpiece, *Fetish #2*, memories of yard-show *minkisi*, and the Dahomean-Kongo mixture practiced by Marie Laveau, and notations from art books, all fell into place in a striking pattern of identity and assertion (pages 230, 231). The piercing flash of the cowrie-inset eyes came from an illustration in a book on African-American art: "I was struck by the vivid flashing of Elegúa's eyes (she is speaking of an Afro-Cuban trickster image) in shells, set into a stone so plain."

Note how adroitly she finds her way back to African antiquity by way of cultural preparation and affinity, paraphrasing original assertions in terms of her own needs and her own condition. Thus she takes the *kundu*-gland projection of the *nkisi* of Kongo at the belly, those often centered with a mirror of protective flash, and transforms it with a different, feminine visualization: "I was always impressed with the mystery of what lay behind the mirror. I knew that what was behind the mirror was positive." And so she inserted an image of a baby in an elegant dress from the turn of the century, hinting of the contribution of infants to worlds to come and to worlds that have happened. Beads, sequins, and coins deepen the body of *Fetish #2* with a heightened sense of capacity. The sequins recall childhood magic, when the artist used to pretend to make

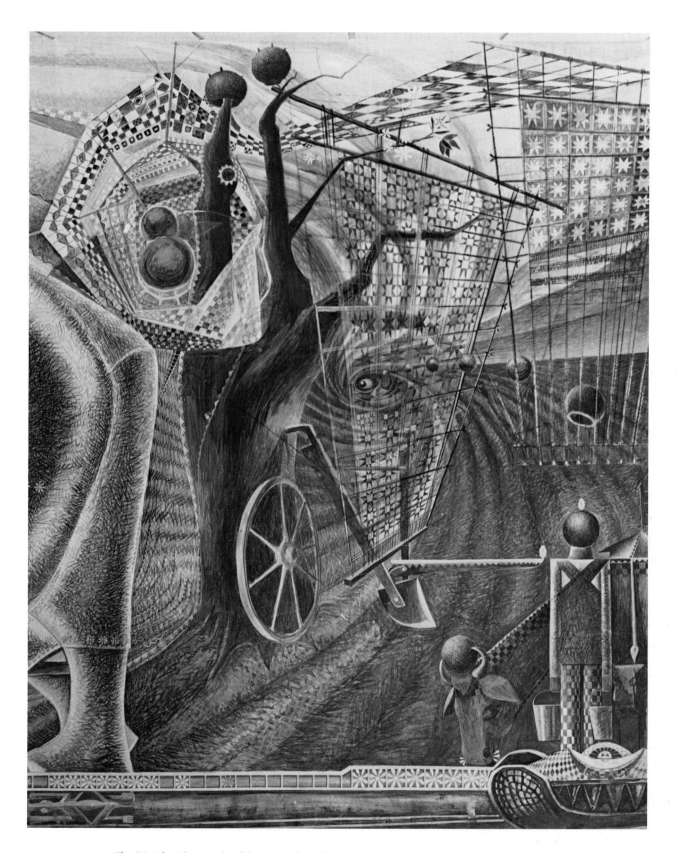

Fig. 34. John Biggers, detail from *Family Unity* mural showing bottle-tree with pots, 1979-1984, Texas Southern University, Sterling Student Life Center, Houston. Photo by Earlie Hudnall, Jr.

things happen with a sequin-studded wand improvised from her grandmother's decorated feather-duster.

The most amazing transposition is the translation of the shape of minkisi-bundles or cloth sachets (*futu*), like the little container of the spirit Mayolo Pandi fashioned for his "bottle-tree" in Kongo (fig. 26). Stout's *futu* are made of paper, "painted with coats and coats of acrylic, soaking through the fibre and making it stronger so that I could wrap and tie it in a Kongo manner." The body is garlanded thus with miniature *minkisi* like an nkondi image in Kongo, like a bottle-tree in Mississippi. And the body is that of the artist, rendered in assembled plaster impressions. The canonical image of the *nkisi nkondi* gives way to feminine assertion, forcefully and equivocably expressing the artist's intentions — "I'm going to be powerful" — and effecting a revolution in Kongo Atlantic art. Forms that once resolved lawsuits in the body of an athletic figure, that guarded black yards in the abstract glitter of myriad bottles, are strikingly filled with the energies of a living, determined, inspired black woman.

When John Biggers was a child growing up in North Carolina, he was taught two things about the bottle-tree: (1) that the myriad bottles would keep birds out of fruit trees, "for the wind striking the bottles would make a wonderful noise" and (2) "if you put pots on the trees at the right time of the moon (i.e. when the moon was full), the bottle-tree would bring rain." In Kongo when the moon is full, "things are fully happening,"[119] the propitious hour for certain rituals. When the rain falls, Bakongo children are told to dance, to please the rain. In return, they receive the rain's blessing.[120] In North Carolina, Biggers was taught to get in the first rain of spring: "you'll never catch a cold, if you catch the first rain."

Biggers' cultural education included learning how to make and place protective medicines: "Our tricks were put under the step to protect the house and they were called *inkabera*. To make an *inkabera* you took a piece of string and put it in a jar and filled the jar with water and put it under the step. The string would turn into a serpent if someone came really to do you in." Biggers saw mirrors on porches in Bessemer City, North Carolina, near Gastonia, and he watched medicinal herbs being planted around the edges of houses.

These memories and lessons coalesce in a detail from a mural called *Family Unity* completed at Texas Southern University, 1979-1984. The artist filled the space with coded constructs, making positive statements about men and women working together in family units. The furrows the men make plowing fields are answered by the lines women make piecing quilts. A line connects the horned cow image of "Great Mother" with the raking angle of the coveralls of a male farmer. And a circle of women's cooking vessels wheel in and out of time.

One of the main protagonists in this work is a bottle-tree, dressed with pots, to bring the rain. The wheel placed at the base of the tree seems to gather its powers into one motion-drenched principle (fig. 34).

That wheeling unity independently echoes the yard-show of Griffin Manning, an African-American in New Haven, Connecticut (fig. 35). Remembering wheels in yards in South Carolina around 1970, Manning clustered wheel on wheel on wheel around the main gate to his house "so that it would draw attention where to enter." He also chained a mortar-mixer wheel and a carriage wheel together high at the summit of a stump of a tree "as part of our heritage." And by heritage he means the black gospel:

Ezekiel saw that wheel
Way up in the middle of the air
Ezekiel saw that wheel
Way up in the middle of the air
The big wheel run by faith
And the little wheel run by the grace of God.
A wheel within a wheel
Way in the middle of the air.[121]

Manning's display of circles on circles, wheel on wheel, is meant entirely positively, bringing in the world in the name of God's faith and grace. It is a welcoming, yet deepened by allusion to ultimate authority, a way of saying that the maker of the house is not alone. It is also biographic: "wagon wheels is country, wagon wheels identify me as a country man, moved from Harrisville, South Carolina, to Washington, to Philadelphia to New England."

John Biggers' strange and marvelous painting, *Wheel in Wheel* (page 201) of the eighties culminates the yard-show fascination with images of wheels, as well as the oral literary reference to gospel music cited by Manning.

The meditation implied, in the gathering of yard-show objects, turns into a painting. Trees that guard the farm become railroad ties, lifted into heaven. A railroad in the sky. Each railroad tie trails transparent cloth, as if each were a person in a larger pattern of spiritual completion. A dog rests on this railroad to the other world: "When you were buried, your dog would sleep on your grave."

From the trees came wood, from the wood came shotgun houses, seen within the wheel. One house is male, dressed in coveralls, the other female, dressed in a quilt. They are elders in heaven.

Shotguns are cogs to Ezekiel's curve and movement. Quilts confirm the radiant beauty of the vision. Black mothers put their boys and girls to bed under star-patterned quilts and God, in turn, covered the cosmos with a quilt of stars. Biggers, like Rosetta Burke of Black Detroit, hears voices in the wheels.

To the sound of those voices is added ideographic richness, imprints of feet, in the circle of the sky: "That's the souls of the people, making up the wheel, their spirits moving, wheeling there in space." Pure Kongo-Christian fusion, black women and men moving as seconds of the sun, diamonds in the sky, dovetailed in Ezekiel's vision.

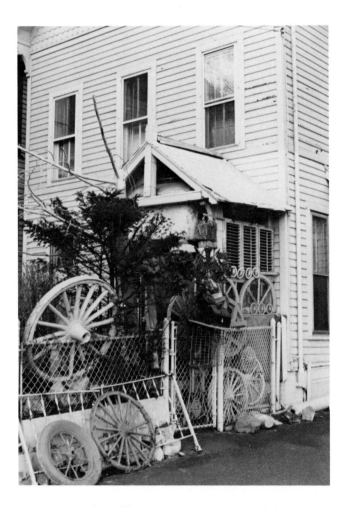

Fig. 35. The Griffin Manning House with yard-show, begun c. 1970, New Haven, Connecticut. Photo by Robert Farris Thompson.

Coda: The Art of Jean Lacy

Jean Lacy's painting embodies, like the work of her colleagues, the theory of this exhibition. She brings us home to Dallas, where she lives, and where this catalog originates. She paints the transformation and enoblement of Western consciousness by African influence.

Egypt is part of the phenomenon. Many black artists in the country have voiced dreams in ways not unlike Marcus Garvey: "And the Nile shall once more flow through the land of science, of art, and of literature, wherein will live black men of the highest learning and the highest accomplishment."

Consider Aaron Douglas. His *Building More Stately Mansions* (1944), which graces the cover of David C. Driskill's important *Two Centuries of Black American Art*, shows silhouetted black persons constructing cities besides the Sphinx and one of the pyramids.[122] In the right foreground black children spin a globe of the world. Their gesture activates expanding radio waves which encompass the whole of the composition. Douglas, it seems to me, chose to use a dominant medium of the forties as a spiritual means to reveal the world of black urban participation, starting from the time of the Pharaohs.

David C. Driskell interviewed the artist about his aims and adds the following: "The concentric spreading out of radio waves was Douglas' way of visualizing the music, black cultural influence, mediated by jazz and blues on radio, becoming global, becoming a universal aspect of North American consciousness."[123]

As to his use of silhouettes in *Mansions* and in *Into Bondage*, 1936 (page 142) and other works, Douglas revealed to Driskell that his pyramidally shaped torsos referred to a *spiritualized revitalization* of the black person by reference to an Egyptianizing past. Even the signature, slitted eyes of silhouetted persons in the Douglas manner symbolized power shared between man and Amon, between man and the sun, the energy that came from heaven. The consistency of the symbolism is confirmed in the resonance between the slitted eyes of the Sphinx and the black workers in *Mansions*, and the ray from a distant star, of survival and hope, that shines through the slitted eyes of a person about to be boarded on slave ship on the coast of Africa in *Bondage*. The antiquity and nobility implied in Douglas' Egyptianizing manner becomes a metaphor for black continuity and achievement.

That theme of spiritualized revitalization reappears in the painting of an African-American closer to our time, Avel de Knight of New York City. In 1970 he painted a pyramid at the center of the horizon line in a work called *Mirage Painting: Shields,* reproduced in Robert Doty's *Contemporary Black Artists in America* of 1971. By centering the famous Egyptian structure on a line between heaven and earth, de Knight turned it into a symbol of perfection.[124]

The transference of ancient black excellence into the present is also the point of McCoy Tyner's superb composition, *Message from the Nile*, which he recorded on February 9, 1970. Ed Love similarly believes that part of the history of the black man and woman is rooted in experiences that took place along the Nile, and he sums it all up in an overlapping series of cabalistic puns:[125]

> ledge of the Nile
> Nile edge =
> knowledge.

Thus, Jean Lacy speaks for her colleagues with *Little Egypt Condo/New York City*, completed in 1987 (page 199). By naming a tenement a "condo," icon of the eighties rich, she alerts the viewer, with a tone of irony, that her subject concerns a deeper kind of wealth: *black people themselves*. The artist explains: "I am claiming this building in the name of my history, in the name of my people and their culture." The tenement becomes a temple, on the walls of which graffiti turn into hieroglyphs.

Black people of the cities of the eastern Sudan, Napata, Meroë, and in the west, in Kano, Timbuktu, and Kángaba, have known writing since antiquity, sometimes indigenous graphic scripts, sometimes Arabic, and sometimes hieroglyphics as in the case of Meroitic, which remains to be deciphered. The point is that writing has always been a part of being black and urban. Jean Lacy uses a fragment of a writing system from ancient Egypt to symbolize her people, now within the cities of the West, as living hieroglyphs of cultural communication.

She honors the makers of the many-voiced interlock of black parlance in the United States today by clothing them in the illustrious shapes and dress of ancient Egypt. The postures and silhouettes of remote antiquity are transformed into "the different speech actions of everyday black life." Young men on the second floor, reading like fugitives from a frieze in Luxor, are actually shown slapping palms, "the way we respond to one another." Two men on the third floor, at left, enlace arms as comrades, while two persons below shout greetings. On the third floor, right, a woman in augmented scale, perhaps a ritual leader, speaks to a father and child who look up at her from below. All the figures are Egyptianizing; all, at the same time, are completely modern. Their conversations, interconnecting rooms and floors, abolish the divisions inherent in the architecture.

One of the conversations is without words, a kind of meditation on the past. A woman in the door converses with everyone in the building, but stares up at the Sphinx, meditating on the image of the famous enigmatic feline that guards the sands of Gizeh. As Lacy explains, "She is pulling us together, giving us strength to go on, for the Sphinx is a sign of renaissance."

The painting is also complicated by a sign of play: Bacchus looms, like a giant Joker from a pack of playing-cards, behind the building at left. The artist adapted this image from a photograph of a Mardi Gras mask in New Orleans: "Bacchus also reaffirms all that we are."

However, all that parlance, all that history, and all that humor and spirit, are still threatened. From a street floor window of the *Little Egypt Condo*, a rat obdurately exits, and a kindred rodent moves in the alley to the right.

When Jean Lacy painted *Welcome To My Ghetto Land* in 1987 (page 183), she modulated, chromatically speaking, into another key, gold and crimson. Again her purpose is to communicate the staying-power of black culture, but this time that perdurable quality is suggested by her reference to the time-defying icons of the Byzantine.

When Rome fell, the spiritualized portrait heads of the Christian Emperor Constantine, staring straight ahead, traveled as an indelible mark of the spirit into the Faiyum portraits of Egypt. The latter are often mentioned as predecessors of the Byzantine icon.[126] That same riveting gaze appears in the paintings of Faras along the Nile,[127] as well as in Byzantium proper. Likewise, Ethiopian painting, probably via black pilgrims to Jerusalem, became heavily indebted to the Byzantine manner.[128] "The gaze" spread there, too. Thus, the spiritualized look of the first Roman emperor to become a Christian binds Faiyum, Faras, Byzantium and Ethiopia in a related set of image-forms "intended to bring peace of mind by teaching the everlasting truths [beyond all] change."[129]

Jean Lacy is no stranger to the National Gallery of Art and the Corcoran Gallery in Washington D.C. where she once lived and where she absorbed art history directly from originals. With this richness of background, she later determined, in *Welcome*, to translate a black tenement into a Byzantine altar so that the latter's aura of everlastingness would honor the equally abiding truths which have stemmed from the classical religion of Kongo in this country.

In the fifties, Jean Lacy witnessed, first-hand, Kongo-influenced bottle-trees and bottle-porches in Plaquemines Parish, in the Mississippi delta south of New Orleans. But she does not allude to those aspects of Central African continuity in

this painting. What she does, rather, is to fill in spaces wherein the frontal stare of the classical Byzantine figure might have occurred, with African-American gestures, some of which stem from Central Africa.

Thus, pride of place is given over to a woman in the doorway who strikes "the Kongo pose": one arm up, the other akimbo, hand on hip. Aggressively dressed in red, this woman is very strong. In the potency of her Kongo gesture, the artist intuits to the viewer that she talks tough, testing us all the time, but only to conceal enormous love. She wants her daughters and her sons to grow up strong.

Further images of protective women deepen an aura of enabling grace. Two black women on the first floor loom like Buddhas, one, behind a woman caught in a pose of lamentation, the other behind a young girl dressed in white, "perhaps in a confirmation dress, or perhaps a sign that she is *iyawo*, an initiate into the Afro-Brazilian Yoruba religion."

Lacy used twenty coats of gesso in building up her icon of the ghetto. She also availed herself in a particularly rich usage of the color gold,[130] as an emblem of Asante and the gold in kente cloth, flowing in from the old Gold Coast to the modern Black American city.

Black women and men enliven this field of gold and red with gesture and action. A man hails the street from the second floor left. In the middle stands a woman in the window, all dressed in white, and to the right a pair of lovers are outlined in another window, embracing.

The top floor is given over to flanking figures who survey the street perspective. In the center appears a Crucifixion, the figure suspended from a cross that is invisible. Christ bursts out of the frame of the window and projects into space. Black Christ takes on the suffering of His people, as symbolized by a rat on the awning at the bottom and roaches crawling on the sidewalk.

Yet, in this very degradation, there is a hidden pocket of transcendent meaning: a pair of pygmies from Central Africa support the entire tenement, as caryatid figures. Lacy's empathetic vision of pygmies is not unlike that of her spiritual sister, the poet Gwendolyn Brooks, who once answered Edward Young's piece of cultural arrogance-

"Pygmies are pygmies still, though percht on Alps"

— with this:

"but can see better there, and laughing there
Pity the giants wallowing on the plain."[131]

Jean Lacy has stated explicitly that the gentle forest people, their laughter and spiritual insight, appear in this painting to symbolize "the beginning" of blackness. Their yodelized song, which arrived via Kongo slaves, structured the holler and the field cry. It leavened the blues. It absorbed the locomotive whistle in the night, becoming a quintessential emblem of black yearning. Pygmies, "the dancers of the gods," beloved of certain Pharaohs in ancient Egypt, helped build the song that named this nation.

Dr. Robert Farris Thompson, Professor of Art History at Yale University, has published important works in the field of African-American and African art which include *Flash of the Spirit: African and Afro-American Art and Philosophy, Four Moments of the Sun: Kongo Art in Two Worlds, African Art in Motion*, and *Black Gods and Kings*. Professor Thompson has curated four exhibitions for the National Gallery of Art and the Museum of Primitive Art and is currently completing his book *New York: the Secret African City.*

1. Toni Morrison, *Beloved* (New York: Alfred A. Knopf, 1987) p. 36.

2. Clyde Taylor, "Henry Dumas," *Black World* (September 1975).

3. Yvette Grimaud and Gilbert Rouget, *Notes on The Music of the Bushmen Compared To That Of The Babinga Pygmies* (Cambridge: Peabody Museum, n.d.) [notes for a long-playing record, LD 9], p. 1.

4. *Ibid.* p. 3.

5. From a conversation with the author, 1975.

6. Quoted in Harold Courlander, *Negro Folk Music U.S.A.* (New York: Columbia University Press, 1963) p. 81.

7. Albert Murray, *Train Whistle Guitar* (New York: McGraw-Hill, 1974) p. 8.

8. Daniel G. Hoffman, 'Jazz: The Survival of a Folk Art', *Perspective USA* No. 15 (Spring 1956) p. 33.

9. For a provisional argument, see my 'The Voice in the Wheel: Ring-Shouts, Wheel- Tire- and Hubcap-Art' in Judith McWillie, ed. *Another Face of The Diamond: Pathways Through the Black Atlantic South* (New York: INTAR Gallery, 1988) pp. 29-37.

10. Robert Farris Thompson, *Soundings* (Washington D.C.: Howard University Gallery of Art, 1986).

11. For remarks on Rosetta Burke see Michael D. Hall, *Stereoscopic Perspective: Reflections on American Fine and Folk Art* (Ann Arbor: U.M.I. Research Press, 1988) p. 242. See also his figures 63 and 63; for a brief notice of Tyree Guyton, and his art, see Brad Darrach with Maria Leonhauser, 'Scene' *People* (August 15, 1988) pp. 58-60.

12. One witnesses an early transformation, of oil drum into percussion drum, in a photograph by Earl Leaf, *Isles of Rhythm* (New York: A.S. Barnes & Co., 1948). Illustrated on p. 191.

13. Interview with Charlie Lucas. Pink Lily, Alabama, July 1988.

14. I am grateful to John Szwed for sharing notes taken from Stanley Crouch's "Albert Ayler: Talking in Tongues," a piece published in the *Soho News* in the early 1970s. For thoughtful discussion of Ralph Ellison's view of blues and jazz musicians, as paradigms of the American experience, see Bernard W. Bell, *The Afro-American Novel and Its Tradition* (Amherst: The University of Massachusetts Press, 1987) p. 204.

15. David W. Phillipson, *African Archaeology* (Cambridge: Cambridge University Press, 1985) p. 75.

16. For an excellent discussion of African-American one-stringed instruments and their relation to African musical bows see David Evans' Afro-American One-Stringed Instruments' in William Ferris, ed. *Afro-American Folk Art and Crafts* (Jackson: University Press of Mississippi, 1983) pp. 181-196. See esp. p. 188.

17. Robert Farris Thompson, 'Body and Voice: Kongo Figurative Musical Instruments' in: *Sounding Forms: African Musical Instruments*, ed. Marie-Therese Brincard (New York: The American Federation of Arts, 1989) p. 43.

18. For a useful recent study, one may profitably consult Wyatt MacGaffey's 'Complexity, Astonishment and Power: The Visual Vocabulary of Kongo Minkisi' *Journal of Southern African Studies* Vol. 14 No. 2 (January 1988) pp. 188-203. See esp. p. 190 where he goes into detail about the correspondence between earth and spirit: 'Ultimately, all of the dead can be contacted through the earth, and for that reason *minkisi* normally include clays, stones, or grave-dirt, incorporating the dead by the principle of metonymy (contiguity).'

19. 'Writing in the spirit' is Judy McWillie's term for the phenomenon. 'Visual glossolalia' is the phrase used by John M. Jansen and Wyatt MacGaffey in their *Anthology of Kongo Religion: Primary Texts from Lower Zaire* (Lawrence: University of Kansas Publications in Anthropology No. 5, 1974) p. 23. I Dizolele, founder of the Kongo Universal Church of the Twelve Apostles, saw a device, in a vision, "like a billboard in the sky" (MacGaffey and Janzen, n. Figure 3, p. 23).

20. Wyatt MacGaffey, *Modern Kongo Prophets: Religion In A Plural Society* (Bloomington: Indiana University Press, 1983) p. 243.

21. Jeannette Hillman Henney, *Spirit Possession Belief and Trance Behavior In A Religious Group in St. Vincent, British West Indies* (Ann Arbor: University Microfilms, 1968) p. 203.

22. Discussed in Robert Farris Thompson, *The Four Moments of the Sun* (Washington DC: The National Gallery, 1981) p. 69.

23. I thank Professor MacGaffey for sharing xeroxes of Solomon Lumuka Kundu's writing in the spirit.

24. Wyatt MacGaffey, *Religion and Society in Central Africa: The Bakongo of Lower Zaire* (Chicago: University of Chicago Press, 1986) p. 239.

25. *Zakama* refers literally to the 'trembling' (caused by the descent of the spirit) K. E. Laman, *Dictionnaire Kikongo-Francais*, II, (Hants: Gregg Press edition, 1964) p. 1151.

26. MacGaffey, *Religion and Society*, p. 124: "The shoulders of a spiritually possessed person manifest divinatory power (mayembo) by trembling."

27. See, for example, Fig. 20, an 'Animated liana', from Sundi in Mayombe in Karl Laman, *The Kongo III* (Uppsala: Studia Ethnolgraphic Upsaliensia XII, 1962) p. 125.

28. MacGaffey, 'Complexity, Astonishment and Power', p. 196: "Mbenza stones are found sculptures (improved by human hands) whose shape was considered to be remarkable (dya ngitukulu) evidence of deliberate action by spirit forces." Found sculptures, especially roots, worked on by artists, defines a whole range of African-American vernacular art, e.g. the early works of Joe Light and Mose Tolliver, and the continuous activity of Ralph Griffin, of Girard, Georgia.

29. Robert Farris Thompson, *Painting From A Single Heart: Preliminary Remarks On Bark-cloth Designs Of The Mbute Women of Haut-Zaire* (Munich: Jahn Galerie fur afrikanische Junst, 1983), In a forthcoming volume, *New York: The Secret African City*, I spell out analogues between pygmy yodelling, hocketing, and polyphony and the characteristic freedom of their visual designs.

30. Robert Farris Thompson, *Writings Witnessed Through the Waters* (New York: Rosa Esman Gallery, 1986) p.1.

31. From a conversation with the late J.B. Murray, December 22, 1985. I heartily thank Judy McWillie and Andy Nasisse for taking me to the house of J. B. Murray in the winter of 1985.

32. Leonard Freed, *Black In White America* (Haarlem: Joh, Enschede en Zonen, n.d.) p. 58.

33. From a long-distance telephone conversation with Renee Stout, spring 1989. Hereinafter, to economize space, all quotations from further artists, e. g. Ed Love, Jean Lacy, John Biggers, *et al* stem from numerous long-distance telephone interviews and follow-up sessions, spring and early summer, 1989.

34. David Boxer, 'The Intuitive Eye: A Heritage Recalled' in *Jamaica Journal* no. 44, p. 18: "Everald Brown: many of his paintings are produced while in a trance, through a process akin to surrealist automatism."

35. For an excellent overview, including photographs of ground and sand drawing in Central Africa, see Gerhard Kubik, 'African Graphic Systems with particular reference to the Benue-Congo or "Bantu" languages zone, *Muntu* (4-5) 1986, pp. 71-135. As to ground-writing in Benin, we have a richly detailed study in Norma Rosen's 'Chalk Iconography in Olokun Worship', *African Arts* Vol. XXII, no. 3 (May 1989) pp. 44-53.

36. Robert Farris Thompson, 'Revelations of the Spirit: The Painting of Modern Haiti; *Artists In Tune With Their World* (New Haven: Yale University Art Gallery, 1985) p. 13.

37. Deborah Solomon, *Jackson Pollock: A Biography* (New York: Simon and Schuster, 1987) p. 179: "he was always working on more than one painting at a time."

38. John S. Mbiti, *African Religions and Philosophy* (New York: Anchor, 1970) p. 97.

39. The concept is discussed in the first chapter of my *Flash of the Spirit* (New York: Vintage, 1984).

40. A. B. Spellman, *Black Music* (New York: Shocken Books, 1973) p. 71.

41. Valerie Wilmer, in her *As Serious As Your Life* (Westport: Lawrence Hill and Co., 1980) glosses Ayler's famous phrase (p. 93) as follows: "screaming — with a kind of peaceful silence at its core."

42. From an interview with Al Smith, Hood College, Frederick, Maryland, 23 February 1989.

43. Kofi Antubam, *Ghana's Heritage of Culture* (Leipzig, Koehler & Amelang, 1963) p. 159.

44. *Mojo*, African-American for 'mystic power', 'charm', 'force', would appear to derive from the Ki-Kongo term for 'soul', *mooyo*.

45. For details on odu signs and Ifa divination in Yoruba culture see William Bascom, *Ifa Divination: Communication Between Gods and Men In West Africa* (Bloomington: Indiana University Press, 1969).

46. cf. T. G. H. James, *Egyptian Painting* (Cambridge: Harvard University Press, 1986) p. 48, Fig. 53: "The creation of the world by the separation of heaven (the goddess Nut, as a naked woman) from the embrace of the earth.

47. David C. Driskell, *Two Centuries of Black American Art* (Los Angeles: Los Angeles County Museum of Art, 1976) p. 157.

48. Lydia Cabrera, *La Sociedad Secreta Abakua* (Havana: Ediciones CR, 1959) p. 280.

49. *Ibid.* pp. 83-88 for the lore of Sikan and Tanze (God Almightly).

50. Marcel Griaule and Germain Dieterlen, *The Pale Fox* (Chino Valley, Arizona: The Continuum Foundation, 1986).

51. Gerhard Kubik, *op. cit.*

52. David Dalby, 'The Indigenous Scripts of West Africa and Surinam: Their Inspiration and Design', *African Language Studies* Vol. IX (1968) pp. 156-197.

53. Lydia Cabrera, *Anaforuana: ritual y simbolos de la iniciacion en la sociedad secreta Abakua* (Madrid: Ediciones R, 1975)

54. Lucy R. Lippard, *Overlay: Contemporary Art and The Art of Prehistory* (New York: Pantheon, 1983) p. 161.

55. *Ibid.* p. 30.

56. *Ibid.* p. 77.

57. *Ibid.* p. 135.

58. *Ibid.* p. 55.

59. *Ibid.* p. 122.

60. For Ejagham signs, see *Flash of the Spirit,* and R. Thompson, *African Art In Motion* (Los Angeles: University of California, 1974).

61. Marcel Griaule, *Conversations with Ogotemmeli* (Oxford: Oxford University Press, 1965) p. 73.

62. Harold Bloom, *Poetics Of Influence* (New Haven: Henry R. Schwab, 1988) p. 119.

63. Jane Barbour and Doig Simmons, *Adire Cloth in Nigeria* (Ibadan: Institute of African Studies, University of Ibadan, 1971) p. 54.

64. Leonard Freed, *op. cit.* p. 58: "the windows and the door frames had been painted — sky-blue, to keep the bad spirits away. Blue is the color of Heaven, and no bad spirits may enter Heaven."

65. Bloom, *op. cit.* p. 120.

66. John Vlach, *Sources of the Shotgun House: African and Caribbean Antecedents For Afro-American Architecture*, Vol. I (Ann Arbor: University Microfilms, 1975) p. 29.

67. I am indebted to John Szwed for sharing, very early on, news of Glassie's exciting vision of the shotgun as black architecture. For a published citation see: Henry Glassie, *Pattern in the Material Folk Culture of the Eastern United States* (Philadelphia: University of Pennsylvania Press, 1968) p 221.

68. Vlach, *op. cit.* Consult also his 'The Shotgun House: An African Architectural Legacy' in: William Ferris, ed. *Afro-American Folk Art and Crafts*, pp. 290: "the Yoruba 10' x 20' unit coincides closely with the 10' x 21' rural shotgun of Haiti. Vertical dimensions are also similar so that wall heights commonly range between six and eight feet in both Haitian and African houses."

69. *Vlach, Sources*, p. 175.

70. Virginia and Lee McAlester, *A Field Guide To American Houses* (New York: Alfred A. Knopf, 1989) see "(French Colonial) Door & Window Details", p. 123.

71. Eli Leon, *Who'd A Thought It: Improvisation in African-American Quiltmaking* (San Francisco: San Francisco Craft and Art Museum, 1987) pp. 37-81.

72. John M. Janzen, *The Quest for Therapy in Lower Zaire* (Berkeley: University of California Press, 1978) Plate 16.

73. Hermann Baumann, *Lunda* (Berlin: Museum fur Volkenkunde, 1935) Plate 15, bottom left. Photographed in the village of Saiyongo, Angola.

74. Vlach, *Sources* p. 73.

75. *Ibid.* p. 72.

76. *Ibid.*

77. I thank warmly Labelle Prussin for bringing this important publication to my attention.

78. *Railroad: Trains and Train People in American Culture* ed. James Alan McPherson and Miller Williams (New York: Random House, 1976) p. 8.

79. Informant: John Biggers. I am enormously indebted to John Biggers for sharing the lore of his youth in Gastonia, North Carolina. He is not only a major American artist, he is also a living Rosetta Stone for the decoding of the African-American yard show. I could not have written this section without him.

80. Informant: John Biggers.

81. Informant: Lonnie Holley, Birmingham, Alabama, 1988. I owe a similar debt to Lonnie Holley, steeped in African-American heritage and always generous with what he knows.

82. Lizetta LeFalle-Collins, Visual Arts Curator, *Home And Yard: Black Folk Life Expressions in Los Angeles* (Los Angeles: California Afro-American Museum, 1988) p. 11.

83. John M. Janzen, *Lemba, 1650-1930* (New York: Garland Publishing Inc., 1982) p. 52.

84. John H. Weeks, *Among The Primitive Bakongo* (London: Seeley, Service & Co., 1914) p. 117.

85. *Ibid.* p. 238.

86. Informant: Fu-Kiau Bunseki, summer 1988.

87. *Ibid.*

88. Weeks, *op. cit.* p. 239.

89. Informant: Fu-Kiau Bunseki, summer 1987.

90. L'Abbe Proyart, *Histoire de Loango, Kakongo, Et Autres Royaumes D'Afrique* (Paris: Bruyset-Pnthus, 1776) pp. 192-193. Translation mine.

91. Janzen, *Quest for Therapy*, pp. 164-168. See especially the fascinating map of Nzoamambu's garden village with its plants and their uses.

92. Janzen and MacGaffey, *op. cit.* p. 35 (2.2).

93. Thomas Atwood, *The History of the Island of Dominica*, (London: J. Johnson, 1971) p. 268.

94. Samuel Selvon, *Ways of Sunlight* (Bungay: Longman Drumbeat, 1957) pp. 95-96.

95. *Ibid.* p. 96.

96. Esteban Montejo, *The Autobiography of a Runaway Slave* ed. Miguel Barnet (New York: Pantheon Books, 1968) p. 142.

97. *Gumbo Yaya: A Collection of Louisiana Folk Tales*, Lyle Saxon, Edward Dreyer, and Robert Tallant (New York: Bonanza Books, 1945) pp. 554-555.

98. *Ibid.* p. 543.

99. *Ibid.* p. 542.

100. Peter H. Wood and Karen C. C. Dalton, *Winslow Homer's Images of Blacks: The Civil War and Reconstruction Years* (Austin: University of Texas Press, 1988) illustrated at p. 57. Wood argues a relation between the gourds and the Big Dipper in the sky at night which blacks called 'The Drinking Gourd' pointing north in the direction of freedom, at the end of the Underground Railroad.

101. Personal communication from Tom Crockett, February 2, 1988. Also, Judith McWillie.

102. Esteban Montejo, *op. cit.* p. 142.

103. Marie Rudisill with James C. Simmon, *Truman Capote* (New York: William Morrow and Company, 1983) p. 144. I have standardized Rudisill's overwrought 'dialect' transcription.

104. From a conversation with Willie Collins, UCLA, Los Angeles, Spring 1989.

105. Informants: Wyatt MacGaffey and Fu-Kiau Bunseki, 1985.

106. James Seay, *Mississippi Folklore Register* Vol. III, no. 3 (Fall 1969) p. 108.

107. I thank Greg Stringfellow, himself an expert in the traditional black arts of Virginia, for this attestation and for the photograph.

108. Interview with "The Texas Kid," Dallas, June 16, 1988.

109. R. F. Thompson, 'The Circle and the Branch', p. 40. Holley adds: I made (this sculpture) to protect me and the growth of my children."

110. I warmly thank Jack Maxie, of Eleuthera, for documenting on my behalf a bottle-tree there in 1985 in a style not unlike the one described by Selvon on the island of Trinidad.

111. Personal communication, December 11, 1986. William Eiland remembers several bottle-trees in his childhood in Perry County, Alabama and notes the making process: "breaking the branches of the tree and jamming onto the sharp end a coke bottle or some similar and readily available bottle." He also notes the recent trend towards plastic clorox bottles, which is also occurring in Mississippi.

112. Robert Farris Thompson, *L'Eclair Primordial* (Paris: Editions Caribeens, 1985) pp. 154-155.

113. Lizetta FeFalle-Collins, *op. cit.* p. 16.

114. *Ibid.* p. 11.

115. Jane Livington and John Beardsley, *Black Folk Art in America* (Washington D.C.: Corcoran Gallery of Art, 1982) p. 65.

116. *Ibid.* p. 82.

117. Source: In the summer of 1989, Judith McWillie identified "The Purple Lady" as Rachael Presha. Judy McWillie is mapping the existence of yard-shows across the South and is involved in intensive research as to their meaning. We look forward to a forthcoming master text.

118. From a letter to the author, dated April 17, 1989.

119. Informant: Fu-Kiau Bunseki, summer 1985.

120. *Ibid.*

121. This is Manning's version, documented in a videotaped interview by Michelle R. Thornton and Michael Harris, May 1989. He repeated the importance of Ezekiel's wheel, as inspiration, in an interview with the author in June 1989. I would argue that African-American women and men were culturally prepared to resonate specially to the prophetic imagery of Ezekiel. The image, of wheels activated by the spirit, is close to the Kongo rationale of the path of the sun, tracing of the motion of the spirit in a circle. 'Dry' bones appear in yard-shows, too, as, for example, in southeastern South Carolina, and hearken back, I think, in part to the minatory language of moral vengeance, in the idiom of the minkisi.

122. David Driskell, *op. cit.*, Plate 100.

123. From a long-distance telephone interview with David Driskell, June 1989.

124. Interview with Avel de Knight, New York City, June 1986.

125. Personal communication, May 1989.

126. From a conversation with Walter Cahn, May 1989. I am indebted to Professor Cahn for sharing his rich knowledge of Byzantine art.

127. *Das Wunder Aus Faras* (Essen: Villa Hugel, 1969). See, for example, Plate 11, reproduced in color on the cover.

128. Stanislaw Chojnacki, 'Ethiopian Paintings' in: *Religious Art of Ethiopia* ed. Walter Raunig (Stuttgart: Institut fur Auslandsbeziehungen, 1973) p. 36.

129. *Ibid.* p. 41.

130. In a personal communication, June 16, 1989, Jean Lacy talked about the painting process in *Welcome To My Ghetto Land* in which gesso (in this case crushed marble, animal glue, and Titanium white) was applied in twenty or more thin coats as a ground in preparation for the piece to receive paint. The colors used in the painting process are tempera and casein, which have been applied while the surface is still damp. Thin sheets of gold leaf are applied to the surface. Design elements have been scratched into the panel partly as a guide for placing the gold leaf and partly to indicate intricate patterns and details. The color beneath the thin layer of gold, which is semi-transparent, adds to the richness.

131. Gwendolyn Brooks, *Selected Poems* (New York: Harper and Row, 1963) p. 37. In a conversation about the poem in April 1980, Ms. Brooks told me "I was thinking of blacks, and what is often thought of them."

Alvia J. Wardlaw

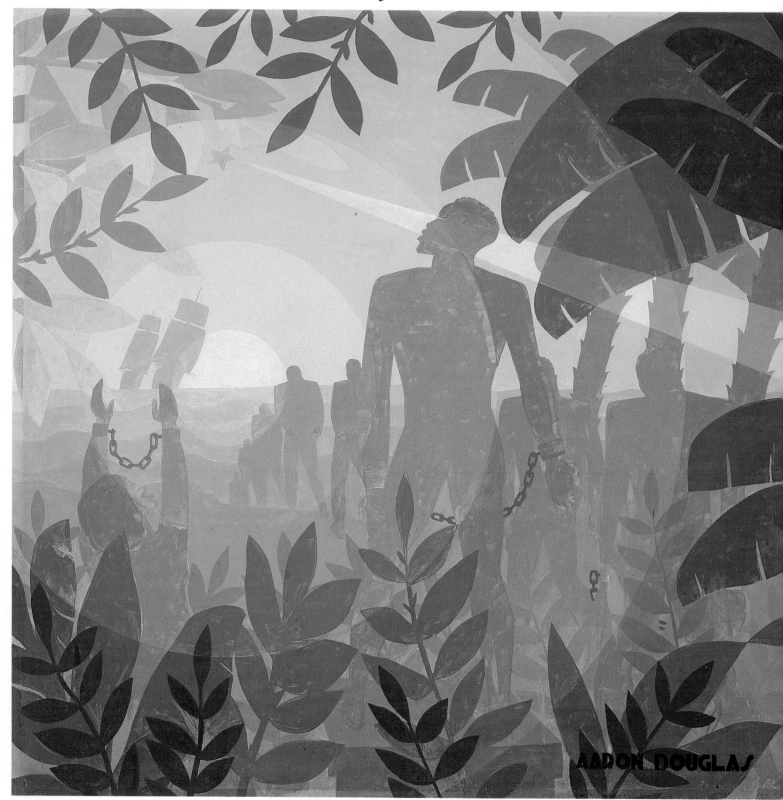

:: THE :: LEGACY

From 1502 on, when the first group of Africans were brought to the Americas, cultural traditions of the African continent have been kept alive in the New World by a prevailing group consciousness among African-Americans. The retentions sheltered by this consciousness reveal themselves in African-American crafts, folktales and storytelling, dance and music, and religious practices. The persistence of these retentions bear out the truth of Alain Locke's comment, in his watershed essay "The Legacy of the Ancestral Arts," that "even with the rude transplanting of slavery, that uprooted the technical elements of his former culture, the American Negro brought over as an emotional inheritance, a deep-seated aesthetic endowment."

Early in the 20th century, these folkways were augmented by the work of fine artists, who in the 1920s departed from their European perspective and began consciously to turn towards their ancestral heritage. With the challenging words of Alain Locke, W. E. B. Du Bois, and Marcus Garvey resounding within the community, African-American artists took up the mandate to "look to the ancestral arts" and to find within those masks and other dynamic sculptural forms not only a challenging visual vocabulary, but also keys to their collective past. The anthem of the United Negro Improvement Association, "Ethiopia, the Land of Our Fathers", was fully in tune with the visual voices of these artists who, in their course of study, regarded Egypt and Abyssinia as the place of origin of the "Negro" race. They saw themselves as descendants of pharaohs and ancient African queens. Other artists grappled with that painful chapter of American history — slavery — and, dealing with it head on, they contributed some of the most powerful history painting to emerge in America.

The Great Migration, which occurred largely between 1910 and 1920, brought inhabitants of the rural South to large urban centers — Chicago, Detroit, New York, Washington, D.C. — and with them came their folkways and southern black social practices. Perpetuated

through the work of self-taught artists, some of whom were part of this migration, were many African retentions such as the heraldic use of the walking cane, the association of divine attributes with particular animals, and the dominance of wood as a sacred medium. Away from urban centers, primarily in the South, rural folkways took strong root in the daily lives of southern blacks. Segregation served as an invisible retaining wall by which African traditions were sustained in the social matrix of the community. Similarly, in the Caribbean, the isolated nature of island cultures served to foster the strong continuities of African cultural and family life. In the islands of Jamaica and Haiti, in particular, where the concentration of blacks was higher and the pressure to assimilate into a mainstream social structure was less intense, there exist a significant number of artistic and ceremonial expressions which have direct African antecedents.

During the 20th century, African-American artists have continued to ask themselves the question first posed by poet Countee Cullen at the height of the Harlem Renaissance in 1926:

> What is Africa to me:
> Copper sun or scarlet sea,
> Jungle star or jungle track,
> Strong bronzed men, or regal black
> Women from whose loins I sprang
> When the birds of Eden sang?
> One three centuries removed
> From the scenes his fathers loved,
> Spicy grove, cinnamon tree
> What is Africa to me?

O V E R L E A F :

AARON DOUGLAS, *Into Bondage*, oil on canvas, 1936. 60 x 60 inches. Evans-Tibbs Collection, Washington, D.C.

Commissioned for the Texas Centennial Exposition in 1936 as part of the Hall of Negro Life, this mural was one of four which Douglas completed for curator Alonzo Aden's exhibition of African-American art. *Into Bondage* is a classic Douglas work which depicts the forced removal of black people from the African continent. In his strong and direct style, Douglas juxtaposes the somber mood of the inevitable boarding of the shackled men and women onto the slaveship with the gaze upward of a black man looking towards an unknown destiny.

NOTE: Dimensions of works are given height by width by depth and are of the image itself unless otherwise indicated.

NANCY ELIZABETH PROPHET, *Congolais,* wood, 1931. Height: 16¾ inches. Lent by the Whitney Museum of American Art, New York; Purchase 32.83 Photograph by Geoffrey Clements, Collection of Whitney Museum of American Art, New York.

The sensitivity of this portrait is conveyed in its downward gaze and introspective visage. The sense of thoughtfulness is heightened by the fact that the subject appears to be a male warrior; the hairstyle is, in fact, similar to that of the Masai. Who posed for the work and whether or not the artist used a model are questions which have not been clearly answered. Because Prophet never visited Africa, one can presume that such an image was probably derived from secondary sources. By developing a portrait bust rather than a full torso, which would have borne much more ornamentation and costume detail, Prophet directs the viewer to examine the inner spirit of this so-called "noble savage". She dissolves stereotypical approaches towards African culture by creating an image of a single human being whose subtlety of emotional expression is deeply engrossing.

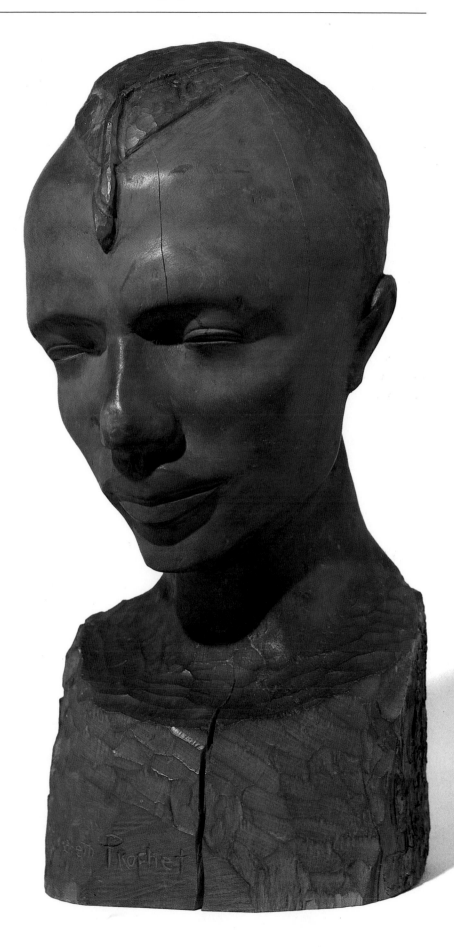

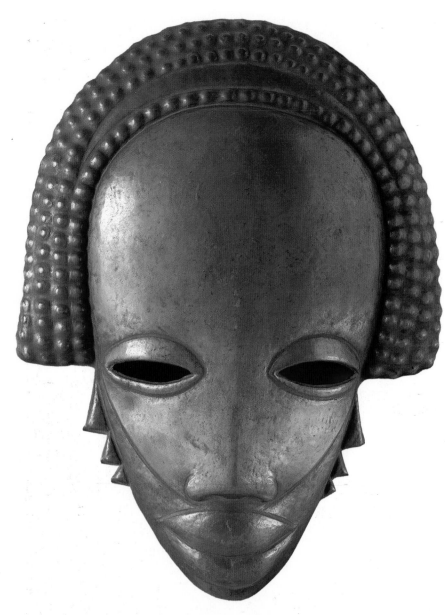

MALVIN GRAY JOHNSON, *Self-Portrait,* oil on canvas, 1934. 38⅛ x 30 inches. National Museum of American Art, Smithsonian Institution, gift of the Harmon Foundation.

Malvin Gray Johnson presents a direct and serious gaze which immediately engages the viewer. It was a popular gesture among black artists during the Harlem Renaissance to indicate an awareness of their ethnicity by frequently placing African art in still-life compositions. Behind the artist on the wall is his painting *Negro Masks* of 1932. The juxtaposition of the two painted masks with the artist's face conveys at once his sense of design in the reduction of his own face to mask proportions while establishing a sense of kindred spirits between the artist's image and the masks. Johnson's heavy brows, in fact, seem to echo the dominant brows of one of the masks in the painting. By including in his self-portrait his completed work *Negro Masks*, Johnson indicates that his self-image as a black artist is incomplete without the demonstration of his connection to African culture. In painting these masks, he paints himself.

SARGENT JOHNSON, *Mask,* copper, 1933. 10 ⅞ x 7⅞ x 2⅜ inches. San Francisco Museum of Modern Art, Albert M. Bender Collection, gift of Albert M. Bender.

Early in his career, Sargent Johnson made great strides towards establishing a particular vocabulary that echoed aspects of African culture. By attempting to depict "that characteristic lip and that characteristic hair, bearing, and manner," Johnson developed a style which echoed clearly but did not duplicate deliberately the forms of African sculpture. His interest in the African mask and the development of personal permutations of this classical African art form continues to challenge other African-American artists in this century. In his understated interpretations, Johnson realized the ideal visual paraphrase of the African presence which translates into a distinctly African-American style. The warm copper tones, the human scale of the work, and the benign expressiveness of the contours all serve to make an engaging statement about black beauty.

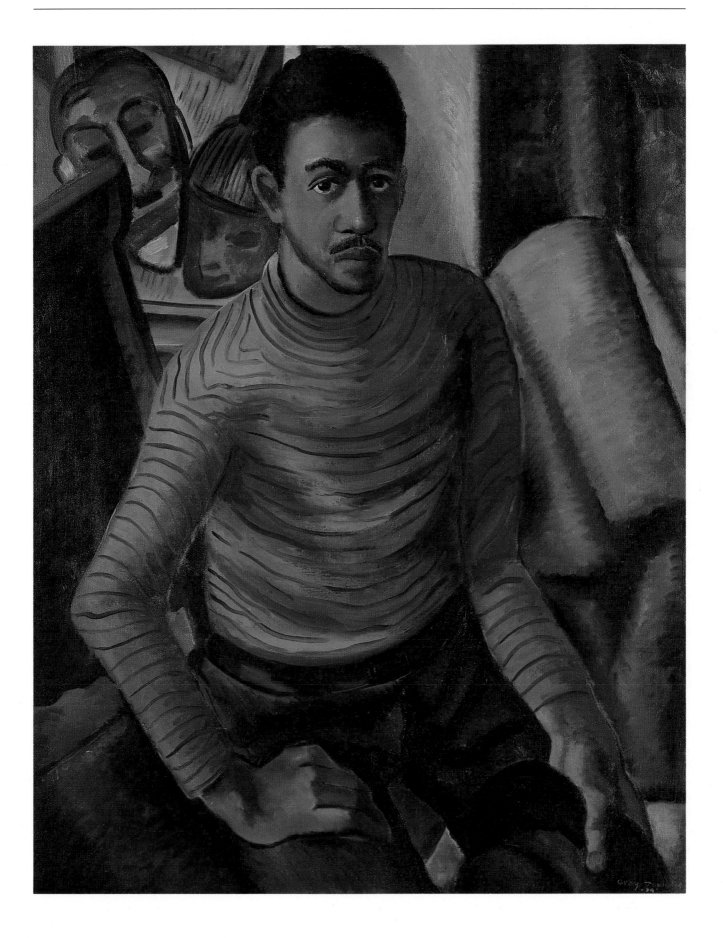

DAVID MILLER, JR., *Head,* wood, c. 1955. 10½ x 4½ x 7¾ inches. Collection of Wallace Campbell, Jamaica. Photograph ©1989 Denis Valentine.

DAVID MILLER, JR., *Head,* wood, 1958. 22 x 7½ x 10 inches. Collection of the estate of David Miller, Jr. Photograph ©1989 Denis Valentine.

DAVID MILLER, JR., *Head,* wood, 1965. 11½ x 4½ x 7½ inches. Collection of Deryck Roberts, Jamaica. Photograph ©1989 Denis Valentine.

The work of David Miller, Jr. exhibits the same deep sensitivity to the nature of wood found in the sculpture of his father, David Miller, Sr. These three portrait heads further demonstrate a deep understanding of the African facial physiognomy, as seen in the depiction of prognathism. The highly polished wood and the simply modulated surfaces indicate a carver who is attuned to his materials and wishes to maintain the integrity of the wood's massive nature. Critical to the strength of Miller's carving is his ability to capture, through minimal means, an often fleeting expression indicative of the subject's personality. It is this attention to the nature of wood as well as his ingenious improvisations on the wood surface which so enliven the forms. Miller's careful modulations of the unique contours of these profiles keep them honest likenesses, rather than simply superficial and humorous visual statements. The strong differences in expression of the eyes and mouths, determined by the definition of lids and lines beneath the lids, indicate the carver's excellent control of both his tools and medium.

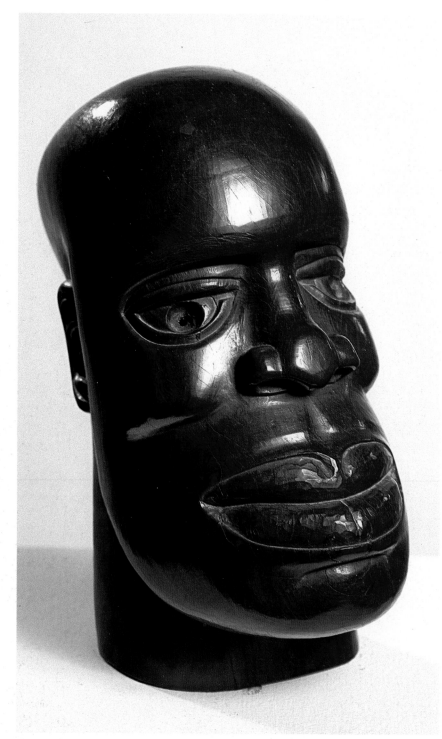

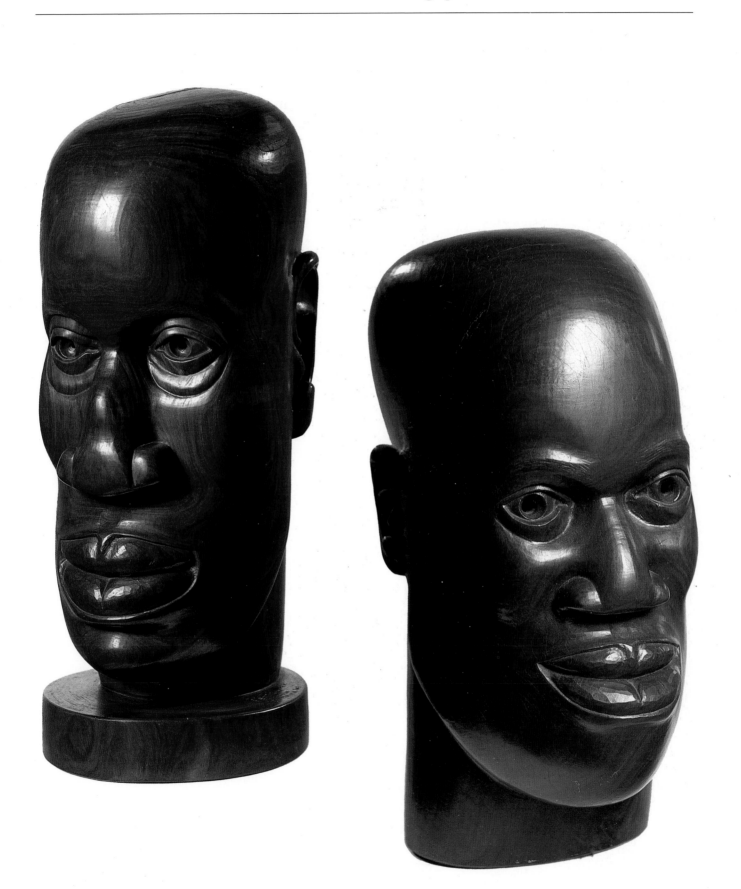

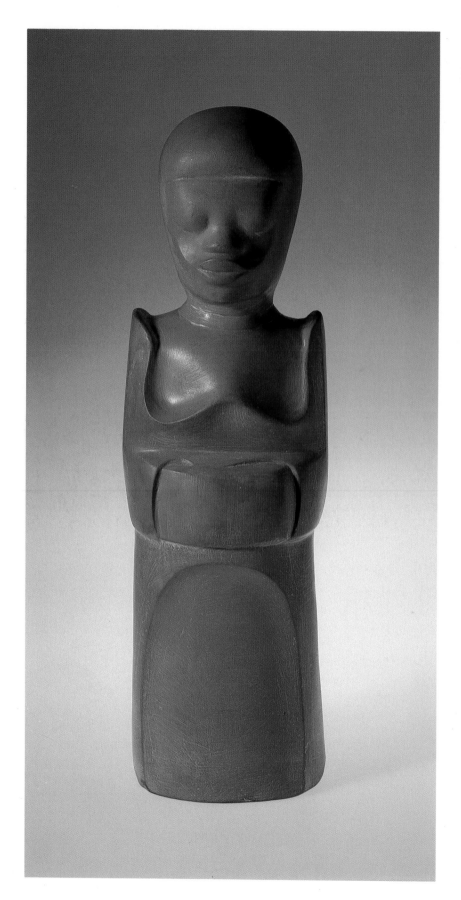

SARGENT JOHNSON, *Standing Woman,*
terra cotta, 1934. 15⅜ x 4½ x 4 inches.
Fine Arts Museums of San Francisco,
Lent by FWP/WPA, 1934.

This small, smoothly contoured work, is
in its serene countenance, a quiet
expression of Johnson's continual quest
to interpret the inherently African qual-
ity of the black body in sculptural form.
The work is an abstracted expression of
female anatomy which calls to mind the
monumental form of the artist's well-
known sculpture, *Forever Free*, also cylin-
drical in appearance. Johnson has
reinterpreted the full contours of the
black female form into that of a self-
contained cylinder which conveys the
essence and quiet power of African
sculpture. The sublime expression of the
woman with her soft smile and closed,
rounded eyes completes the expression
of serenity. The face is reminiscent of an
Ife terra cotta, while the body, with its
convex forms reinterpreted as concave
opposites, suggests the volumetric style
of Central African ancestral carving.

EARL RICHARDSON, *Negro Pharaoh,* oil on board, 1934. 12 x 16 inches. Schomburg Center for Research in Black Culture, The New York Public Library, Art & Artifacts Division.

With the discovery of King Tutankhamen's tomb by Howard Carter in 1922, the American public became enraptured with the mystique of Egypt. Painted in a loose, cubistic style, this small work reflects Richardson's imaginative conceptualization of ancestral royalty in Egyptian culture. Like other artists of the period, Richardson was influenced by the atmosphere of cultural awareness and exploration which existed in New York during the Harlem Renaissance. The enthronement of the pharaoh and his attentive court is deftly depicted by the artist as a narrative vignette reflecting Egyptian ceremony and panoply.

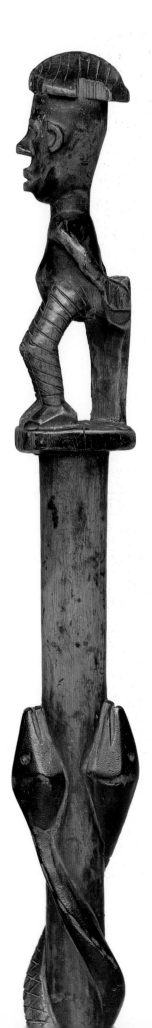

UNKNOWN ARTIST, (Zaire: Kongo), *Staff with Figure, Snakes and Reptile,* **wood. 35¾ x 1¼ x 1⅜ inches. Dallas Museum of Art, The Clark and Frances Stillman Collection of Congo Sculpture, gift of Eugene and Margaret McDermott (1969.S.37).**

Here is represented a central African source for the rich tradition of staff carving as demonstrated in the work of a number of African-American carvers. The serpents, located beneath the seated figure at the staff's handle, allude to the power of the owner. The figure, in a seated position, is enthroned in a formal social pose indicative of urban human order. The bearer of the cane, in turn, carries the structured order of the universe in his or her hand.

WILLIAM EDMONDSON, *Turtle* **(Beasty, above right), limestone, c. 1940. 6 x 7 x 13¾ inches. Collection of Mr. and Mrs. Robert L. Gwinn.**

WILLIAM EDMONDSON, *Turtle,* **limestone, c. 1940. 6¼ x 10½ x 14¾ inches. Collection of Mr. and Mrs. Robert A. McGaw, Nashville.**

This witty combination of a smiling turtle with an armored back gives the animal an ancient and yet modern countenance. Edmondson's sculpture is a visual testimony to the longevity of imagery linked to African and African-American folk tales such as "Tiger Slights the Tortoise" by the Igbo, and "The Tortoise and the Falcon" by the Bondei. The figure is carved in an understated fashion out of limestone, with the artist emphasizing the bulk and weight of the form. Fitting within the artist's pantheon of serpents, birds, and angels, the turtle is Edmondson's record of the antiquity of nature.

The turtle is one of a pantheon of animals depicted by William Edmondson in monumental terms. His work, shaped in part by his experience as a tombstone carver, possesses an undeniable formal presence. The turtle plays an important role in African and African-American folklore and sculptural imagery. Its shells are thought to bring the wearer good luck and are considered a symbol of the sun. Because of its age and slow, deliberate movements, the turtle is frequently associated with the wisdom of the African griot, or storyteller.

BILL TRAYLOR, *Snake at the Crossroads,* graphite and colored pencil on cardboard, c. 1939. 13½ x 14 inches. Collection of David and Bobbye Goldburg.

The "crossroads" can be considered that meeting point at which humans and animals encounter one another. Traylor's roughly sketched lines accentuate the fluidity of the snakes' movements, while the bar, apparently drawn with a straight edge, is an oddly telling reference to the road itself. It has been pointed out that the work may illustrate an old Alabama belief about encountering snakes along the road, which in turn refers to the Fon of Benin belief in the powers of the great snake, *Dan.*

The rhythmic, flowing nature of the serpent's movements are here captured by the linear strength of Traylor's drawing style. The work calls directly to mind the statement of the writer Zora Neale Hurston who wrote, "Africans love to depict the beauty of snakes."

BILL TRAYLOR, *Serpent,* showcard color (tempera) on cardboard, c. 1940. 13¼ x 26¼ inches. Luise Ross Gallery, New York.

154

UNKNOWN ARTIST, *Haitian Drum,*
wood and goat skin, 1940s. 43 x 24 x 24
inches. Collection of Virgil Young.

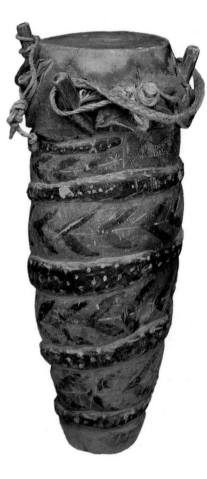

The presence of the African drum in
Caribbean countries can be regarded as
a fundamental symbol of the African
Diaspora. Because the drum was prohib-
ited on southern plantations in America,
the isolated island cultures of the Carib-
bean became an area of protection for
the tradition of ceremonial drumming.
The practice of drum-making itself was
kept alive and passed on from one
generation to the next, sustaining the
traditional rhythms of *conga, samba,
calypso* and sacred *vodun.* When
brought together, the drum, song and
dance make a powerful reference to the
strength of African spiritual traditions.
This particular drum, the *maman* is the
largest of three drums used in the *vodun*
ceremony of *rada* which originated in
Dahomey. The *maman* drummer uses his
hands rather than sticks to play his
drum, unlike the other two drummers.
The monumental conception of the great
serpent around the base of the drum
represents Damballah, the Haitian god of
life. The marked patterns on the drum
itself refer to similar patterns in central
African textiles.

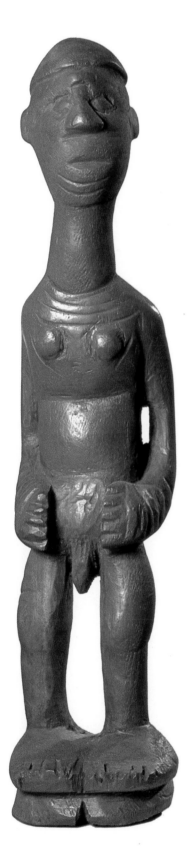

WILLIAM "WOODY" JOSEPH, *Brother
William,* wood, 1981. 29½ x 6 x 6
inches. National Gallery of Jamaica, King-
ston. Photograph ©1989 Denis Valentine.

The carved figure in Jamaican art is a
central statement of expression among
untrained artists. Continuing the strong
woodcarving tradition begun in West
Africa, sculptors such as William
"Woody" Joseph seem especially
interested in interpreting the human
form in wood. The exaggerated head
size of this figure is common in Nigerian
sculpture where the human figure is
endowed with a 4 to 1 proportion rather

than the 6 to 1 Greek proportion. This
emphasis upon the head is in keeping
with African thought that the head,
rather than the heart, is the center of
the body. Dr. David Boxer, Director of the
National Gallery of Jamaica, describes
William Joseph as a carver of works
which are "remarkably African in feel-
ing." Beginning to carve in the 1960s
from some "inner compulsion," Joseph's
work often combines human and animal
forms.

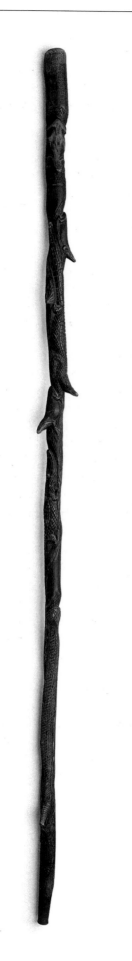

UNKNOWN ARTIST, *Untitled* (walking stick with serpents and frog), wood, c. 1840. 49⅝ x 1¼ (diam.) inches. Collection of Anne and Allan Weiss.

This walking stick, attributed to an unknown African-American carver, records in the tradition of the famous Gudgell walking stick at Yale University a number of elements of nature with which the carver was familiar. The walking stick is adorned with a fish and boldly projecting frogs at the branch points which together refer to water. The motif of entwined serpents is one that occurs frequently on staffs of African-American carvers. The use of conglomerate reptilian imagery is also frequently found in Benin bronze casting and related works from the Ile-Ife tradition, in which spiritual prowess is suggested through the presence of fish and reptiles on such sacred objects as carved ivory tusks, bronze armlets and pendants.

BESSIE HARVEY, *Jonah and the Whale,* wood and mixed media, 1986. Jonah: 7¾ x 3½ x 1¾ inches; whale: 9 x 11 x 23¾ inches. Private Collection.

The biblical story of Jonah becomes in the hands of Bessie Harvey a vivid depiction of man overwhelmed by a force of nature larger than himself. By having Jonah fit fully, yet freely, into the mouth of the whale rather than depicting him in the whale's belly, the artist emphasizes the struggle between man and beast, and the ultimate necessity for man to understand his place in the cosmos. An awareness of and an accompanying respect for the prowess and attributes of various animals have challenged African artists since the time of ancient Egypt to express similar themes of man's struggle with and dependence upon animals.

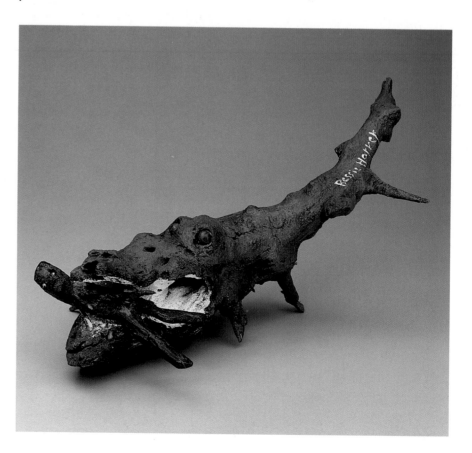

SULTAN ROGERS, *Walking Stick* (notched with snake handle), wood, 1985. 36¼ x ⅝ (diam.) inches. University Museums, The University of Mississippi, University, Mississippi.

SULTAN ROGERS, *Walking Stick* (with snake and openwork handle), wood, 1985. 33¼ x 1 (diam.) inches. University Museums, The University of Mississippi, University, Mississippi.

The artist establishes in the walking stick at left a rhythmical approach to the wood by marking and measuring the length in regular triangular wedges. The placement of the wedges at angles to one another provides a kind of syncopation which is formal and dynamically solid. The rhythmic patterning of these wedges, playing off of one another's form as they ascend the vertical length of the walking stick, are reminiscent of the dynamic rhythms found in many West African textiles. The ending flourish of the design, the serpentine form of the snake itself, creates an organic counterpoint to the regular geometry of the wedge elements.

The openwork handle on the walking stick at right (unvarnished work) shows Rogers' dexterity in handling the medium of wood. The serpent motif itself is one which African-American staff carvers have repeatedly utilized in their work. The walking stick is an emblem of status, and thus the carved handle becomes a particular motif associated with both the carver and the owner. Rogers, who learned to carve by observing his father create small animals of wood, continues the strong tradition of African-American walking stick carving.

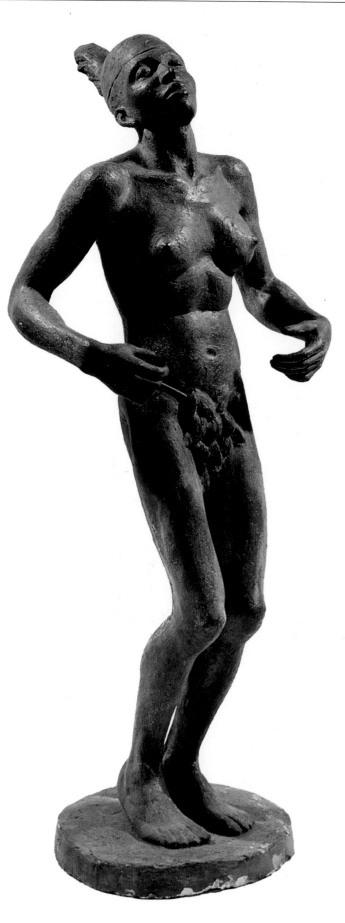

RICHMOND BARTHE, *African Dancer,* plaster, 1933. 42½ x 16¾ x 14 inches. Lent by the Whitney Museum of American Art, New York; purchase 33.53. Photograph by Geoffrey Clements. Collection of Whitney Museum of American Art, New York.

Dance becomes a visual metaphor of cultural survival in this female figure. Clad simply in a pelvic covering of leaves and wearing a cloth headdress, the woman is totally at ease with herself, engrossed in the expressiveness of her body and seeming to hear the drumbeats which will lead her into the next movement. Since Africans brought only their bodies to the New World, the importance of music and dance as an expression of cultural identity has always been central to African-American culture. Barthé's characteristic classical interpretation of the body understates effectively the woman's rapture. Rather than depict her in grand gesture, he captures her on the balls of her feet, knees bent, arms and hands relaxed but ready to move into the next expression. This very accurate interpretation is even more remarkable when one considers the fact that Barthé never used models for his works.

LOIS MAILOU JONES, *The Ascent of Ethiopia,* oil on canvas, 1932. 23½ x 17¼ inches. Collection of the artist.

Lois Mailou Jones daringly juxtaposed the pharaonic presence of Egypt with the artistic expression of the Jazz Age as represented by black art, music, and drama. Painted in the popular indigo blues of the period, the pharaoh appears to be studying this scene of contemporary black creativity. The black literary and art salons which were then popular in both New York and Washington, D.C. frequently cited Egyptian imagery in discussions of African civilization. Jones' keen sense of design is demonstrated in the dramatic spatial interpretations within the work. Behind the profile of the pharaoh, all activity takes place on what appears to be a miniature earth with a single urban skyscraper rising from its steeply curved surface. The full yellow moon in the background is accentuated at its circumference with dramatic masks in profile and silhouettes of musicians. The concentric curves upon which the figures are placed yield an oddly energized space.

HALE WOODRUFF, *The Mutiny Aboard the Amistad, 1839,* **sketch for the Amistad Mural Series, oil on canvas, 1939. 12¼ x 20 inches. Aaron Douglas Collection - Amistad Research Center - New Orleans, Louisiana.**

Developed in 1938-39 for Woodruff's outstanding mural series for Talladega College in Alabama this first of three mural sketches represents the pivotal event, the actual mutiny by Sierra Leonese captive Cinque and his country-men against the Spanish slavers aboard the ship Amistad. Cinque is depicted in the left foreground; he stands face to face with his victim, the ship's cook; the mutineers overwhelm the crew with sugar cane knives which they had seized for their fight. The physicality of this scene is one of the strongest visual expressions of the black struggle for freedom.

HALE WOODRUFF, *The Amistad Slaves on Trial at New Haven, 1840,* **sketch for the Amistad Mural Series, oil on canvas, 1939. 12 x 40 inches. Aaron Douglas Collection - Amistad Research Center - New Orleans, Louisiana.**

HALE WOODRUFF, *The Return to Africa, 1842,* **sketch for the Amistad Mural Series, oil on canvas, 1939. 12¼ x 20 inches. Aaron Douglas Collection - Amistad Research Center - New Orleans, Louisiana.**

The second panel depicting the trial of the Amistad captives contrasts in its sober, static mood with the intense action of the first panel. In this scene the mutineers are situated to the left with the defense counsel conferring in the foreground. For the portraits of the slaves at the trial, Woodruff carefully studied the thirty-two pencil drawings made of the African captives during their confinement in a New London jail

by a young American artist, William Townsend. On the second row, seated next to the young girl Marque, who after the trial was to return to the United States and attend college, is a slave whom the artist has taken the liberty of painting in his own image. Across the courtroom on the right side of the panel sit the Spaniards and their attorney. In this scene, Cinque's posture symbolizes the Mende's steadfastness in maintaining their oath of battle. Aware of their deeds, they believe that they were justified and no amount of opposi-tion and accusation will break them from this stance. Separated from the Africans by the space of a courtroom and by opposing ethics, the Spaniards and their counsel focus simply upon the death of crewmen while ignoring the larger issue of slavery itself, the immoral practice which led to these deaths.

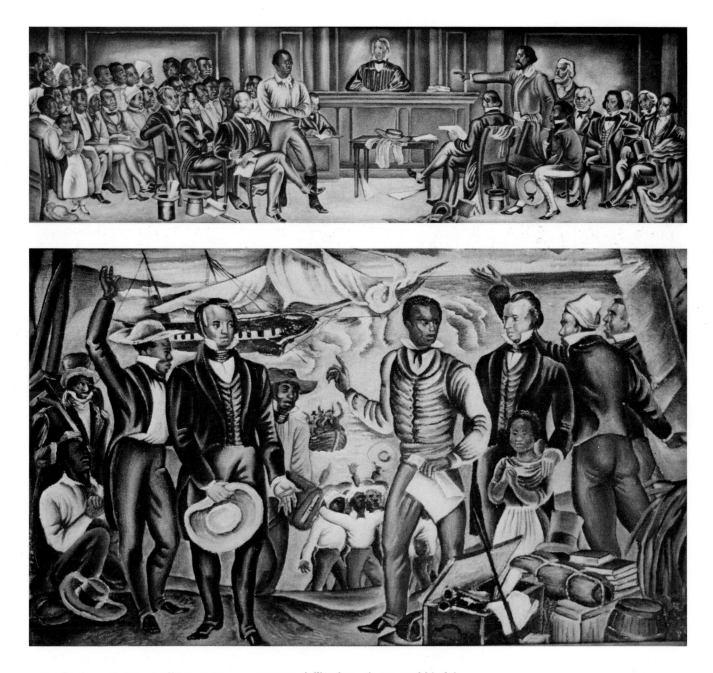

In the final panel, Woodruff integrates his tabloid method of positioning figures in a somewhat static manner with the use of an expansive background to depict the landing in Sierra Leone. There is a sense of excitement conveyed not only through the figures with their expressive gestures but also in the background of the furling sails, the rush of seagulls about the landing boat, the men waving hats, as well as the swirling sea itself. Dressed in the trappings of western civilization, Cinque and his followers together with the American missionaries will begin to reconstruct the lives of those who survived the Amistad experience. The manner in which Woodruff sought accuracy of details in clothing and settings as well as in his portraiture is reminiscent of eighteenth century history painting.

161

PRIVATE
:: VISIONS ::

The African tradition of inspired vision has permeated the African-American community since the slave craftsman created *gri-gris* and other protective amulets for his family and friends. One who "sees" visions unknown to others is considered a sacred individual within the African community and is at once embraced and given his or her sacred space. So, too, do African-American artists work within a sacred space that is theirs alone and from which frequently emerge visual expressions of a "cultural self."

Such a tradition is traceable to ancient African *griots,* such as the Dogon *hogon* (priest) of Mali who "read" both events of the past and future for their communities. These very personal and internal views of African-American culture emerge in the works of both trained and untrained artists, and represent some of the strongest expressions of divine inspiration. They are often rooted in religious values, and frequently given initial shape in dreams or unexpected imprints of images upon the mind. The artists who make them have studied both western and African religions and regard their work as a visual extension of their spiritual beliefs. In the case of artists like Everald Brown, Minnie Evans, and David Miller, Sr., markings, movements, and "signs" from external society take on a particular significance. The human soul, the power of creativity, the destiny and origins of man, and the secrets of creation are

all aspects of life which these artists investigate in their very personal visual statements.

Precedents found in African art and culture, such as the ceremonial use of carved figures and their inherent sense of empowerment, is often transferred to works created by African-American artists. Many use wood in the same evocative fashion as did the traditional African carver. This dominant use of wood can be considered a transferral of carving skills across the Atlantic, as well as a result of artists living in a social environment that perceives the "rightness" of wood as a material to express the essence of transformation and alteration of form.

The exploration of a cosmic sense of time and its relationship to human behavior is a recurring theme among artists of private vision. The midnight hour, night migration, and judgment day are all temporal references which allude to those mystical moments during the

earth's calendar when man and time become spiritually entwined. The suggestion that such moments provide spiritual empowerment and/or destruction to the individual parallels strongly the impact of seasonal festivals in West Africa, such as the *Bedu* full moon festival of the Nafana of Ghana and Ivory Coast, or the Dogon *Sigui* festival in Mali which occurs only every sixty years and through which an individual receives spiritual strengthening.

The fusion of man with nature is presented as that moment in which man chooses to combat nature and thus loses to its stronger forces, or he embraces nature and thus gives his or her identity over to nature and ascends to a more mystical plane, one more fully attuned to the energies of the universe. The participation by a dancer in the African masking tradition parallels this transformation when the dancer embraces and therefore becomes the spirit and identity of the mask. Leon Renfro's *Trees of Life* (1977) and Everald Brown's *Spiritualism* (1979) both suggest such spiritual metamorphoses.

Mystical powers of animals such as snakes, birds, and cows are also suggested in many works by both trained and self-taught African-American artists. Birds are often associated with thought and higher consciousness, as in *Landscape with Blue Birds* by Minnie Evans and *Eulipian I* by Bert Samples, in much the same way that birds decorating the top of a Yoruba beaded and veiled crown give the *Oba* divine powers of thought. The serpent as a symbol of renewal and silent power is common in African sculpture, and its appearance in the work of untrained black artists adds to its prominence in the New World as a bearer of mystical energy. Hence, serpents depicted on walking canes provide the owner with both protection and intellectual cunning. Finally, the all-seeing eye and its gaze into the four cardinal directions of the sun is the ultimate testimony to man's own identity as a mystical animal.

OVERLEAF:

Bessie Harvey, *Blissful Blessing,* wood and mixed media, 1988. 68¼ x 40¼ inches. Collection of the artist.

Bounty and harvest emerge from the branches of a young tree in this fanciful depiction of what the artist describes as "the haves and the have nots." Harvey uses the tree as the unifying form which connects the various figures within the work. A loaf of bread and a jug of wine extend from branches, while a woman with Rastafarian dreadlocks is formed by another branch. At the top of the tree a woman carrying a basket of fruit on her head seems to be the tree's crowning bounty.

RIP WOODS, *It Seems That I've Been Here Before,* acrylic on paper, 1988. approx. 40 x 30 inches. Collection of Sheila and Gregory Wells.

The sense of animals having special communicative powers is a theme that Rip Woods emphasizes in his work. It is a theme which extends the African concept of the "living" nature of the universe into the realm of animal behavior. Dogs barking behind a fence might not readily be recognized as having particular significance. However, the power of animals, forest, water, and fire spirits are all conveyed in African folk tales, narratives, music and visual imagery. The suggestion in the title that the spirit of the animal may have existed before indicates the artist's attempt to interpret the connectedness of time through the physical properties and spiritual presence of this subtle subject matter.

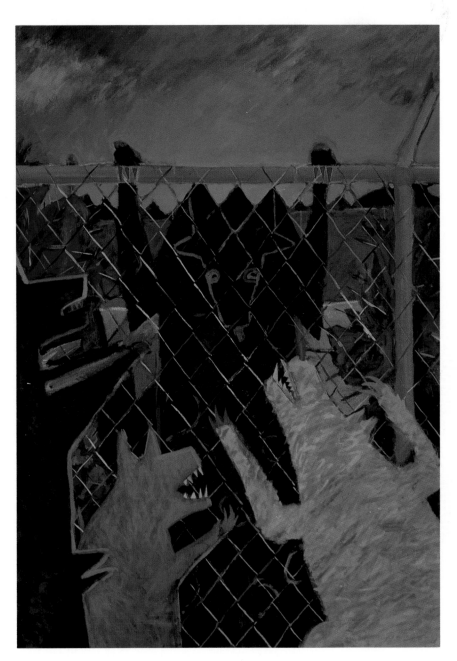

MR. IMAGINATION, *Eye,* **sandstone and paint, 1985. 6 x 10½ x 5 inches. Collection of Mr. Imagination.**

The all-seeing eye of Mr. Imagination is, in his words: "the third eye, the eye of Egypt, the eye of Mr. I." This symbolic eye has become a personal icon to this artist whose self-study of African culture has led him into mystical subject matter. Mr. Imagination combines a single-minded and assured approach to his material that has resulted in the production of numerous compelling images, including the "eye" which he frequently produces in emblematic fashion for popular consumption. He paints eyes on shells, rocks, and smaller sandstone fragments to sell or give as gifts. From his own imagination emerge more serious works as well. The genius of Mr. Imagination lies in his unique blend of street culture and serious art.

UNKNOWN ARTIST, (Gabon: Fang), *Four Faced Helmet Mask* **(Ngontan), wood and paint, 10⁵⁄₁₆ x 8¹⁵⁄₁₆ x 8⁹⁄₁₆ inches. Dallas Museum of Art, The Gustave and Franyo Schindler Collection of African Sculpture, gift of the McDermott Foundation in honor of Eugene McDermott (1974.SC.33). Exhibited at DMA only.**

The mystical attribute of appearing all knowing, of facing all four cardinal directions of the sun at once is clearly presented in this work. This image of having all-seeing eyes is echoed in the work of David Miller, Sr., Bessie Harvey, Derek Webster, and Sultan Rogers. The work represents the belief among the Fang that the figure will protect the spirits from any approaching dangers. The ability to see in this way, with this very "private vision" is only bestowed on particular figures within the community who have achieved communal grace, serenity, and wisdom.

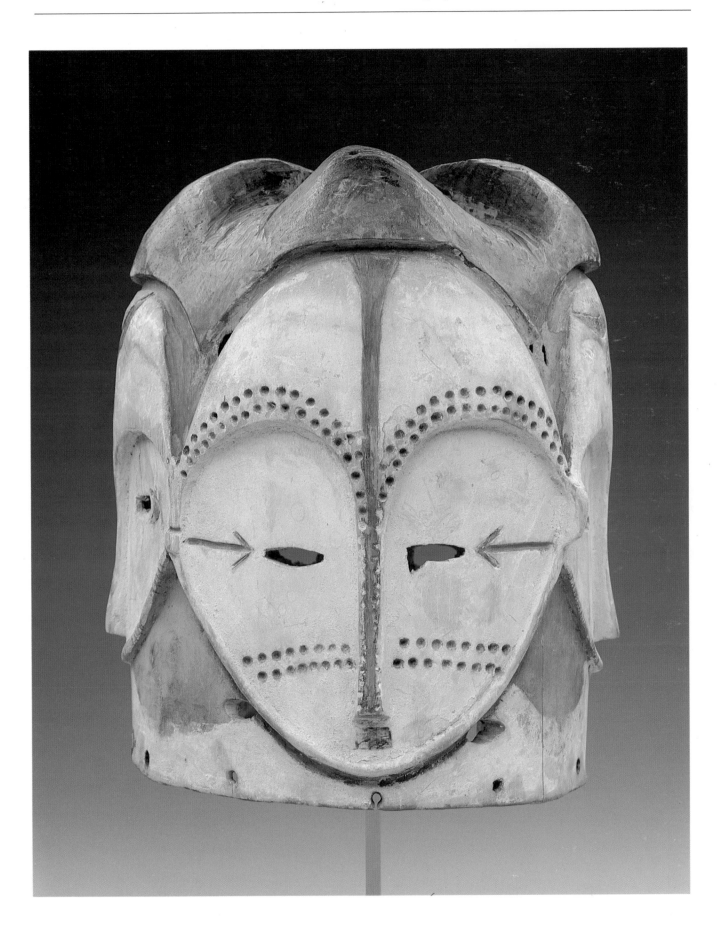

BERT SAMPLES, *Eulipian I*, conté crayon on paper, 1983. 28½ x 22½ inches. Collection of Bert Samples.

This odd and haunting self-portrait depicts the artist with psyche enshrined. The head as shrine of the body has been recorded by Robert Farris Thompson in his writings on the Yoruba, among whom the bird is associated with the human ability to perform supernatural feats. By associating the head with architectural structure, the artist conveys the notion of ordered thought which leads to an ordered life for society. The bird refers to spiritual ascension, attainable only by those whose head or shrine is clear and open. The title of the work comes from the song *Eulipian* by Rashaan Roland Kirk. The word according to Kirk means "journey agent".

SULTAN ROGERS, *Untitled* (four-headed goblet with snake base), wood, 1985. 6¼ x 2¾ inches. University Museums, The University of Mississippi, University, Mississippi.

SULTAN ROGERS, *Untitled* (goblet with coiled snake base), wood, 1985. 6 x 2⅝ inches. University Museums, The University of Mississippi, University, Mississippi.

SULTAN ROGERS, *Untitled* (coiled snake holding sphere), wood, 1985. 6 x 2¾ inches. University Museums, The University of Mississippi, University, Mississippi.

The artist reveals an understanding of the hierarchy of form which so often characterizes the structure of objects made for ritual use — cups, boxes, and other vessels — in a number of traditional societies in Africa. Rising from a base built upon the form of a coiled serpent, the works establish a reptilian shape as the basis upon which all other forms are built. The superstructures of the forms — a sphere (or egg), a hollowed cup, and a cup bearing four faces gazing in the direction of the "four moments of the sun" — serve as climactic statements when situated atop the serpent. The dual Janiform faces recur in the path of the African Diaspora with noticeable frequency. That such an image and motif should appear here in the work of a self-taught Mississippi artist is yet another indication that codified messages have passed through the African-American communities not only by drum beat, but also by the rhythmic visual patterns of woodcarving and other decorative skills.

UNKNOWN ARTIST, (Zaire: Yombe) *Seated Male Figure,* wood, glass and fiber. 9 x 4½ x 3½ inches. Dallas Museum of Art, The Clark and Frances Stillman Collection of Congo Sculpture, gift of Eugene and Margaret McDermott (1969.S.27).

The Central African Yombe figure indicates the recognition of the human figure as itself a sacred shrine. The magic placed in the center of the body through the mirrored torso serves as an unknown eye, a third eye, a view into one's own soul. It is this sense of sacred presense which is expressed by a number of African-American artists. The body as temple and shrine, as sacred and creative space is expressed through the performance of African dance, through personal body adornment, and the engagement of the body in ritualized posture.

DAVID MILLER, SR., *Talisman*, wood, c. 1940. 26 x 14 x 5½ inches. Collection of the estate of David Miller, Jr. Photograph ©1989 Denis Valentine.

An artist in the tradition of the "intuitive" sculptors of Jamaica, David Miller, Sr. created spiritually conceived works for most of his forty years as a wood sculptor. His masterpiece, *Talisman*, makes a direct reference to the four cardinal directions as represented by the figure which simultaneously faces the "four moments of the sun" as expressed in Kongo masks, textiles, and functional objects. The mighty Talisman peers simultaneously into the four directions, with arms outstretched and a strange hand-like form emerging upright from the arm. The base upon which the work is placed adds to its ceremonial formality, and the beauty of the variegated woods lends an additional element of visual richness. Miller was an extremely religious man throughout his life and this work is a testimony to his visionary spirituality.

UNKNOWN ARTIST, (Zaire: Lega) *Four Faced Half Figure,* wood, kaolin, 12⅝ x 5½ x 5¾ inches. Dallas Museum of Art, The Gustave and Franyo Schindler Collection of African Sculpture, gift of the McDermott Foundation in honor of Eugene McDermott (1974.SC.49). Exhibited at High Museum of Art, Milwaukee Art Museum, and Virginia Museum of Fine Arts.

The four-faced figure is a work whose truncated forms indicate a plurality of spirit linking the faces into a single central spiritual force as symbolized by the cylindrical base of the form. The elimination of limbs indicates that the work is addressing the capacity of the figure to look squarely and simultaneously into the four cardinal directions while anchored to a single powerful source of energy.

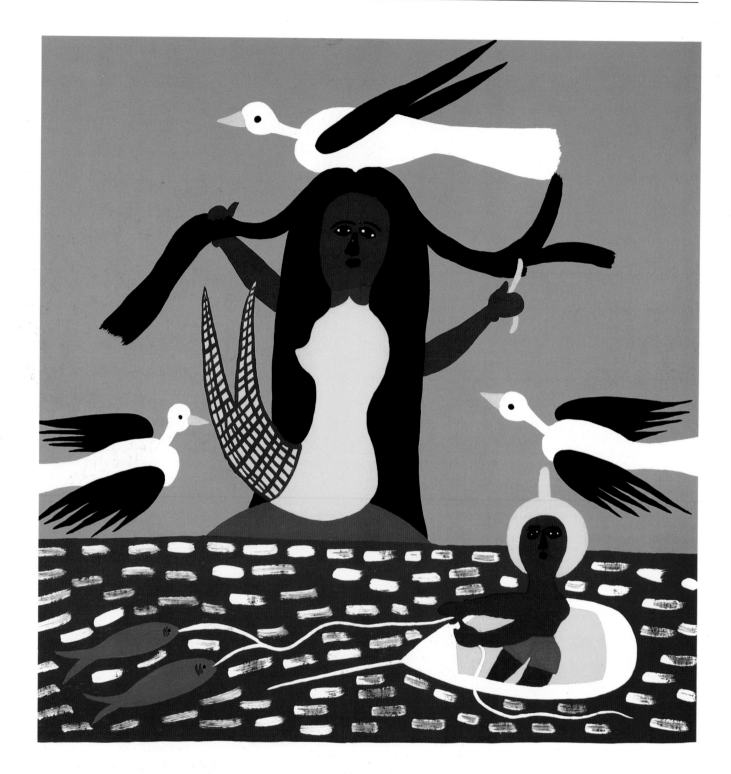

PAINT BY MR AMOS FERGUSON

AMOS FERGUSON, *Untitled* **(mermaid), house paint on cardboard, c. 1983. 30³⁄₁₆ x 36⅛ inches. International Folk Art Foundation Collections in the Museum of International Folk Art, a unit of the Museum of New Mexico, Santa Fe.**

The mermaid is depicted in Amos Ferguson's open and joyous painting style as a friendly and approachable female water spirit, which belies her more traditional persona as temptress to men at sea. The work can also be regarded as Ferguson's personal interpretation of the Haitian sirène, the sacred deity associated with water. The broad, flat coloration, so characteristic of Ferguson's works places the mermaid and the fisherman in the larger context of sea and sky. The bird's eye view of the scene elevates the mermaid above the fisherman, suggesting the vast power of her home, the sea.

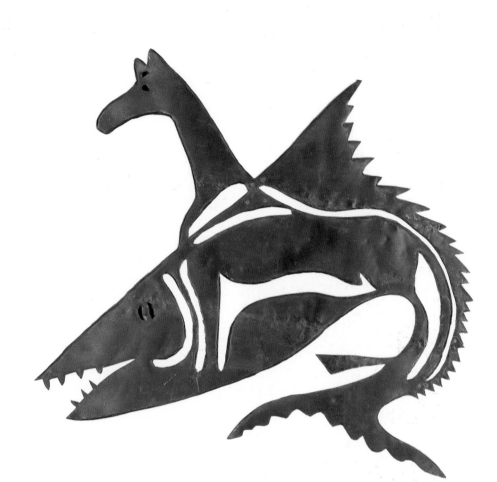

MURAT BRIERRE, *Chien de mer* **(Dog of the sea), metal from oil drum, 1974. 46 x 39 inches. Ute Stebich Gallery, Lenox, Massachusetts.**

This imaginative form is inspired by a Haitian folk tale in which the "dog of the sea" is described as a mysterious animal living in the waters near Haiti. The story, elaborated according to local customs, arose from an incident in which a young man's arm was bitten off by an unidentified creature. Such tales prevent young children from venturing out too far into the water without proper supervision. Simultaneously, water and its powers are a part of the forces of the universe which are personified by deities. The Yoruba *orisha* (deity) of water finds her way to the Americas and the power of the water is represented repeatedly in Haitian and Brazilian religious rites. The endowment of deities with supernatural powers is basic both to the African folk tale and masking traditions. The image of the dog riding a fish calls to mind the Haitian vodun belief that when possessed an individual is "mounted" by the possessing spirit. The openwork characteristic of Brierre's metalwork leads to an elegant visual marriage of the two forms in which the dog appears to serve as observant navigator for the moving fish.

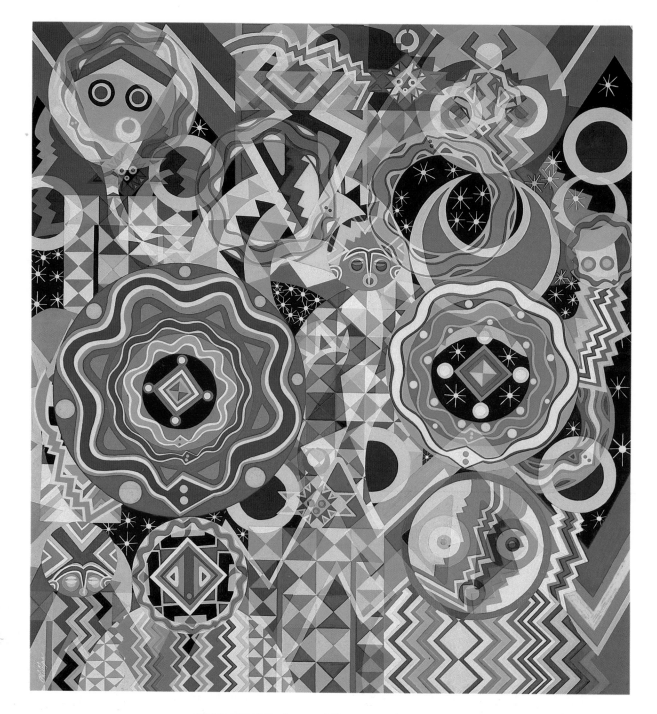

JAMES PHILLIPS, *Ancestral Dream,* acrylic on paper, 1985-86. 47½ x 42½ inches. Collection of the artist.

Mask forms appear in this painting amidst overlapping, concentric forms, all adhering to a fluid pattern in their curvilinear outlines. This work is somewhat atypical of Phillips' designs which generally are characterized by strongly geometricized patterning that creates sharply defined rhythmical compositions. The floating quality of the images which pass across the picture plane suggest free-flowing and dreamlike images. In this vibrant color scheme, the images converge upon one another in a polyrhythmic display of hue.

ANDERSON PIGATT, *Caught in the Middle Earth,* **wood and paint, 1970. 28 x 11 x 19 inches. Schomburg Center for Research in Black Culture, The New York Public Library, Art & Artifacts Division.**

ANDERSON PIGATT, *Alone Together and Alone Again,* **wood and paint, 1972. 18½ x 21½ inches. Schomburg Center for Research in Black Culture, The New York Public Library, Art & Artifacts Division.**

Pigatt's work reveals a deep mystical connection between man and his planet. In *Caught in the Middle Earth* a figure, seemingly in the position of prayer, is enshrouded by vibrant polychrome wood with openwork spaces. The form seems to emerge naturally from the wood. With his high gloss polychrome, Pigatt accentuates heavily the fact that he is altering the wood.

In *Alone Together and Alone Again* small vignettes decorate the sides of a tree trunk whose growth pattern has been forced forward by the wind. In this episodic work a black angel watches over various scenes from a man's life.

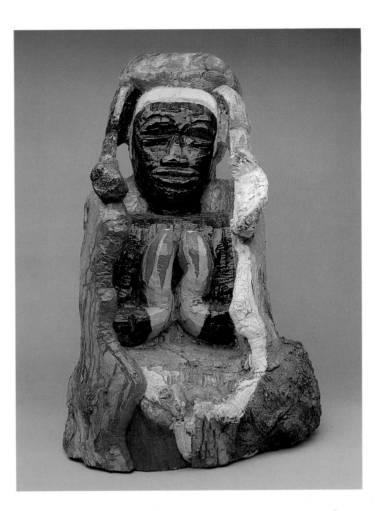

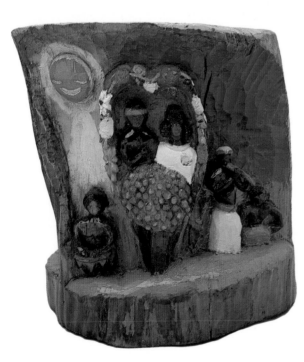

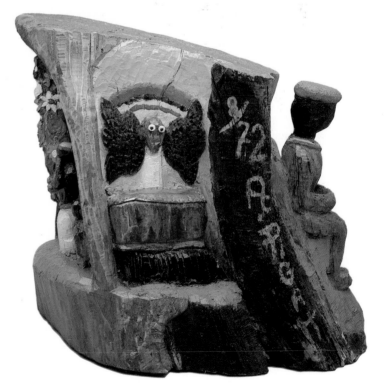

DANIEL PRESSLEY, *Acapulco,* **wood and paint, c. 1970. 31 x 23 x 1½ inches. Courtesy of Cavin-Morris Gallery, New York City.**

In this enigmatic work, a woman wears a headdress while a bull stands nearby and a man plays a guitar. The composition suggests some type of ritual connection between the three. The woman stands in a pose that is both heraldic and provocative. Whether Pressley himself was familiar with the ritual of bullfighting is unclear, but the regal crown made from the horns of a bull is distinctive. Pressley utilizes music and musicians in his work frequently. The addition of music here adds a sense of pageantry to the scene even though the musician seems to be lost in his own world of thought.

SULTAN ROGERS, *Snake,* **wood and mixed media, 1987. Length 33½ inches. University Museums, The University of Mississippi, University, Mississippi.**

The upraised movement of the serpent's body is poised to capture potential prey while its rhinestone eyes glisten with keen awareness. The rhythmical sway of the snake's body reflects an awareness of the serpent's movements while simultaneously Rogers shows the control which the snake has over such movement. By representing the snake in action, the artist thus indicates the reptile's psychological cunning and powerful presence.

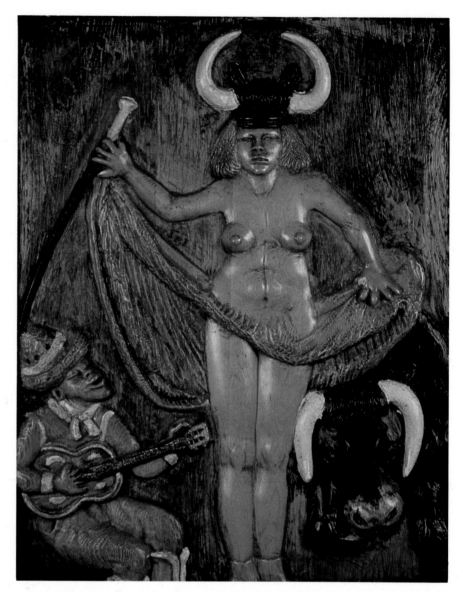

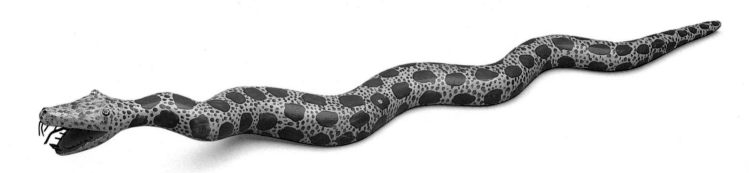

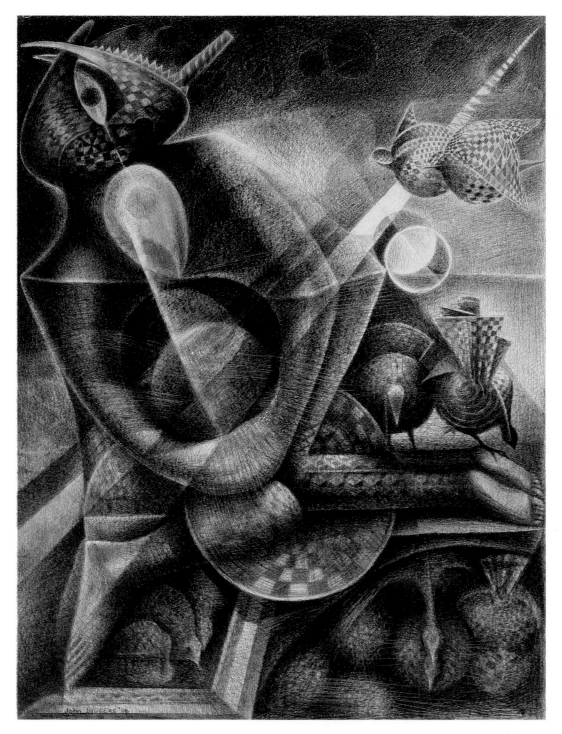

JOHN BIGGERS, *Midnite Hour,* conté crayon on paper, 1986. 39 x 29¼ inches. Collection of John and Hazel Biggers.

This powerful drawing reflects the artist's awareness of those forces of nature which periodically converge to create moments of great cosmic energy. The "midnite hour" alludes at once to the passionate lyrics of the song by Otis Redding and to the widely held thought that midnight is that charged moment at which the gears of the universe shift noiselessly into a final passage towards dawn. Biggers depicts a couple in emotional union. The woman wearing the crown of Ife queen mothers bends over the man like a protective bird, while all about them other animal forms crawl, nest, and fly. The union depicted here is that one which ultimately perpetuates all species.

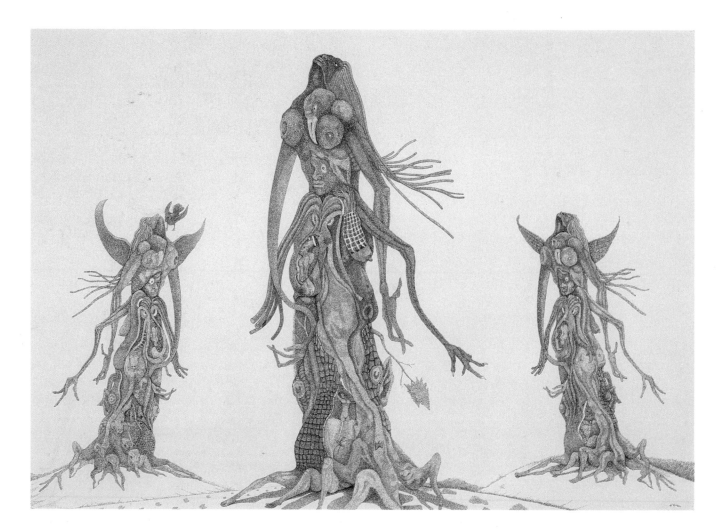

LEON RENFRO, *The Trees of Life,* pen and ink on paper, 1977. 15½ x 21½ inches. Collection of Leon Renfro.

Conglomerate figures signifying the merging of man with nature and the spiritual quality of trees has its origins deep in the forests of Nigeria, where writers like Amos Tutuola have written of the spirits of the forest. Renfro's own exacting technique lends itself to the careful delineation of the anthropomorphic qualities which are frequently seen in tree forms. The anthropomorphic quality of trees is indeed a universal theme in art, and yet, in African culture, the tree has a particularly sacred aspect. Often when selecting a tree to make a carving or a drum, the African artist will offer a prayer to that tree. The concept of the bottle tree as a spirit protector evolved from the Kongo to the South. The title of the work, finally, seems to underscore the dichotomy between trees of life, those which bear positive spirits, and trees of death, those associated with the violent legacy of the lynching tree of the South.

DEREK WEBSTER, *Turtle,* **wood and paint, 1988. 7 x 14½ x 16½ inches. Private Collection.**

Webster's turtle is a lively and energized creature, not static and ponderous as typically perceived. Holding an object in its mouth, the turtle has only two feet and a tail upon which to rest its weight. Its shell is constructed much like a cantilevered architectural structure which covers the body beneath. The turtle is created through Webster's sense of additive anatomy. Its body, darkly colored, is enlivened by touches of bright orange and white inside the mouth and accents of white upon the feet.

WILLARD WATSON, *Holey Snake,* **wood and mixed media, 1986. Length 52¼ inches. Collection of Willard "The Texas Kid" Watson.**

WILLARD WATSON, *Snake* **(Snake out of snake), wood and mixed media, 1980s. Length 48 inches. Private Collection.**

The limb of a cactus plant forms the body of this "holey" snake. When dried, the porous material of the cactus becomes rigid and screen-like in appearance. Watson, fascinated by natural materials, exploits the textural quality to create a unique skin surface for the serpent. His name for the work itself becomes a pun as holey can be heard as "holy." Interpreted in this way, the snake acquires a sacred meaning, just as the Dan of the Ivory Coast revered the snake as a symbol of rebirth and empowered spirituality.

The "snake out of a snake" motif was inspired by a story which "The Texas Kid" heard frequently from the elders in his community of Caddo Parish, Louisiana. It was said that a mother snake upon sensing danger would swallow her young only to release them from her mouth after the danger had passed. A great visual tension exists in the emergence of the one snake from the other, as the "child" serpent appears to be larger than the mother. The emergence thus becomes a metaphor for the maternal sacrifice which a mother will provide her young — protecting them literally within her belly until they are old and strong enough to go forth on their own. The work also suggests rebirth through the image of the snake's shedding of its skin.

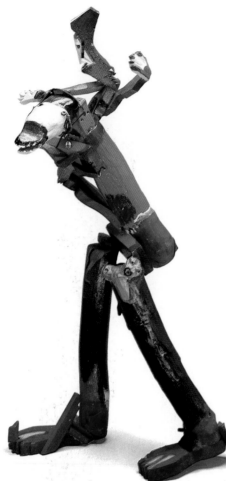

DEREK WEBSTER, *Untitled* **(red figure with lightning bolt headdress, two views), wood, paint, cement and rubber, 1988. 57¼ x 22¼ x 13¾ inches. Collection of Derek Webster.**

The genius of Derek Webster is found in his ability to give animate presence to many of his figures. Their energized poses suggest figures frozen for only a moment, ready to leap into another eccentric attitude. The body of the figure is abstracted in its lower extremities and it breaks down into a number of smaller figures and faces on one entire side. The "lightning bolt" headdress of this figure suggests the double axed headdress of Shango, the Yoruba god of thunder in West Africa. Though Webster indicates no former knowledge of African art, his approach to the use of wood parallels many of the additive configurations created in the great masquerade traditions of West Africa.

DEREK WEBSTER, *Red Rider,* **wood, paint, rubber, metal and sunglasses, 1987. 54½ x 22 x 31¼. Collection of Derek Webster.**

Webster's combination of man-made wooden forms — planks and blocks — with natural wood forms creates a work of edgy energy. The forms seem almost forced to interact with one another against their will and yet they work ultimately in a tightly conceived pattern of movement. The use of multiple faces on the knees, heels, and back of the figure heighten its internal dynamics. The faces are adorned with Webster's trademark rubber "earrings" which serve to personalize the figures.

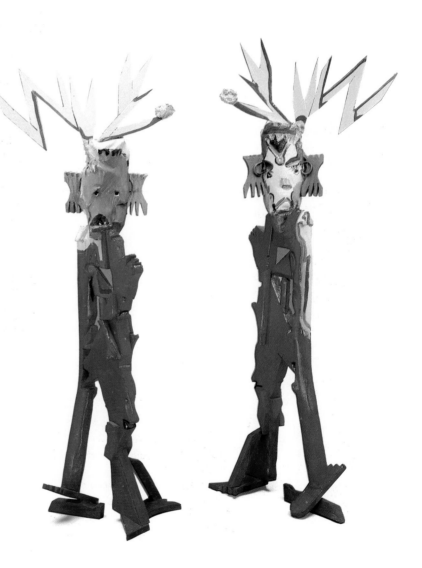

DEREK WEBSTER, *Untitled* (figure with black and green legs), wood, paint and plastic, 1987. 54¼ x 29½ x 17½ inches. Collection of Derek Webster.

The emphatic, knee-bent posture of this figure suggests a dancing attitude. The figure contorts itself into an oddly struck stance while from all of its limbs emerge other faces and figures. The broadly applied colors act in strong contrast against one another, underscoring the suggestion of unexpected and jarring movement within the form.

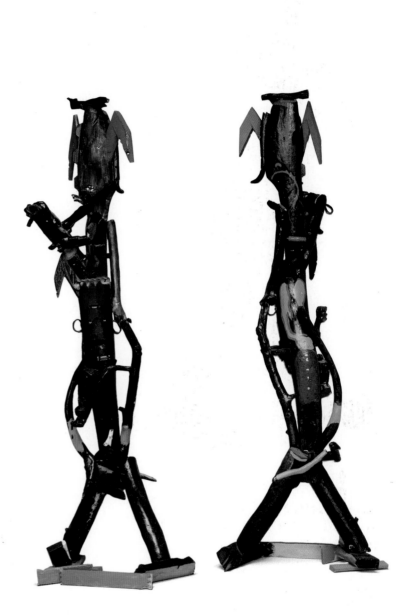

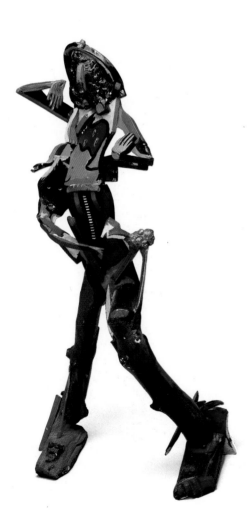

DEREK WEBSTER, *Untitled* (figure with red horns, two views), wood, rubber and paint, 1986. 75¼ x 24½ x 21 inches. Collection of Regenia A. Perry.

The totemic nature of Webster's untitled work builds itself up using oppositional figures who suggest simultaneous movement. With myriad facial configurations and eccentrically postured limbs, what was initially a massive tree trunk takes on a life of its own. The additive quality of the work, i.e., the seemingly spontaneous addition of beads, and other such accoutrements, gives the work an undisputed connection with the masquerades in West Africa. Webster places many of his works outside in his yard, where they create a total environment.

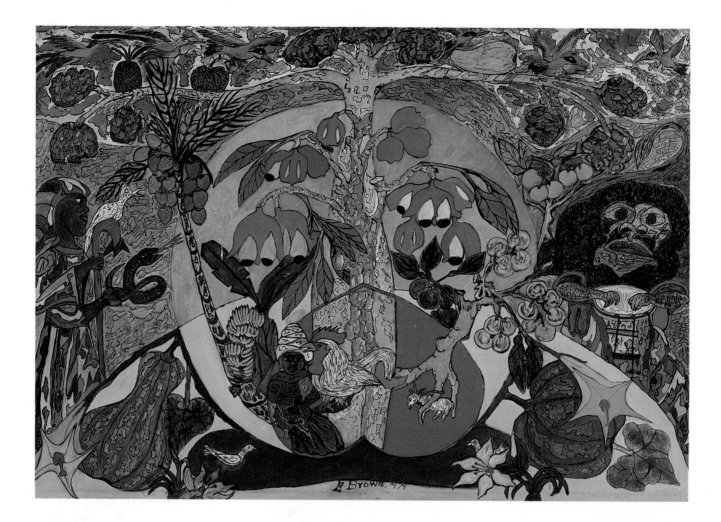

EVERALD BROWN, *Spiritualism,* **oil on canvas, 1979. 40⅜ x 54½ inches. Wadsworth Atheneum, Hartford, CT. The Ella Gallup Sumner and Mary Catlin Sumner Collection.**

In *Spiritualism*, Everald Brown interprets the many creative elements, including music, which lead to a divine order in the world. David Boxer, director of the National Gallery of Jamaica, observes that many of Brown's designs appear to him in visions and the Jamaican artist has developed "a rich personal iconography based upon the island's fauna, flora, and cultural traditions." In this richly interwoven scene, the artist combines a number of ritual icons of the African Diaspora — the walking cane of the elder, the snake coiled around a staff, and the sacred drummer.

JEAN LACY, *Welcome to My Ghetto Land,* **mixed media on wood panel, 1986. 6⅛ x 3 x ⅝ inches. Dallas Museum of Art, Metropolitan Life Foundation Purchase Grant.**

In this small and engaging work, the artist has coupled the Renaissance technique of gold leaf panel painting with the contemporary subject matter of a black urban setting. Lacy is a student of Italian panel paintings, Early Christian illuminated manuscripts, and Russian icons. In this miniature panel depicting the community camaraderie of black urban life, she evokes that sense of human vibrancy which often emanates from the African-American community.

182

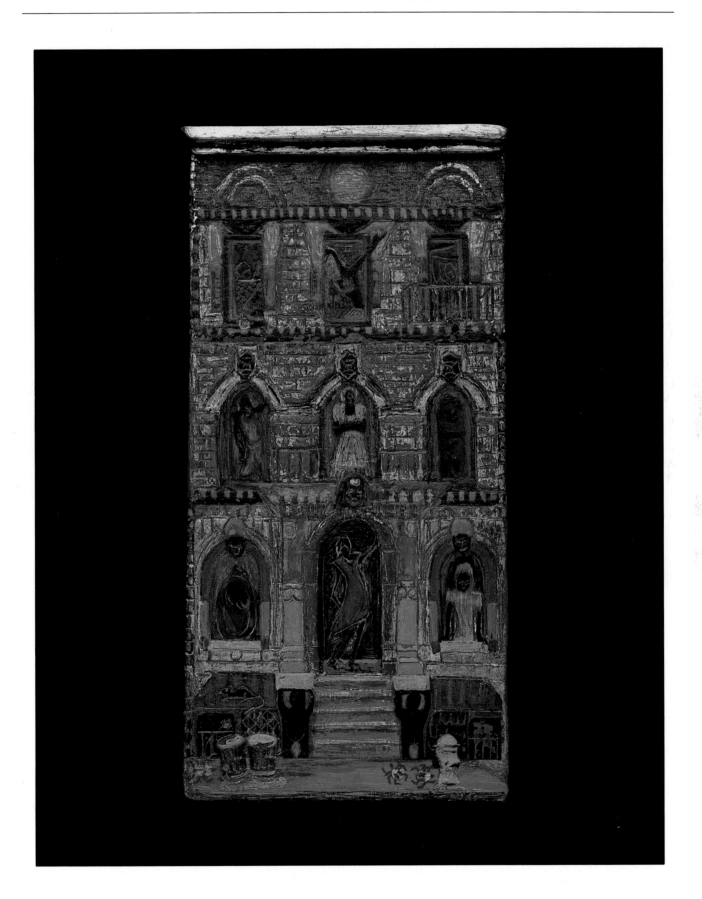

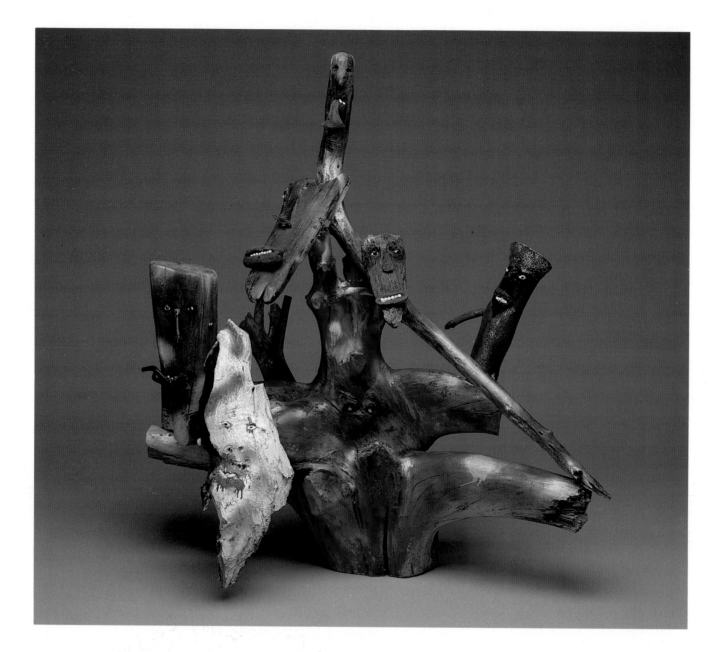

BESSIE HARVEY, *The Family*, wood and mixed media, 1988. 47¼ x 43½ x 21 inches. Private Collection.

The oneness of the human race is a strong message in the work of Bessie Harvey. *The Family*, which shows Mother Earth giving birth to all races of mankind, is a work compelling in its directness. This image calls to mind a Dogon story of creativity in which the earth is said to have given birth to her first son. Softly modulated blues and reds call to mind the elements water and fire, as well as air and blood. Through the addition of sequins and the regal colors of gold, royal blue, and purple to the surface of the wood, the artist provides her own dynastic order to man.

BESSIE HARVEY, *Untitled* (hand out of head), wood and mixed media, 1985. 31 x 15 x 16 inches. Courtesy of Cavin-Morris Gallery, New York City.

BESSIE HARVEY, *Mask,* wood and mixed media, 1986. 14 x 10⅜ x 7⅛ inches. Private Collection.

The sudden and unexpected abberation of a hand emerging from a head is startling in its psychic energy. In this single image, Harvey demonstrates the powers that exist within her "spirits." Contrary to its strange appearance, the figure bears a happy countenance, unburdened by its novel anatomy. Harvey's ability to "read" the surface of wood and discern unique forms within it is an indication of her sensitivity to the evocative powers of her material. She regards this ability as a divinely endowed gift.

The strong curve of a branch fragment leads Bessie Harvey to create an elegant hand-held mask whose haunting eye and mouth openings are created by natural open crevices in the bark. Harvey's sensitivity to form allows her to "bring out" a piece, as she states, without altering it dramatically. Glitter and red and green paint elevate the work from its completely natural state, giving it a celebratory and ceremonial presence. This is one of a series of masks which the artist has created from found pieces of wood.

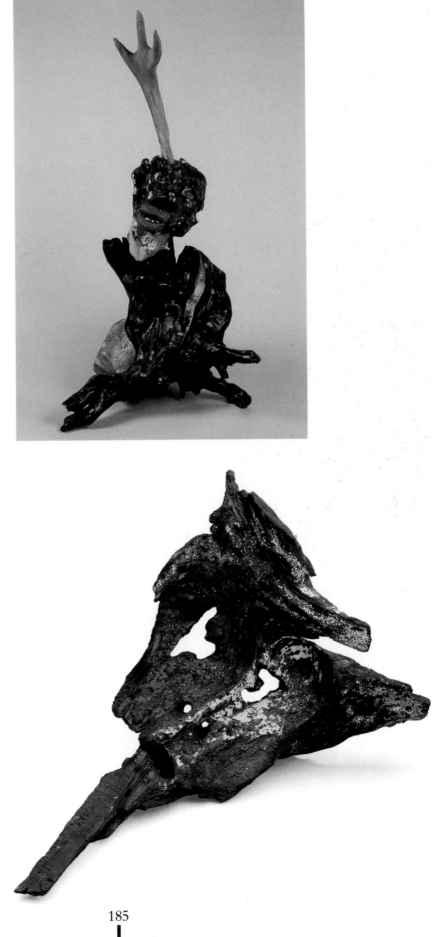

MR. IMAGINATION, *Meditation*, sandstone, 1985. 10½ x 4¼ x 4¼ inches. Collection of Mr. Imagination.

A mystical temple, described by the artist as a monument from an "ancient East African culture," sets forth the four directions in an imposing design. The artist's ability to create images which appear to have been unearthed from periods of antiquity provides a visual bridge to what he describes as his ancestral roots. Mr. Imagination thus continues in the tradition begun by artists from the Harlem Renaissance who were interested in learning about African antiquity. In this work three prophets (originally there were four) face the four cardinal directions, standing imposingly between the pillars of the temple. Because the nature of sandstone does not allow features to be carved in great detail upon its surface, the viewer is presented with a haunting, veiled image of these figures.

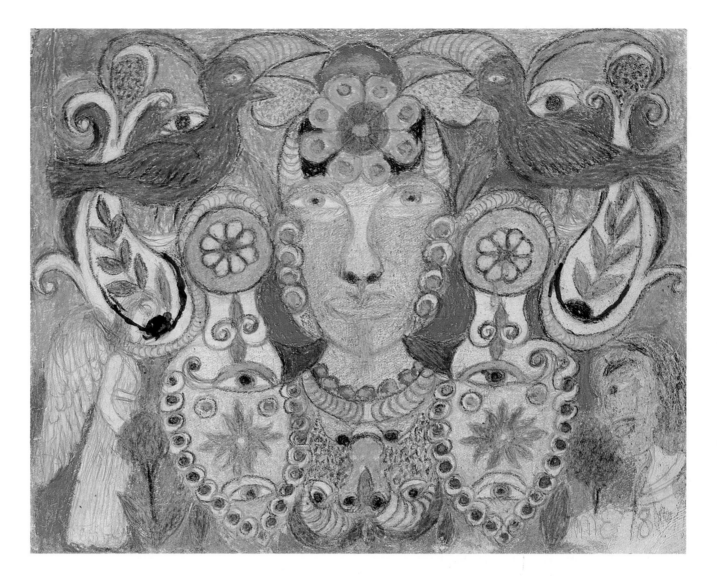

MINNIE EVANS, *Landscape with Head and Blue Birds,* **wax crayon, pencil and ink on cardboard, 1978. 11 x 13¾ inches. Private Collection.**

Among the Yoruba, birds often adorn the beaded crowns of the *oba* (king) as an indication that his head (spirit) is in communication with divine powers. In Egypt, the head of the great pharaohs was often protected by the outstretched wings of Horus, the falcon god. In this "landscape," Minnie Evans establishes her own personal divinity by juxtaposing blue birds in close proximity to a woman's head. The rich foliate nature of this scene as well as the tight symmetry are typical of the design approach of Minnie Evans, yielding an overt expression of the total unity of humanity with nature.

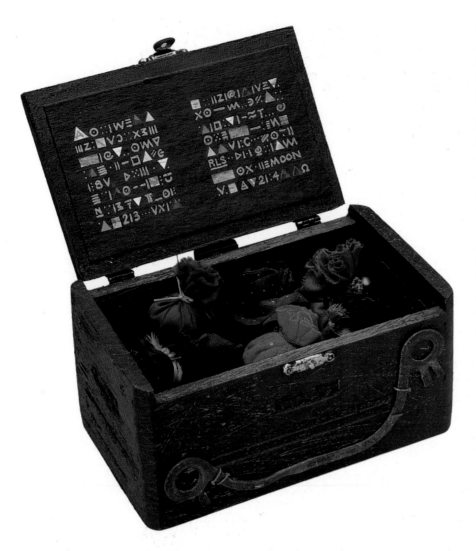

RENEE STOUT, *Instructions and Provisions/Wake Me Up on Judgement Day,* **mixed media, 1987. 6 x 6¼ x 3³⁄₁₆ inches (box open). Marie Martin Gallery, Washington, D.C.**

Like a *kuduo* filled with precious gold nuggets in Ghana or a *bakota* from Gabon guarding the remains of an ancestor, Renée Stout's container evokes a sacred presence which she attempts to define by containment, concealment and interpretation with her own script. An aura of mystery is typical of Stout, yet here she provides numerous clues as to how one is to prepare (instructions) to endure (provisions) on judgment day. What emerges is a carefully constructed work whose enigmatic contents are tempered by a visible clarity, palpable in its measure of comfort.

RENEE STOUT, *The Guardian of the Medicine Boxes,* **mixed media, 1988. 12 x 6 x 4 inches. Collection of Clarencetta Jelks.**

Standing like a small sentinel atop two carefully staggered boxes, the child guardian of the mysterious medicine boxes brings an eternal and innocent power to this work. Like the carved, armless figures of the Yoruba which serve as handles for ceremonial utensils, the figure is an integral part of the boxes below it while standing as a

spiritual finial to its content. The figure is created from a plastic doll which the artist has layered with paper towels, tissue, and paint to yield its subdued and textured patina. One of the boxes contains a fragment of brick which Stout says symbolizes the ritual spreading of "brick dust" on the floors of New Orleans homes after they are cleaned.

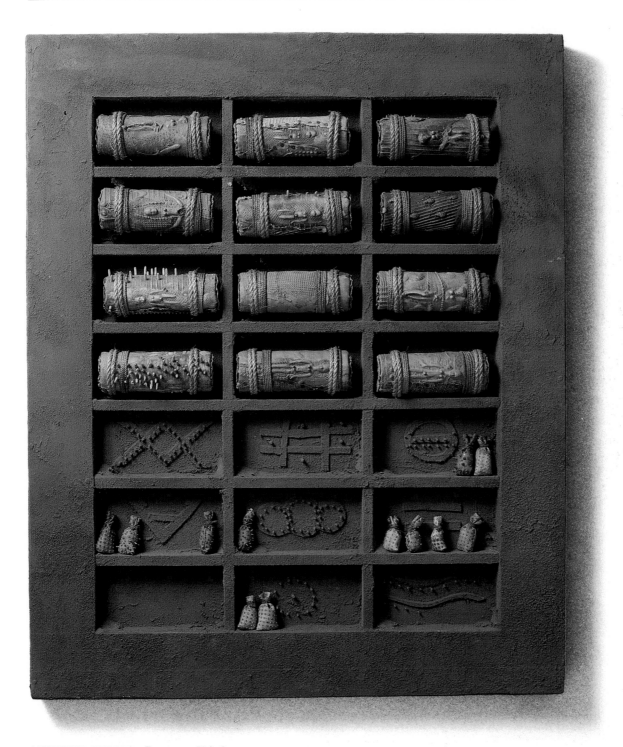

HOUSTON CONWILL, *Passages: KA-2,* mixed media, 1979. 48 x 38 x 4 inches. Collection of the artist.

The impact of African cultures is clearly evident in this work by Conwill, whose composition suggests both the ritualized house facades of the Dogon and the *nkisi* juju bags of the Congo. Among the Dogon, niches are built in the exterior walls of homes to accommodate various offerings by family members in honor of their ancestors. Conwill adopts the grid pattern of these Dogon niches and places within them offerings of *nkisi* (the artist calls them "juju bags"), medicine bags common to the Congo region which are worn for protection. By combining the two traditions, the artist brings a broad perspective of African ritual to his own work. Conwill's personal vision enables him to create a work of sacred nature, whose title alludes to the safe journey through the passages of one's life.

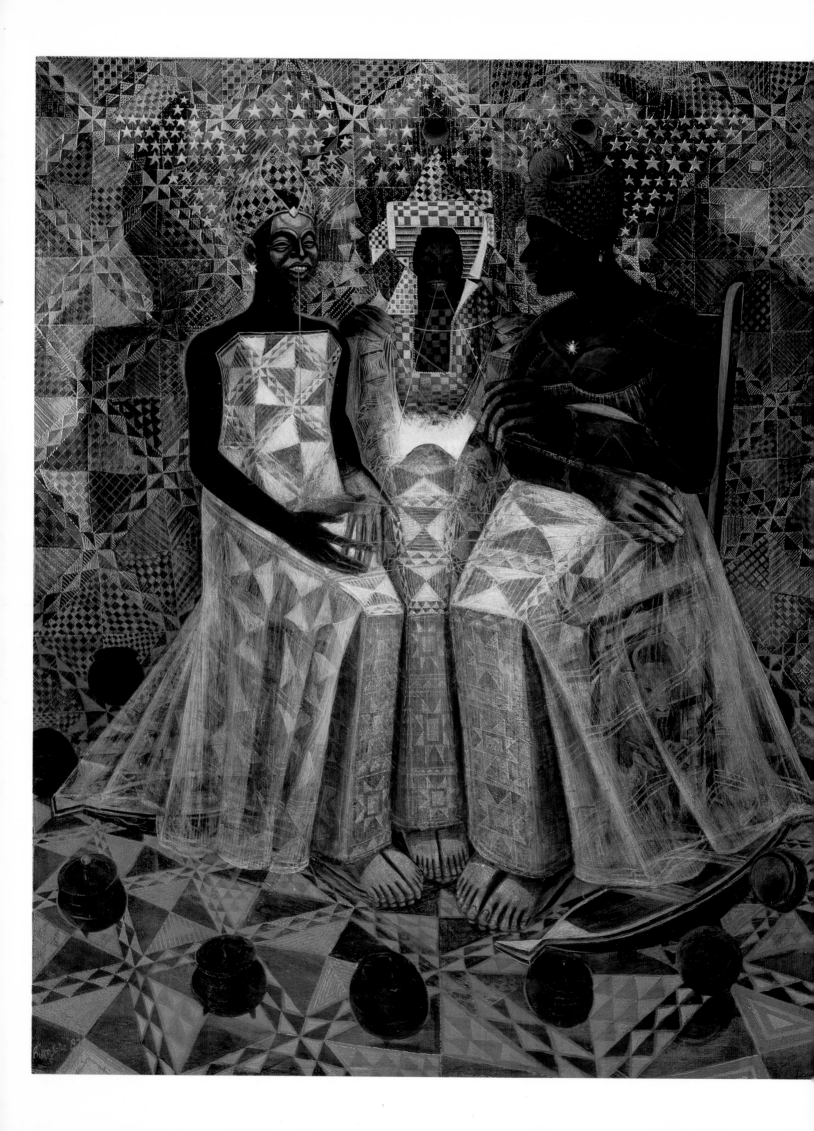

:: RECLAMATIONS ::

During the Harlem Renaissance Alain Locke observed that African sculpture had been for contemporary European painting and sculpture "a mine of fresh motifs, . . . a lesson in simplicity and originality of expression." He went on to prophesize that "surely, once known and appreciated, this art can scarcely have less influence upon the blood descendents, bound to it by a sense of cultural kinship, than upon those who inherit it by tradition only." Locke was to be proven right. Over the next years he himself would direct artists such as Richmond Barthé, Aaron Douglas, and Lois Mailou Jones in their search for the ancestral roots that would nourish the most profound work of their artistic careers. Travel, military service, rising political consciousness and increased flow of information would all contribute to the experience of young African-American artists, encouraging them to reclaim their cultural past.

After World War II, African-American artists began to travel in rising numbers. They moved the focus of their vision from Europe where their predecessors Duncanson, Bannister, and Tanner had enjoyed prominence (even though Tanner had ventured into northern Africa), and fixed their gaze on the "Motherland," as Africa came to be called. The rise of Kwame Nkrumah (President 1960-66) as the leader of Africa's first modern independent nation, Ghana, served as a symbolic catalyst for many artists. They began to journey individually and in groups to West Africa — Nigeria, Togo, Senegal, Ghana, Liberia — and in East Africa to Egypt and the Sudan. Their personal experiences and involvements in the culture gradually began to replace or fuse with their previous and necessarily more generalized view of Africa.

In the mid-sixties, at the height of the Civil Rights movement, a number of politically conscious artists began to look to Africa as the center of their political/artistic mandate. As young black professionals were being urged to develop skills to take "back to the community," so too were artists developing aesthetic platforms within their intellectual circles which provided them with a sense of direction and purpose. With the instigation of such movements as Weusi

ya Sanaa in New York, and AfriCobra in Chicago and Washington, D.C., the artists began to evolve styles and fields of narrative interest which demonstrated their aesthetic/political points of view. Perhaps the most emphatic public statement of reclamation emerged from their organization of FESTAC '77, a pan-African festival which celebrated the Diaspora through the convergence of black arts groups from all over the world in Lagos, Nigeria. Participation in this had a major impact upon many artists, including Charles Searles, Leon Renfro, and Ademola Olugebefola. More recently, in 1984, the National Conference of Artists, the oldest organization of African-American artists in America, met for the first time in Dakar, Senegal. There they left a commemorative plaque in honor of their ancestors at Gorée Island, the infamous slave port off the coast of West Africa. The voices of Garvey, Locke, and

Du Bois continue to echo in the minds of artists who return again and again to the Motherland. As John Biggers observed after his first trip to Ghana in 1957:

Here man was truly one with nature. He walked upon the land without shame for his nakedness, so much was he a part of the surroundings, the same as the trees, the birds, the lower animals that moved on four feet. These people possessed an obvious pride, but it could not be associated with conceit, selfishness, pretentiousness; it was a pride . . . born simply of being, of sharing in nature's immensity. Upon this land man lived with the rhythm of the seasons.

OVERLEAF:

JOHN BIGGERS, *Starry Crown*, acrylic on canvas, 1987. 59½ x 47½ inches. Dallas Museum of Art purchase, The Museum League Fund.

The three Marys of the African-American community represent the three cultures of African antiquity: Egypt, Benin, and the Dogon of Mali. The woman in the center, the Dogon weaver of the "word," sits with a string running through her teeth, symbolizing the transferral of knowledge across generations and continents through the spoken word in folk tales, proverbs and divine teachings. The quilt pattern receives dual meaning from its origins in Kuba design motifs and the patterns of a quilt crafted by the artist's own mother, Cora Biggers. *Starry Crown*, the name of a traditional spiritual, also refers to the headdresses of the women, crowns of their cultural glory.

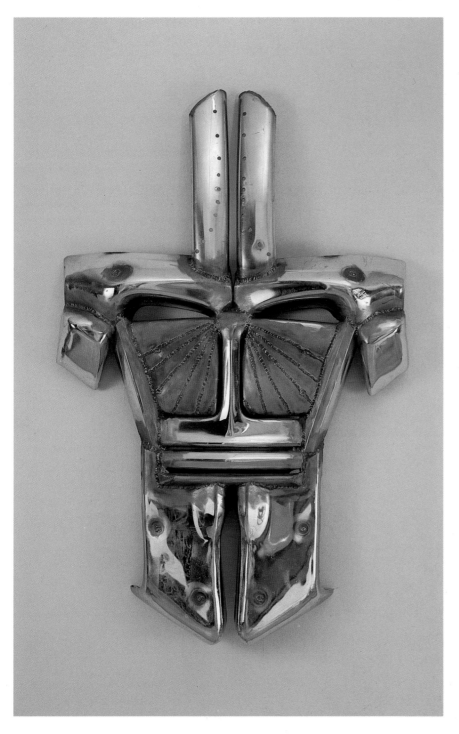

ED LOVE, *Mask for Mingus,* **welded steel, 1974. 51 x 34 x 9 inches. Collection of the artist.**

A huge steel mask with strong facial features confronts us as Ed Love's testimony to the strength of Charlie Mingus' music. In its scale alone, the work evokes the strong and imposing jazz sounds of this master bassist. The music of Mingus is monumental, sharp, hard-edged, and mysterious; it was born in an urban and intellectual framework that allows for the fusion of seemingly discordant tones into an audio tapestry distinctly recognizable as Mingus' sound. Similarly was the life of Charles Mingus an assemblage of seemingly disparate aspects. Love welds together masterfully a number of strong facial elements. He exploits the metallic surface of his work, knowing that its shiny, reflective surface acts much more aggressively than the deep patinas of a wooden mask. Thus the work becomes contemporary, an African-American expression of the African masking tradition.

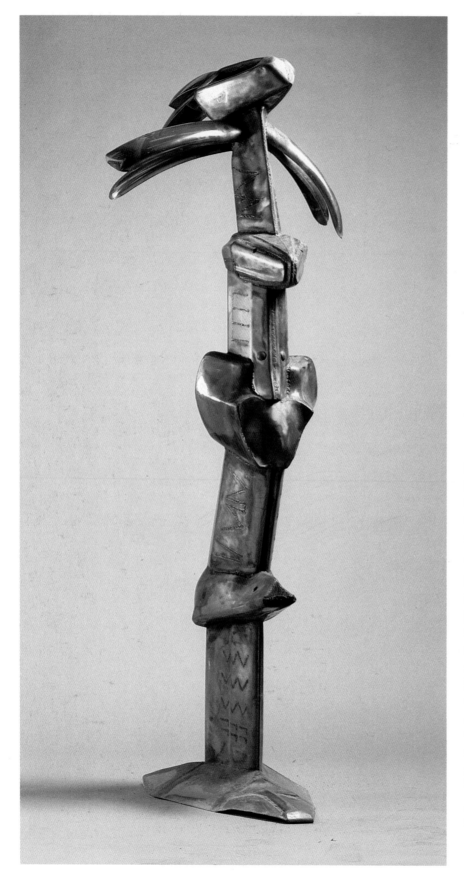

ED LOVE, *Totem for Senufo* (left), welded steel, 1974. 89 x 24 x 33 inches. Collection of the artist.

Totem for Senufo translates into contemporary steel the traditional headdress of the *porpianong,* or "Senufo bird," among the Senufo people of the Ivory Coast, West Africa. The bird represents fertility and continuity of familial legacy within the community. The headdresses are immense wooden superstructures worn by men who dance the pattern associated with the bird's movement. These carvings are generally larger in scale than other bird and animal figures created in the West African masking tradition. A heavy-bellied posture emphasizes the *porpianong's* association with fertility, making it seem more mammal than bird. Love translates that fertile quality into a soaring strength which is strongly indicated by the steel itself and also by the majestic height of the bird.

MATTHEW THOMAS, *Symbol of Earth Soul II* (4 elements, right), unfired clay, soil and acrylic on plywood wrapped with burlap, 1989. 96 x 15 x 1¾ inches (each element). Collection of the artist.

The interest of Matthew Thomas in North African architecture is apparent in this work. The superstructure of each piece makes reference to Islamic tile decorations in its careful interpretation of ornamentation, while the colors of the elements call to mind the sun-baked hues of ancient mosques and private dwellings in northern and western Africa. It is the artist's belief that each world culture contributes in a creative way to the definition of the earth's creativity, and, in this sense, he pays tribute to the contribution of Native American, Asian, and African visual expressiveness.

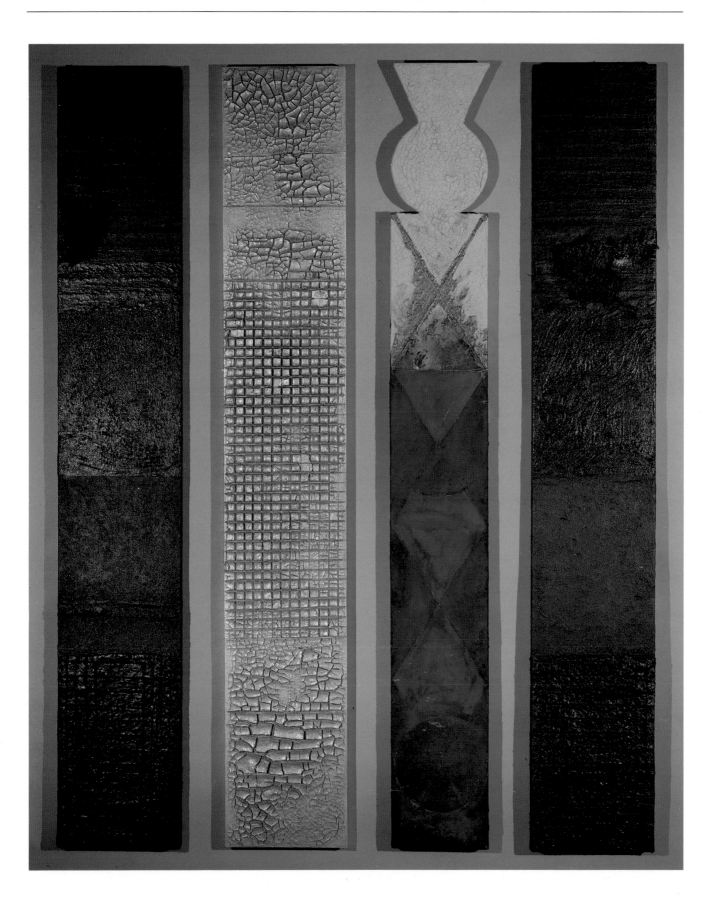

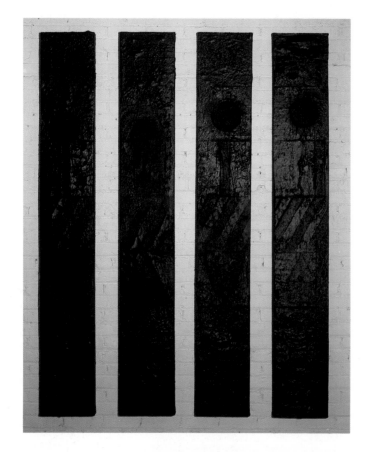

MATTHEW THOMAS, *Absorption*
(4 elements), unfired clay, soil and acrylic
on plywood wrapped with burlap, 1987.
84 x 12 x 2¼ inches (each element).
Collection of the artist and Ellen M. Hill.

The surface texture of this work's four
distinct elements relate specifically to the
tradition of ritualized patina that is so
often found on African sculpture. The
mixture of clay, ash, and soil which
achieves this textured effect suggests
Thomas' interest in yielding a work
which is "of the earth" in its appearance.
Though identical in shape, the four
elements are distinct in surface defini-
tion and reflect in an eloquent dark
simplicity their own particular identities.
Just as the houses of great men in parts
of West Africa are made from mud and
earth and ash, so do these elements
refer in a haunting way to ancient pillars
of African civilization which over time
have absorbed various offerings from
man and nature and maintain their
strength and support.

GEORGE SMITH, *Korobo,* **steel, paint, oil
stick, 1985. 13 x 39 x 30 inches.
Collection of the artist.**

Korobo refers to the region in Mali
where the oldest *toguna*, or men's house
of the Dogon, is still in existence. The
toguna is the center of learning and
ritual for the community and is the place
that men gather to exchange stories
about the origins of the Dogon people.
This structure and its mud relief images
have been a repeated source of inspira-
tion for Smith's sculpture. His zigzag
figure is a dual reference to the Dogon
emblem for water and to the image of
Lebe the serpent, who according to
legend, safely led the Dogon people to
Mali across the Bandiagara plateau to a
source of lifesaving water. The checker-
board pattern of the sculpture's surface
is a reference to the traditional black
and white checked burial shroud of the
Dogon.

CHARLES SEARLES, *Fantasy Animal I,* wood and acrylic, 1978. 40 x 28 x 40 inches. Lent by the artist.

CHARLES SEARLES, *Flight of My Father,* wood and acrylic, 1980. 90 x 72 x 48 inches. Lent by the artist.

Drawing upon the openwork rhythms of sculpture by such people as the Bambara of Mali or the Bobo of the Ivory Coast, Charles Searles has invented anthropomorphic shapes whose rhythmic forms work together to create an animal which is at once witty and visually engaging. The painted surfaces of the various components of this freestanding animal echo the interwoven patterns of the elements themselves. A student of the tradition of sculpture in West Africa, Searles seeks to draw freely from their structure while developing his own vocabulary of forms. The colorful sculpture is closely akin to the artist's paintings which demonstrate a similar development of tightly related elements. *Flight of My Father* seems to leap into air as it emerges from the wall against which it is placed. The rhythmical forms, tightly controlled by the artist, express a contained elegance and power, and the large scale of the work adds to its airborne quality. It appears capable of movement and, much like the costumed masqueraders of a West African community such as the Yoruba *epa* dancers, the work takes on a motionless grace. The allusion to flight in the title, as well as the tribute to an ancestor, suggest the artist's intent to create within the work a spiritual and commemorative context.

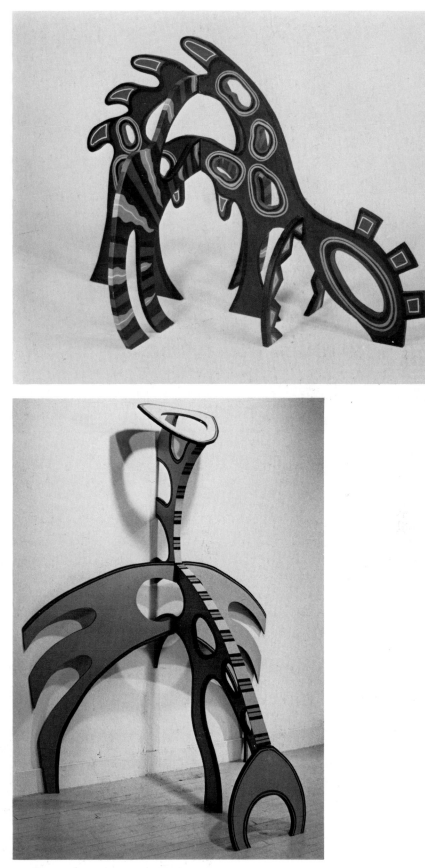

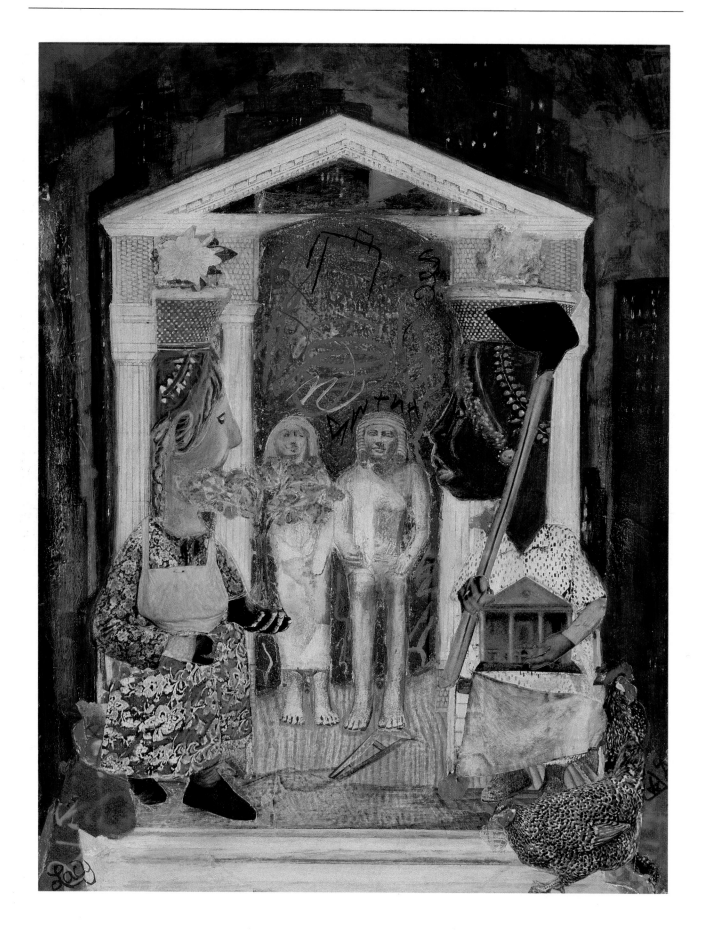

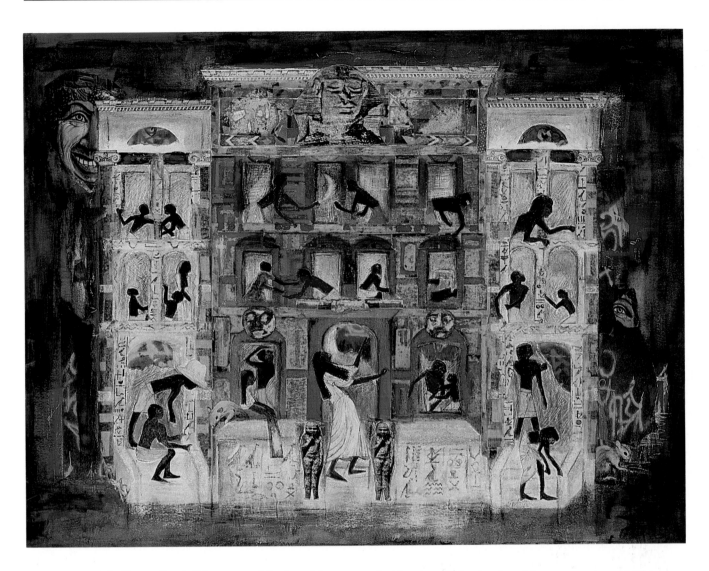

JEAN LACY, *Little Egypt Condo/New York City,* mixed media on museum board, 1987. 10½ x 13½ inches. Collection of the artist.

JEAN LACY, *Twins in the City* (left), mixed media on museum board, 1987. 11½ x 8¾ inches. Collection of the artist.

This highly autobiographical piece expresses, as the artist explains, the "duality" of her ancestral roots. Skillfully combining gold leaf and xerography, Lacy places Egyptian funerary statues in the center of the work while flanking them with two women whose faces are derived from Janus-face pottery. One figure is black, the other is white. The black woman holds a hoe in her hand,

while the white woman holds a tree. This scene of interwoven histories, the duality of fate and the racial opposition of these "twins," are all concepts which intrigue the artist on a personal level. A student of African art, Lacy also makes frequent reference in much of her work to the tradition of the Yoruba *ibeji,* twin figures symbolic of a twin birth. Upon one's death, the living twin is believed responsible for the care of the spirit of the deceased twin. *Twins in the City* makes subtle reference to such responsibility by giving these twins a single task to share.

Little Egypt Condo/New York City attests to the artist's serious interest in Egyptian culture. For the past decade, she has

developed her own system of African iconography based upon her studies of Egyptian hieroglyphs and West African architectural symbols. Collage, xerography, and gold leaf application are techniques which Lacy deftly combines to create this richly visual urban scene. In this collage, the migration reference suggests not only the movement by blacks from the rural South to the urban North, but also the more ancient passage from east to west Africa and across the Atlantic to a younger western culture.

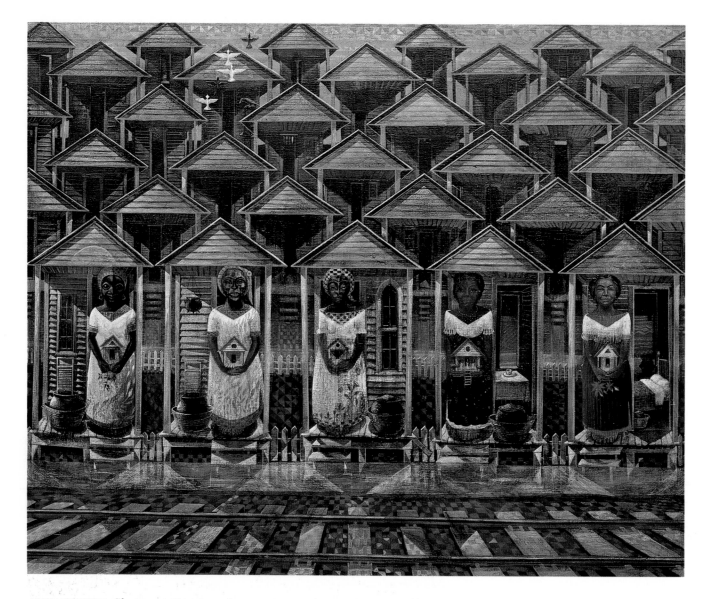

JOHN BIGGERS, *Shotguns,* oil and acrylic on canvas, 1987. 40 x 56 inches. Private Collection.

The concept of ascension, of the rising spirit, is presented in this scene of the black community in Houston's Third Ward. Women stand on porches and hold in their hands miniature houses very much like shrines of the home. Like black caryatids that support their households, these women are for Biggers the archetypes of their community. He brings to this work his interest in African textiles. The overall patterning of the painting — rooftops of shotgun houses — is clearly derived from Kuba cloth patterns. The railroad track in front of the houses is another motif which has evolved in Biggers' work over the years. The railroad track is itself a horizontal path of the ghetto, a symbol of migration, mechanization, and the spread of the Diaspora from the South to the North. It represents both the underground railroad and a contemporary passage to a better way of life. The Africanized features of these indomitable women who remained behind and their royal bearing are testimony to the strength of their heritage. The ascension of the birds suggests a spirituality in the community which sustains the necessary resolve for a people's continuity.

JOHN BIGGERS, *Wheel in Wheel,* oil and acrylic on canvas, 1986. 50 x 30 inches. Collection of Dr. and Mrs. William R. Harvey.

Wheel in Wheel is Biggers' further testimony to the symbolic imagery of African-American spirituals. In this work the family is conveyed aloft by the African xylophone, the man and woman together forming joined shotgun houses while the children form a constellation symmetrically placed in the sky. These constellations are derived from quilt patterns which the artist saw in his mother's quilts. The pots in the foreground of the work echo the creative hands of the women potters of West Africa whom Biggers has portrayed in earlier drawings. Frequently in the artist's works several generations look away from the viewer, turning inward as they deal with pressing tasks and inner thoughts. The dog resting on the xylophone is Hapi, the artist's dog, named after an Egyptian deity.

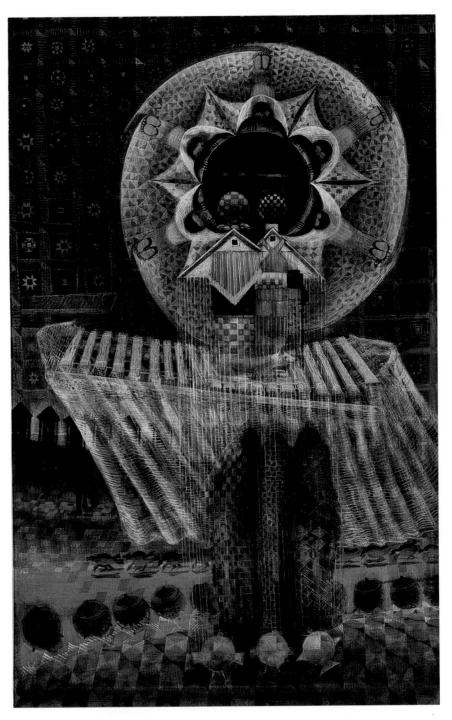

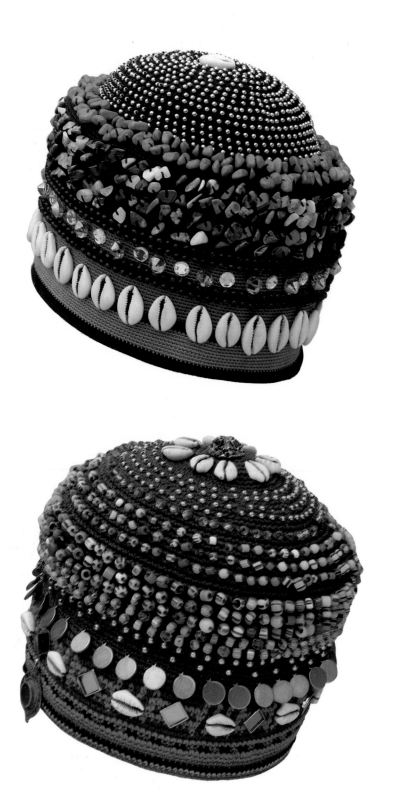

XENOBIA BAILEY, *Royal Crown #5*, acrylic yarn and mixed media, 1985. 7¼ x 6¾ (diam.) inches. Schomburg Center for Research in Black Culture, The New York Public Library, Art & Artifacts Division.

XENOBIA BAILEY, *Mali Formal Crown*, cotton yarn, multi-colored beads, and mirrors, 1989. 8½ x 9½ (diam.) inches. Collection of Xenobia Bailey.

The Yoruba of West Africa believe that the head is the temple, the sacred shrine of the body. It is from this center of thought and moral strength that the persona of an individual emerges. It is not surprising then, that elaborate head-dresses, crowns, and coiffures are commonplace in African culture. So, too, is the adornment of the head and hair among African-Americans a symbol of the celebration of self and personal identity. In this tradition Xenobia Bailey creates hats which are more than simple stylish additions to a wardrobe. They are part of the artist's personal reflection on the Diaspora, contemporary statements regarding the very personal African ritual of body adornment.

Mali Formal Crown is a more formal expression of head adornment with a densely festooned surface of crystal beads and mirrored brass circles. The shape of the hat is simple and conserva-tive, sitting neatly upon the skull. It is the richness of the added materials and their implied weight which lends a regal formality to this headdress. The "crown," upheld by a strong spine and neck, suggests the need for slow and mea-sured movement. Such movement would, in turn, create myriad reflections on the mirrored brass circles, while the crystal beads would reflect the light of the sun.

XENOBIA BAILEY, *Fulani Brim,* acrylic and cotton yarn and button, 1989. 7 x 20½ (diam.) inches. Collection of Xenobia Bailey.

XENOBIA BAILEY, *Zulu Princess,* acrylic and cotton yarn and cowrie shell, 1989. 6½ x 9 (diam.) inches. Collection of Xenobia Bailey.

Wide brimmed hats like *Fulani Brim* are worn by Fulani herdsmen as protection from the savannah sun. Made of painted leather, the Fulani hat became popular among artists during the late sixties and seventies. The musician Taj Majal became one of the first public figures to wear the traditional Fulani hat. As part of the cultural expression of black men, the Fulani hat came to symbolize the roots and independence personified in the isolated movement of the nomadic herdsman. Bailey used the shape of the traditional hat to create a dynamic image of contemporary African-American cultural self-assertion. Bright orange with a definite pattern of black running through the crown, the hat makes an emphatic statement which the wearer must be able to extend.

Zulu Princess echoes the dynamic rhythms found in African textiles, as well as the repetitive patterns of African mud-walled house exteriors. The strongly developed shape of the hat serves as a volumetric foil to the equally vibrant surface patterning of the hat. Bailey, who herself has never traveled to Africa ("only in my dreams"), has studied extensively the costumes, textiles, and traditional decorative dress of African women. Also a dollmaker and storyteller, Bailey creates intricately designed costumes for her doll characters each of whom has her own personal story relating to African and African-American history.

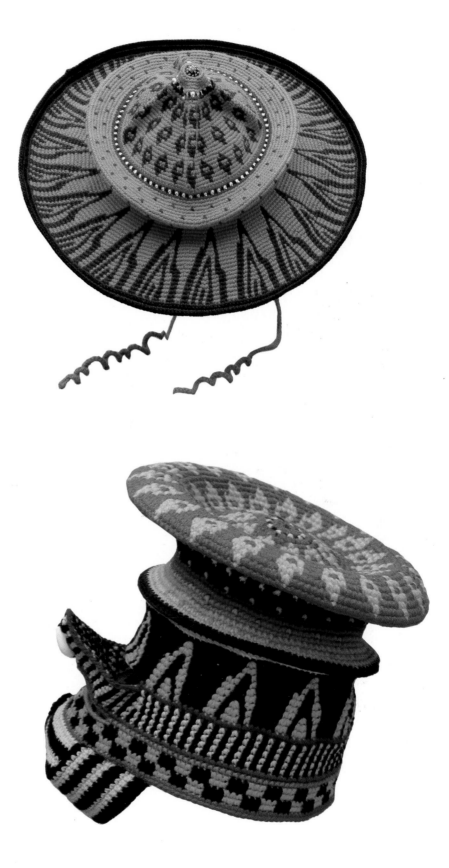

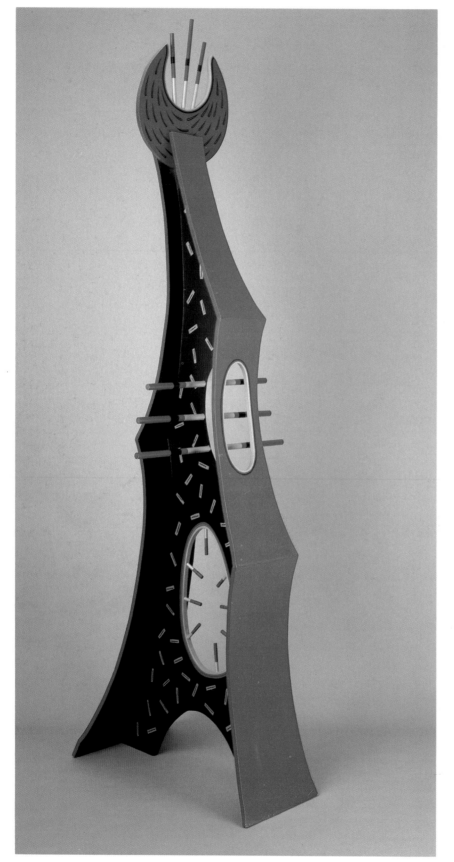

CHARLES SEARLES, *Warrior,* wood and acrylic, 1987. 114 x 18 x 36 inches. Lent by the artist.

Searles has successfully distilled into one image several attributes of the traditional African warrior. The crescent shape at the apex of the form calls to mind a headdress, while the central openwork area suggests arrows and shields. It is, however, the abstracted monumentality of the form which gives the work its psychological impact. The wide base gives it a sure-footed anthropomorphic quality, while the narrowness of the upper structure suggests lightness and agility, characteristics necessary for a warrior in battle.

JAMES PHILLIPS, *Spirits,* acrylic on canvas, 1986. 72¼ x 37¼ inches. Collection of Michael D. Harris.

In this strongly geometricized work, James Phillips indicates how he has been guided by the tightly controlled forms of African patterned motifs to create the emphatic, rhythmic abstractions that are decidedly his own. *Spirits* recalls the woven geometric motifs found in Ghanaian *kente* cloth and Central African design forms on Kongo cups and boxes. Merged with an unhesitant use of bold and contrasting colors, the patterns display a vibrancy that illuminates the canvas in waves. The artist, however, is not simply seeking to create a colorful duplicity of African pattern, but rather to explore the dynamics of those patterns and to translate them into a personal system of symbolic motifs. Through the expression of intense, unrelenting but everchanging rhythms, one feels the evocation of spirits, the spirits of those who have come before and who will one day follow. In facing the challenge of creating a visual counterpart to African and African-American music, the artist continues a tradition which has existed among black artists since Aaron Douglas began creating his codified images with concentric circles.

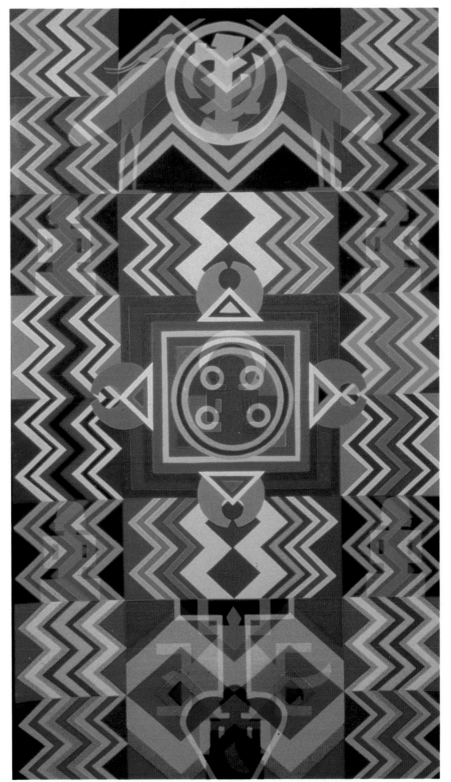

JAMES PHILLIPS, *Spirits of Resistance,* acrylic on paper, 1986. approx. 44 x 30 inches. Collection of the artist.

In a mandala pattern Phillips creates five tightly constructed circular motifs which depict Janiform ancestral figures who brandish the Benin *ewe,* the ceremonial swords of the great *oba* of Benin. Around the neck of each Janus figure is a serpent, referring perhaps to the serpent which adorns the top of the Benin palace. Similarly, terra cotta figures unearthed from Jedde, Mali bear serpents around their necks and torsos. The general patterning of the work includes strong triangular wedges which weave together the spaces around the five forms. The circles located in pairs within the circles and also around the edge of the dynamic patterns act as "eye" forms. These eye and mouth forms further enliven the surface, yielding an anthropomorphic presence to what initially seems to be simply strong geometric patterning.

VUSUMUZI MADUNA, *JuJu Blue* (above), wood, paint, and metal, 1978-79. 23 x 17¾ x 5 inches. Lent by the artist.

Maduna explores the mystery of the African mask in this work and gives it a deep blue spiritual countenance. The term "blue" refers not only to the color used in the work, but also to the colloquial expression "blue," as commonly associated with jazz and the blues. Because iron or any metal in African culture is considered superior to other materials, there is a sense of permanency or strength associated with the presence of nails and wire mesh in the work. Maduna adapts contemporary materials, such as bullet casings and tire rims, into traditional mask compositions.

VUSUMUZI MADUNA, *La Diablesse as Sentinel* (below, two views), wood and mixed media, 1987-88. 82¼ x 10¼ x 10½ inches. Lent by the artist.

La Diablesse as Sentinel is a majestic work in which the female form is transformed into a timeless figure of universal strength and mystical grace. Although the form itself is female, the blade-like head is abstract. The sharp blades and nails which are stuck into the form's hip area suggest a strength against adversity, a denial of pain. The mask form in the frontal pelvic area suggests that from this form will emerge a continuity of civilization.

207

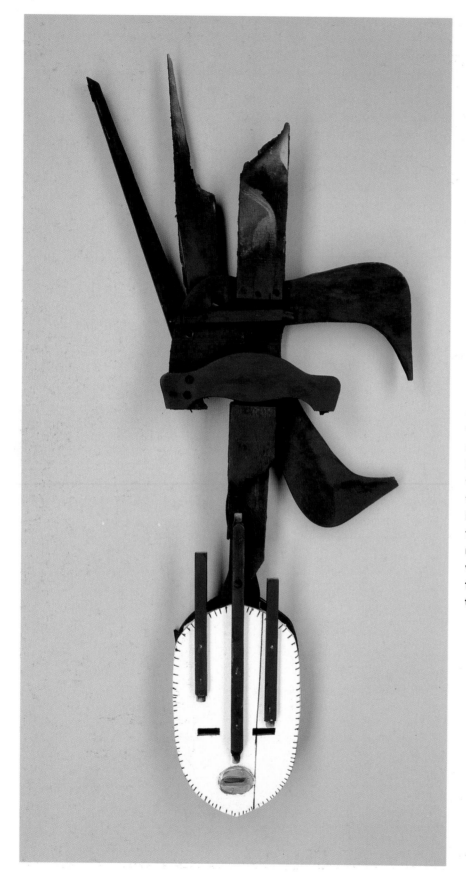

VUSUMUZI MADUNA, *Untitled,* wood and acrylic, 1980s. 47½ x 24 x 3¼ inches. Collection of Renée Stout.

Reminiscent of the Dogon *kanaga* mask in its use of a soaring superstructure, Maduna has given this mask a certain free-form content in its composition by the addition of seemingly random inter-secting planes of black. Like *JuJu Blue,* the effect is at once spontaneous and highly controlled. The roughness of plane edges is belied by the elegance of the stark black and white colors.

ADEMOLA OLUGEBEFOLA, *Emerging Spirit,* mixed media and collage on paper, 1970-71. 24 x 18 inches. Courtesy of Grinnell Gallery.

In *Emerging Spirit,* Olugebefola jux-taposes the brilliant colorations of blue, red, black, and white, the basic Yoruba ceremonial colors, to create an evocative work depicting spiritual birth. The artist's experience in *Weusi Ya Sanna* provides him with a sound frame of reference for this work and the ritual symbolism of these colors adds another level of mean-ing to the image. The colors, flamelike in their formation, acquire a deeper reso-nance in their close proximity. A kind of visual vibrancy is set up which emanates from the spiritual form upwards, beyond the edges of the paper.

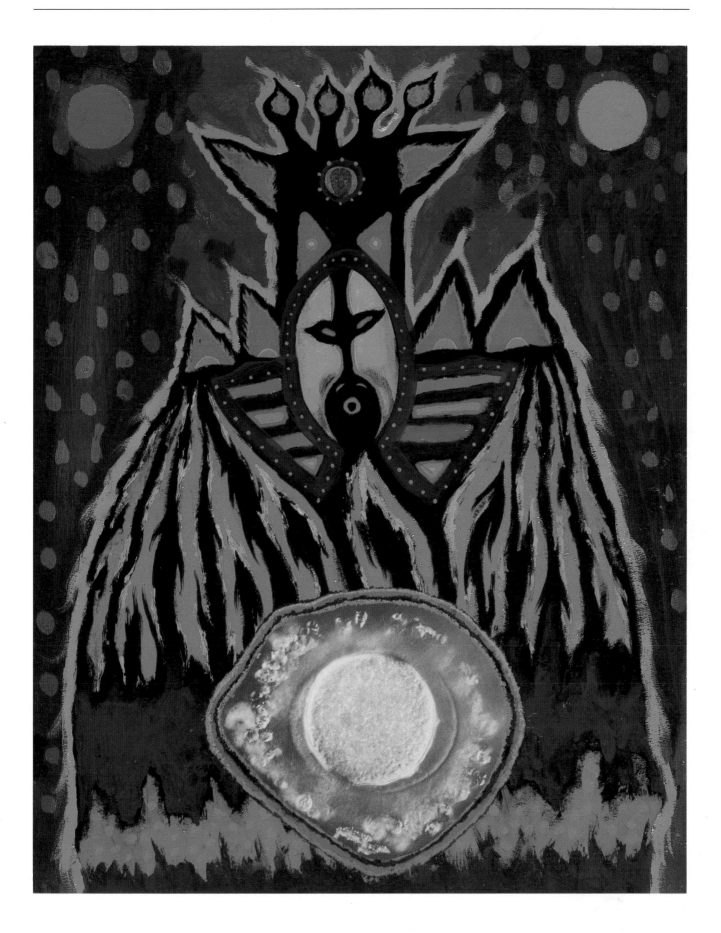

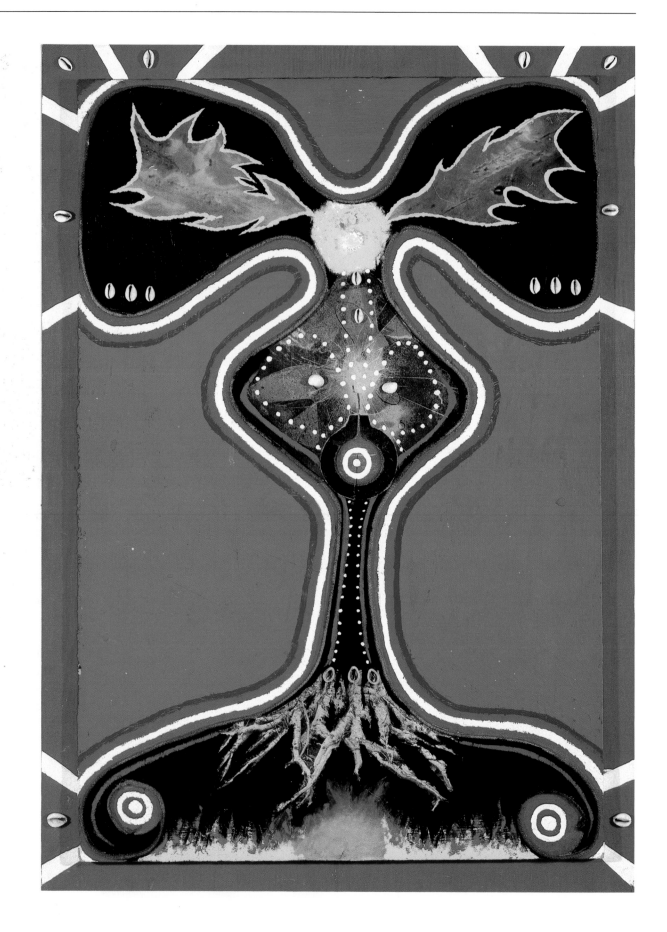

ADEMOLA OLUGEBEFOLA, *Shango,*
acrylic and mixed media on panel, 1969.
33 x 24 inches. Courtesy of Banks
Enterprise.

Through his involvement in the artist
group, Weusi Ya Sanaa, which promoted
the study of African culture, Olugebefola
has examined the diversity of deities
that exist within the Yoruba pantheon of
gods. Shango, the Yoruba god of
thunder, is here presented in mighty
glory, with an emphatic palette of
primary red and blue, while black and
white serve in strong visual opposition.
These are all fundamental hues in the
Yoruba ritual use of color in sculpture.
Olugebefola further adds to the ritual
use of materials by underscoring the
outline of the Shango form with a line
of cowrie shells. Known for their mone-
tary worth throughout Africa, and
having a ritual association with child-
birth traceable to ancient Nubia, these
shells frequently adorn divination instru-
ments used by Yoruba priests and often
were used in the divination activities
themselves. The internalization of the
flamelike forms lends the work an
internal dynamism which is appropriate
for a figure of the powerful god Shango.

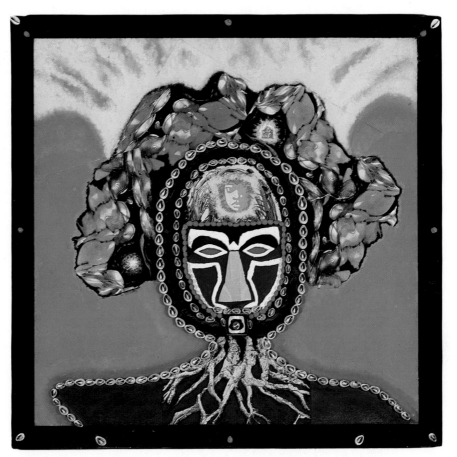

ADEMOLA OLUGEBEFOLA, *The Prophesy,*
acrylic and mixed media on panel, 1969.
28 x 28 inches. Courtesy of Grinnell
Gallery.

The Prophesy was used by Olugebefola
in a ritual play performed by the New
Lafayette Theater in New York City. The
artist uses mixed media and a dark
palette to create an air of mystery about
the mask-like form depicted in the
painting. There is no clear indication of
what the prophesy refers to, but the
adornment of the facial features with
cowries speaks strongly to the ritualistic
content of the work. The original
Lafayette Theater was a part of the
cultural activity of the Harlem Renais-
sance, during which time artists
performed dramas by black playwrights.
During the Civil Rights Movement the
New Lafayette Theater was organized
and works by a number of important
African-American writers were pre-
sented. Olugebefola served as artistic
director for the group and *The Prophesy*
was used in a scene for a play dealing
with African spiritual heritage.

211

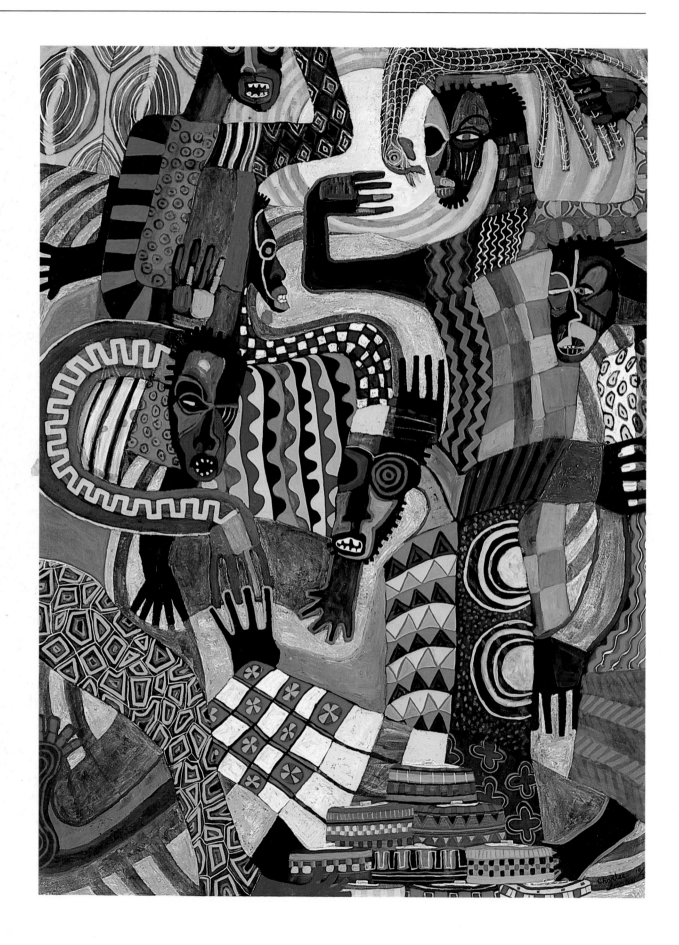

CHARLES SEARLES, *Filàs for Sale* (from *Nigerian Impressions* series), acrylic on canvas, 1972. 72 x 52 inches. Lent by the Museum of the National Center of Afro-American Artists, Inc., Boston

The African marketplace has become a frequent subject for the African-American artist. The filà, a brightly woven skullcap, is commonly sold in marketplaces throughout Africa. The energy of exchange and bartering and the overwhelming abundance of color and sound inherent to the marketplace experience is captured by Searles in this work. The vibrant colors and strongly interlocking anthropomorphic forms and textile motifs merge effectively with the large and self-assured scale of the work. The lack of horizon line in the scene and the positioning of the figures in opposing postures is the artist's visual interpretation of the bustle and flurry of movement which envelopes one in the heart of the market.

JAMES PHILLIPS, *Mojo,* acrylic on canvas (jute), 1987. approx. 114 x 66 inches. Collection of the artist.

The black background of this work creates a much more emphatic pattern than Phillips' geometricized works on a white ground. Experimenting with a black background led Phillips to discover that his zigzag motifs acquire a stronger resonance against the darkness. The scale of the work also adds to the impact. The movements of the repetitive patterns are reminiscent of Kuba textiles, while the interlocking motifs move across the picture plane with the rhythmical tightness of an African drum ensemble.

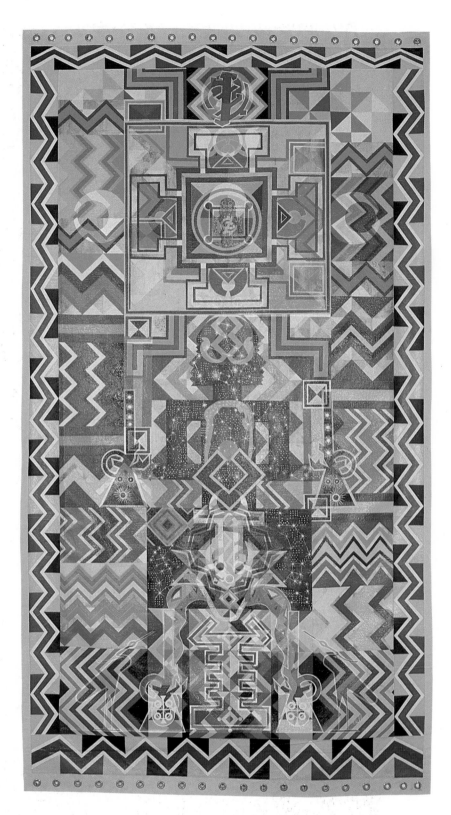

KOFI KAYIGA, *Fertility Mask,* **mixed media on cardboard, 1979. 7 x 9⅜ inches. Gallery Light Center, Cambridge, Massachusetts.**

Next to the white dotted mask hovers a black symbol in the shape of the Egyptian *ankh* hieroglyph. The form also suggests the *akuaba*, the doll of fertility among the Akan of Ghana which is almost identical in shape to the *ankh*. Duality of symbolism of this anthropomorphic image increases the richness of its underlying meaning.

KOFI KAYIGA, *Baboon,* **mixed media on board, 1979. 12¼ x 22¼ inches. Gallery Light Center, Cambridge, Massachusetts.**

Kayiga gradually develops his images from marks initially placed upon the surface. Many times he will stand and look at the work for awhile until, as in the case of *Baboon*, **he suddenly sees something which dictates the definition of the shape. Kayiga feels that this representation of the baboon may have its roots in his lifelong interest in Egyptian religion. At age 10 or 11, he became an avid reader of the Rosicrucian Digest which draws heavily upon Egyptian religious thought. This interest became even stronger when, as an adult, he traveled to London and visited the National Gallery, studying for days the Egyptian galleries. The artist feels** this gradual concentration of information on Egyptian culture may be partially responsible for his subconscious formation of the image of a baboon, the highly intelligent animal who was personified by the Egyptians as the god Thoth.

KOFI KAYIGA, *Moonlight,* **pastel on paper, 1987. 8¼ x 10½ inches (sight). Collection of Kofi Kayiga and Ivy Beckles.**

In 1974, Kayiga traveled to Uganda where he taught art at Makerere University and studied traditional African religions of the region. The artist witnessed a number of nocturnal ceremonies, including a marriage ceremony which lasted two days. It is this vibrant energy and imagery which serve as the inspiration for *Moonlight*. The work was done very quickly and the artist made a deliberate change of surface color to black. The darker surface gives a particular kind of intensity which he wanted, adding a dimension of immeasurable depth while retaining the flat dynamics of his graphic approach. Since *Moonlight*, Kayiga has done a series of works with a black background.

KOFI KAYIGA, *Rolling Calf,* mixed media on board, 1979. 22½ x 13¾ inches. Gallery Light Center, Cambridge, Massachusetts.

The story of the rolling calf is a familiar Jamaican folk tale. The creature was said to have roamed about the countryside, frightening young children. The calf, on the other hand, was afraid of shining car lights. That the creature described in the stories is a calf rather than a full-grown cow or bull has particular psychological significance since it is more unexpected that a seemingly innocent animal could take on monstrous qualities. In Kayiga's depiction of the calf, there is a wildness about the animal which is accentuated by its huge gaping eyes and mal-formed face and body. The distorted contours of the face seem to indicate a creature capable of changing shape at will. The calf seems itself fearful. With-out the structure of a community and the constraints of a society which would domesticate the animal, the calf roams in the wilderness, orphaned and wild, frightening to all who encounter it.

HOUSTON CONWILL, *Gutbucket,* mixed media, 1976. 13 x 12 (diam.) inches. Collection of the artist.

This work was a major component in a 1978 performance piece by Houston Conwill entitled *JuJu Installation.* The object takes its name from the gut-bucket used on farms to hold the innards of slaughtered animals. In the African-American vernacular, the term "gutbucket" refers to something that is very basic, common, or soulful, as in "gutbucket blues." On the exterior of the vessel Conwill has attached four "juju bags," objects which the artist considers protective packets in the tradi-tion of the Kongo *nkisi.* The sides of the bucket are textured with the artist's personally created hieroglyphs.

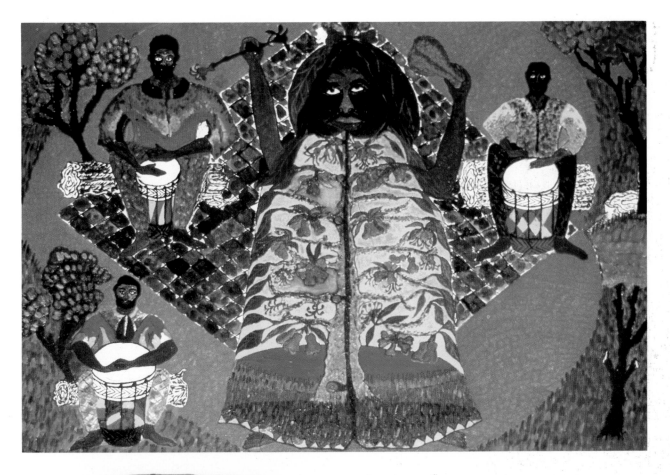

EVERALD BROWN, *Ethiopian Apple*, oil on canvas, 1970. 25½ x 35½ inches. National Gallery of Jamaica, Kingston. Photograph © 1989 Denis Valentine.

In this painting Brown refers to the importance of music, the drum in particular, as an expression of African continuity in the New World. It is the drum's rhythms which express some of the strongest cultural retentions in Caribbean life. The symmetry of *Ethiopian Apple* suggests a visual balance echoed by a balanced musical structure. The central figure emerging from the tree of life indicates that all aspects of nature are living spirits. It is from such a tree that the drum itself comes, and thus the drum is endowed with the spirit of that tree.

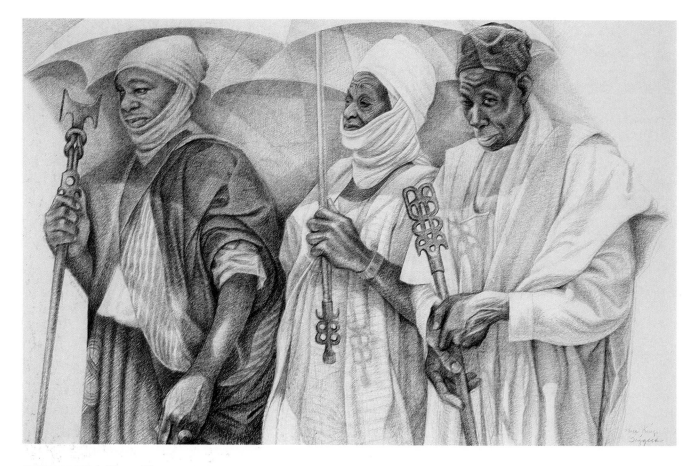

JOHN BIGGERS, *Three Kings,* conté and colored pencil on paper, 1960. 38½ x 59⅛ (sight) inches. Collection of Camilla Trammell, Houston.

As Barry Gaither has stated, *Three Kings* is one of the earliest portraits of Africans which conveys deep psychological presence. In this work the three elders personify wisdom. Their visages depict not the aggressive assurance of youth, but rather the spiritual wisdom, inner strength and total humility which is acquired only with age. This single drawing counters the stereotypical images of black men common in America during the early twentieth century. Gracefully bearing the panoply of their royal rank, the umbrella and the staffs with royal knots, the three men become metaphors for the beauty and antiquity of African civilization.

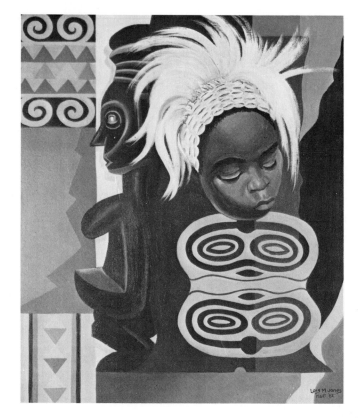

LOIS MAILOU JONES, *Initiation - Liberia* (right), acrylic on canvas, 1983. 35½ x 23½ inches. Collection of the artist.

In *Initiation-Liberia,* Jones interprets the Sande society initiation ritual which requires of its initiates the public performance of dances and rites which they have learned as part of social maturation. With her ritual swath of white paint across the eyes indicating her role as an initiate, the girl effectively becomes a ceremonial object, a part of a tradition much larger and more powerful than her solitary self. In her performance in the Sande society, the girl leaves behind her everyday self and gives herself over to the power of the drums and the rhythmic demands of the *shake-rai*. This humbling of her spirit both frees and elevates her to her fullest capacity. In obeying the drum, she expresses her own strong will and spirit. Lois Jones focuses upon the cerebral connotations of this act and, in so doing, condenses the image of the initiation to a vibrant facial image.

LOIS MAILOU JONES, *Petite Ballerina,* acrylic on canvas, 1982. 42 x 36 inches (framed). Courtesy of The McIntosh Gallery, Atlanta, Georgia.

In *Petite Ballerina*, the artist uses the image of the young female initiate as she appears in a dance headdress of cowrie shells and monkey hair. The female ancestor figure which Jones has juxtaposed against the image of the young girl indicates that the ancestral past is a link between generations of creativity. Though she may only dance for the moment and under the keen scrutiny of her elders and competitive peers, the young dancer will soon take her place among the mature women of her community and from there will pass on into the realm of her ancestors.

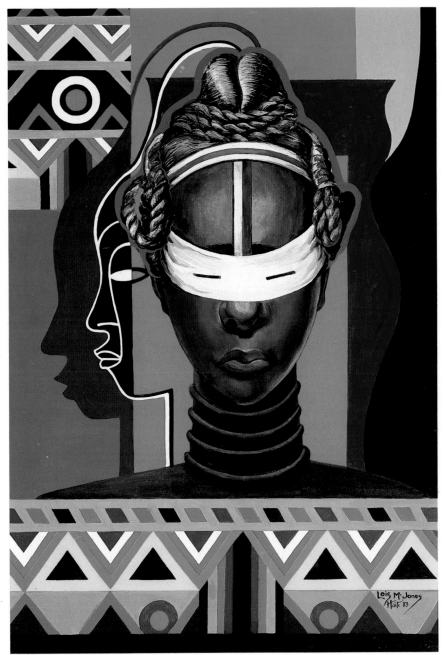

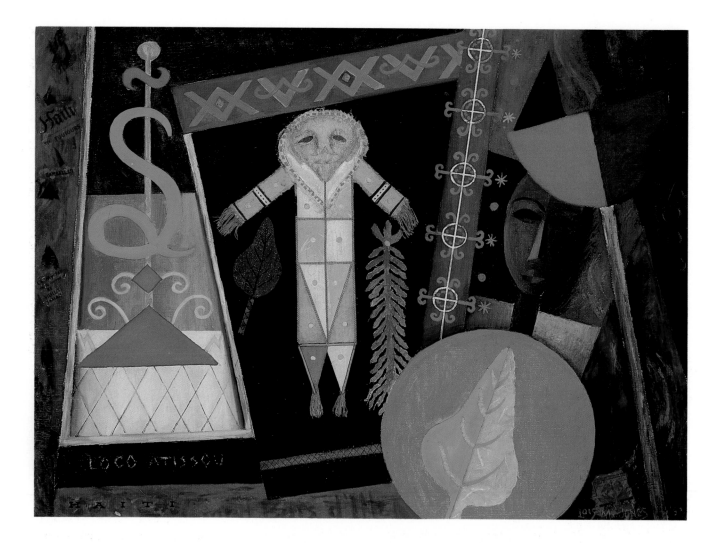

LOIS MAILOU JONES, *Veve Voudou III,* oil and collage on canvas, 1963. 30 x 38⅝ inches. Collection of the artist.

LOIS MAILOU JONES, *Magic of Nigeria* watercolor on paper, 1971. 33¾ x 22 inches. Collection of the artist.

The impact of Haitian religious culture is profoundly interpreted in *Veve Voudon III*, as Lois Jones places upon a black background a number of religious *veve* symbols which are associated with the *vodun* religion. The serpent, Damballah, shown here winding itself up a staff, is the sacred snake ritualized by the Yoruba of Nigeria and the Fon of Benin. The work is part of her series exploring *vodun* symbolism and represents her interpretation of an environment which

she finds closely akin in spirit to West Africa. Lois Jones, who lives part of her life in Haiti, recognizes the strong impact of *vodun* upon African-American art.

The combined images of mask, textile patterns and functional objects in *Magic of Nigeria* create for Jones a powerful grouping which is at once jewel-like in its texture and strongly graphic in its composition. The work focuses upon the intricacy of form and volume. As a graphic artist, Lois Jones demonstrates particular sensibility when it comes to approaching the work of African artists. For her, the "magic" alluded to in the title resides not only in the functions of the ritual objects but also in their singular beauty.

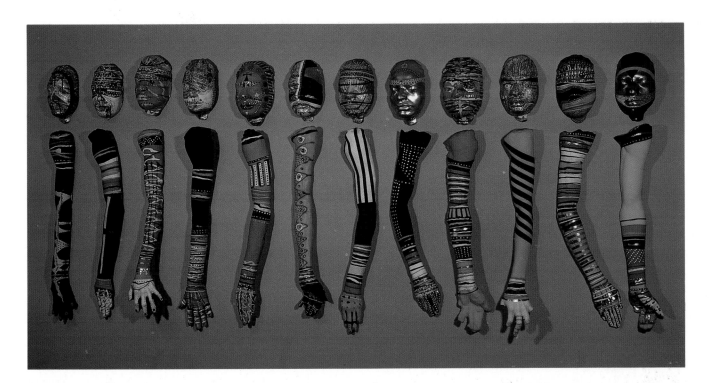

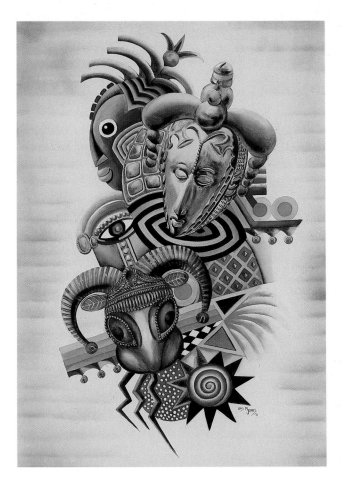

BEN JONES, *Black Face and Arm Unit,* plaster and paint, 1971. Life size. New Jersey State Museum Collection Purchase, FA 1984.92 A-X.

The twelve-unit black face and arm sculpture created by Ben Jones has become a classical statement of African-American art. The work celebrates the recognition of the black body as a temple of creativity. Like jazz musicians improvising on the same theme, each face and arm element has distinctive patterns which make them visually unique. The ensemble has its greatest impact, however, as a visual chorus, each element contributing a slight variation within the grand and rhythmical repetition. The surface markings upon the faces and arms suggest the customs of body painting and scarification. In his travels to West Africa, Brazil, and the Caribbean, Jones became sensitive to the importance of body adornment within black culture.

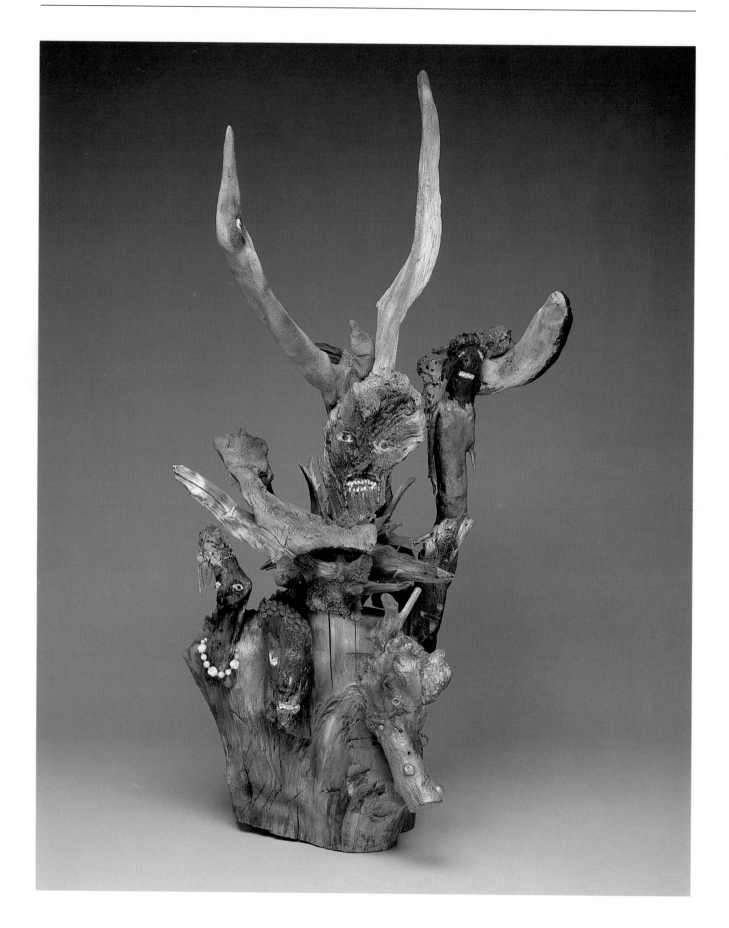

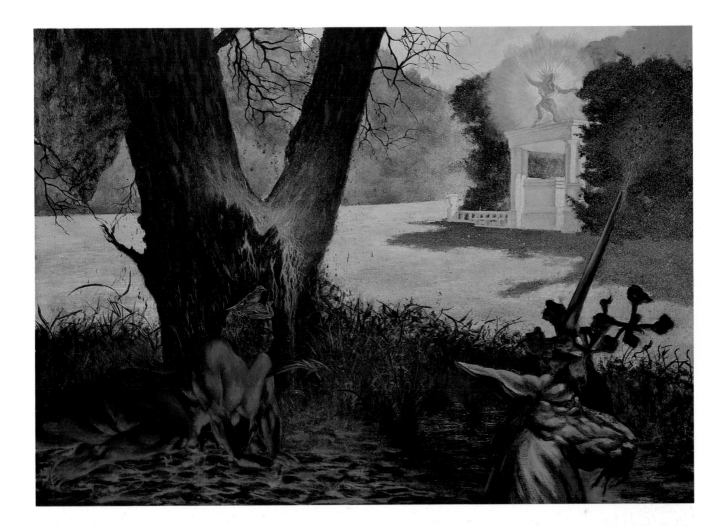

BESSIE HARVEY, *Tribal Spirits,* wood and mixed media, 1988. 45 x 26 x 20 inches. Dallas Museum of Art, Metropolitan Life Foundation Purchase Grant.

The sculptures of Bessie Harvey express a sense of assuredness, an unerring exploitation of her natural materials which makes them visually compelling. Her ability to build upon a central core and retain a sense of monumentality amidst additive whimsy is strikingly demonstrated in *Tribal Spirits*. The work expresses Harvey's interest in her own past as well as that of African-Americans, and, ultimately, all people. The bird which soars above the group is said by the artist to be removing conflict from the midst of humanity.

BERT SAMPLES, *Jubilee, Jubilee,* acrylic on board, 1983. 36 x 48 inches. Collection of Bert Samples.

The duality of European and African cultures is the underlying theme of this painting. Peering from behind a tree is the goddess of the earth, wearing a diadem, and representing the mysteries of women, their feminine nature as personified in Ishtar, Venus and Isis. The ample form of the figure and her mode of dress call to mind the ancient queens of Nubia, whose great forms grace the walls of temples at Karnak. From the privacy of the forest this mysterious figure, regal yet earthbound, gazes onto a clearing where a white figure glows amidst a circle of columns in a formal garden. The female figure seems to be a part of the earth itself, her pendulous breasts grazing the ground as she moves across the damp, fertile earth, red with the blood of birth. The shaman at the top of the mausoleum represents the sun worshippers and the powers of the sky while the woman represents harvest and lunar movements. Together the figures are two personifications of power. The title of the work is itself a celebratory chant, an explosive word with spreading energy.

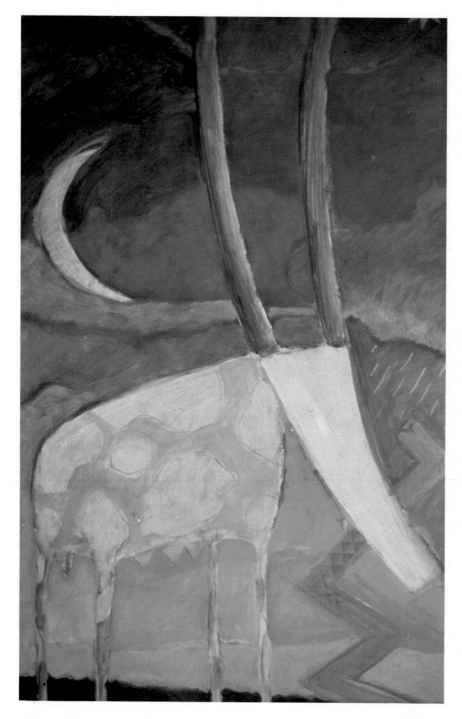

RIP WOODS, *On This Night the Snake Will Not Get Wet* **(left), acrylic on paper, 1988. approx. 40 x 30 inches. Collection of the artist.**

RIP WOODS, *Cows Never Wear Masks,* **charcoal on paper, 1988. approx. 30 x 40 inches. Collection of the artist.**

A reference to the serpent in the title indicates Woods' continuous exploration of the mystical presence of animals. The serpent and the cow here interact in a way that reflects a certain kind of understanding between them, a kindred intelligence which is shared in the animal kingdom. The relationship between animals, which Woods is so sensitive to, is an awareness that many African-Americans have kept with them through the African and African-American folk tale. Particularly in the South and the Caribbean, many of the tales about the spider, the cow and the snake have their roots in story cycles such as the Ananse tales of Ghana.

The association of the cow with a masking tradition makes reference to the animal's mystical presence. Woods seems to suggest that the cow is mysterious enough in its own right not to seek transformation through masking. The darks and lights of the charcoal on paper add to the haunting quality of this work. The broad manner in which the artist places the forms of the cow and the background blends the animal completely into its environment in a way that reaches spiritual dematerialization.

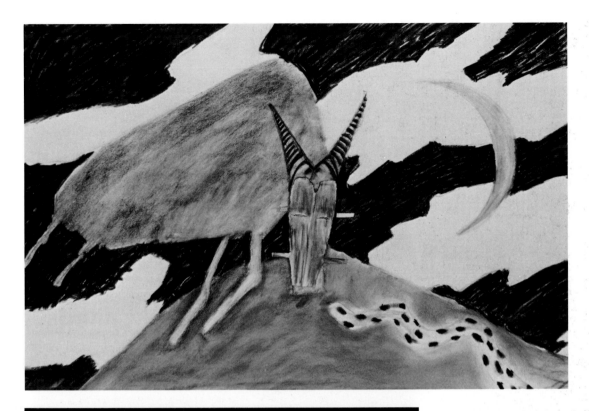

MR. IMAGINATION, *Self-Portrait as King,* sandstone and paint, 1988. 3 x 1½ x 1½ inches. Collection of Mr. Imagination.

The self-portrait is one of the most revealing results of the movement by African-American artists to express "roots" in their art. Although Mr. Imagination has not traveled to Africa, he follows in the tradition of self-taught black scholars who have studied African and African-American history. Because much of his work is considered popular art for the person on the street (he sells a number of works such as this on a daily basis) rather than "high" art for the serious art collector, the work of Mr. Imagination indicates another avenue by which the African Diaspora is spread. Popular imagery sold by Mr. Imagination in the form of pins, charms, and even Christmas ornaments, is a way of heightening the public's consciousness of the antiquity of their heritage.

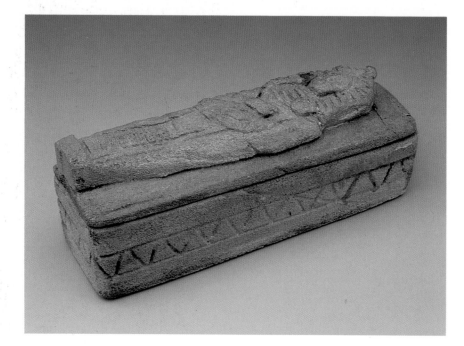

MR. IMAGINATION, *Pyramid with Eye,* sandstone, 1986. 9¾ x 10¼ x 3¼ inches. Collection of Mr. Imagination.

MR. IMAGINATION, *Egyptian Sarcophagus* (2 parts), sandstone and paint, 1986. 2 x 9⅝ x 3 inches (top); 2¼ x 9¼ x 3 inches (bottom). Collection of Mr. Imagination.

A major focus of the Egyptian pyramid was the preservation of culture, the reaffirmation of one's spiritual presence within a physical construct whose geometry is solid and enduring. The basic and monumental shape of the pyramid, as well as the exactitude by which it was constructed, are among the structure's qualities which impress Mr. Imagination. His own inexactitude in creating this sculpture — the sides of the pyramid gently swell rather than form perfectly acute angles — presents an individualized approach which makes it a personal reinterpretation of the pyramid rather than simply a scale model. Similarly, the eye at the top of the pyramid is the artist's personal addition to the structure representing both the all-seeing spiritual eye representing the impenetratable mystery of the pyramid and his distinctive hieroglyphic signature.

Mr. Imagination, who is particularly interested in reincarnation, utilizes the sarcophagus as a symbol of death and spiritual rebirth. His use of blue and gold, regal colors, add an air of formality to the work. The small scale invites close study, and in this intimate encounter, one confronts one's own mortality. It is the Egyptian's highly ritualized manner of regarding death that intrigues the artist. He considers Egypt one of antiquity's richest cultures and finds the Egyptian embrace of death as part of the cycle of life, a human affirmation of existence that is calming.

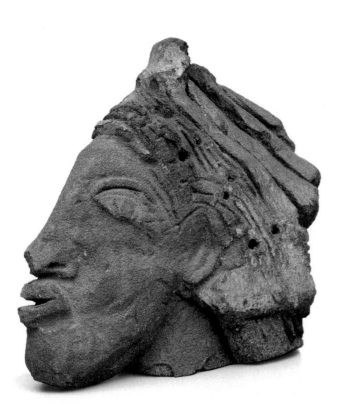

MR. IMAGINATION, *African King,* **sandstone and paint, 1980. 10 x 5½ x 11 inches. Collection of Mr. Imagination.**

The face of this work, carved in narrow profile, suggests a man aged and learned. The exaggerated extension of his chin and nose are reminiscent of the profile of pharaoh Akhenaten. The artist chose to sculpt only the head of a king rather than a complete torso. This makes the work seem like a fragment from a larger sculpture, suggesting the ravages of time. The faded polychrome of the work also suggests exposure to the natural elements and a sense of age. By alluding to a larger environment in which this sculpture was placed, Mr. Imagination creates an index of time for the work quite different from the one of reality.

MR. IMAGINATION, *African Princess,* sandstone, paint and mixed media, 1985. 17½ x 10½ x 5¾. Courtesy of Carl Hammer Gallery, Chicago, Illinois.

The *African Princess* with her dreadlocked hair and metallic choker is the artist's representation of the African presence in the black woman. Using found materials, the artist presents to the viewer a vivid profile whose mass of dark hair, bright eye and mobile shell earring creates a persona of strong clarity. That he made only half the face of the Princess (the flat half bears his signature) indicates that the artist is content to give us one simple, strong impression of the woman's presence. The sandstone readily lends itself to an expression of monumentality which combines to balance the sense of forward movement created by the angle of the neck, the penetrating forward gaze of the eye, and the flow of hair to her neck.

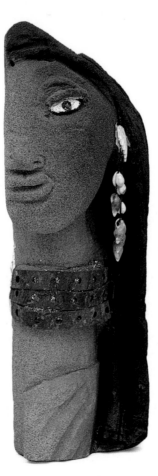
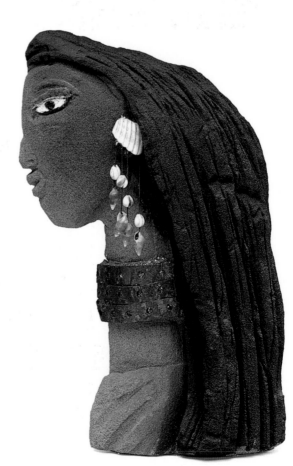

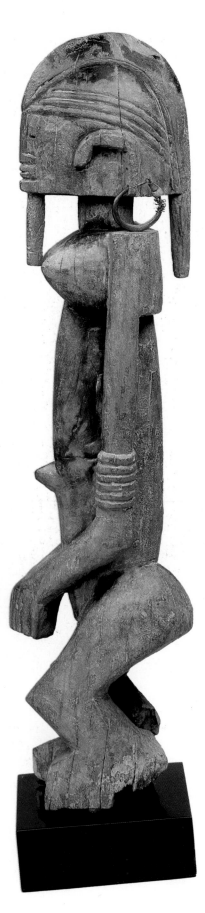

UNKNOWN ARTIST (Mali: Dogon), *Standing Female Figure,* wood, metal, beads and patination, late 19th century. 22⅞ x 4½ x 5⁹⁄₁₆ inches. Dallas Museum of Art, The Gustave and Franyo Schindler Collection of African Sculpture, gift of the McDermott Foundation in honor of Eugene McDermott (1974.SC.5).

This ancestral figure displays the rigorous geometric balance of Dogon sculpture. The figure's arms, raised upward, represent the movement of the original ancestors from the heavens to the earth. They also serve as a reference to the fall of rain along that same path. The Dogon, in particular, have been a source of study for a number of African-American artists because of their intricate cosmological system. Not only do works of African art distinguish themselves as masterful expressions of three-dimensional form, the cultural legacies surrounding their creation provide a number of black artists with an unending source of inspiration.

LEON RENFRO, *Egyptian Bulls,* pen and ink on paper, 1987. 14 x 24 inches. Collection of Leon Renfro.

Renfro's bulls do not exist in space or time but instead are emblematic of the great bull/procreator of antiquity. The sacrificial nature of the cow and bull has spread through the African continent, adding to the sacred nature of these animals. In both African and African-American folk tale and mythology, the bull occupies a position of great significance. In *Egyptian Bulls*, Renfro has deliberately removed these animals from any sense of reality, and the pale coloration of yellows and golds creates an other worldly quality. As masked bulls, they become symbols of an ancient civilization. The Egyptian connotation is probably a result of the artist's investigation of Egyptian art and culture, where images of the pharaoh's cattle are frequently seen on the walls of ancient tombs. These bulls represent mates for Hathor, the great cow goddess who watched over the families of Egypt.

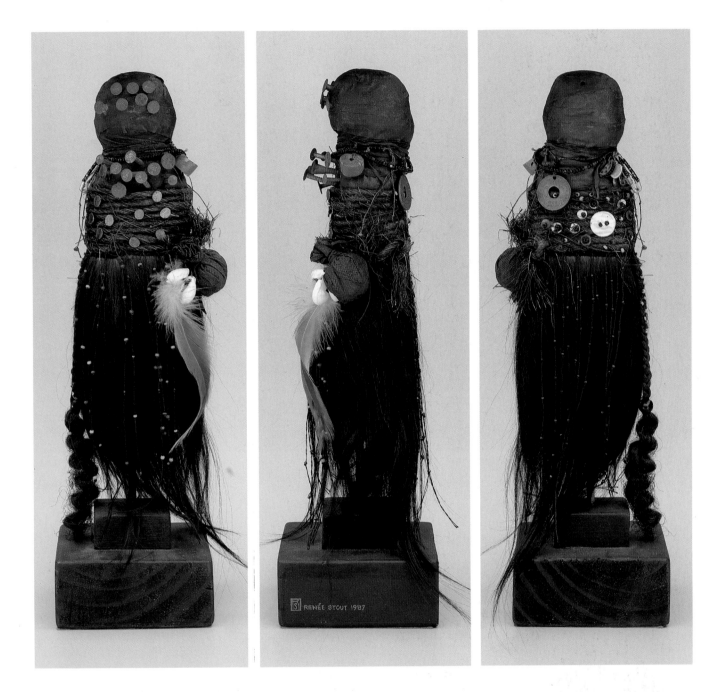

RENEE STOUT, *Fetish #1* (three views), mixed media, 1987. 12¾ x 3½ x 3½ (including base). Collection of the artist.

The Kongo ancestral figure is the inspiration for Renée Stout's *Fetish #1*. The artist's interest in African art focuses upon both the additive and textural components of central African sculpture, as well as its sense of contained power. Her mixture of authentic materials such as monkey hair, nails and cowrie shells are coupled with her own found and collected beads and coins. Because of her sensitive attention to detail, the work presents itself as a haunting echo of an African ritual object. Its sense of mystery is further heightened by the deliberate omission of facial features. Stout reinterprets classical African forms as a means of conveying that mystical presence which she finds inherent in many aspects of African-American culture. Influenced by the art of Betye Saar and the writing of Robert Farris Thompson, Stout has also found inspiration from those many practitioners of folk medicine who live in her Washington, D.C. community.

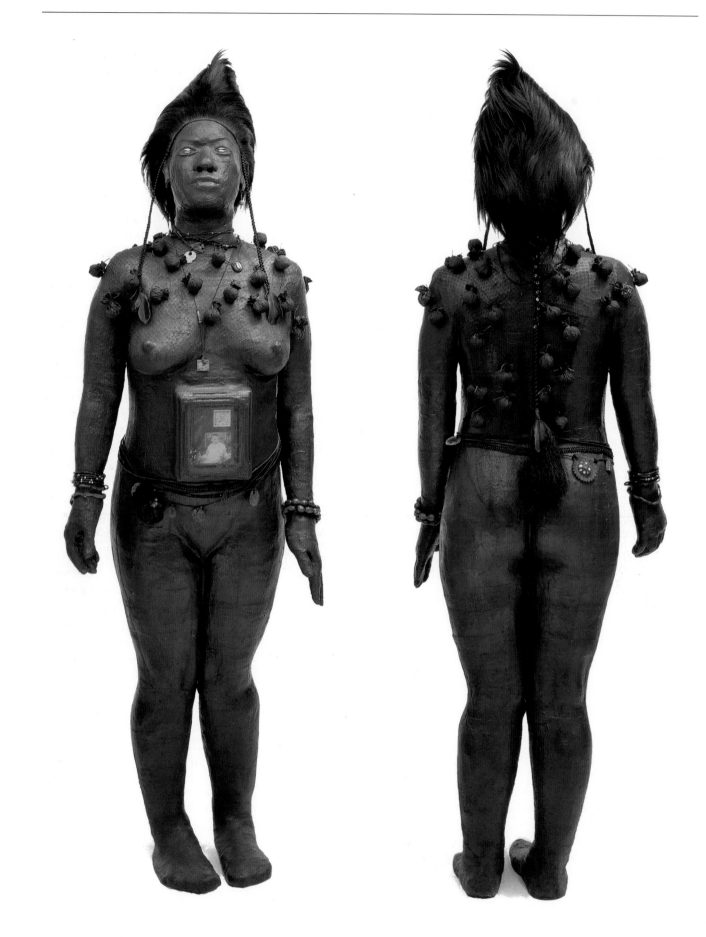

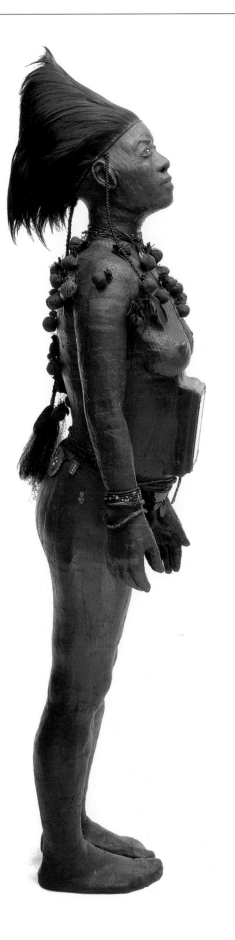

RENEE STOUT, *Fetish #2*, mixed media, 1988. Height 63 inches. Dallas Museum of Art, Metropolitan Life Foundation Purchase Grant.

In this dramatic work, Renée Stout has developed an ambitious visual idea, i.e., the interpretation of self as a figure of empowerment. Stout boldly presents herself as a life-sized *nkisi* figure enshrouded in those accoutrements of power and magic which are characteristic of this Central African sculpture. *Nkisi* is the name given to a traditional fetish figure made by the Yombe of Zaire. The glass or mirror which covers material in the abdomen signifies the possibility of seeing beyond visible objects.

In a process which took several months, the artist cast her own body in plaster and then painted the mold with several layers of black paint. A mesh collar holds medicine bags while in the glass-covered "medicine pouch" of the torso is placed a Niger stamp, dried flowers and a picture of a young black girl. Cowrie shells are used to define the eyes of the figure, braided extensions adorn her head, and a pelt of monkey hair forms a dramatic headdress.

Her accuracy in conveying the proper size, texture, and shape of the traditional accoutrements indicates her sensitivity to original form, and thus her understanding of the spiritual importance of these assembled materials. In *Fetish #2*, Stout addresses directly her sense of power and possibility. The slightly upturned gaze of the figure yields an unmistakable air of conviction, much like Sargent Johnson's sculpture *Forever Free*. In her brilliant execution of idea, Stout creates a sculptural *tour de force*.

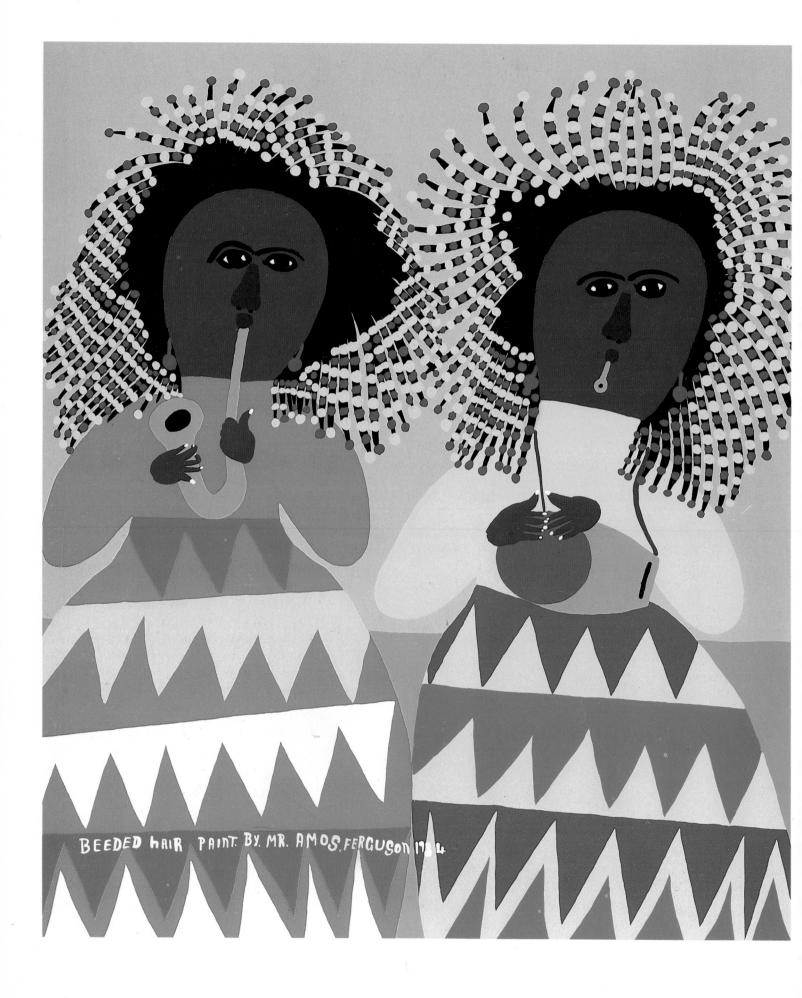

:: FESTIVAL :: AND RITUAL

The impulse for public expression in African–American art has deep roots in African tradition. The African call-and-response in religious ceremonies, those communal cultural experiences which involve music, drama, and costume as well as visual arts and crafts — all were fundamental aspects of African life, represented for example in the Yoruba *eshu* festival and the Bambara *tyiwara* harvest dance. In the New World, these African traditions manifest themselves in Caribbean and American festivals such as Junkanoo, Mardi Gras, and Kwanzaa. Similarly, art produced for these festivals is regarded as simply one of a number of artistic components which combine to create an exciting public ritual.

The presence of music at such events is not simply to provide entertainment, but to elevate the ceremony to another level of spiritual involvement. Drumming, in particular, creates rhythms which intensify call-and-response patterns between dancers and musicians. In turn, the theme of dance has become an important metaphor among African-American visual artists, who regard the practice as a spiritual celebration of self. Similarly, the mask, which is donned in public dance rituals in many parts of Africa, is widely recognized by African-American artists as a recurring symbol of transformation and spiritual energy.

The acknowledgment of self as the purest expression of creativity can be seen in the work of many African-American artists, such as in Ben Jones' *Black Face/Arm Unit* (1971) and *Stars II* (1983). Xenobia Bailey's strikingly adorned hats are less a statement of fashion than crowns for the head, the center of the body according to the Yoruba. David Philpot's staffs yield a ceremonial presence to those who carry them and are much in the tradition of African royal panoply. Just as the music played for ritual and festival is more than entertainment, so, too, do these works of art serve as more than mere decorative body adornment; they add ritual

significance, bespeak rank and status, and a sense of the precious inner spirit found in the wearer.

In the Caribbean, musical festivals are public expressions of sacred religious beliefs. As such, these festive ceremonies represent some of the strongest parallels of African culture found in the western hemisphere. Haitian *vodun* ceremonies have inspired such African-American artists as Lois Jones and James Phillips, both of whom incorporate *veve* symbols in their paintings. Many Haitian works of art, including *vodun* flags, are themselves ceremonially charged with spiritual energy when "walked" during a ceremony.

The temporal quality of rituals and festivals of the Diaspora pose a special challenge and attraction to African-American artists. Faced with a fleeting moment, an ecstatic passage of time, many artists choose to depict in narrative fashion scenes from festivals as in Charles Searles' *Dancer Series* (1975) or Osmond Watson's *Revival Kingdom* (1969). For John Landry, capturing forever the color and festive nature of Mardi Gras Zulu floats in his beaded miniatures was an ingenius way of freezing in time this carnival celebration. For Ed Love, the ultimate challenge

was to translate visually the tradition of African-American music; his kinetic and colorful *Arkestra* (1984-1988) conveys a strong sense of rhythmical African references, improvisational spans, and finely tuned harmonies.

Ritual and festival ultimately return to the sound of the drum, and it is the rhythmic drum patterns which challenge African-American visual artists for interpretation, and poets such as Ted Wilson for description:

Mighty Drums echoing the voices
of Spirits determining the movement
of human forms
These sounds are rhythmatic
The rhythm of vitality,
The rhythm of exuberance
and the rhythms of Life
These are sounds of blackness
Blackness — the presence of all color.

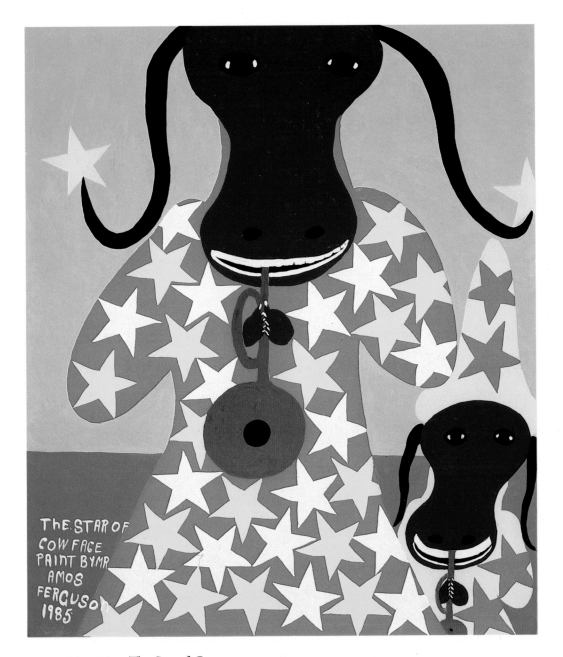

THE STAR OF
COW FACE
PAINT BY MR
AMOS
FERGUSON
1985

AMOS FERGUSON, *The Star of Cow Face,* **house paint on cardboard, 1985. 36 x 30 inches. Ute Stebich Gallery, Lenox, Massachusetts.**

The graphic strength of this work derives from the flat application of paint and the artist's highly stylized formation of figures. In the painting, Ferguson depicts the face of a cow in close view, focusing upon the cow's highly animated expression. The star marking on the cow has particular significance for Ferguson, who emphasizes its presence as a form of distinctive character.

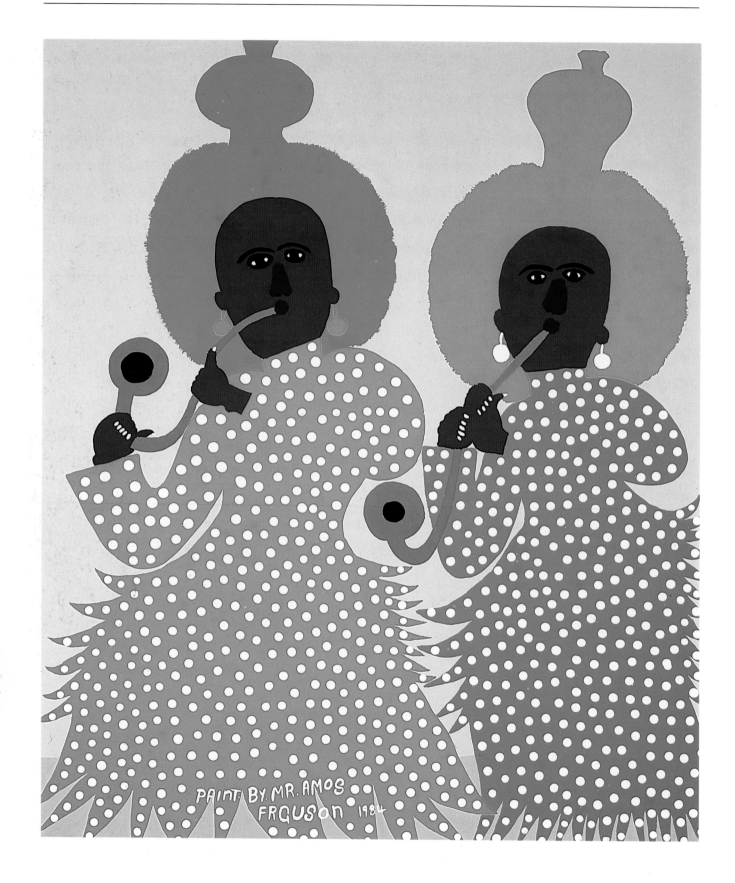

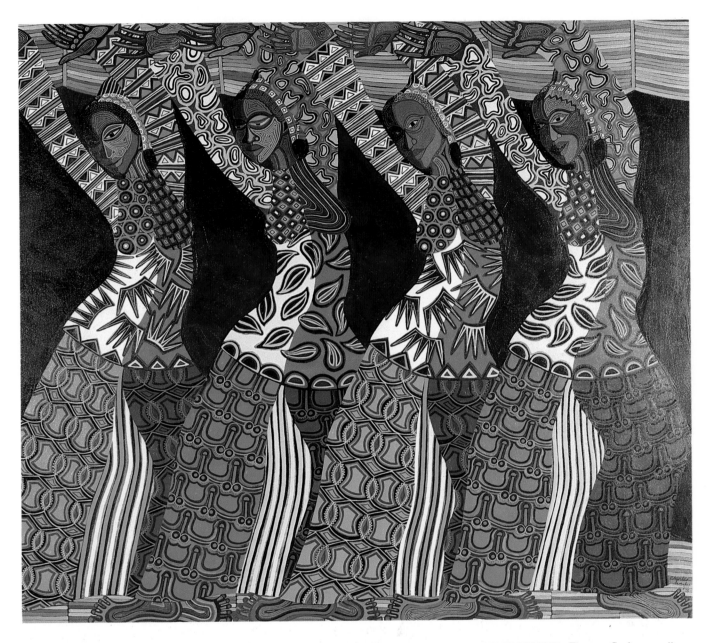

AMOS FERGUSON, *Polka Dot Junkanoo,* house paint on cardboard, 1984. 36 x 30 inches. Collection of Geoffrey Holder.

The Junkanoo festival celebrated in the Bahamas originated as a British observance of the explorations of seaman John Canoe. Gradually, the European holiday merged with Caribbean and African sacred festivals and became known as "Junkanoo." Ferguson depicts two Junkanoo figures, both wearing polka dot dresses and headdresses, and both playing ornately curved pipes. As is typical of Ferguson paintings, the background is a simple and flat sky blue. The inversion of costume colors (one wears a blue headdress and orange dress, the other an orange headdress and a blue dress) creates a tight visual interweaving of the forms, which underscores the unison in which they appear to play their horns. The gay and festive nature of the design suggests that these two musicians are part of a much larger celebration, whose participants are as numerous as the polka dots on the clothing.

CHARLES SEARLES, *Dancer Series,* acrylic on canvas, 1975. 65 ⅛ x 75⅛ inches. Collection of Dr. and Mrs. Maurice Clifford, Philadelphia.

As a result of his 1972 trip to West Africa, Charles Searles created a series of paintings focusing on the movement and meaning of African dance. In this work, Searles captures a series of dancers whose synchronized movement across the picture plane recalls figures in Egyptian wall paintings.

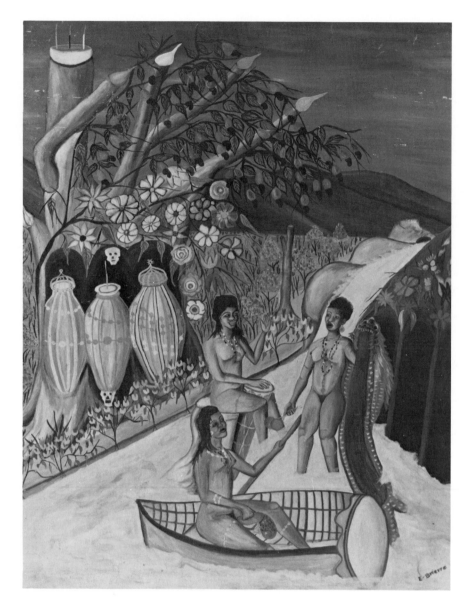

GABRIEL BIEN-AIME, *La Sirène and Damballah,* **cut and forged iron, 1973. Height 22½ inches. The Flagg Collection, Milwaukee.**

La Sirène, Haitian goddess of the sea, is here paired with Damballah, the serpent and god of life who intertwines himself around a tree. This tree of life is inhabited by other spirits whose faces emerge from its branches. Bien-Aimé effectively brings together earth and water, two major forces in the Haitian pantheon of the powers of nature. Holding an *assan,* the ritual shaker, in her right hand, the sirène serves as the celebrant in the ceremony. The juxtaposition of Damballah with the female water spirit stresses the fact that Damballah is known to dwell in water holes, rivers and beneath the roots of the great *mapou* tree. The conviviality in which all seem to co-exist beneath the branches of the tree of life indicate that a divine state of bliss is reached when all of these forces are in balance. The cross formations which combine to create the branches of the tree are patterned after the iron cemetery crosses for the vodun spirits of the dead.

EDGAR BRIERRE, *Three Female Figures in a Stream,* **oil on masonite, c. 1968. 16 x 19⅞ inches. The Flagg Collection, Milwaukee.**

The healing property of water and its intimation of spiritual renewal are shown in this work. The painting probably refers to the annual Haitian ceremony at Saut d'eau waterfall. Each July 16, many Haitians make a pilgrimage to Saut d'eau and women go under the powerful waterfall for rejuvenation. Like the women in the painting, they tie string around their waists before entering the waters. A strong connection can be made between the subject of this work and the African-American religious ceremony of baptism, which frequently takes place in a natural water source in the South. Nature can be read here as a metaphor for the nourishment of the human spirit.

MURAT BRIERRE, *La Sirène Conveyed by Two-Headed Goat,* **cut and forged metal, 1970. 35⅝ x 22¾ inches. The Flagg Collection, Milwaukee.**

The art of fashioning figures from cut metal is widely practiced in Haiti. As a draftsman, Brierre approaches his technique in a different way from most Haitian artists who work in metal. Brierre creates carefully rendered preparatory drawings which he then traces onto the metal, rather than cutting the metal directly. In this work, Brierre creates a mythical being, a goat with two heads, to transport a spirit or sirène on her journey.

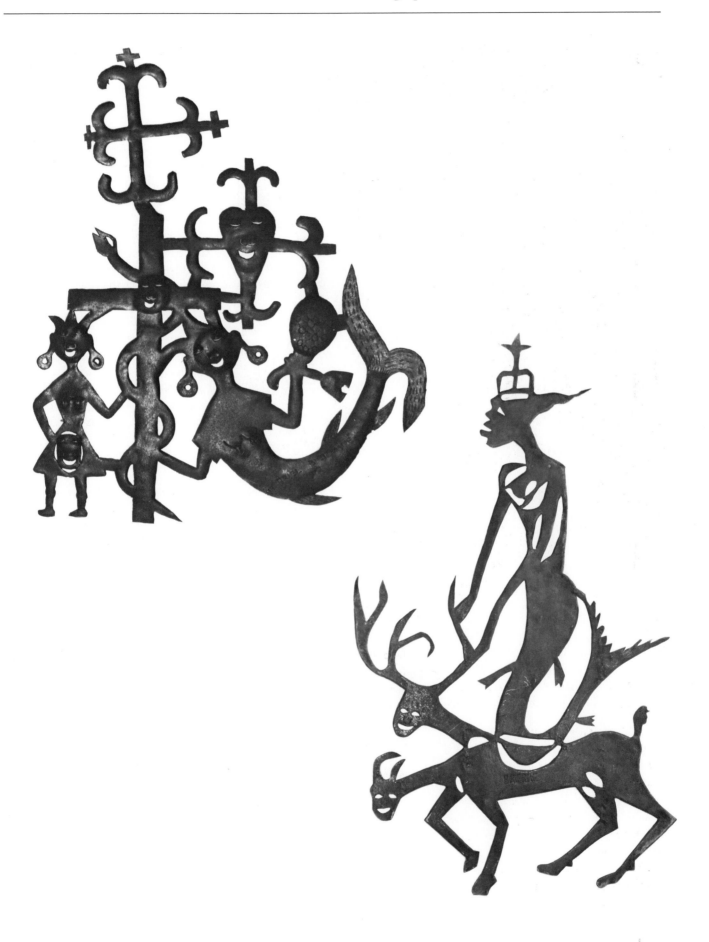

GEORGE SMITH, *Dual Kanaga,* **steel, paint and oil stick, 1985. 27 x 32 x 8 inches. Collection of the artist.**

In this work George Smith pays tribute to the Kanaga ceremony of the Dogon of Mali which generally occurs upon the death of an elder of the village. The Kanaga mask reinterprets the movements of the great crocodile, who was said to have led the Dogon through the Bandiagara escarpment and to their first source of water after a long journey from the heavens to earth. The Kanaga mask has a superstructure attached to it which is painted black and white and has four crossed wooden slats representing the crocodile. Smith has taken the basic Kanaga form and reinterpreted it by giving it his own ritual application of white paint. This work represents one in a series which Smith created in honor of the Dogon.

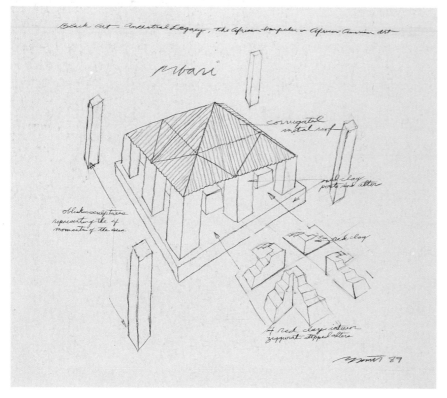

GEORGE SMITH, *Mbari Installation,* **black marker on paper, 1989.**

Based upon the *mbari* shrine of the Ibo people of Nigeria, George Smith has created an African-American artist's interpretation of this traditional public shrine of West Africa. The *mbari* was built periodically by Ibo villages whenever it was felt that a community needed spiritual renewal or strengthening. Generally, the *mbari* would be constructed after a period of drought, disease or other major challenge to the community's natural order. Smith's *mbari* structure will travel with the exhibition to other venues and will be the focal point of a number of celebrations by the African-American community in each city. As the decoration of the shrine was traditionally done by village members, community members will create small shrine offerings to be placed in the *mbari* at each site.

GEORGES LIAUTAUD, *Male Spirit,* **forged metal, 1950s. 31 x 9⅛ x 9⅛ inches. Ute Stebich Gallery, Lenox, Massachusetts.**

The male spirit of this work rises above the food offering bowl, suggesting the movement of ascension, the lifting of oneself out of one's physical being which occurs to the participants of vodun ceremonies. The two smaller figures around the bowl's rim are making the offering of food. The horizontal movement of the bowl and the two figures and the vertical ascension of the spirit converge to create the meeting of the world of spirits and the world of humans. It is Liautaud who became the first artist working in metal to sign his works. He was instrumental in developing the technique of cutting a form directly from metal to create a figure. Liautaud's forms express a lightness of beauty, a humorous finesse and balance which underscores the sense of spiritual ecstasy which is the ultimate expression of the vodun ceremony.

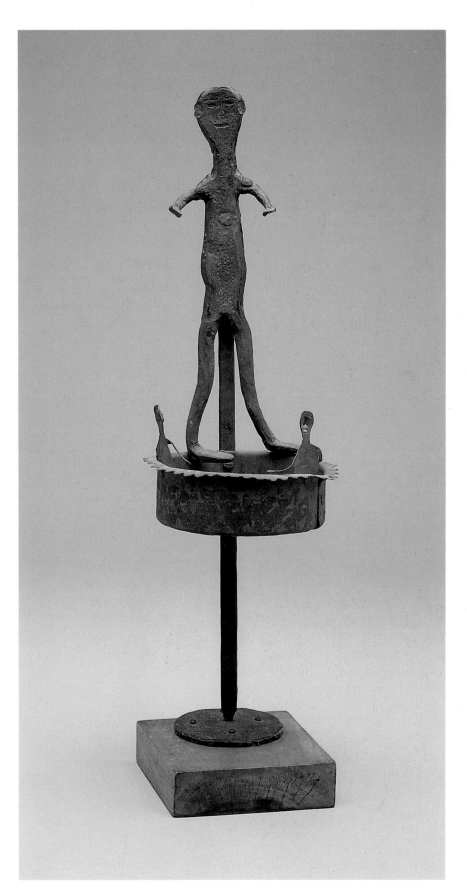

EVERALD BROWN, *Instrument for Four People*, wood and paint, 1986. 29 x 72 inches. National Gallery of Jamaica, Kingston. Photograph ©1989 Denis Valentine.

As a self-ordained minister in the Ethiopian Orthodox Church, Everald Brown considers music a fundamental expression of his creative spirit. It is not surprising, then, that he creates not only highly decorative paintings, but unique musical instruments which are themselves works of art. This particular instrument which contains two percus-

sion and two string components (guitar, harp, drum, and rhumba box) is in its communal concept a reflection of Brown's art in general — a public, festive celebration of African-American creativity.

EVERALD BROWN, *Dove Harp*, wood and paint, c. 1976. 43 x 15 x 18 inches. National Gallery of Jamaica, Kingston. Photograph ©1989 Denis Valentine.

In the early seventies, Everald Brown had a vision in which he was instructed to produce thirty-two musical instruments to celebrate the glory of God. The dove harps and star banjoes were created as part of his response to this spiritual command. Because music is an integral element in religious movements in Jamaica, such as the Revivalists, and the Ethiopian Orthodox Church, the creation of new and ingeniously shaped instruments is a testimony to the originality and the creative spirit of the practitioners of these faiths. Brown, himself a musician as well as an artist, gives to the surface of his harp the same colorful treatment that one finds in his paintings.

ROBERT ST. BRICE, *La Siréne,* oil on masonite, c. 1950s. 35 x 24 inches. Collection of William Watson Hines, III.

This image of a sirène in a boat is typical of the broadly painted forms for which St. Brice is so well-known. The unfocused contours and muted colors add to the sense of mystery with which the artist deliberately wishes to surround his spiritual beings. As a vodun priest, St. Brice created a visual vocabulary which, nearly abstract in its content, suggests the other worldly nature of the Haitian deities. He could not use solid and tangible shapes and forms to depict the fluid form of the sirène, but merely suggests her presence in broad splashes of color. Floating on water in a boat with no visible oarsman, the figure faces the viewer through a misty atmosphere into which one expects the figure to momentarily disappear.

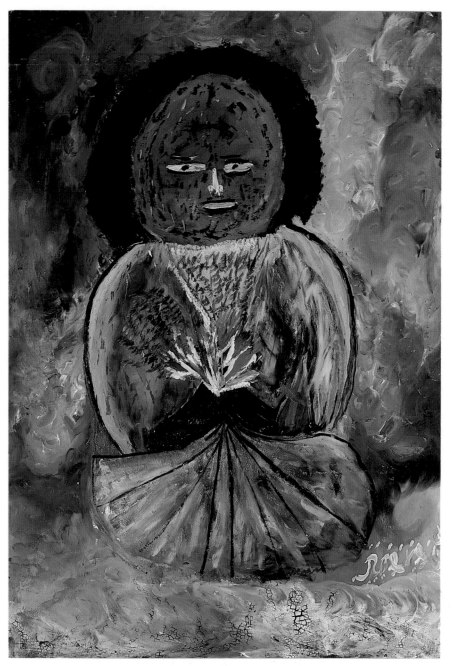

DANIEL PRESSLEY, *When the Sharecrop-per Daughter Do a Dance* **(right), wood, c. 1970. 48 x 23 x 1½. Courtesy of Cavin-Morris Gallery, New York City.**

DANIEL PRESSLEY, *Down by the River-side* **(facing page), wood, 1966. 50 x 19 x 1¾ inches. Schomburg Center for Research in Black Culture, The New York Public Library, Art & Artifacts Division.**

The tradition of the celebratory, ecstatic nature of black music is clearly articulated in *When the Sharecropper Daughter Do a Dance.* The abandon with which the young girl gives herself over to the music is placed in a different, more sensual context in this scene of rural African-American life, but the origin of this public ritual in which male musicians and female dancers are united may be found in many an African village. Pressley has thus, perhaps unknowingly, redefined the context of a very ancient rite of passage within the black community: the public display of emotion, a rhythmical command of various dance forms, and an original interpretation of a classic melody or dance pattern by a young dancer. Placed in this context, the sharecropper's daughter is seen undergoing her initiation ceremony on American soil.

In richly carved wood, Daniel Pressley captures the magical resonance of musicians playing in *Down By the Riverside.* The strength of their music and the intensity with which they play together is underscored by the narrow frame of the composition. Pressley's genius for rendering controlled yet volumetric form from the wood's surface seems a perfect visual pairing with guitar, harmonica, and voice. Pressley was inspired by those scenes which recall the richness of material culture found in rural African-American communities such as his birthplace in South Carolina.

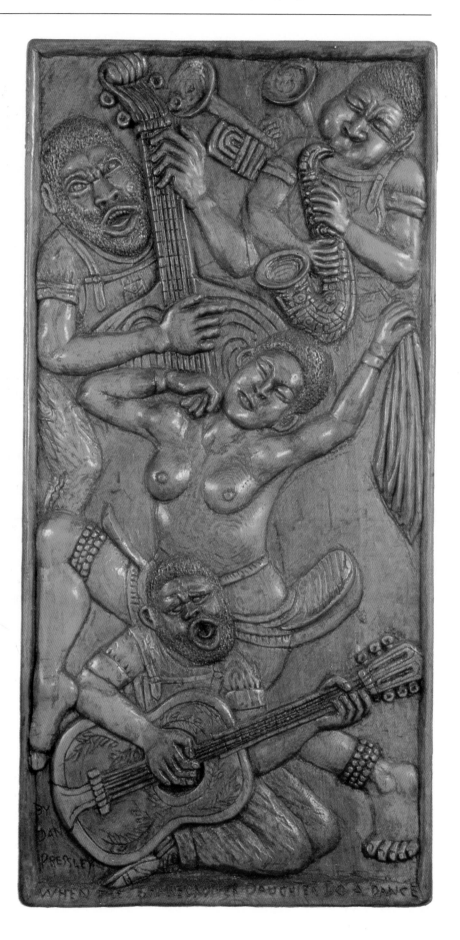

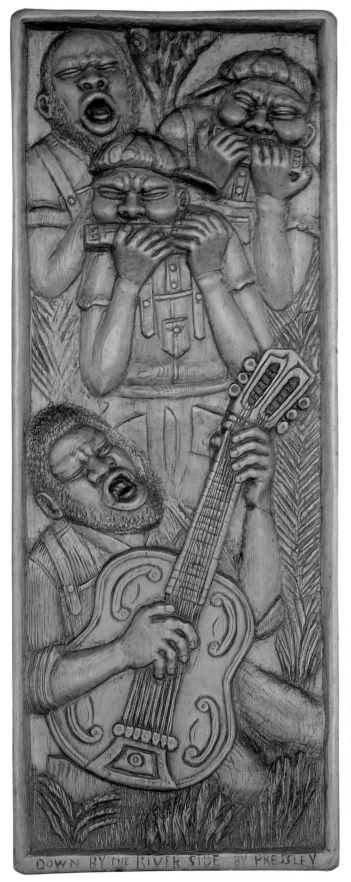

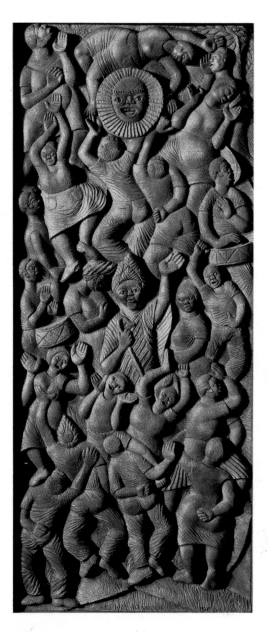

OSMOND WATSON, *Revival Kingdom,*
wood and paint, 1969. 60 x 29 inches.
National Gallery of Jamaica, Kingston.
Photograph ©1989 Denis Valentine.

In *Revival Kingdom* Osmond Watson
interprets the joy of a religious awaken-
ing. Religion remains a central focal
point in Watson's work. His relief carv-
ings also express the same horror vacuii
characteristic of many Yoruba carved
wooden doors and ivory tusks.

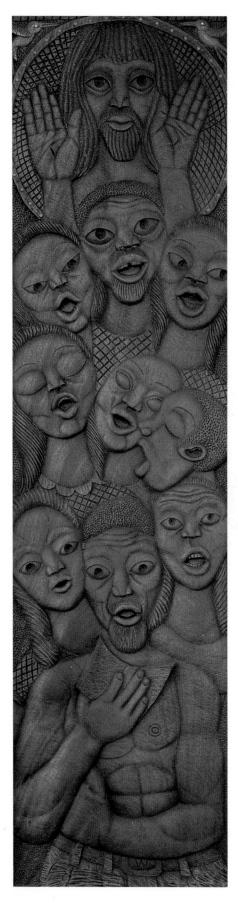

OSMOND WATSON, *Hallelujah,* **wood and mixed media, 1969. 59 x 18½. Olympia International Art Centre, Kingston, Jamaica. Photograph ©Denis Valentine.**

This low relief carving of Watson's suggests the spiritual ecstacy associated with revivalist religion as practiced in Jamaica. Watson here attests to the communal impact of spirituality upon a people, hence there is a deliberate concentration on the visual interpretation of the mass energy and movement of people who together have received spiritual enlightenment. His simple title, *Hallelujah,* attests to this unanimity of recognition of spiritual force. The single tonality of the wood, and the manner in which the artist has imposed figure upon figure in his tightly contained composition adds to the visual impact of the work. The density of the carving and the movement of the multiple figures calls to mind the narrative scenes of Yoruba house doors, in which entire histories of the village are carved upon wooden panels.

UNKNOWN ARTIST, (Mali: Bambara) *Antelope Headdress* **(tji wara), wood, metal, fiber and pigment. 10⁵⁄₁₆ x 3¼ x 21. Dallas Museum of Art, The Gustave and Franyo Schindler Collection of African Sculpture, gift of the McDermott Foundation in honor of Eugene McDermott (1974.SC.10).**

The spirit of tji wara, as this antelope headdress is traditionally called, is invited back to the annual planting festival by the Bambara people of Mali. By invoking his presence through a ceremony which celebrates the animal's early role in teaching the people how to farm the rough savannah land of Mali, it is felt that the villages of the Bambara will be assured of a successful farming season. Two headdresses are created, one male and the other female, to represent tji wara. Young farmers dance in these headdresses from sunup to sundown, miming the planting movements of the animal while the entire village sings praises to the spirit of tji wara.

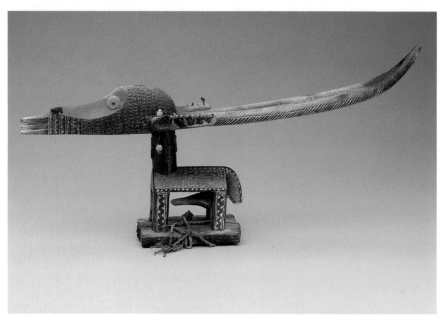

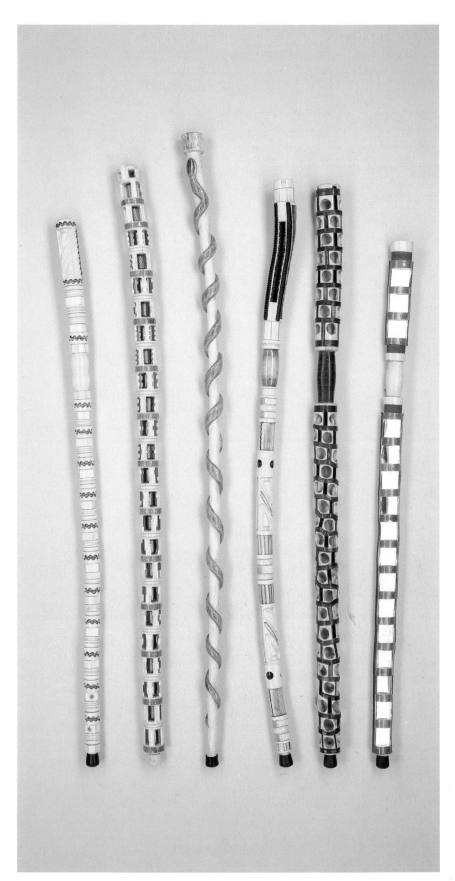

DAVID PHILPOT, *Untitled* (carved staff with squares), wood and metal, 1987. 72 x 2¼ (diam.) inches.

DAVID PHILPOT, *Untitled* (carved staff with openwork design and rope core), wood and rope, 1979-81. 79 x 3 (diam.) inches.

DAVID PHILPOT, *Untitled* (carved staff with urban cutback flatback snake), wood, 1988. 83¼ x 3 (diam.) inches.

DAVID PHILPOT, *Untitled* (carved staff with openwork design and curved top with black braid), wood, leather and fabric, 1984-86. 76¾ x 2¼ (diam.) inches.

DAVID PHILPOT, *Untitled* (carved staff with circular openwork design), wood and leather, 1982. 76 x 3 (diam.) inches.

DAVID PHILPOT, *Untitled* (carved staff with mirrors), wood, mirrors, leather and fabric, 1977. 68¾ x 2½ (diam.) inches. All six staffs are in the Collection of David R. Philpot.

Despite professing no intentional African appearance in his six staffs, David Philpot's strongly ceremonial works suggest an undeniable sense of the African meaning of ritual presence. The staff with mirrored inlay, for instance, is in many ways like the protective mirror placed in the stomach area of a Kongo ancestral figure. Just as the African device serves as a view into the inner spirit of a person, so, too, do Philpot's mirrors reflect repeatedly the inner spirit of the staff bearer. Other works such as the staff with "cutback, flatback snake" express a definite relationship with the folklore of rural African-Americans. That Philpot creates them out of "stink" trees found in vacant lots in and around his Chicago neighborhood indicates the creative vision of this master carver. In the tradition of great African woodcarvers, Philpot alters nature through his resourcefulness to create wonderful ritual objects for public appreciation.

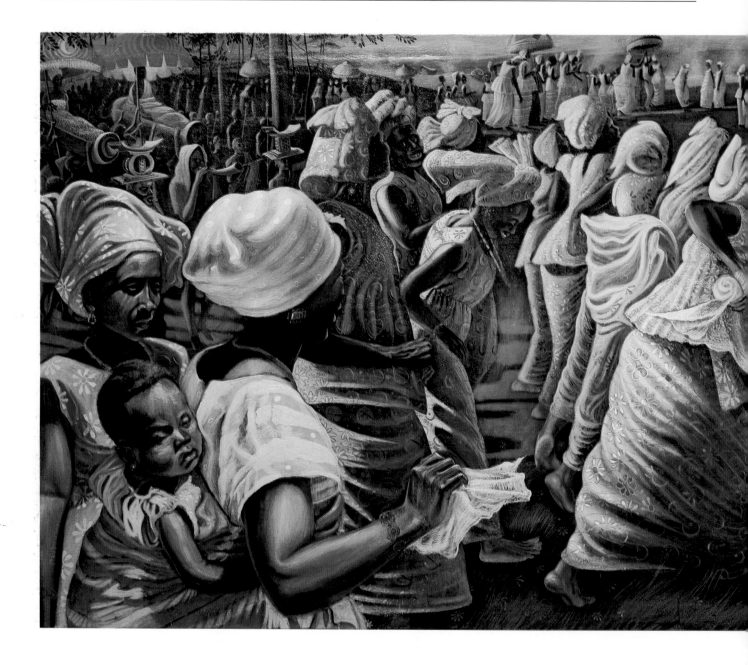

JOHN BIGGERS, *Jubilee-Ghana Harvest Festival,* **mixed media on canvas, 1959. 38⅜ x 98 inches. The Museum of Fine Arts, Houston, Museum purchase with funds provided by Texas Eastern Corporation.**

This painting was completed soon after Biggers' return from a UNESCO trip to West Africa, where he witnessed a public ceremony in which the entire community gathered to celebrate the harvesting of the crops. To Biggers the

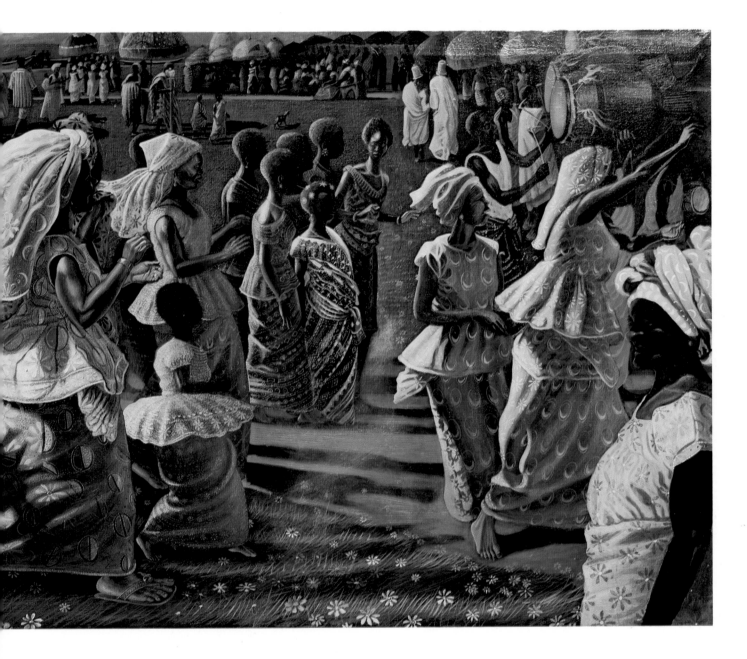

focal point of this celebration was the dance. Through the dance movements of the women, depicted watching the royal procession in the distance, Biggers truly captures the spirit of the moment. In a broad sweep from left to right across the canvas, one senses the rhythmical wave of motion passing across the crowd as they hear the drums in the distance and respond to its rhythms. African and African-American woman in dance are frequent themes in Biggers' work. For this artist, like other African-American artists, dance is an expression of spiritual ecstasy, and the bright underpainting of this work lends a jeweled light to the scene which contributes to its festive nature.

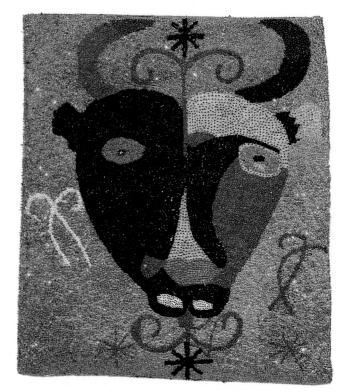

UNKNOWN ARTIST, *Haitian Vodun Flag, Untitled (Tree of Life with Drum),* (far left, above), glass beads and sequins on cloth, c. 1940s. 39 x 35 inches. Collection of Virgil Young.

UNKNOWN ARTIST, Haitian Vodun Flag, *Papa Damballah,* , glass beads and sequins on cloth, c. 1950s. 34 x 34 inches. Collection of Virgil Young.

UNKNOWN ARTIST, Haitian Vodun Flag, *Saint Jacques,* (below, far left), glass beads, sequins, pearls, paint and plastic on cloth, c. 1950s. 34 x 34 inches. Collection of Virgil Young.

UNKNOWN ARTIST, Haitian Vodun Flag, *Untitled (Bull),* (below, right), glass beads and sequins on cloth, c. 1980. 30 x 29 inches. Collection of Virgil Young.

UNKNOWN ARTIST, Haitian Vodun Flag, *Damballah et Aida Woedo,* (directly below), glass beads and sequins on cloth, c. 1940s. 31 x 29 inches. Collection of Virgil Young.

The Haitian vodun flag is essential to the full enactment of a vodun ceremony. The flag above left, with the tree of life and a drum, suggests the arms of the Republic of Haiti. The palm tree is a symbol of Aizan, the patriarch of the vodun pantheon. The serpent represents Damballah, the deity of life. Flag poles hanging from the trees resemble the Haitian flag while the military drum at the base of the palm tree is an added reference to the might of the republic.

The function of the vodun flag is to greet and invite the *loas* (spirits) to honor the ceremony with their presence. Depending upon the wealth of the *houngon* (priest) and his society, the flags may be made of either painted fabric or embroidered and sequined fabric. The richly embroidered flag shown below, encrusted with sequins and glass beads, is a subtle tribute to Damballah, the serpent god of life and his wife, Aida Woedo. The artist includes a depiction of the *hasson* gourd with a bell on its handle, and a basin, probably with water for Damballah. Both objects are traditionally used in *vodun* cere-

monies. Between the four stars found in the corners of the flag are embroidered the Masonic symbol of the two compasses, the sign of the builder of the universe. The image of Damballah is represented repeatedly upon vodun flags for the *houmfor* society. The lettering on many flags is as intricately worked as the actual image of the deity. Much more boldly produced for easy visibility from a distance, these letters attest to the presence of Papa Damballah at the ceremony. In order to actually see the artist's visual rendering of Damballah's spirit the viewer/participant would have to venture much closer to the flag.

Saint Jacques was a Catholic saint cre-olized by the Haitians as a western personification of Ogoun Ferailles, the blacksmith whose attributes are fire, metal, and the color red. He was often depicted on horseback as a victorious conquerer. Generally a flag image of St. Jacques such as the one shown below left is "walked" with an image of Damballah, in this case the flag *Papa Damballah.*

The bull symbolizes the fertility of the soil and represents the vodun deity Bossu. The image of Bossu is frequently seen in vodun temples. The geo-metricized presentation of the face in the flag on the opposite page heightens one's sense of the form as an abstract pattern rather than an interpretation of a natural form. By giving the bull this masklike countenance, the flag's artist increases the bull's impact as a powerful but abstracted force in the universe. Because flags are usually ordered or commissioned by a patron and are not created in the context of ritual like the veve symbols, the artist has authorization to work out his fantasy in making a vodun flag.

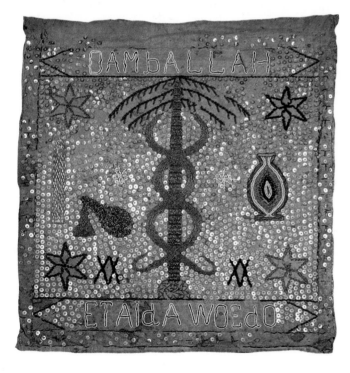

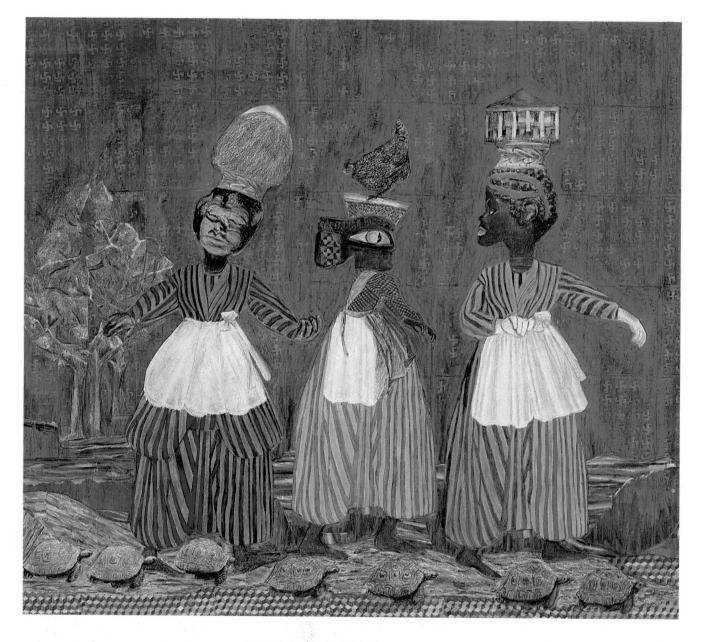

JEAN LACY, *Night Migration,* **mixed media on museum board, 1988. 17½ x 19⅛ inches. Collection of the artist.**

The migration which Jean Lacy depicts in this work is not simply the Great Migration of African-Americans from the South to the North, which figured so prominently in the writing of Alain Locke, nor is it simply the migration of blacks to freedom through the Underground Railroad. It is, in fact, all of these migrations, and more, for included in this picture is the migration of great tortoises who, after laying their eggs, move on into the night to another resting spot. It is this primal movement with which the women in this work are associated. The figure in the center, with her single Udjat eye of Egypt, gives recognition to the fact that such migrations predate even the most ancient of our civilizations and, in that context, the movements of humanity are attuned to the cycle of nature.

BEN JONES, *Stars II* (15 elements), mixed media, 1983. 68 x 75 inches. Collection of The Newark Museum. Purchase 1985 Metropolitan Life Foundation Grants for Minority Visual Arts and The Members' Fund.

In his travels, Ben Jones "collects faces." The images of black men in this installation work come from faces he has seen in the Caribbean, in Africa, and in the United States. One of the men is a journalist, another a dancer, another a musician, and a fourth a political activist. What caused Jones to pause and photograph these individuals was what he describes as a very real presence, a certain kind of strength in their faces. Around these images, the artist has created a celebratory installation in which his interpretations of central African masks, adorned with colorful ribbons, underscore the integrity and individuality of each of these men. To the artist, they are the true stars of contemporary life, those who continue with an inner determination to do something meaningful during their time on earth.

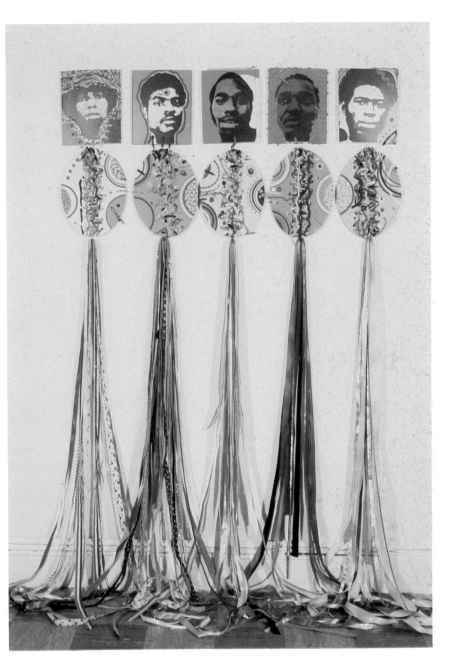

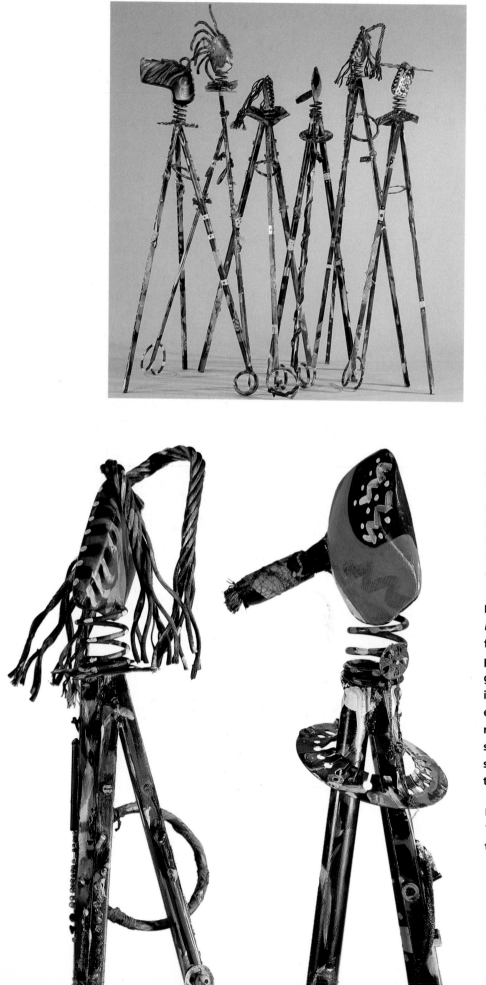

ED LOVE, *The Sweet Rockers* from *The Arkestra,* **welded steel, paint and mixed media, 1988. Height ranges from 68 to 82 inches. Collection of the artist.**

ED LOVE, *The Wailers* from *The Arkestra* **(right), welded steel, paint and mixed media, 1984. Height ranges from 71 to 83 inches. Collection of the artist. Exhibited at DMA only.**

The 27-piece *Arkestra,* named after Sun Ra's *Arkestra,* is Ed Love's visual testimony to the richness of the African-American musical heritage. With a combined grouping of nine separate groups and units, Love pays tribute to the music of *Bob Marley and The Wailers, Sweet Honey in the Rock,* as well as major jazz musicians such as John Coltrane, Duke Ellington and Charlie Parker. A distinctly kinetic approach to these figures, combined with a free application of color to the works, results in an assemblage whose figures convey all of the passion, the quirky genius, the irrepressible rhythm and dynamism, and the great surges of energy and emotion which characterize black music.

This depiction of the female singing group *Sweet Honey in the Rock* is the strongest expression of portraiture of all of Love's groups in *The Arkestra.* One can sense the individual personalities of the women emerging from Love's cleverly conceived forms.

Ed Love's tribute to the reggae group *Bob Marley and The Wailers* repeats the fluid rhythmical structure of Marley's particular sound and reggae music in general. The linear quality of the figures is an appropriate depiction of a musical ensemble which was known for its rigorous stretches of melody. The kinetic swaying of which the works are capable sets in motion the flowing rhythms of the music in a very immediate way.

For the exhibition's display in Dallas, *The Arkestra* will be shown for the first time in its entirety.

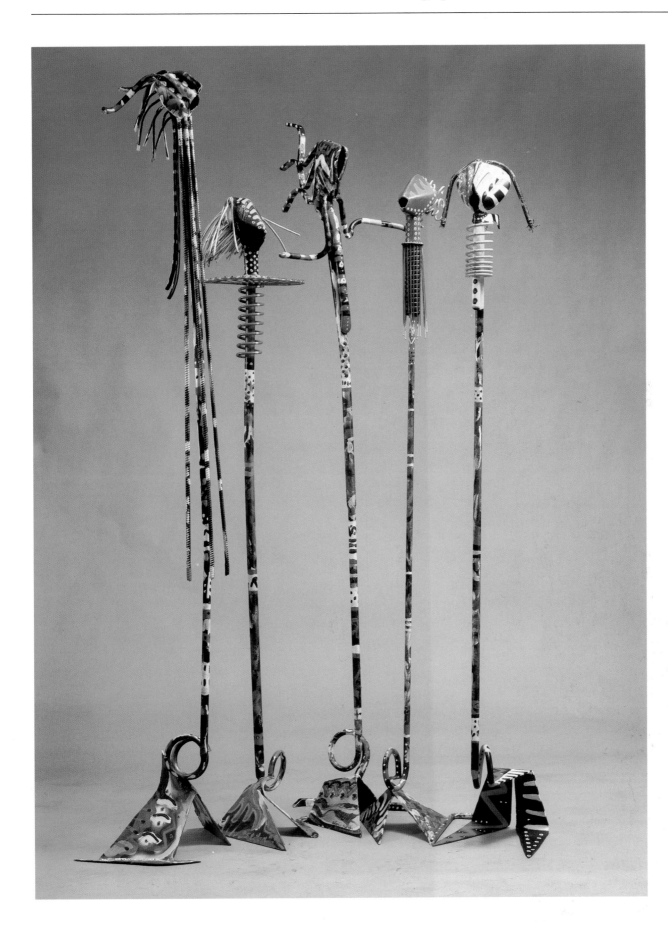

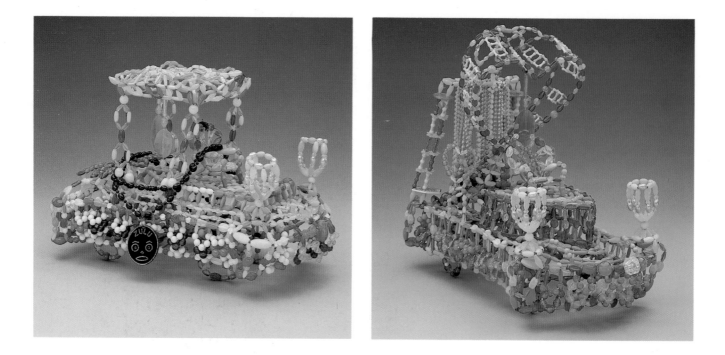

JOHN LANDRY, *Beaded Zulu Float with Black Zulu Bead,* beads and wire, 1976. 9½ x 8½ x 14 inches. Collection of Regenia A. Perry.

JOHN LANDRY, *Beaded Heart Float with Lanterns,* beads and wire, 1976. 13 x 8½ x 16 inches. Collection of Regenia A. Perry.

JOHN LANDRY, *Cardboard Zulu Float with Crown,* cardboard, lettering enamel and glitter, 1985. 12 x 7½ x 12¾ inches. Collection of Regenia A. Perry.

JOHN LANDRY, *Green, Yellow, and Purple Cardboard Float with Glitter,* cardboard, lettering enamel and glitter, 1986. 10½ x 8⅝ x 14½ inches. Collection of Regenia A. Perry.

JOHN LANDRY, *Cardboard Float with Birds,* cardboard, lettering enamel, and birds, 1986. 12½ x 7¼ x 13⅜ inches. Collection of Regenia A. Perry.

For John Landry, Mardi Gras was a celebration of the black community in New Orleans to which he had special ties. As a strong supporter of the Zulu society, the black social organization which annually organized its own parade, Landry felt compelled to commemorate the joyous beauty of Mardi Gras through the development of his own miniature floats. Made of beads collected from past parades, as well as cardboard and glitter, the floats depict some of the festive qualities that exist in the New Orleans celebration of carnival. Particularly striking are the two black-and-gold floats which utilize the Zulu colors. In addition, a Zulu float adorned with two white doves has a base for a coconut, the emblem of the Zulus which was thrown out into the crowds. It has been pointed out that the umbrellas which are carried by many of the black band members who perform in the Mardi Gras parades are decorated with birds on the top of the open umbrella, in much the same way that birds adorn the royal umbrellas of the Akan in Ghana.

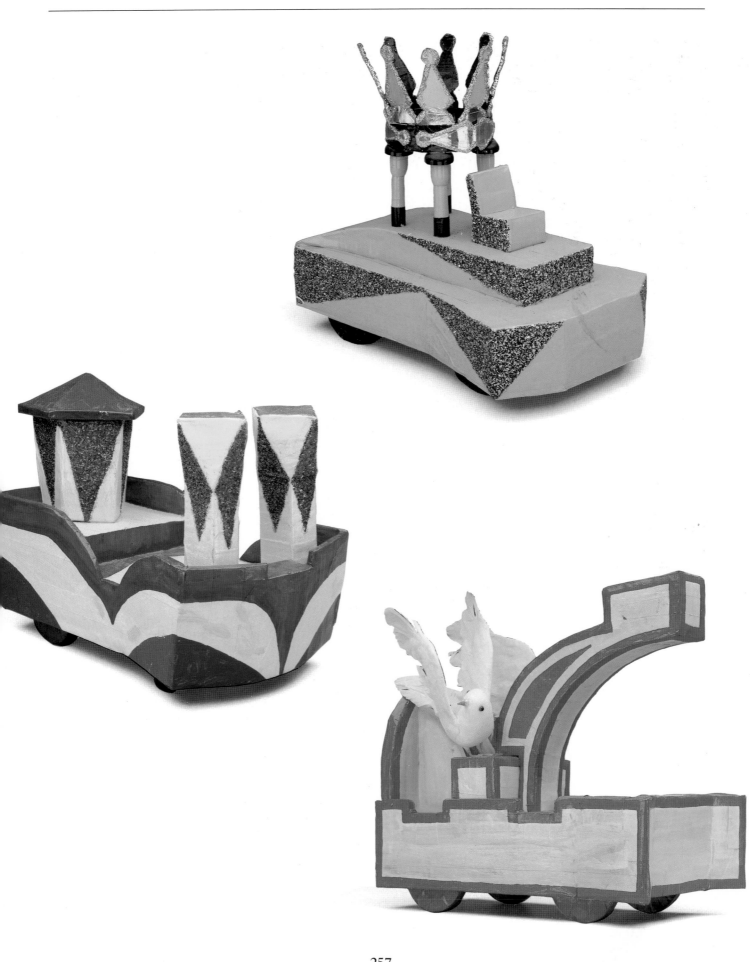

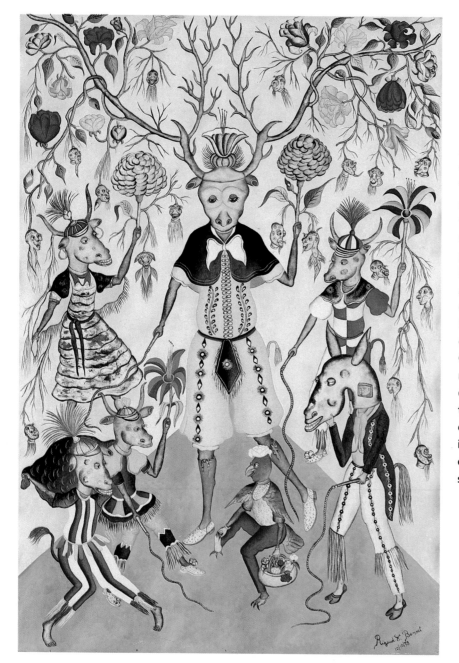

RIGAUD BENOIT, *Carnival Participants in Demonic Guise,* **oil on masonite, 1973. 36 x 24 inches. The Flagg Collection, Milwaukee.**

Known for his paintings of traditional Haitian festivals and religious ceremonies, Rigaud Benoit utilizes his detailed technique to provide a sense of the elaborate quality of Haitian carnival. The abundance of flowers suggests the rebirth of vegetation in the spring while the heads hanging from the plant roots symbolize the last vestiges of death. The great bull with its elaborate mask antlers has been compared to similar West African headdresses. In the northern part of Haiti a costumed figure wearing the bull headdress of Bossu, the spirit of the earth's fertility, traditionally opens the Carnival of Flowers by leading the public masquerade. In one hand Bossu brandishes a whip which he cracks while in the other hand he holds a cow bladder or stomach. The scene reflects the Haitian love of masquerades and the sense of renewal which such ceremonies symbolize.

THE ARTISTS

Xenobia Bailey

Richmond Barthé

Rigaud Benoit

Gabriel Bien-Aime

John Biggers

Edgar Brierre

Murat Brierre

Everald Brown

Houston Conwill

Aaron Douglas

William Edmondson

Minnie Evans

Amos Ferguson

Bessie Harvey

Mr. Imagination

Malvin Gray Johnson

Sargent Johnson

Ben Jones

Lois Mailou Jones

William "Woody" Joseph

Kofi Kayiga

Jean Lacy

John Landry

Georges Liautaud

Ed Love

Vusumuzi Maduna

David Miller, Jr.

David Miller, Sr.

Ademola Olugebefola

James Phillips

David Philpot

Anderson Pigatt

Daniel Pressley

Nancy Prophet

Leon Renfro

Earl Richardson

Sultan Rogers

Robert St. Brice

Bert Samples

Charles Searles

George Smith

Renée Stout

Matthew Thomas

Bill Traylor

Osmond Watson

Willard Watson

Derek Webster

Hale Woodruff

Rip Woods

XENOBIA BAILEY

Xenobia Bailey was born in Seattle, Washington and currently lives in Brooklyn, New York. Deeply interested in her cultural heritage, she began to do decorative hair braiding while a student at the University of Washington. After learning the technique from several African women who were also students, Bailey developed their techniques further, creating sculpted and beaded braids that covered the head like a crown. In the 1970s she decided to move to New York City. The move to New York was motivated by a desire, she explains, ". . . to have access to African art . . . and for the color, and the community of artists." In 1985 she began making her hats, inspired by a desire to create something "rich and beautiful" to celebrate her cultural heritage. "From moving around different cultures, I saw how others could celebrate themselves and be proud of their culture. . . . I wanted to be proud of my own culture and heritage too. . . . I wanted to look beautiful. I wanted to create a beautiful African-American culture." She finds ideas for her hats not only in traditional African designs, but in the dynamic way in which people in Brooklyn mix colors and patterns in their dress. She goes to the West Indian Day parade, the African Street Festival, and other parades and festivals to people-watch. She looks at groups of people, noting how the colors and patterns of their clothes all mix and work together, getting ideas for colors and combinations. "Watching them, watching groups go by, is like a living kaleidoscope," she says, ". . . sometimes those things (colors and patterns) fill me for the entire year." Bailey is also inspired by the music of Duke Ellington. "Duke Ellington is one of the main inspirations for my

style. He captures the African sound, the African beat, the African rhythm in his music. His whole source of sound is African, combined with the African-American experience. What he does with his music is what I want to do with my hats. . . . The emotional thing you feel when you hear his music, that's what I want you to feel when you see my hats. . . . He can go anywhere in the world and communicate with his music — my hats can do the same."

Education: Pratt Institute, Brooklyn, New York, Bachelor of Industrial Design, 1977; also studied at University of Washington, Seattle, 1968-1970 (ethnomusicology).

Related Activities: Bailey also makes puppets and dolls, and is a story-teller who works with the Organization of African-American Folktalers in Brooklyn.

Group Exhibitions: *Arts of Adornment: Contemporary Wearable Art from Africa and the Diaspora*, New Muse Community Museum of Brooklyn, Inc., New York, 1984 (tour).

Collections: Schomburg Center for Research in Black Culture, The New York Public Library, Art & Artifacts Division, New York City; private collections.

Quotes in above passage from telephone conversations held with the artist in June, 1989.

RICHMOND BARTHE

Born in Bay St. Louis, Mississippi in 1901, Richmond Barthé became one of the most important African-American sculptors of the twentieth century. His work which represents African-Americans in genre postures — picking berries, dancing, boxing — attracted the attention of major museums and collectors early in his career. He was the first African-American artist added to the

permanent collection of the Whitney Museum of American Art. Barthé's work was shown for the first time to the public when at age twelve his paintings were shown at a County Fair in Mississippi. To put himself through school Barthé worked in a restaurant before and after his classes at the Art Institute of Chicago. Originally planning to study painting at the Institute, Barthé began to seriously pursue sculpture after portrait busts which he completed for his study with Charles Schroeder were displayed during Chicago's first Negro History Week exhibition. In an historic conversation/interview with Elizabeth Catlett on October 23, 1982 published in the *International Review of African-American Art*, Barthé stated, ". . . Like music, you get from a work what you take to it . . . All of the dance figures I've done — and I've done many — I do them in front of the mirror. I don't do my body, but if I can get the position, feel the position with my body, I can do it with my fingers." After leaving New York for reasons of health in 1946, Barthé spent most of his time between his home "Iolaus" in Jamaica and travel in Italy.

In 1939, he was quoted as saying, "When I look at the rest of the world, I wonder if perhaps Africa is not more civilized." The artist died in 1989.

Education: Art Students League, New York City, 1931; Art Institute of Chicago, 1924-1928; private study with Charles Schroeder and Albin Polasek.

Honors and Awards: Guggenheim Fellowship, 1940-1941; Honorary MA from Xavier University, New Orleans, 1934; Rosenwald Fellowship, 1928-1929; Eames McVeagh Prize, 1928.

One-Person Exhibitions: Arden Gallery, New York City, 1938; New Jersey State Museum, 1935; Salons of America, New York City, 1934; Caz-Delbos Gallery, New York City, 1933; Delphic Studios, New York City, 1925; Rankin Gallery, Washington; University of Wisconsin.

Group Exhibitions: *Hidden Heritage: Afro-American Art, 1800-1950*, Bellevue Art Museum, Washington and the Art Museum Association of American, 1985 (tour); *Two Centuries of Black American Art*, Los Angeles County Museum of Art, 1976 (tour); Newark Museum, 1971; Grand Central Gallery, New York City, 1947; Margaret Brown Gallery, Boston, 1947; World's Fair, New York City, 1947; Baltimore Museum, 1939; Whitney Museum, New York City, 1939, 1935, 1933; Pennsylvania Academy of Fine Arts, Philadelphia, 1939, 1938; Howard University, Washington, D.C., 1934; Harmon Foundation, New York City, 1933, 1931, 1929.

Collections: Armstrong High School, Richmond, Virginia; Atlanta University; Harlem River Houses, New York City; Lake Country Children's Home, Gary, Indiana; Metropolitan Museum of Art, New York City; New Theater,

London; Schomburg Center for Research in Black Culture, the New York Public Library, Arts & Artifacts Division, New York City; Anson Phelps Stokes Foundation, New York City; U.S. Treasury Project; Whitney Museum of American Art, New York City; private collections.

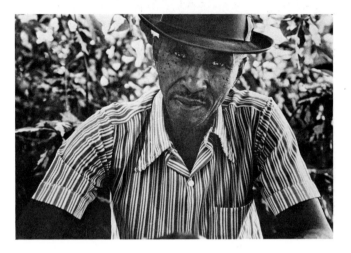

RIGAUD BENOIT

Rigaud Benoit was born in 1911 in Port-au-Prince, Haiti and died in 1987. Early in his life he worked as a musician and as a pottery decorator. In 1944 Benoit was among the first naive artists to join Le Centre d'Art. His subjects include folklore, vodun and scenes from Haitian life. His paintings are characterized by painstaking precision and meticulous detail. Later in his career his palette became cooler and more delicate, and his work, which includes surrealist elements, became freer. Benoit is considered one of the most significant artists of the Haitian art movement.

One-Person Exhibitions: Le Centre d'Art, Port-au-Prince, Haiti, 1969.

Group Exhibitions: *Where Art is Joy: Forty Years of Haitian Art*, Museum of Art, Fort Lauderdale, Florida, 1989; Davenport Art Gallery, Iowa, 1985, 1983-84, 1980, 1974, *The Art of Haiti*, 1969; Yale University Art Gallery, New Haven, Connecticut, 1985; Le Centre d'Art, Port-au-Prince, Haiti, 1984, 1969, 1964; *Under the Spell: The Art of Haiti*, The Chicago Public Library Cultural Center, 1983; *Haitian Art*, The Brooklyn Museum, New York, 1978 (tour); *The World of Haitian Painting From the Collection of Claude Auguste Douyon*, Smithsonian Institution Traveling Exhibition Service (S.I.T.E.S.), Washington, D.C., 1978 (tour); *The Naive Tradition: Haiti: The Flagg Tanning Corporation Collection*, Milwaukee Art Center, Wisconsin, 1974; *Haitian Painting: The Naive Tradition*, American Federation of Arts, New York Cultural Center, New York City, 1973 (tour); Ruhrfestspiele Recklinghausen, Staed-

tische Kunstalle, Recklinghausen, Germany, 1971; *Popular Paintings from Haiti From the Collection of Kurt Bachmann*, Hayward Gallery, London, 1969 (tour); Museum am Ostwall, Dortmund, Germany, 1969; Center for Inter-American Relations, New York City, 1968; Museum Boymans-van Beuningen, Rotterdam, 1964 (tour); Pan American Union, Washington, D.C., 1963; *Das Naive Bild der Welt*, Staatliche Kunstalle, Baden-Baden, Germany, 1961 (tour); Knokke-le Zoute, Albert Plage, Casino Communal, Belgium, 1958; Museum of Fine Arts, Houston, 1956 (tour); *19 schilders uit Haiti*, Stedelijk Museum, Amsterdam, 1950; American British Art Center, New York City, 1947, 1946.

Collections: Davenport Museum of Art, Iowa; The Flagg Collection, Milwaukee, Wisconsin; Holy Trinity Cathedral, Port-au-Prince, Haiti (mural); Musée d'Art Haitien du Collège St. Pierre, Port-au-Prince, Haiti; Museum of Modern Art of Latin America, Washington, D.C.; private collections.

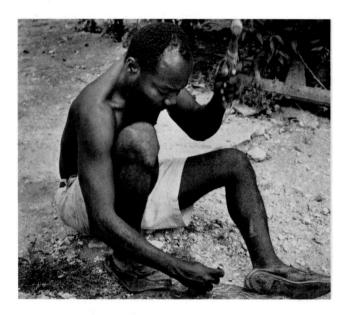

GABRIEL BIEN-AIME

Gabriel Bien-Aimé was born in Croix-des-Bouquets, Haiti in 1951. Introduced to art by the Haitian sculptor Janvier Louisjuste, his work seems more influenced by artists Liautaud and Jolimeau. Bien-Aimé often cuts and forges metal, and he is considered an innovator in iron sculpture in his unique method of twisting the metal or clamping additional pieces to it, thus trying to achieve a three-dimensionality. His subject matter is mostly derived from his religion and from daily life, and it is in the latter that he often expresses a sense of humor. He is considered one of the foremost Haitian artists working in metal.

Group Exhibitions: *Magiciens de la terre*, Musée National d'Art Moderne, Paris, 1989; *Where Art is Joy: Forty Years of Haitian Art*, Museum of Art, Fort Lauderdale, Florida, 1989; *Haiti: art naif/art vaudou*, Galeries Nationales d'Exposition du Grand Palais, Paris, 1988; Musée du Panthéon National, Port-au-Prince, Haiti, 1987; *The Naive Tradition: Haiti: The Flagg Tanning Corporation Collection*, Milwaukee Art Center, Wisconsin, 1974.

Collections: Le Centre d'Art, Port-au-Prince, Haiti; The Flagg Collection, Milwaukee, Wisconsin; Musée d'Art Haitien du Collège St. Pierre, Port-au-Prince, Haiti; Musée National d'Art Moderne, Paris; private collections.

JOHN BIGGERS

John Biggers was born in 1924 in Gastonia, North Carolina. His study with Victor Lowenfeld and Charles White encouraged him to pursue mural painting as a means of expressing his cultural heritage. Many of his early works draw upon his experiences growing up in an autonomous black community in the rural South. One of the first black artists to go to Africa and study the

traditions and culture of the people, Biggers' book *Ananse, the Web of Life in Africa* chronicles his reactions to his UNESCO journey. An outstanding educator as well as artist, Biggers was chairman of the Art Department at Texas Southern University for thirty-six years. He wrote with his colleague Carroll Simms, the history of that Art Department, *Black Art in Houston*. A collector of African art, Biggers has used the motifs of African sculpture to inspire his own work. In *Fresh Paint: The Houston School*, the artist stated, "I have always attempted to express the profound beauty of the Afro-American people, especially the spirituality and love to soar above the mundane, as expressed in music, the Negro spiritual, and jazz. The texture and color of the Afro-American as a part of the "Southern earth" — fields, farmlands, and the forests, unfolding in their seasons — the silver gray texture of "shotgun" or row houses silhouetted against the earth — pinks and black-greens . . . The role of art is to express the triumph of the human spirit over the mundane and material. It is also to express the universal myths and archetypes of the universal family of man."

Education: Hampton Institute, Hampton, Virginia, 1946, 1941-43; Pennsylvania State University, B.S., 1948, M.S., 1948, Ph.D., 1954.

Professional Experience: University of Wisconsin, visiting professor, 1965-1966; Texas Southern University, Art Department Head, 1949-1983, Distinguished Professor, 1967-1983, Associate Professor, 1949-1953; Professor, 1954-1967, Alabama State Teachers College, Montgomery, Instructor, 1949; Pennsylvania State University, teaching fellow, 1948-1949.

Honors and Awards: Texas Artist of the Year, The Art League of Houston, 1988; Pennsylvania State University, Distinguished Alumnus Award, 1972; E. Harris Harbison Award for Distinquished Teaching, Danforth Foundation, 1968; Piper Professor Award for outstanding scholarly and academic achievement by the Minnie Stevens-Piper Foundation, 1964; Chicago Book Clinic Award, "Excellence of Design", *Ananse: The Web of Life in Africa*, 1963; Southern Book Competition, "Excellence of Design," *Ananse, The Web of Life in Africa*, 1963; Dallas Museum of Art, "Best Texas Book Design," *Ananse: The Web of Life in Africa*, 1963; UNESCO Fellowship for study of traditional cultural patterns in West Africa, 1957; Ella Lyman Cabot Trust Stipend for special study of graphic arts at the University of Southern California and Pennsylvania State University, 1952-1953; Purchase Prize, Atlanta University Annual Exhibition, 1953, 1950; Neiman Marcus Prize for Drawing, Dallas Museum of Art, 1952; Schlumberger Prize, Museum of Fine Arts, Houston, 1951; Purchase Prize, Museum of Fine Arts, Houston, 1950.

One-Person Exhibitions: *Patchwork Quilts and Shotguns,*

Transco Energy Company, Houston, 1987; *Bridges*, California Museum of Afro-American History and Culture, Los Angeles, 1983; *Ceremonies and Vision*, Laguna Gloria Art Museum, Austin, Texas; United States Information Agency, traveling exhibition to African countries, 1963; Lubbock Museum of Fine Arts, Lubbock, Texas, 1963; Dallas Public Library, 1963; Museum of Fine Arts, Houston, 1962; Pennsylvania State University, University Park, 1955.

Group Exhibitions: *Fresh Paint: The Houston School*, Museum of Fine Arts, Houston, 1985; *Two Centuries of Black American Art: 1750-1950*, Los Angeles County Museum of Art, 1976 (tour); *Celebrating the 50th Anniversary of the Golden State Mutual Insurance Company, Exhibition of the Afro-American Art Collection*, California Museum of Science and Industry, Los Angeles, 1975; *Reflections: The Afro-American Artist*, Winston-Salem Delta Fine Arts, Inc., Winston-Salem, North Carolina, 1972; *12 Black American Artists*, University of Wisconsin, Madison, 1969; Ford Foundation Invitational Art Exhibit, Fort Worth Art Center, 1959, 1958; Howard University Art Museum, 1956; *Texas Southern University Art Department*, Contemporary Arts Museum, Houston, 1953; *Texas Contemporary Artists*, M. Knoedler and Company, New York City, 1952; Baltimore Museum of Art, 1945; Virginia Museum of Fine Arts, Richmond, 1944; Museum of Modern Art, New York City, 1944.

Mural Commissions: *East Texas Patchwork*, Paris, Texas Public Library, 1987; *The Song of the Drinking Gourds*, Tom Bass Regional Park, Harris County Texas, 1987; *The Adair Mural*, Christia Adair Park, Harris County Texas, 1982; *The Quilting Party*, Music Hall, City of Houston, 1981; *Family Unity*, Sterling Student Life Center, Texas Southern University, 1976; *Birth from the Sea*, W. L. Johnson Branch, Houston Public Library, 1966; *History of I.L.A. Local 872*, International Longshoreman's Association Local 872, Longshoreman's Temple, Houston, 1957; *The Contribution of Negro Women to American Life and Education*, Blue Triangle YWCA, Houston, 1953; *Negro Folklore*, Eliza Johnson Home for the Aged, Houston, 1951; *The Country Preacher*, and *Dying Soldier*, United Transport Workers Labor Temple, C.I.O., Chicago, Illinois, 1946.

Collections: Atlanta University; Barnett-Aden Collection, Washington, D.C.; Dallas Museum of Art; Golden State Mutual Life Insurance Company, Los Angeles; Hampton University Museum, Virginia; Howard University, Washington, D.C.; Museum of Fine Arts, Houston; National Museum of American Art, Smithsonian Institution, Washington, D.C.; Lubbock Museum, Texas; Texas Southern University; private collections.

EDGAR BRIERRE

Edgar Brierre, born in Port-au-Prince, Haiti in 1933, attended primary school and secondary school until the 4th grade. Later he became a tailor and theater artist and in 1967 joined Le Centre d'Art encouraged by his brother Murat and Rigaud Benoit. His metal sculptures, which he began to make in 1972, following his brother's example, are assured and convey a sense of immediacy. His sculptures are devoted to his religious beliefs and have a powerful presence, possibly due to his involvement with vodun. His carefully executed paintings are mostly of landscapes and scenes of rural life and vodun ceremonies. In the last 15 years Brierre has stopped creating art because his works in metal were often confused with his brother Murat's sculptures. The artist traveled to the United States, spending 4 years in Miami, Florida before returning to Haiti where he currently lives.

Group Exhibitions: *Ritual and Myth: A Survey of African American Art*, The Studio Museum in Harlem, New York City, 1982; *Haitian Art*, The Brooklyn Museum, New York, 1978 (tour); *The Naive Tradition: Haiti: The Flagg Tanning Corporation Collection*, Milwaukee Art Center, Wisconsin, 1974.

Collections: Le Centre d'Art, Port-au-Prince, Haiti; The Flagg Collection, Milwaukee, Wisconsin; Musée d'Art Haitien du Collège St. Pierre, Port-au-Prince, Haiti; The Studio Museum in Harlem, New York City; private collections.

MURAT BRIERRE

Murat Brierre, who was born in Mirebalais, Haiti in 1938 and died in 1988, worked as a brick mason, cabinet maker, tile setter and blacksmith and he painted in his spare time. Rigaud Benoit introduced Brierre to Le Centre d'Art in 1966, the same year Brierre turned from painting to sculpture. His sculptures are made of metal from old oil drums that have been cut and forged into flat images like those of Georges Liautaud, yet Brierre's forms are often considered more complex and varied. He compares the strength, endurance and honesty of metal, his chosen medium, to those characteristics of the Haitian people. His images, derived from religious beliefs, relate to vodun and Christian themes. Brierre, who has exhibited widely including in Haiti, the United States, Europe and Israel, is considered one of the major Haitian artists who have worked in metal.

One-Person Exhibitions: Areta Contemporary Design, Boston, 1979; Le Centre d'Art, Port-au-Prince, Haiti, 1973, 1972, 1971, 1970, 1969, 1968; Roko Gallery, New York City, 1972, 1968; Showcase Gallery, Washington, D.C., 1969; The Botolph Group, Boston, 1969; Bradley Galleries, Milwaukee, Wisconsin, 1968; Georgetown Graphics Gallery, Washington, D.C., 1968; Menschoff Gallery, Chicago, 1968; John Michael Kohler Arts Center, Sheboygan, Wisconsin, 1968; Haitian Art Gallery, New York City, 1967.

Group Exhibitions: *Where Art is Joy: Forty Years of Haitian Art*, Museum of Art, Fort Lauderdale, Florida, 1989; *Haiti: art naif/art vaudou*, Galeries Nationales d'Exposition du Grand Palais, Paris, 1988; Musée du Panthéon National, Port-au-Prince, Haiti, 1987; Davenport Art Gallery, Iowa, 1985, 1980, 1974, *The Art of Haiti*, 1969; *Under the Spell: The Art of Haiti*, The Chicago Public Library Cultural Center, 1983; *Ritual and Myth: A*

Survey of African American Art, The Studio Museum in Harlem, New York City, 1982; *Haitian Art*, The Brooklyn Museum, New York, 1978 (tour); *Tamara Baussan and Murat Brierre*, Le Centre d'Art, Port-au-Prince, Haiti, 1975; *The Naive Tradition: Haiti: The Flagg Tanning Corporation Collection*, Milwaukee Art Center, Wisconsin, 1974; Fabian Gallery, New York City, 1973; John Michael Kohler Arts Center, Sheboygan, Wisconsin (tour); Abby Aldrich Rocke-feller Folk Art Center, Williamsburg, Virginia; Charles and Emma Frye Art Museum, Seattle, Washington; Sears Vincent Price Gallery, Chicago, 1969; *Artists of the Western Hemisphere: Art of Haiti and Jamaica*, Center for Inter-American Relations, New York City, 1968; The Botolph Group, Boston, 1968; *Naive Art from Haiti Lent by the Smithsonian Institution*, The Society of the Four Arts, Palm Beach, Florida, 1967.

Collections: Le Centre d'Art, Port-au-Prince, Haiti; Davenport Museum of Art, Iowa; The Flagg Collection, Milwaukee, Wisconsin; Musée d'Art Haitien du Collège St. Pierre, Port-au-Prince, Haiti; New Orleans Museum of Art, Perry E. H. Smith Collection; The Studio Museum in Harlem, New York City; private collections.

EVERALD BROWN

Everald Brown was born in 1917 in St. Ann, Jamaica and grew up in Sandy River. A carpenter by trade, Brown began painting and carving in the late 1960s while living in Kingston. At this time Brown, who was a self-ordained priest of a sect related to the Ethiopian Orthodox Church, was inspired by a vision to decorate a small church he had built. In addition to adorning the church with his

paintings, he also carved ceremonial objects for it. These first works were very well received not only by his own congregation, but by other visitors. This encouraged Brown to continue painting and carving. He began participating in exhibitions and in the early 1970s received several awards for his work. Because of the close connection between Brown's artistic and spiritual life, his imagery drew heavily upon his spiritual experiences (including his interest in Rastafarianism), and his visions. In the early 1970s Brown left Kingston to move to the country with his family. They settled in the remote district of Murray Mountain, in the hills near St. Ann. Here on a limestone hill he named Meditation Heights, Brown built a house. The early years on Murray Mountain were especially productive and Brown produced many works, including the first of his highly-decorated musical instruments (the drums, dove harps and star banjoes). Since then Brown has continued to live and work in his private sanctuary on Murray Mountain, inspired by nature and his mystical visions.

Honors and Awards: Artist Fellowship, National Gallery of Jamaica, 1978; Silver Musgrave Medal, Institute of Jamaica, 1974; Bronze Festival Medal, 1970.

Group Exhibitions: *Fifteen Intuitives*, National Gallery of Jamaica, Kingston, 1987; *Jamaican Intuitives: Visionary Paintings and Sculpture Direct From Jamaica*, Art Gallery, Commonwealth Institute, London, England and Wolverhampton Art Gallery, Wolverhampton, England, 1986; Annual National Exhibition, National Gallery of Jamaica, Kingston, 1977-86; Harmony Hall, Ocho Rios, Jamaica, 1982-86; Harmony Hall at the Paul Waggoner Gallery, Chicago, 1984; *Jamaican Art: 1922-1982*, an exhibition organized by the National Gallery of Jamaica and circulated by the Smithsonian Institution Traveling Exhibition Service (SITES), 1983 (tour); *Aspects I*, National Gallery of Jamaica, Kingston, 1983; *The Intuitive Eye*, National Gallery of Jamaica, Kingston, 1979; *Four Primitive Painters from Jamaica (Everald Brown, Clinton Brown, Sidney McLaren, Kapo)*, Museum of Modern Art of Latin America, Washington, D.C., 1978; *Everald and Clinton Brown*, Olympia International Art Centre, Kingston, 1977; *Self-Taught Artist's Exhibition*, Institute of Jamaica, Kingston, late 1960s through 1977 (annual exhibitions held until 1977); *Eight Jamaican Primitives*, Havana, Cuba, 1976; *Contemporary Art From the Caribbean*, Art Gallery, Organization of American States, Washington, D.C., 1972; Kingston and St. Andrew Parish Library, Kingston, 1972; Creative Arts Centre, Kingston, 1969.

Collections: Museum of Modern Art of Latin America, Washington, D.C.; National Gallery of Jamaica, Kingston; Olympia International Art Centre, Kingston; Wadsworth Atheneum, Hartford, Connecticut; private collections.

HOUSTON CONWILL

Born in 1947 in Lexington, Kentucky, Houston Conwill combines his interest in African culture, world religions, and the relationship of man to the universe to create sculpture which stretches the traditional boundaries of three dimensional art to incorporate music, dance, oratory, and audience response in multi-dimensional performances. States Rosiland Jeffries in the catalogue *Cakewalk*:

> Houston Conwill's is one of the most important voices ever to emerge within the world of Black Atlantic art. Triumphantly, he has managed to fuse the myriad energies of African-American communicative spirit, lineage and cosmic journeying, as in the Cross River *nsibidi* and Kongo *bidimbu* traditions of earth and ground calligraphy; traditions of messages wrapt with messages, dressing spirit with material works, as in the great charm-making processes and rituals of Kongo, and their performances in maps of ritual enactments and quests with the sublime.

Education: University of Southern California, Los Angeles, M.F.A., 1976; Howard University, Washington, D.C., B.F.A., 1973.

Honors and Awards: New York Foundation for the Arts Fellowship, 1985; Prix de Rome Fellowship, 1984; John Simon Guggenheim Fellowship, 1982-83.

Travel: Europe, Africa, Asia, The Caribbean.

One-Person Exhibitions: *Houston Conwill-Works,* Hirshhorn Museum and Sculpture Garden, Smithsonian Institution, 1989; *The Passion of St. Matthew,* The Alternative Museum, New York City, 1986; *The Joyful Mysteries 1984-2034 A.D.* (Installation/Performance), The Studio Museum in Harlem, New York City, 1984; *Pointing,* Roanoke College, Salem, Virginia, 1984; *Cakewalk,* Just Above Midtown Downtown, New York City, 1983; *Hagia Sophia,* Islip Museum, East Islip, New York, 1983; *Seven Storey Mountain,* P.S. 1, Long Island City, New York, 1982; *Easter Shout,* P.S. 1, Long Island City, New York, 1981; *Passages,* Space Gallery, Los Angeles, California, 1979; *Notes of a Griot,* Just Above Midtown, New York City, 1978; *JuJu,* The Gallery, Los Angeles, California, 1976; *JuJu Funk,* Lindhurst Gallery, University of Southern California, 1975.

Group Exhibitions: *Traditions and Transformations: Contemporary Afro-American Sculpture,* Bronx Museum of the Arts, New York City, 1989; *The Eloquent Object,* Philbrook Museum of Art, Tulsa, Oklahoma, 1987; *The Artists Language: African Traditional and Modern Art,* Nassau County Museum of Fine Art, New York, 1986; *Choosing,* Museum of Science and Industry, Chicago (tour), 1986; *Artists in Residence,* American Academy in Rome, 1985; *Since the Harlem Renaissance,* Pennsylvania State University (tour), 1985; *Art Across the Park* (site work), Central Park, New York; *Ritual and Myth: A Survey of African-American Art,* The Studio Museum of Harlem, New York City, 1982; *Personal Iconography,* The Sculpture Center, New York City, 1982; Atlanta Arts Festival Invitational (site work), Piedmont Park, Atlanta, 1981; *Afro-American Abstraction,* P.S. 1 Long Island City, New York (tour), *Private Icon,* Bronx Museum, New York, 1979; *Houston Conwill/Bob Glover/Diana Hobson,* Space Gallery, Los Angeles, 1978; *FESTAC '77,* Second World Black and African Festival of Arts, Lagos, Nigeria, 1977.

Performances: *The Joyful Mysteries 1984-2034 A.D.,* (with the Boys Choir of Harlem), The Studio Museum in Harlem, New York, 1984; *Cakewalk* (with choreographer Ronald Alexander), Just Above Midtown Downtown, New York, 1983; *Passages: Earth/ H3,* The Third Floor Gallery, Atlanta, 1980; *Getup* (written by Senga Nengudi), The Paper Mill, Los Angeles, 1980; *Warrior Chants, Love Songs and New Spirituals* (collaboration), Watts Towers Art Center, Los Angeles, 1979; *Thanatopsis: Contemplations on Death,* Space Gallery, Los Angeles, 1978; *Steppin Stones* (written by Gregg Pitts), Watts Tower Art Center, Los Angeles, 1978; *Notes of a Griot,* Just Above Midtown Gallery, New York, 1978; *JuJu,* the Gallery, Los Angeles, 1976; *JuJu Funk,* Lindhurst Gallery, University of Southern California.

Commissions: Justice Building, Philadelphia, 1987; Arts Festival of Atlanta, 1987; York College (outdoor site

work), Jamaica, New York, 1986; Social Security Building (outdoor site work), Jamaica, New York, 1986; Metropolitan Transit Authority (125th Street Subway Station, Lexington Avenue Line, New York City), 1984; Bellevue Hospital, New York City, 1983; Home Life Insurance Company, New York City, 1981; Hartsfield International Airport, Atlanta, 1980; St. Augustine Church, Louisville, Kentucky (joint project with Kinshasha Holman Conwill).

Collections: Gallery of Art, Howard University, Washington, D.C.; The Studio Museum in Harlem, New York City; private collections.

AARON DOUGLAS

Born in Topeka, Kansas in 1899, the painter, muralist and illustrator Aaron Douglas is regarded as one of the most important figures of the Harlem Renaissance of the 1920s, a time of intense creative activity by black artists and writers. He was among the first artists to celebrate black culture and history in his work. He not only acknowledged his African heritage with pride but also promoted the recognition and significance of African-American artists and their art. Douglas died in 1979 in Nashville, Tennessee.

Education: Columbia University Teachers College, New York City, M.A., 1944; L'Academie Scandinave, Paris, 1931; studied under Winold Reiss in New York City, 1924-27; University of Nebraska, Lincoln, B.F.A., 1922.

Professional Experience: Founder and Chairman of Department of Education at Fisk University, Nashville, 1937-1966.

Travel: Haiti, Dominican Republic, Mexico, Canada, Portugal, Senegal, Liberia, Ghana, Nigeria, Italy, Spain, England.

Honors and Awards: Honorary degree of Doctor of Arts, Fisk University, Nashville, 1973; Carnegie grant-in-aid for the Improvement of Teaching Project, 1951; Julius Rosenwald Travel Grant, 1938; Barnes Foundation Fellowship, 1928.

One-Person Exhibitions: Fisk University, Nashville, *Retrospective Exhibition, Paintings by Aaron Douglas,* 1971, 1953, *Watercolors by Aaron Douglas,* 1952, 1948; Mulvane Art Center, Washburn University, Topeka, Kansas, 1970; University of California, Berkeley, 1964; Riley Art Galleries, New York City, 1955; Chabot House, Los Angeles, 1948; The People's Art Center, St. Louis, 1947; University of Kansas, Lawrence, 1942 (tour); American Contemporary Art Gallery, New York City, 1939, 1938; Howard University, Washington, D.C., 1937; D'Caz-Delbo Gallery, New York City, 1934.

Group Exhibitions: *Harlem Renaissance: Art of Black America,* The Studio Museum in Harlem, New York City, 1987 (tour), *Ritual and Myth: A Survey of African American Art,* 1982, *New York/Chicago: WPA and the Black Artist,* 1978; *Hidden Heritage: Afro-American Art 1800-1950,* Bellevue Art Museum, Washington and the Art Museum Association of America, 1985 (tour); *Since the Harlem Renaissance: 50 Years of Afro-American Art,* The Center Gallery, Bucknell University, Lewisburg, Pennsylvania, 1984 (tour); Fisk University, Nashville, 1984, *Amistad II: Afro-American Art,* 1975, 1951; *Painting in the South: 1564-1980,* Virginia Museum, Richmond, 1983 (tour); *Two Centuries of Black American Art,* Los Angeles County Museum of Art, 1976 (tour); *Black Artists: Two Generations,* The Newark Museum, New Jersey, 1971; *The Evolution of Afro-American Artists: 1800-1950,* City College of New York, 1967; *The Negro Artist Comes of Age: A National Survey of Contemporary American Artists,* Albany Institute of History and Art, New York, 1945; *Atlanta University Third Annual Exhibition of Paintings, Sculpture, and Prints,* Atlanta University, 1944; *Exposition of the Art of the American Negro, 1851-1940,* Tanner Art Galleries, Chicago, 1940 (tour); Baltimore Museum, 1939; Hall of Negro Life, Texas Centennial, Fair Park, Dallas, 1936; The Brooklyn Museum, New York, 1935; Harmon Foundation and College Art Association, 1934-35 (tour); Art Institute of Chicago, 1932; Harmon Foundation, New York City, 1928.

Collections: Amistad Research Center, New Orleans; Bennett College, Greensboro, North Carolina; Countee Cullen Library, 135th St. Branch, The New York Public Library, New York City (mural, WPA); Evans-Tibbs Collection, Washington, D.C.; Fisk University Museum of Art, Nashville; Governor's Residence, Madison, Wisconsin; Hampton University Museum, Virginia; Gallery of Art, Howard University, Washington, D.C.; 135th St. Branch YMCA, New York City (mural, WPA); Schomburg Center for Research in Black Culture, The New York Public Library, Art & Artifacts Division, New York City; Texas Southern University, Houston; private collections.

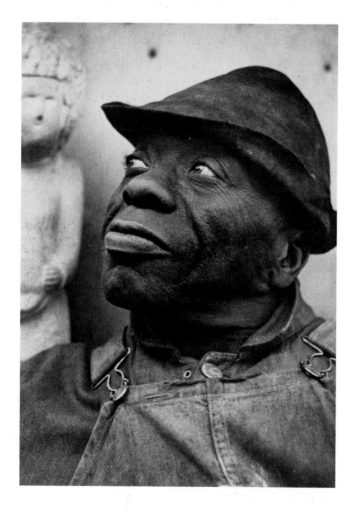

WILLIAM EDMONDSON

Born c. 1870 in Davidson County, Tennessee, William Edmondson was the son of slaves. He grew up in Nashville and worked for the Nashville, Chattanooga, and St. Louis Railway Shops and then the Woman's Hospital (later the Baptist Hospital). His first carvings were

tombstones that he created for the black community in Nashville in the early 1930s. By the late 1930s and 1940s he was also carving a variety of animals, angels, Biblical characters, and other figures. The inspiration for his carving, he said, came directly from God:

> I was out in the driveway with some old pieces of stone when I heard a voice telling me to pick up my tools and start to work on a tombstone. I looked up in the sky and right there in the noon daylight He hung a tombstone out for me to make. . . . I knowed it was God telling me what to do. God was telling me to cut figures. First He told me to make tombstones; then He told me to cut figures. He gave me them two things.

Edmondson died in 1951 in Nashville.

Professional Experience: WPA Art Program (Art Program of the Work Projects Administration of the Federal Works Agency), 1939-1941.

One-Person Exhibitions: *William Edmondson: A Retrospective*, Tennessee State Museum, Nashville, 1981; The Montclair Art Museum, Montclair, New Jersey, 1975; Cheekwood Fine Arts Center, Nashville, 1964; Nashville Artist Guild, Nashville, 1951; Museum of Modern Art, New York City, 1937.

Group Exhibitions: *Black Folk Art in America: 1930-1980*, Corcoran Gallery of Art, Washington, D.C., 1982 (tour); *Two Centuries of Black American Art*, Los Angeles County Museum of Art, 1976 (tour); *Amistad II: Afro-American Art*, Carl Van Vechten Gallery of Fine Arts, Fisk University, Nashville, 1975; La Jolla Museum of Contemporary Art, La Jolla, California, 1970; City College of the City University of New York, New York City, 1967; *Painting and Sculpture by Four Tennessee Primitives*, Lyzon Galleries, Nashville, 1964; *Trois siecles d'art aux Etats-Unis (Three Centuries of Art in the United States)*, Musée du Jeu de Paume, Paris, France, 1938.

Collections: Abby Aldrich Rockefeller Folk Art Center, Williamsburg, Virginia; Cheekwood Fine Arts Center, Nashville; Columbus Museum of Arts and Crafts, Columbus, Ohio; Hirshhorn Museum and Sculpture Garden, Smithsonian Institution, Washington, D.C.; Memorial Art Gallery, University of Rochester, New York; The Montclair Art Museum, Montclair, New Jersey; National Museum of American Art, Smithsonian Institution, Washington, D.C.; The Newark Museum, Newark, New Jersey; San Francisco Museum of Modern Art; private collections.

Quote in above passage is from Edmund L. Fuller, *Visions in Stone: The Sculpture of William Edmondson* (Pittsburgh: University of Pittsburgh Press, 1973), p. 8, cited in William H. Wiggins, Jr., "'Jesus Has Planted the Seed of Carvin' in Me': The Impact of Afro-American Folk Religion on the Limestone Sculpture of William Edmondson," in *William Edmondson: A Retrospective* (Nashville: Tennessee State Museum, 1981), p. 32.

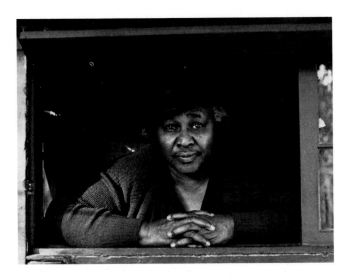

MINNIE EVANS

Minnie Evans was born in 1892 in Long Creek, Pender County, North Carolina and died in Wilmington, North Carolina in 1987. In 1893 she and her mother moved to Wilmington, North Carolina where she lived for most of her life. In 1908 she married Julius Evans and together they raised three sons. Throughout her life Minnie Evans experienced vivid dreams and it was these dreams that inspired her work, beginning with the first drawings she made on Good Friday, 1935. "My whole life has been dreams, (and) sometimes day visions . . . they would take advantage of me. No one has taught me about drawing. No one could because no one knows what to teach me. No one has taught me to paint; it came to me."

One-Person Exhibitions: *Heavenly Visions: The Art of Minnie Evans*, North Carolina Museum of Art, Raleigh, 1986; *The Visionary Art of Minnie Evans, with Photographs by Susan Mullally Weil*, Wake Forest University Fine Arts Gallery, Winston-Salem, North Carolina, 1981; St. John's Museum of Art, Wilmington, North Carolina, 1980, and c. 1961 (when St. John's Museum was The Little Gallery); Roko Gallery, New York City, 1977; Whitney Museum of American Art, New York City, 1975; Portal Gallery, London, 1970.

Group Exhibitions: *Black Folk Art by Minnie Evans and Bill Traylor*, African-American Museum, Hempstead, Long Island, 1989; *Another Face of the Diamond: Pathways Through the Black Atlantic South*, New Visions Gallery of Contemporary Art, Atlanta, 1989 (exhibition organized by INTAR Latin American Gallery, New York City); *Outside the Main Stream: Folk Art in Our Time*, High Museum of Art at Georgia-Pacific Center, Atlanta, 1988; *North Carolina Afro-American Women*, The Hickory Museum of Art, Hickory, North Carolina, 1985; *Reflections of Faith:*

Religious Folk Art in America, IBM Gallery of Science and Art, New York City, 1983-84; *The Museum Collects: New Directions; New Acquisitions*, Museum of American Folk Art, New York City, 1983; *What it is: Black American Folk Art from the collection of Regenia Perry*, Anderson Gallery, Virginia Commonwealth University, Richmond, 1982; *Forever Free: Art by African-American Women 1862-1980*, Center for the Visual Arts Gallery, Illinois State University, Normal, 1981 (tour); *Southern Works on Paper, 1900-1950*, Southern Arts Federation, Atlanta, 1981 (tour); *Two Centuries of Black American Art*, Los Angeles County Museum of Art, 1976 (tour).

Collections: The Ackland Art Museum, University of North Carolina at Chapel Hill; High Museum of Art, Atlanta; Museum of American Folk Art, New York City; National Museum of American Art, Smithsonian Institution, Washington, D.C.; The Newark Museum, Newark, New Jersey; North Carolina Museum of History, Raleigh; Weatherspoon Art Gallery, University of North Carolina at Greensboro; Whitney Museum of American Art, New York City; private collections.

Quote in above passage is from Regenia Perry, *What it is: Black American Folk Art from the collection of Regenia Perry* (Richmond: Virginia Commonwealth University, 1982).

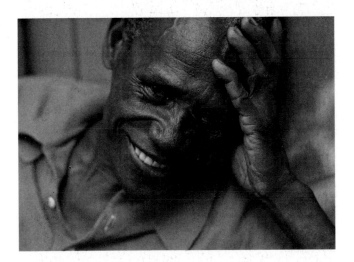

AMOS FERGUSON

Born in 1920 in Exuma, the Bahamas, Amos Ferguson currently lives in Nassau, the Bahamas. Ferguson grew up in Exuma where he attended school until the age of 14. He then worked with his father on their farm (his father was also a carpenter and preacher) until he left for Nassau.

Although Amos Ferguson enjoyed drawing in school, it wasn't until he was in his forties that he began to paint.

He recognizes his artistic talent as a gift from God and explains, ". . . To paint, the Lord gives a vision, a sight, that you goes by. But you have to see and check that Bible and don't forget God. And the more you keeps up with your Bible, and get the understanding, the better you paint."

One-Person Exhibitions: Popularis (Gallery), San Antonio, 1989; Ute Stebich Gallery, Lenox, Massachusetts, 1988; *Amos Ferguson*, Alexander Gallery, Atlanta, 1985; *Paint by Mr. Amos Ferguson*, Wadsworth Atheneum, Hartford, Connecticut, 1985 (tour).

Collections: Brooklyn Children's Museum, Brooklyn, New York; DuSable Museum of African-American History, Inc., Chicago; Museum of International Folk Art, Museum of New Mexico, Santa Fe; The Studio Museum in Harlem, New York City; Wadsworth Athenuem, Hartford, Connecticut; Waterloo Municipal Galleries, Waterloo, Iowa; private collections.

Quote in above passage is from Ute Stebich and Sukie Miller, "'I Paint by Faith, Not by Sight:' An Interview with Amos Ferguson," *Paint by Mr. Amos Ferguson* (Hartford: Wadsworth Atheneum, 1984), p. 12.

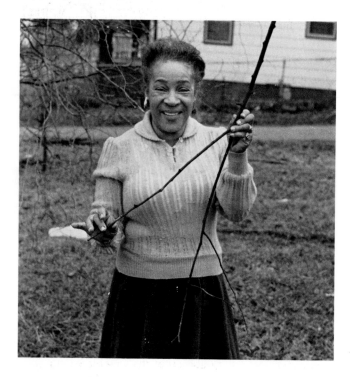

BESSIE HARVEY

Born in Dallas, Georgia in 1928, Bessie Harvey, who is the seventh of thirteen children and mother of eleven children, began her artistic career only in 1972. Her work is based on her visions inspired by God. The material she

works with is found wood, which she believes has a spiritual presence. In the natural organic forms of tree limbs and roots she discovers figures and anthropomorphic shapes to which she adds paint and found objects. Her powerful and spiritual work, it has been observed, is a collaboration between the artist, God, and nature. The artist has commented:

> I believe that the whole thing is a gift from God to me because I've always felt like that the trees and nature . . . was just of God and that the trees praised God, and that seeing the faces in the limbs and the roots and all, I know that it's a gift, a spiritual gift because I can feel the presence of something there that I could communicate with. . . . He [God] reached out at my lowest point in life and He gave me what He had put within me where that I could see it, and then He let me let the whole world see it, and so I know that it's a spiritual gift and I do enjoy it and it has changed my life completely.

One-Person Exhibitions: *Spirit Visions*, Carroll Reece Museum, East Tennessee State University, Johnson City, 1989; *Bessie Harvey — Recent Work*, Cavin-Morris Gallery, New York City, 1987.

Group Exhibitions: *Bessie Harvey, Sammie Nicely*, Bennett Galeries, Knoxville, Tennessee, 1989; *Democracy*, Dia Art Foundation, New York City, 1989; *From Africa to Appalachia*, Rose Center, Morristown, Tennessee, 1989; *Art From the African Diaspora*, Aljira Center, Newark, New Jersey, 1988; *Women of Vision — Black American Folk Art*, University of Connecticut, Storrs, 1988; *Outside The Main Stream: Folk Art In Our Time*, The High Museum at Georgia-Pacific, Atlanta, 1988; Cavin-Morris Gallery, New York City, 1988, 1987, 1986; *Baking In The Sun: Visionary Images from the South*, University Art Museum, University of Southwestern Louisiana, Lafayette, 1987 (tour); *The Naive Figure: Eccentric Visions*, Robeson Center Gallery, Rutgers University, Newark, New Jersey, 1987; *American Mysteries*, San Francisco Arts Commission Gallery, 1987; Janet Fleisher Gallery, Philadelphia, 1987; SVC Fine Art Gallery, University of South Florida, Tampa, 1987; Women's Art Registry of Minnesota, 1986; Harris Brown Gallery, Boston, *Bessie Harvey: Sculpture and Janyra Janas: Paintings*, 1986, 1985.

Collections: Carroll Reece Museum, East Tennessee State University, Johnson City; Dallas Museum of Art; Museum of the National Center of Afro-American Artists, Inc., Boston; University of Tennessee, Knoxville; private collections.

Quote in the above passage from a telephone conversation held with the artist July 12, 1989.

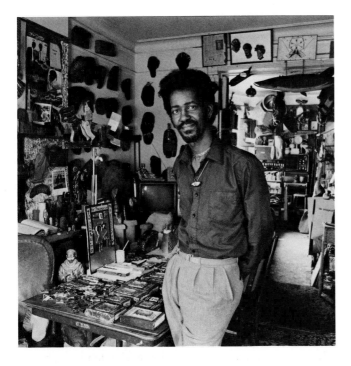

MR. IMAGINATION

"Imagination is something people use twenty-four hours a day . . . it's a universal thing."

This statement reveals much about the artist's belief that creativity abounds in one's everyday existence and that it needs only to be set into motion. Born in 1948 and raised in Chicago, Mr. Imagination, as the artist chooses to refer to himself, is the third of nine children. Self-taught, Mr. Imagination uses found materials, particularly sandstone, to create sculpture which calls forth remembrances of times past and other cultures. With an amazing ability to capture the essence of Nok sculpture and other ancient African and near eastern cultures, Mr. Imagination displays a deftness with his materials which is haunting. He became deeply interested in Egyptian art and culture, especially the belief in reincarnation, while recovering from a gunshot wound. It was during that period of convalescence in 1978 that his thoughts led his hands to create Egyptian sarcophogi, numerous Udjat eyes, and his interpretations of the Great Pyramids. His own personality is one which invites exchange among those he meets, and this artist, interested in learning more of his own culture, is able to pass on this information to the public in an informal, yet enriching manner. Mr. Imagination sells his works as ornaments, personal jewelry and popular art to the general public and he frequently conducts children's workshops in the area. He gives small tokens away to friends and strangers alike. "I just feel like passing out gifts. I've been doing that all my life."

One-Person Exhibitions: *The World of Mr. Imagination*, Carl Hammer Gallery, Chicago, 1986.

Group Exhibitions: *Artists of the Black Experience*, Carl Hammer Gallery, Chicago, 1983.

Collections: Private Collections.

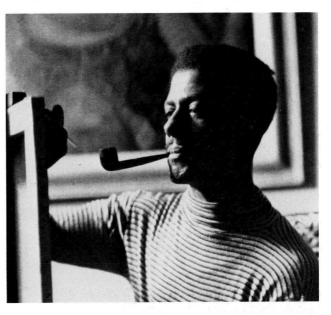

MALVIN GRAY JOHNSON

Malvin Gray Johnson was born in 1896 in Greensboro, North Carolina. Active in New York City during the Harlem Renaissance, he joined fellow artists Aaron Douglas, Palmer Hayden, and Archibald Motley, Jr., in exploring black subject matter in his work. From the late 1920s until his early death in 1934, Johnson participated in exhibitions sponsored by the Harmon Foundation. The Harmon Foundation, established by New York philanthropist William E. Harmon, began sponsoring exhibitions of work by African-American artists in the 1920s. The Foundation's annual exhibitions, which often traveled to other cities after opening in New York, introduced the work of black artists to a national audience. In 1928 Johnson received the Foundation's Otto H. Kahn Prize, and in 1935 he was honored posthumously in a special 3-artist exhibition presented by the Harmon Foundation in conjunction with its exhibition at the Delphic Studios in New York City, *Negro Artists/An Illustrated Review of Their Achievements* (the other 2 featured artists were Sargent Johnson and Richmond Barthé).

Education: National Academy of Design, New York City.

Professional Organizations: Society of Independent Artists, New York City.

Professional Experience: commercial artist; PWAP (Public Works of Art Project), 1934.

Group Exhibitions: *Hidden Heritage: Afro-American Art, 1800-1950*, Bellevue Art Museum, Bellevue, Washington, and The Art Museum Association of America, 1985 (tour); *Since the Harlem Renaissance: 50 Years of Afro-American Art*, The Center Gallery of Bucknell University, Lewisburg, Pennsylvania, 1984 (tour); *Two Centuries of Black American Art*, Los Angeles County Museum of Art, 1976 (tour); *Black Artists: Two Generations*, The Newark Museum, Newark, New Jersey, 1971; The Library of Congress, Washington, D.C., 1940; Baltimore Museum of Art, Maryland, 1939; New Jersey State Museum, Trenton, 1935; *Exhibition of Fine Arts Productions by American Negroes*, Hall of Negro Life, Texas Centennial, Dallas, 1936; Harmon Foundation, 1935, 1933, 1931, 1929, 1928; Corcoran Gallery of Art, Washington, D.C., 1934; Nicholas Roerich Museum, New York City, 1934; Smithsonian Institution, Washington, D.C., 1929.

Collections: Aaron Douglas Collection, Amistad Research Center, New Orleans; Atlanta University, Georgia; Fisk University Museum of Art, Nashville; Gallery of Art, Howard University, Washington, D.C.; National Museum of American Art, Smithsonian Institution, Washington, D.C.; Schomburg Center for Research in Black Culture, The New York Public Library, Art & Artifacts Division, New York City; private collections.

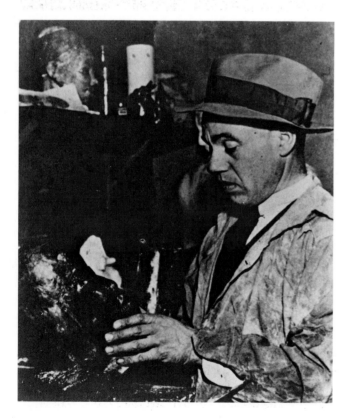

SARGENT JOHNSON

Sargent Johnson, sculptor, printmaker, ceramist, was born in 1887 in Boston, Massachusetts. In 1915 he moved to the Bay area of California where he lived until his death in 1967. Following studies at the avant-garde A. W. Best School of Art and the California School of Fine Arts, Johnson began exhibiting with the San Francisco Art Association and the Harmon Foundation. Through participation in the Harmon Foundation's touring exhibitions he became nationally known and achieved recognition as one of the outstanding artists of the Harlem Renaissance era. Like Aaron Douglas, Malvin Gray Johnson, Palmer Hayden, and Archibald Motley, Jr., Johnson explored black subject matter in his work. In 1935 he explained:

> I am producing strictly a Negro Art, studying not the culturally mixed Negro of the cities, but the more primitive slave type as existed in this country during the period of slave importation. Very few artists have gone into the history of the Negro in America, cutting back to the sources and origins of the life of the race in this country. It is the pure American Negro I am concerned with, aiming to show the natural beauty and dignity in that characteristic lip and that characteristic hair, bearing and manner; and I wish to show that beauty not so much to the white man as to the Negro himself. Unless I can interest my race, I am sunk, and this is not so easily accomplished. . . .

Education: California School of Fine Arts, San Francisco, 1940-42, 1919-1923; A.W. Best School of Art, San Francisco.

Professional Organizations: San Francisco Art Association.

Professional Experience: Art Instructor for Junior Workshop program of San Francisco Housing Authority (1947); sculpture instructor, Mills College (summer, 1947); WPA/FAP (Works Progress Administration's Federal Art Project).

Travel: Mexico, numerous trips between 1945-65; Japan, 1958.

Honors and Awards: prize for lithograph, San Francisco Art Association, 1938; medals for sculpture, San Francisco Art Association, 1935, 1931, 1925; Harmon Foundation awards, 1933 (Robert C. Ogden Prize), 1929 (Harmon Bronze Medal), and 1927 (Otto H. Kahn award).

One-Person Exhibitions: *Sargent Johnson*, Richmond Art Center, Richmond, California, 1987; *Sargent Johnson: Retrospective*, The Oakland Museum, Oakland, California, 1971.

Group Exhibitions: *African-American Artists 1880-1987: Selections from the Evans-Tibbs Collection*, Smithsonian Institution Traveling Exhibition Service, 1989 (tour); *Hidden Heritage: Afro-American Art, 1800-1950*, Bellevue Art Museum, Bellevue, Washington, and The Art Museum Association of America, 1985 (tour); *Since the Harlem Renaissance: 50 Years of Afro-American Art*, The Center Gallery of Bucknell University, Lewisburg, Pennsylvania, 1984 (tour); *Two Centuries of Black American Art*, Los Angeles County Museum of Art, 1976 (tour); *Dimensions of Black*, La Jolla Museum of Contemporary Art, La Jolla, California, 1970; *The Negro in American Art: One Hundred and Fifty Years of Afro-American Art*, University of California at Los Angeles, 1966; San Francisco Art Association annual exhibitions, 1952, 1938, 1936, 1935, 1931, 1929, 1925; *Art of Our Time*, San Francisco Museum of Art, 1945; *California Art Today*, Palace of Fine Arts, San Francisco, 1940; Harmon Foundation, 1939, 1937, 1935, 1933, 1931-1926.

Commissions: City Chambers, Richmond, California, mural (porcelain enamel on steel), 1949; Dohrmann store, Nathan Dohrmann & Company, San Francisco, mural (porcelain enamel on steel), 1948; Federal Art Project: Sunnydale Housing Project Childcare Center, San Francisco, cast terrazzo animals, 1939; Maritime Museum, Aquatic Park, San Francisco, entrance reliefs and mosaic murals on promenade deck, 1939; Court of Pacifica, Golden Gate International Exposition, two large stone sculptures, 1939; Alameda-Contra Costa County Building, Golden Gate International Exposition, three sculptures, 1939; California School for the Blind, Berkeley, redwood organ screen carved in relief, 1937.

Collections: Aaron Douglas Collection, Amistad Research Center, New Orleans; Evans-Tibbs Collection, Washington, D.C.; The Fine Arts Museums of San Francisco; Fisk University Museum of Art, Nashville; Gallery of Art, Howard University, Washington, D.C.; National Museum of American Art, Smithsonian Institution, Washington, D.C.; The Newark Museum, Newark, New Jersey; The Oakland Museum, Oakland, California; San Diego Museum of Art; San Francisco African American Historical and Cultural Society, Inc.; San Francisco Museum of Modern Art; Schomburg Center for Research in Black Culture, The New York Public Library, Art & Artifacts Division, New York City; Whitney Museum of American Art, New York City; private collections.

Quote in above passage is from an article in the *San Francisco Chronicle*, October 6, 1935, pg. D3, col. 4, quoted in Evangeline J. Montgomery, *Sargent Johnson: Retrospective* (Oakland: The Oakland Museum, 1971), pp. 17-18.

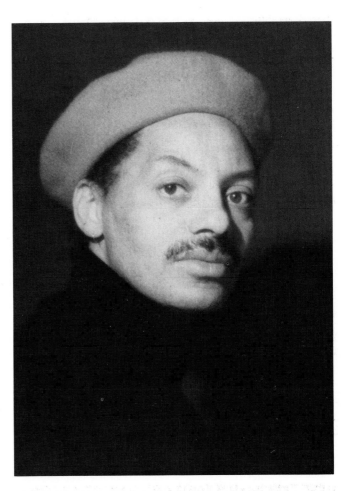

BEN JONES

Benjamin Jones was born in Paterson, New Jersey in 1942. A painter, sculptor, printmaker and mixed media artist, Jones incorporates symbols, signs and figures derived from both his African heritage and from the contemporary black experience to portray not only a personal expression, but also to relate this to a universal humanity. The artist states:

> Celebration, inspiration, beauty, dignity, integrity, challenge, responsibility, and respect, are some of the qualities which come to mind for me when I reflect on the form and content of my work, the needs of the African Diaspora, the world, and the universe. The art I do, whether abstract, symbolistic, or representational, tries to use these qualities in balance and intention: evolution to revolution or revolution to evolution: balance and change or change to balance.

In addition to his productivity as an artist, Jones has been involved in many related activities such as research on the art of various countries worldwide, extensive travel and free instruction and lectures to students. Furthermore he has been a dancer and costume designer for the Chuck

Davis Dance Company in New York City, a costume designer for the Sulaimaan Dance Company in Newark, as well as a designer of posters and record album covers.

Education: Pratt Institute, Brooklyn, New York, M.F.A., 1983; University of Kumasi, Ghana, Postgraduate study, 1970; New York University, New York City, M.A., 1966; William Paterson College, Wayne, New Jersey, B.A., 1963.

Professional Organizations: World Print Council, National Conference of Artists.

Professional Experience: Professor of Art, Jersey City State College, New Jersey, 1967 to present.

Travel: Spain, Soviet Union, Cuba, Haiti, Martinique, Guadaloupe, France, Mauritania, Senegal, Mali, Niger, Guinea, Ghana, Ivory Coast, Togo, Nigeria, Canada, Brazil.

Honors and Awards: Award of Excellence in the Arts, Delta Sigma Theta Sorority, Arts and Letters Commission, 1985; Fellowship, New Jersey State Council on the Arts, 1983-84; Purchase Award, National Afro-American Art Exhibition, Atlanta, Georgia, 1982-83; Fellowship, New Jersey State Council on the Arts, 1977-78; Grant, National Endowment for the Arts, 1974-75.

One-Person Exhibitions: *Transformations and Juxtapositions: Serigraphs and Paintings by Ben Jones*, New Jersey State Museum, Trenton, 1986; *Transformations: Recent Serigraphs/Ben Jones*, Newark Museum, New Jersey, 1984; Broadway Art Gallery, Passaic County College, Paterson, New Jersey, 1984; Jersey City Museum, New Jersey, 1982; The Robeson Campus Center Art Gallery, Rutgers University, Newark, New Jersey, 1979; *48th Fine Arts Festival: Benjamin Jones*, Fisk University, Nashville, 1977; Acts of Art Gallery, New York City, 1975; *Ben Jones: Sculptures, Paintings and Drawings*, Howard University, Washington D.C., 1975; *Ben Jones & Joe Overstreet*, The Studio Museum in Harlem, New York City, 1969.

Group Exhibitions: *Masks: Cultural and Contemporary*, Afro-American Historical and Cultural Museum, Philadelphia, 1989; Nice, France, 1988; *The Art of Black America in Japan*, Terada Warehouse, Tokyo, Japan, 1987 (tour); Kenkeleba Gallery, New York City, 1987; Museum of African-American Life & Culture, Dallas, Texas, 1986; Pennsylvania Academy of Art, Philadelphia, 1986; *Since the Harlem Renaissance: 50 Years of Afro-American Art*, The Center Gallery, Bucknell University, Lewisburg, Pennsylvania, 1984 (tour); Atlanta Life Insurance Company, Georgia, 1982; *Ritual and Myth: A Survey of African American Art*, The Studio Museum in Harlem, New York City, 1982; Newark Museum, New Jersey, 1982, 1981, 1971, 1970, 1969; Los Angeles County Museum, California, 1979; FESTAC '77, Lagos, Nigeria, West Africa, 1977; Museum of Modern Art, New York City, 1973; Dusable

Museum, Newark, New Jersey, 1973; Nyumba Ya Sanaa Gallery, New York City, 1971; *Afro-American Artists New York and Boston*, Museum of Fine Arts, Boston, 1970; Martha Jackson Gallery, New York City, 1970.

Commissions: Painting of Sarah Vaughan and Paul Robeson for the dedication of the Paul Robeson Campus Center, Rutgers University, Newark, New Jersey, 1979; Painting of Steven Biko for the National Black Lawyers Association, New York City, 1976.

Collections: Adam Clayton Powell Jr. State Office Collection, New York City; Atlanta Life Insurance Company, Georgia; Fisk University Museum of Art, Nashville; Howard University, Washington, D.C.; Jersey City State College, New Jersey; Johnson Publication, Chicago; Musée Dynamique, Dakar, Senegal, West Africa; New Jersey State Museum, Trenton; Newark Museum, New Jersey; Terada Warehouse, Tokyo, Japan; private collections.

Quote in above passage from a telephone conversation held with the artist on July 13, 1989.

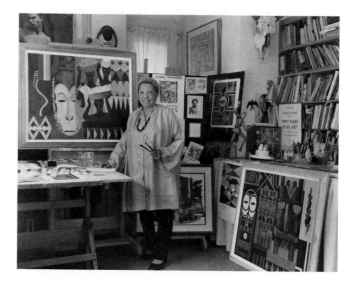

LOIS MAILOU JONES

Lois Mailou Jones, born in 1906 in Boston, Massachusetts, has been shaped by her travel, her teaching, and her immense love of her culture. States the artist, "Mine is a quiet exploration — a quest for new meanings in color, texture, and design. Even though I sometimes portray scenes of poor and struggling people, it is a great joy to paint."[1] As a black woman, Jones displays repeatedly a particular sensibility to the rites of passage of the young black female. Her depictions, couched in the graphic symbols characteristic of the many African communities which she has visited, operate on a more universal level which deals with the realization of one's greatest sense of self. As a teacher at Howard University for over forty

years, the career of Lois Mailou Jones has served as a stellar example of the possibilities available to young and gifted black artists. Still actively painting, Jones divides her time between her homes in Washington, D.C., Martha's Vineyard, and Haiti. She was married to Louis Vergniaud Pierre-Noel, the noted Haitian artist, for twenty-nine years and in the course of the marriage, Haitian culture became a particular source of very personal joy and inspiration to the artist. As an educator, Jones recognizes the importance of documenting her works as well as those of other African-American artists. She has published *Caribbean and Afro-American Women Artists*, one of the first works to analyze the art of women of color in the Americas, as well as *Peintures-Lois Mailou Jones 1937-1957* which documents a twenty-year span of her own career. States Edmund Barry Gaither in the catalogue of her 1932-1972 retrospective at Howard University: "The measure of her gift is in the eternal giving of joy, color and warmth which her paintings will always afford us, for behind the splendor of her design and color is the love she bears for black people, for all people and when the artist can make art the medium for a greater love, only triumph is possible."

Education: Certificate for Advanced Study, Academie de la Grande Chaumiere, Paris, 1962; Howard University, A.B., Art Education, magna cum laude, 1945; Academie Julian, Paris, Certificate of Study, 1938; Ecole des Beaux Arts, Paris, 1937-38; Designers' Art School, Boston, Diploma, 1928; School of the Museum of Fine Arts, Boston, Diploma in Design, 1927.

Professional Organizations: National Conference of Artists; Vineyard Haven (Mass.) Artists Guild; American Artists Congress; Society of Independent Artists, France; American Watercolor Society; Washington Art Guild; Washington Watercolor Club; Art Directors Club; Society of Washington Artists; Fellow, Royal Society of the Arts, London; Artists Equity Association.

Professional Experience: Professor of Design and Watercolor Painting, Howard University, Washington, D.C., 1930-77; Palmer Memorial Institute, Sedalia, North Carolina, 1928-30.

Travel: Europe, Africa, Caribbean, Central America, Asia.

Honors and Awards: Womens Caucus for Art Honor Award for Outstanding Achievement in the Arts, 1986; The Candace Award, National Coalition of 100 Black Women, 1983; White House "Outstanding Achievement in the Arts" award presented by President Jimmy Carter, 1980; Professor Emerita, Howard University, 1977; Howard University Research Grants to survey black visual arts in Africa, the United States, and Haiti, 1969-71; National Gallery, Washington, D.C. awards, 1964, 1960, 1954, 1948

(1st prize), 1947, 1940 (1st prize); Elected Fellow of Royal Society of Arts, London, 1962; Certificate, Academie de la Grande Chaumiere, Paris, 1962; Washington Society of Artists Award, 1962; Atlanta University awards, 1960, 1955, 1952, 1949 (1st award), 1942; Elected member of Society of Washington Artists, 1955; Lubin Award, 1954; Diplome et Decoration de l'Ordre National, Honneur et Merite au Grade de Chavalier, Government of Haiti, 1955; Corcoran Gallery of Art awards, 1953 (1st prize), 1951, 1949; Robert Woods Bliss Landscape Prize in Oil Painting, Corcoran Gallery, 1941; Honorable Mention, American Negro Exposition, 1940; General Education Board Fellowship for study in Italy, 1938; General Education Board Fellowship for study at Academie Julian, Paris, 1937; Nathaniel Thayer Prize for excellence in design, School of the Museum of Fine Arts, Boston, 1927; Boston Museum of Fine Arts School Prize, 1926.

One-Person Exhibitions: *Lois Mailou Jones: 58 Years of Watercolors 1930-1988*, Brody's Gallery, Washington, D.C., 1988; *Reflective Moments*, Museum of Fine Arts, Boston, 1973; Galerie International, New York City, 1968, 1961; Howard University Gallery of Art, 1963, 1937; Whyte Gallery, Washington, D.C., 1954; Museum of Haitian Art, Port-au-Prince, Haiti, 1954; Vose Galleries, Boston, 1939; Soulanges Gallerie, Paris; Barnet Aden Gallery, Washington, D.C.; Phillips Collection, Washington, D.C.

Group Exhibitions: *Hidden Heritage: Afro-American Art, 1800-1950*, Bellevue Art Museum, Washington and the Art Museum Association of America, 1985 (tour); *Two Centuries of Black American Art*, Los Angeles County Museum of Art, 1976 (tour); *Since the Harlem Renaissance: 50 Years of Afro-American Art*, The Center Gallery, Bucknell University, Lewisburg, Pennsylvania, 1984 (tour); Boston Museum of Fine Arts, 1970; National Academy of Design, 1969, 1951, 1949, 1944, 1942; Corcoran Gallery of Art, 1968, 1951, 1939; American Watercolor Society, 1964, 1946, 1944, 1942; ACA Galleries, New York, 1952; Barnet Aden Gallery, Washington, D.C., 1946; Albany Institute of History and Art, 1945; National Gallery of Art, Washington, D.C.; Baltimore Museum of Art, 1944, 1939-40; Dillard University, 1941; Salon des Artistes Francais, Paris, 1938-39; Pennsylvania Academy of Fine Arts, 1938-9, 1934-6; Harmon Foundation 1930-31; Galerie de Paris, 1938; Texas Centennial Exposition, Dallas, 1936; Washington Art Guild, 1928-58.

Collections: Atlanta University, Georgia; Barnett Aden Gallery, Washington, D.C.; Bowdoin College; The Brooklyn Museum; Corcoran Gallery of Art, Washington, D.C.; Hirshhorn Museum and Sculpture Garden, Smithsonian Institution, Washington, D.C.; Howard University Gallery of Art, Washington, D.C.; IBM Corporation, New

York City; Johnson Publishing Company, Chicago; Museum of Fine Arts, Boston; Metropolitan Museum of Art, New York City; National Portrait Gallery, Smithsonian Institution, Washington, D.C.; 135th St. Branch, New York Public Library; Palais National, Haiti; Phillips Collection, Washington, D.C.; Rosenwald Foundation, New York City; Walker Art Center, Minneapolis; West Virginia State College; private collections.

1 Black Artists on Art.

WILLIAM (WOODY) JOSEPH

Born in 1919 in Castleton, St. Mary, Jamaica, William Joseph is a farmer who currently lives and works in Stony Hill, Jamaica. He began creating his wood carvings in the early 1960s. These carvings were presented for the first time in an exhibition at the Paisley Gallery in Stony Hill in 1978, and since that time his work has been included in a number of exhibitions.

One-Person Exhibitions: Makonde Gallery, Kingston, Jamaica, 1985; Paisley Gallery, Stony Hill, Jamaica, 1978.

Group Exhibitions: *Fifteen Intuitives*, National Gallery of Jamaica, Kingston, 1987; *Jamaican Intuitives: Visionary Paintings and Sculpture Direct From Jamaica*, Art Gallery, Commonwealth Institute, London, England and Wolverhampton Art Gallery, Wolverhampton, England, 1986; Makonde Gallery, Kingston, 1986; Harmony Hall, Ocho Rios, Jamaica, 1979-1986; Annual National Exhibitions, National Gallery of Jamaica, Kingston, 1979-1986; *Aspects I*, National Gallery of Jamaica, Kingston, 1983; *Jamaican Art: 1922-1982*, an exhibition organized by the National Gallery of Jamaica and circulated by the Smithsonian Institution Traveling Exhibition Service (SITES), 1983-85; *The Intuitive Eye*, National Gallery of Jamaica, Kingston, 1979.

Collections: National Gallery of Jamaica, Kingston; The Studio Museum in Harlem, New York City; private collections.

KOFI KAYIGA

Born in 1943 in Kingston, Jamaica, Kofi Kayiga has been inspired not only by Caribbean culture, but by the traditions of East Africa, for much of the development of his work. The folk tale, music, and traditions of each region have all combined to provide him with immeasurable inspiration for his vibrant, small paintings. States Edmund Barry Gaither, curator of *Kayiga: Interior Landscapes*,

> Kofi Kayiga continues to probe the interior landscape of his feelings in order to find, explore and reveal through his art a mythic world of primordial archetypes. The structures that fill his inner world are expressed via overlapping color fields and bars occasionally articulated by bold and strident linear elements.

As a painter, Kayiga immerses himself in his work, working frequently on several ideas simultaneously. He brings to his work an awareness developed through serious scholarship. Having studied traditional African religions at Makerere University in Kampala, Uganda while teaching there for two years, Kayiga absorbed much of the history of this region of Africa. His work is currently the subject of a monograph being written by Robert Farris Thompson.

Education: Makerere University, Kampala, Uganda, 1971-73; Royal College of Art, Masters in Art, 1971; Jamaica School of Art, Diploma, 1966.

Professional Experience: Associate Professor, Massachusetts College of Art, 1981-present; lecture and

exhibition tour in Costa Rica, 1987; Resident Artist, African-American Master Artist in Residence Program, Northeastern University; the College of Holy Cross, Worchester, Massachusetts; the Jamaica School of Art, Kingston, 1973-81; Instructor of Fine Arts, Makerere University, Kampala, Uganda, 1971-73; design of theater sets and costumes, University of the West Indies, Mona, Kingston, Jamaica and the National Dance Theatre of Jamaica.

Travel: Europe, Central America, South America, Caribbean, Africa.

Honors and Awards: 2nd Prize, Festival Costume Queen, Jamaica, 1975; Silver Medal, Jamaica Festival, 1969; Jamaica Fellowship to the Royal College of Art, 1968; subject of a half-hour film *Kayiga: The Artist in His Studio* produced by the Jamaica Broadcast Service.

One-Person Exhibitions: Cinque Gallery, New York; The Museum of the National Center of Afro-American Artists, Boston; the New York State University at Brockport; the Bolivar and John Peartree Galleries, Kingston, Jamaica; the Jamaica High Commission, Port-of-Spain, Trinidad; the Carreiro Gallery, Massachusetts College of Art; the Sala de Exposiciones, San Jose, Costa Rica.

Group Exhibitions: National Gallery of Jamaica, Kingston; the Commonwealth Institute, London; the Devon House, Kingston; the Casa de los Americanos, Havana, Cuba; Sussex University, England; Uganda Museum, Kampala, Uganda; *Massachusetts Masters*, Museum of Fine Arts, Boston, 1987.

Collections: The Museum of The National Center of Afro-American Artists, Boston; private collections.

JEAN LACY

Jean Lacy was born in 1932 in Washington, D.C. and grew up near the campus of Howard University. Lacy was introduced at an early age to the philosophical thought and writings of Locke, Du Bois and other African-American intellectuals. A museum education specialist, Ms. Lacy has developed a number of educational programs aimed at emphasizing cultural enrichment through student study of art, artifacts, and memorabilia related to African-American history. Ms. Lacy's extensive collection of black dolls and memorabilia have been exhibited widely in Texas. The artist says,

"I feel a kinship with the ancient architects of the past. I relate to ancient forms, images and monuments. There is a heightened tension that arises from a conscious

and critical relationship to the past. This has enabled my art to be viable as social commentary on the present.

"There are certain artists today like Imamu Baraka, Spike Lee and Soul to Soul whose work relates to what I'm doing. This shows a real kinship. Earth, sky, numbers, words, places, rituals and journeys are all forms basic to our human identity . . . there is a connection between woman and nature. Everything begins with that feminine aspect. In the ancient world, the woman's body is synonymous with the earth."[1]

Education: North Texas State University, Denton, Texas, graduate studies in museum education, 1977; Southern Methodist University, Dallas, graduate studies in art education, 1977; Otis Art Institute, 1958; Art Students League, New York City, 1956-57; B.A., Art Education, Southern University, Baton Rouge, Louisiana, 1956.

Professional Organizations: Texas Association of Museums, African-American Museums Association.

Professional Experience: Director, African-American Cultural Heritage Center, Dallas Independent School district, Dallas, Texas, 1977-1988; curator of Education and Exhibitions, Museum of African-American Life and Culture, Dallas, 1975-1977; Art Instructor, Walnut Hill High School, Shreveport, Louisiana, 1956-59.

Travel: Europe, Caribbean, Mexico and Central America.

Honors and Awards: Scholarship, Winedale Museum Seminar, Texas Historical Commission, Roundtop, Texas, 1981.

Group Exhibitions: *Black Artists/South*, Huntsville Art Museum, Huntsville, Alabama, 1979; National Urban League Art Expo, Houston, 1987; *African-American Artists of Dallas*, Southern Methodist University, 1988.

Collections: Dallas Museum of Art; private collections.

[1]Quotes from conversation with the artist on September 18, 1989.

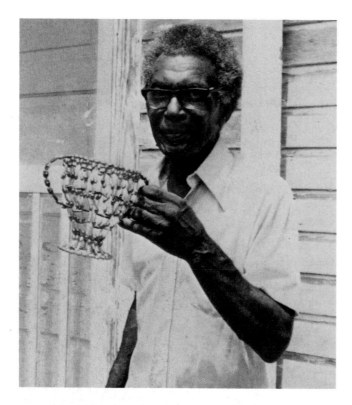

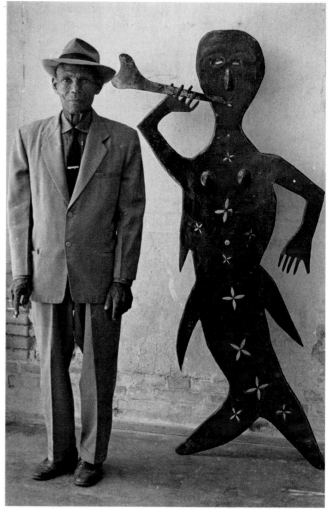

JOHN LANDRY, SR.

John Landry, Sr. was born in 1912 in New Orleans and lived there until his death in 1986. His artistic interest in Mardi Gras floats stemmed from his childhood where he frequently vied with other youngsters for the coveted positions of carrying flambeaux in the annual Mardi Gras parades. Landry used to make necklaces of restrung beads thrown from Mardi Gras floats for his brother and two sisters. Later, when Landry's eight children were growing up, he would restring carnival beads into necklaces for the girls and make toys for the boys using the same type of beads. Shortly after his retirement, Landry began experimenting with miniature, shoebox-sized replicas of the elaborate Mardi Gras floats which had fascinated him since childhood. He had hoped to become an architect and perhaps it was the instinct to build which motivated Landry to create his complex, miniature floats.[1]

Group Exhibitions: Caspari Gallery, New Orleans, 1987; *What it is: Black American Folk Art from the collection of Regenia Perry*, Anderson Gallery, Virginia Commonwealth University, Richmond, Virginia, 1982.

Collections: Private Collections.

1 This narrative taken from the catalogue to the exhibition *What it is: Black American Folk Art from the collection of Regenia Perry*. Catalogue by Dr. Regenia Perry, Virginia Commonwealth University, Richmond, Virginia, 1982.

GEORGES LIAUTAUD

Georges Liautaud was born in Croix-des-Bouquets, Haiti in 1899. He worked as a railroad repairman, then as a blacksmith making tools, branding irons and cemetery crosses. He was discovered by DeWitt Peters who saw his graveyard crosses and who then encouraged him to sculpt. Liautaud joined Le Centre d'Art in 1953 and became the first artist at that institution to work in metal. His images are made from chiseled and forged metal from oil drums. The subject of much of his work is inspired by vodun spirits. It has been said of the artist, "He knows how to stop time and shape reality into personal and universal metaphors, to simplify compli-cated images enough to render them instantly under-standable to anyone who looks at them."[1] Because of Liautaud, metal sculpture has become a traditional art form used by many Haitian artists. He is considered the master of Haitian metal art. Liautaud, who has exhibited

widely in such dispersed areas as Mexico and Japan, is now retired, still living in his hometown Croix-des-Bouquets.

One-Person Exhibitions: Pan American Union, Washington D.C., 1960; Port-au-Prince, Haiti, 1960.

Group Exhibitions: *Magiciens de la terre*, Musée National d'Art Moderne, Paris, 1989; *Where Art is Joy: Forty Years of Haitian Art*, Museum of Art, Fort Lauderdale, Florida, 1989; *Haiti: art naif/art vaudou*, Galeries Nationales d'Exposition du Grand Palais, Paris, 1988; *Redemption Song*, Cavin-Morris Gallery, New York City, 1987; Musée du Panthéon National, Port-au-Prince, Haiti, 1987; Davenport Art Gallery, Iowa, 1985, 1983-84, 1974, *The Art of Haiti*, 1969; Yale University Art Gallery, New Haven, Connecticut, 1985; *Under the Spell: The Art of Haiti*, The Chicago Public Library Cultural Center, 1983; *Ritual and Myth: A Survey of African American Art*, The Studio Museum in Harlem, New York City, 1982; *Haitian Art*, The Brooklyn Museum, New York, 1978 (tour); Institut Francais d'Haiti, Port-au-Prince, 1976; *The Naive Tradition: Haiti: The Flagg Tanning Corporation Collection*, Milwaukee Art Center, Wisconsin, 1974; Fabian Gallery, New York City, 1973; Ruhrfestspiele Recklinghausen, Staedtische Kunstalle, Recklinghausen, Germany, 1971; Le Centre d'Art, Port-au-Prince, Haiti, *Georges Liautaud and Jasmin Joseph*, 1970, 1964, 1954; Museum am Ostwall, Dortmund, Germany, 1969; Center for Inter-American Relations, New York City, 1968; Museum Boymans-van Beuningen, Rotterdam, 1964 (tour); Pan American Union, Washington, D.C., 1963; *Naive Painters of Latin America*, Duke University, Durham, North Carolina, 1962; *Das Naive Bild der Welt*, Staatliche Kunstalle, Baden-Baden, Germany, 1961 (tour); Pan American Building, New York City, 1960; Museu de Arte Moderna de São Paulo, Brazil, 1959; Knokke-le Zoute, Albert Plage, Casino Communal, Belgium, 1958; Museum of Fine Arts, Houston, 1956 (tour); *19 schilders uit Haiti*, Stedelijk Museum, Amsterdam, 1950; American British Art Center, New York City, 1947, 1946.

Collections: Le Centre d'Art, Port-au-Prince, Haiti; Davenport Museum of Art, Iowa; The Flagg Collection, Milwaukee, Wisconsin; Musée d'Art Haitien du Collège St. Pierre, Port-au-Prince, Haiti; Museum Boymans-van Beuningen, Rotterdam; Museum of Modern Art, New York City; Museum of Modern Art of Latin America, Washington, D.C.; New Orleans Museum of Art, Perry E.H. Smith Collection; Pan American Union, Washington, D.C.; Paris; The Studio Museum in Harlem, New York City; Yale University Art Gallery, New Haven, Connecticut; private collections.

1 Quote in above passage is from Randall Morris, "Georges Liautaud," *Black Art*, vol. 4 no. 4 (1981):35.

EDWARD A. LOVE

Ed Love, born in 1936 in Los Angeles, is an artist and educator who moved to Miami in 1987 to serve as the founding dean of visual arts at the New World School of the Arts. Love describes the biggest influence in his life as ". . . (my) attempt to bring about a constructive wholeness that is somehow manifested in my Africaness." Love also explains that "the most important thing about my work is (that) it allows me access into myself." An awareness of Africa came early to Love. During his childhood in Los Angeles he remembers his father and uncles arguing about Marcus Garvey and his "back to Africa" movement on Sunday afternoons after dinner. This ". . . got me thinking about Africa," Love says. In the late 1960s his developing interest in Egyptian mythology served as an entry point into a greater understanding of Africa and its vastness and complexity. "In the 1960s I had so little access to what was going on south of Egypt. I didn't understand emotionally Africa's complexity, that it was the birthplace of civilization. I was thinking of Africa as a country, not a continent. Egypt was the opening door for me to walk into Africa." Egyptian mythology, a

growing awareness of Africa and its cultural complexity, the powerful imagery of David Alfaro Siqueiros, the dynamism and passion of African-American musicians, writers and poets, the Vietnam War, the lynchings that went on in America when he was a child, and the life struggles of people he knows; these and many other influences are reflected in Love's work. Among the strongest of these influences are the writers and musicians. In his 1986 *Soundings* catalogue, Love described the impact of key writers and poets: "I have looked to the sonic warriors named (Richard) Wright, (Langston) Hughes, (Paul Laurance) Dunbar, (Sterling) Brown . . . earth pounders. They are my influences, my standard bearers. I somehow learn most from them. I hear them like great echoes, reminding and informing and guiding me through, where some fell or were side-tracked. . ."[1] From 1984 to 1988 Love created a large, multi-group sculpture called *The Arkestra* as an homage to African-American musicians. Vibrating with color and energy, these 27 kinetic sculptures of polychromed steel pay tribute to those "soundmakers" with whom Love has felt "linked." Included are The Wailers (Bob Marley and the Wailers), The Strutters (World Saxophone Quartet), The Sweet Rockers (Sweet Honey in the Rock), The Callers, Three Griots, The Bear's Harp, Nia's Parable, Duke's Mast, and Series (which includes Trane's Bird, Rahsaan's Trane, and Thread's Rahsaan). As Love explains, ". . . whether it's Max Roach or Duke Ellington, Sun Ra, Rahsaan Roland Kirk, Fats Waller, the World Saxophone Quartet, Trane, Bird, or Monk, I'm not trying to recreate their sounds. What I am responding to is the process of their work. I pay homage to them for leading me to certain places. I recognize in them a struggle to live with contradictions . . ."[2]

Education: California State University at Los Angeles, M.F.A. (1967), B.F.A. (1966); also studied at the University of Uppsala, Sweden (1967-68); University of Southern California (1960-61).

Professional Experience: Dean, Visual Arts Division, New World School of the Arts, Miami, July 1987 to present; Professor of Art, Howard University, Washington, D.C., 1968-1987; Associate Fellow, Institute for Pan-African Culture, University of Massachusetts, Amherst, 1972.

Related Activities: *The Osiris Papers* (co-author), a work in progress that addresses Love's long-standing interest and research into Egyptian mythology and its relationship to world mythologies, civilization, art, and art education. Love has also designed theatrical sets and costumes, and created light and sound designs.

Travel: Egypt and the Middle East, 1983; Mexico, 1978; Western Europe, late 1960s; Japan, 1956-58; Love has also traveled extensively throughout the U.S.

Honors and Awards: John Simon Guggenheim Memorial Foundation Fellowship, 1987-88; District of Columbia Mayor's Awards in the Arts, 1987; D.C. Commission on the Arts Individual Fellowship, 1986-87.

One-Person Exhibitions: *Ed Love: The Beloved Drawings*, Coral Gables Branch Library, Metro-Dade Public Library System, Florida, 1989; *Signs (The Maximum Security Series)*, Miami-Dade Community College, Miami, 1988; *Soundings: An Exhibition of Sculpture by Ed Love*, Gallery of Art, Howard University, Washington, D.C., 1986; *The Sounders Boogie*, Nyangoma's Gallery, Washington, D.C., 1983; *Winter in America*, Washington Project for the Arts, Washington, D.C., 1983; *Convergence*, Washington Project for the Arts, Washington, D.C., 1976; *Ed Love*, The Corcoran Gallery of Art, Washington, D.C., 1975.

Group Exhibitions: *Parallels*, Brickell Square, Miami, 1989; *Collaborations*, North Miami Center for Contemporary Art, 1989; *African Art and the Diaspora*, Hood College, Frederick, Maryland, 1989; Faculty Exhibition, New World School of the Arts, Miami, 1988; *Artscape '86, Elements of Style*, Maryland Institute of Art, Baltimore, 1986; *Afro-American Abstract Artists: 1945-1985*, The Evans-Tibbs Collection, Washington, D.C., 1986; *Choosing: An Exhibit of Changing Perspectives in Modern Art and Art Criticism by Black Americans, 1925-1985*, Hampton University, Hampton, Virginia, 1985 (tour); *Collections Show*, The Studio Museum in Harlem, New York City, 1985; *The Washington Show*, Corcoran Gallery of Art, Washington, D.C., 1985; *History in the Making*, University of Maryland, College Park, 1985; *11th International Sculpture Conference*, Washington, D.C., 1980.

Collections: Golden State Life Insurance Company, Los Angeles; Goucher College, Baltimore; Gallery of Art, Howard University, Washington, D.C.; Navy, Marshall, and Gordon, AIA, Washington, D.C.; University of the District of Columbia, Washington, D.C.; University of Massachusetts, Amherst; private collections.

1 Monifa Atungaye, "Epistrophy: A Biographical Dance," *Soundings: An Exhibition of Sculpture by Ed Love* (Washington, D.C.: Howard University Gallery of Art, 1986), p. 3.
2 *Ibid*, p. 3

All other quotes in above passage from telephone conversations held with the artist in July, 1989.

VUSUMUZI MADUNA

Vusumuzi Maduna, sculptor, painter and draughtsman was born in Cambridge, Massachusetts in 1940. In his work, the artist explores the combination of characteristic African configurations and his own personal expressive style. He has explained, "In my work I am attempting to forge a personal and legitimate synthesis between certain traditional African sculptured forms and forms that I have been developing while considering the life perspectives that prompted both into being."

Education: School of the Museum of Fine Arts, Boston, 1967.

Professional Experience: Northeastern University African-American Master Artists-in-Residency Program, Boston, 1981; Co-Founder and Director, Harriet Tubman Gallery, Boston, 1977-87; served on the Board of Directors of the Cambridge Art Association, 1976; taught at the University of Massachusetts Harbor Campus, 1975-78.

Travel: Barbados, Trinidad, Saint Vincent, Saint Croix, Belize, Surinam, China, Japan.

One-Person Exhibitions: Northeastern University, Boston, *The African Spirit: Bicultural Synthesis Part 2,* 1988, 1981; Friends of Great Black Music Loft, Boston, 1979.

Group Exhibitions: *Massachusetts Masters: Afro-American Artists,* The Museum of Fine Arts, Boston, 1988; *Trading Places,* Artists Foundation, Boston, 1988 (tour); Japanese Visual Artists Union, Tokyo, Japan, 1986; Guangzhou Fine Arts Academy, People's Republic of China, 1986; Institute of Contemporary Art, Boston, 1984; Museum of African-American Life & Culture, Dallas, Texas, 1981; Museum of the National Center of Afro-American Artists, Boston, Massachusetts, *Head-Heart-Hands-Heritage,* 1981, 1979.

Commissions: "The Judge," sculpture for Dudley Plaza, Roxbury, Massachusetts, City of Boston, Edward I. Browne Fund, 1989; "After Bambara," outdoor sculpture for Harriet Tubman House, WBZ-TV Fund for the Arts Award, 1983; "Inner City Totem No. 2," outdoor sculpture for Margaret Fuller House, Cambridge, Cambridge Arts Council, 1982; "Inner City Totem No. 1," outdoor sculpture for Cambridge Community Center, Cambridge Arts Council, 1981; graphic designs for Black Studies department, Social Studies department, Harvard University, Cambridge, 1980; "Martin Luther King, Jr. Memorial Sculpture," indoor steel mural for Martin Luther King Jr. School, City of Cambridge, 1975.

Collections: Private collections.

DAVID MILLER, JR.

Born in 1903 in Kingston, Jamaica, David Miller, Jr. began carving wooden sculptures in the mid-1930s. He and his father, David Miller, Sr., who also made carvings, lived and worked together in a small cottage in Kingston. Miller, Jr. often used lignum vitae, an extremely hard wood, in his carvings. Among his most outstanding sculptures are a series of heads he created between 1940 and 1974 which reflected his study of black physiognomy. Miller, Jr. stopped carving in 1974 and died in 1977.

Honors and Awards: Bronze Musgrave Medal (with his father), Institute of Jamaica, 1962.

Group Exhibitions: *Jamaican Intuitives: Visionary Paintings and Sculpture Direct From Jamaica,* Art Gallery, Commonwealth Institute, London, England and

Wolverhampton Art Gallery, Wolverhampton, England, 1986; *Jamaican Art: 1922-1982*, an exhibition organized by the National Gallery of Jamaica and circulated by the Smithsonian Institution Traveling Exhibition Service (SITES), 1983-85; *The Intuitive Eye*, National Gallery of Jamaica, Kingston, 1979; Memorial Exhibition, National Gallery of Jamaica, Kingston (show of work by David Miller, Jr. and David Miller, Sr.), 1977; *Five Centuries: Art in Jamaica Since the Discovery*, National Gallery of Jamaica, Kingston, 1976.

Collections: National Gallery of Jamaica, Kingston; Olympia International Art Centre, Kingston; private collections.

DAVID MILLER, SR.

Born in 1872 in Kingston, Jamaica, David Miller, Sr. began carving curios in the 1920s (one of his earliest known works is a carved coconut). In the mid-1930s he began working with his son, David Miller, Jr., in carving wooden sculptures. The work of David Miller, Sr. is very imaginative and among the carvings he created are unusual figures that incorporate his own personal symbolism. He and his son worked together in Kingston until his death in 1969.

Honors and Awards: Bronze Musgrave Medal (with his son), Institute of Jamaica, 1962.

Group Exhibitions: *Jamaican Intuitives: Visionary Paintings and Sculpture Direct From Jamaica*, Art Gallery, Commonwealth Institute, London, England and Wolverhampton Art Gallery, Wolverhampton, England, 1986; *Jamaican Art: 1922-1982*, an exhibition organized by the National Gallery of Jamaica and circulated by the

Smithsonian Institution Traveling Exhibition Service (SITES), 1983-85; *The Intuitive Eye*, National Gallery of Jamaica, Kingston, 1979; *The Formative Years*, National Gallery of Jamaica, Kingston, 1978; Memorial Exhibition, National Gallery of Jamaica, Kingston (show of work by David Miller, Jr. and David Miller, Sr.), 1977.

Collections: Private collections.

ADEMOLA OLUGEBEFOLA

Ademola Olugebefola was born in 1941 in the Virgin Islands. As co-founder of "Arts Seven," the artist helped promote black culture in the Lincoln Square area of Manhattan. In 1964 Olugebefola organized with other artists *20th Century Creators*, an art association which a year later changed its name to Weusi (Swahili for 'blackness'). In 1967, Weusi obtained a building to use as a community art gallery. The gallery, Nyumba Ya Sanaa, gave artists a place to work while the artists offered training in visual arts to the general public at the Weusi Academy. As resident designer of the New Lafayette Theatre, Olugebefola created a work, *The Prophecy*, to appear especially in the play "A Ritual to Bind Together and Strengthen Black People So That They Can Survive The Long Struggle That Is To Come." In 1969, the artist joined other pioneer arts activists to organize the first Harlem Outdoor Art Festival. Olugebefola is committed to the development of art that will change in the minds and hearts of those who form the African-American community in the New World. States the artist,

> The traditional guidelines of our ancestors are the progressive directions and manifestations of our art today . . . a sacred living art that works towards

promoting symbols and effects that are synonymous with spiritual progress . . . and blackness will be our accomplishment.

Professional Organizations: Weusi Nyumba Ya Sanaa; New Lafayette Theatre.

Professional Experience: Resident Designer, New Lafayette Theater, New York City, 1964-68; Associate Director, *Black Theatre* Magazine, 1964-68.

Travel: Africa, Europe, Caribbean.

Group Exhibitions: *Art Institute of Chicago*, Acts of Art Gallery, New York City; The Storefront Museum; Queens, New York; The Museum of the National Center of Afro-American Artists, Boston; Pennsylvania Academy of Fine Arts; Brooklyn Museum; *FESTAC '77*, Second World Festival of Black Arts and Culture, 1977; Corcoran Gallery of Art; Illinois State Museum.

Commissions: Painting series for the *Blues for Nat Turner Jazz Suite*.

Collections: Private collections.

JAMES PHILLIPS

Born in Brooklyn, New York in 1945, James Phillips' compositions of brightly colored patterns draw upon motifs from traditional African imagery that are incorporated into his own personal visual statement. Phillips has remarked, "My work is an endless search of discovery, reflective thinking and invention based on my ancestral heritage. These motifs, images and icons are copied, reshaped and integrated into a contemporary artistic aesthetic."

Education: Philadelphia College of Art, 1964-65.

Professional Organizations: Weusi Nyumba Ya Sanaa; National Conference of Artists; Africobra/Farafindugu.

Professional Experience: California State Council on the Arts, Artist-in-Residence, San Francisco County Jail, San Bruno, 1988-89; Artist-in-Residence, Howard University, Washington, D.C., 1973-77; Artist-in-Residence, The Studio Museum in Harlem, New York City, 1971-72.

Honors and Awards: National Endowment for the Arts Exchange Fellowship, Tokyo, Japan, 1980; Creative Artists Public Service Award, New York City, 1971.

One-Person Exhibitions: Sargent Johnson Gallery, San Francisco, 1987; American Center, Tokyo, Japan, 1981 (tour); Howard University, Washington, D.C., 1975, 1972; Pennsylvania Academy of Fine Arts, Philadelphia, 1972; Weusi Nyumba Ya Sanaa Gallery, New York City, 1970; Children's Museum, New York City, 1968.

Group Exhibitions: *Africobra: Paintings, Drawings, Prints and Wallhangings*, Fay Gold Gallery, Atlanta, Georgia, 1988; *Negritude*, Fort de France, Martinique, 1987; The Studio Museum in Harlem, New York City, *Tradition and Conflict: Images of a Turbulent Decade, 1963-1973*, 1985 (tour), *Resurrection 1*, 1971; *Africobra Farafindugu*, University of Maryland Eastern Shore, Princess Anne, Maryland, 1985; *Since the Harlem Renaissance: 50 Years of Afro American Art*, The Center Gallery, Bucknell University, Lewisburg, Pennsylvania, 1984 (tour); *Correlations of Painting and Afro-American Classical Music*, Kenkeleba House Gallery, New York City, 1983; *Third World Festival of African Diaspora*, Surinam, 1982; *Second New World Festival of the African Diaspora*, Port-au-Prince, Haiti, 1979; *Universal Units*, Afro-American Historical and Cultural Museum, Philadelphia, 1979; FESTAC '77, Lagos, Nigeria, 1977; Howard University, Washington, D.C., 1976, 1975, 1974; *Jubilee: Afro-American Artists on Afro-America*, Museum of Fine Arts, Boston, 1975; *Levels and Degrees*, Fisk University, Nashville, 1974; *Directions in Afro-American Art*, Herbert F. Johnson Museum of Art, Cornell University, Ithaca, New York, 1974; Selma Burke Center, Pittsburg; Corcoran Gallery of Art, Washington, D.C., 1973; Wesleyan University, Middletown, Connecticut, 1972.

Commissions: "For the Future" and "Ritual of Justice" murals, Criminal Courts Building, Philadelphia, 1987 (in progress); "Freedom Trane" mural, CalTrain Station, California State Council on the Arts, Art in Public Places, San Francisco, 1986-87; "A Tribute to Duke Ellington" mural, Duke Ellington Primary School, City of Baltimore, Maryland, 1979.

Collections: Adam Clayton Powell Jr. State Office Collection, New York City; Hall of Justice, City of San Francisco; Fisk University Museum of Art, Nashville; Gallery of Art, Howard University, Washington, D.C.; Schomburg Center for Research in Black Culture, The New York Public Library, Art & Artifacts Division, New York City; private collections.

DAVID PHILPOT

David Philpot was born in Chicago in 1940 and has lived there all his life. He began carving his staffs in 1971 as a hobby. Always interested in working with wood, and inspired by a desire "to create something different and nice," he decided in 1971 to carve a staff. Looking back at it now, Philpot says he is amazed he was able to make a staff since he wasn't an experienced carver. "I just started carving, trying to find my way." He feels he was "inspired by the Hand of God," explaining, "I had to have had a

higher being helping me because I didn't know what I was doing." He worked for a year on the staff which he now considers his masterpiece. Philpot, who has carved many staffs since this first one, works with the wood of the local Ailanthus tree since it is readily available. He not only carves intricate designs in his staffs, many of which are over six feet tall, but often inlays them with coins, mirrors, leather, or jewels obtained from craft supply shops. This decoration is inspired, he says, by a desire to make his staffs (and the canes he began carving two years ago) "unique, different, one-of-a-kind, unlike anything else."

Group Exhibitions: *David Philpot and Lydia Hardaway*, Chicago Circle Center, The University of Illinois at Chicago, 1989; *Outsider Art: The Black Experience*, Carl Hammer Gallery, Chicago, 1988; *Four Black Folk Artists of Chicago*, DuSable Museum of African-American History, Inc., Chicago, 1984.

Collections: DuSable Museum of African-American History, Inc., Chicago; private collections.

Quotes in above passage from telephone conversations held with the artist in June, 1989.

ANDERSON PIGATT

Anderson J. Pigatt was born in 1928 in Baltimore. He studied woodworking and carpentry on the G.I. Bill and soon after began to apprentice in New York with the well known furniture craftsman, James Leach. It was his training in the exacting craft of woodworking which led him to consider sculpture as a means of expressing his

ideas. The transition led to some powerful works created as a spiritual response to the often troubling dynamics of black life in America. In his New York Times review of the 1969 Brooklyn Museum exhibition, *New Black Artists*, John Canaday wrote of Pigatt's work:

> Mr. Pigatt's style is devoid of niceties; his blunt crude forms have a power like that of speech in a simplified vocabulary by an angry poet who uses each word the way a natural fighter uses a fist.

The artist collects wood forms — stumps, branches, blocks, etc. — and then lets the form and surface character of the material suggest to him what should be done with it. About his vibrant palette, Pigatt says,

> I'm into the seven colors — in the rainbow, the sky, the moon, the sun. It seems to be the only thing that's real.

The artist uses the history of African-Americans, their strife and struggle as well as the glory of their ancient past to describe the joy and pain of being not only black, but universally human. His analysis of his African origins is poetic and purposeful and gives form to his subject matter as he observes,

> The original people of Africa, "the blue people", they were full of color, blue-black color, and they were the keepers of the earth.

One-Person Exhibitions: *Spirits in Wood*, Anderson Pigatt Gallery, Baltimore, 1973; *Speaking Spirits*, Museum of the National Center of Afro-American Artists, Boston, 1973.

Group Exhibitions: *Dreamtime is Realtime*, Meyerhoff Gallery, Maryland Institute College of Art, 1989; *Afro-American Jubilee*, Boston Museum of Fine Arts and the Museum of the National Center of Afro-American Artists, Boston, 1974-75; Illinois Bell Telephone (tour), 1971; *New Black Artists*, Brooklyn Museum (tour, sponsored by the American Federation of Fine Arts, the Urban Center of Columbia University, and the Harlem Cultural Council), 1969; PanAm Building, New York City, 1968; Empire State Building, New York City, 1967.

Commissions: *In Honor of the Brothers and Sisters of Reclamation Site No. 1*, Harlem State Office Building, New York City, 1975.

Collections: Schomburg Center for Research in Black Culture, The New York Public Library, Art & Artifacts Division, New York City; private collections.

DANIEL PRESSLEY

Daniel Pressley was born in Wasamasaw, South Carolina in 1918 and died in New York City in 1971. From the catalogue *New Black Artists* (1969), Pressley stated:

> The son of backwoods farmer and a quilt sewing mother, grandson of former slaves, I began to draw at age 5. At six I modeled clay from the farm ditches into human and animal figures. At seven, I began to whittle wood, like my grandfather whom I had never seen. Old Henry Pressley, the former slave had died many years before, but he had left many wood carvings behind. I have never studied art of any kind, but I call my art the lost art — folk art.

Group Exhibitions: *Outside The Main Stream: Folk Art In Our Time*, The High Museum at Georgia-Pacific, Atlanta 1988; Cavin-Morris Gallery, New York City, *Urban Outsiders* 1988, *Art of the Black Diaspora* 1987; *The Art of Black America in Japan*, Terada Warehouse, Tokyo, Japan 1987 (tour); American Academy of Arts and Letters, New York City 1972; *New Black Artists*, Harlem Cultural Council in cooperation with Columbia University, New York City and The Brooklyn Museum, New York 1969.

Collections: Schomburg Center for Research in Black Culture, The New York Public Library, Art & Artifacts Division, New York City; private collections.

NANCY ELIZABETH PROPHET

Nancy Elizabeth Prophet was born in Warwick, Rhode Island in 1890. After her studies at the Rhode Island School of Design, she spent a number of years in Paris where she exhibited her sculpture frequently at salons. Her talent gained the attention of Henry O. Tanner who recommended her for the Harmon Foundation prize. He wrote of the young artist, "Of the many, many, many students over here either white or black, I know of none of such promise as Mrs. Prophet and it is for this reason that I should like to call your favorable attention to her — to her also it would be a 'God Send'."[1] Upon her return to the United States in 1932, she was received in triumph by Newport society. In 1933, at the encouragement of her friend W.E.B. Du Bois, she joined the art department at Spelman College. Initiating a sculpture program at Spelman, she remained in Atlanta until 1944. Frustrated by the lack of opportunities for a black sculptor in Atlanta, Ms. Prophet returned to Providence, Rhode Island in 1945, where her career began to take a downward path. No longer able to support herself through her art, Ms. Prophet worked again as a domestic, as she had done while a student. Many of her contacts were no longer in place in Rhode Island and ultimately, as Kirchenbaum points out, "Prophet did not quite achieve the comeback she wanted."[2] Few works of Prophet's have survived, many having been destroyed by the artist, while others rotted out-of-doors because she could not pay storage costs. In 1960, at age 70, Nancy Elizabeth Prophet died in poverty and obscurity.

Education: Ecole des Beaux Arts, Paris; Rhode Island School of Design, Diploma in Drawing and Painting, 1918.

Professional Organizations: Elected to membership in the Art Association of Newport, Rhode Island, 1932.

Professional Experience: Art Instructor, Spelman College and Atlanta University, Atlanta, 1933-1944.

Honors and Awards: Harmon Prize for Best Sculpture (*Head of a Negro*), Harmon Foundation, 1930; Richard Greenough Prize, Art Association of Newport, 1932.

One-Person Exhibitions: Providence Public Library, Rhode Island, 1945.

Group Exhibitions: *Hidden Heritage*, Bellevue Art Museum, Washington, and the Art Museum Association of America, 1985 (tour); *Four from Providence*, Bannister Gallery, Rhode Island College, 1978; Whitney Sculpture Biennial, 1937, 1935; Harmon Foundation, 1936, 1931, 1930; Salon d' Automne, Paris and Paris August Salons 1932, 1931, 1924-27.

Collections: Black Heritage Society of Rhode Island, Providence; Rhode Island School of Design; Whitney Museum of American Art, New York City.

1 As noted in Blossom S. Kirchenbaum's article, *Nancy Elizabeth Prophet, Sculptor* in SAGE, vol. IV, no. 1, Tanner's letter is in the Harmon Foundation files.

2 All biographical information on Prophet was gathered from the Kirchenbaum article cited above.

LEON RENFRO

Born in 1937, and raised, in Houston, Texas, Leon Renfro began to create art at an early age. After college, he worked for a number of years at the Manned Space Craft Center of NASA and at Brown and Root Engineering Company as a graphic designer. The exactitude required for creating illustrations of highly technical equipment accentuated Renfro's highly detailed drawing style and served later as a point of departure for his imaginative and introspective works which bring together in crosscur-

rent the traditional folk ways of Africa and the rural South and the technological forces of contemporary urban America. Renfro's trip to FESTAC '77, his first trip abroad, had a tremendous impact upon his own inner vision. Experiencing firsthand the culture of Nigeria and viewing the art of fellow African-Americans reinforced his commitment to his own inner vision. States the artist: "The experience was very enlightening because some of the things my Daddy had told me about Africa I saw for myself were true. You could see the same things, the same people that you grew up around in your own neigborhood were there. I saw that link everywhere, everything just fell into place. When I got there I just got down and kissed the dirt."

Education: Sam Houston State University, Huntsville, Texas, M.F.A., 1982; Texas Southern University, Houston, B.A., Art Education, 1964.

Professional Organizations: National Art Education Association; Texas Art Education Association; Houston Art Education; National Conference of Artists; Texas Association of College Teachers; Cultural Arts Council of Houston.

Professional Experience: Associate Professor, Department of Art, Texas Southern University, 1989; Assistant Professor, Texas Southern University, 1983-1989; Instructor, Texas Southern University, 1976-1983; Assistant Instructor, 1972-1976; Brown and Root Incorporated, Houston, 1970-1973; NASA Manned Spacecraft Center, 1964-1965.

Travel: Nigeria, West Africa; Mexico; Central America; the Caribbean.

Honors and Awards: Graduate Assistantship, Sam Houston State University, Huntsville, Texas, 1980-81; 2nd Place, Houston Art Educators Seventh Biennial Membership Exhibition; Exhibitor, FESTAC '77, Second World Black and African Festival of Art and Culture, Lagos, Nigeria, 1977.

One-Person Exhibitions: Sam Houston State University, 1982; Galveston Art Center, 1978.

Group Exhibitions: Faculty Exhibition, Sam Houston State University, Huntsville, Texas, 1980; *Black Artists/South*, Huntsville Museum of Art, Huntsville, Alabama, 1979; *FESTAC '77*, Lagos, Nigeria; Organization of Black Artists (OBA) Exhibition, Beaumont, Texas, 1977; College of the Mainland, Texas City, Texas, 1975; Clear Lake City Art League, Clear Lake City, Texas, 1975; Texas A & M University, College Station, Texas, 1976; House of Representatives, Texas State Legislature, Austin, Texas, 1974.

Collections: Texas Southern University, Houston; private collections.

rdson's
iown at
yette
—
illun," the Fed-
first production
t the Lafayette
rs this week
of exceptional
oung Negro ar-
ed in the thea-

it color sketch-
ail panel, were
lented twenty-
Earl Richard-
death just be-
e series unfin-
pict Negro he-
real. Ranging
o discoverer of
ugh the Revo-
ars, the mural
of the Negro's
and literature.
ad been em-
Arts Project
to death had

Earl Richardson.

EARL (EARLE) RICHARDSON

Born in 1912 in New York City, the painter Earl Richardson was only 23 years old when he died there in 1935. During his brief career, he not only produced and exhibited his paintings but was also active as a muralist. At the time of his death he was working on two mural projects — one under the Federal Arts Project of the WPA in which he had completed several color sketches for murals which later became a part of the Schomburg Center. For the other project, he had completed cartoons for proposed murals of Negro sharecroppers and the fall of Crispus Attucks at Boston Common.

Education: National Academy of Design, New York City, 1929-1932; New York Public Schools.

Professional Organizations: Artist's Union, Negro Artists Guild.

Honors and Awards: Alon Bement Portrait Prize, Harmon Foundation, 1933; Wanamaker Contest Prize, National Academy of Design School.

Group Exhibitions: *The Evolution of Afro-American Artists: 1800-1950*, City College of New York, 1967; *American Negro Exposition*, Chicago, 1940; Howard University, Washington, D.C., 1937; Hall of Negro Life,

Texas Centennial, Fair Park, Dallas, 1936; Lafayette Theatre, New York City; New York Federal Arts Project (mural division), 1934-45; Harmon Foundation and College Art Association, 1934-35 (tour); Corcoran Gallery, Washington D.C. (Public Works Art Project), 1934; Harmon Foundation, New York City, 1933; Urban League, 1932.

Collections: Gallery of Art, Howard University, Washington, D.C.; National Museum of American Art, Smithsonian Institution, Washington, D.C.; Schomburg Center for Research in Black Culture, The New York Public Library, Art & Artifacts Division, New York City; private collections.

SULTAN ROGERS

Sultan Rogers was born in 1922 in Lafayette County, near Oxford, Mississippi. As a young man he left Mississippi and lived in many states including Missouri, Illinois, and Michigan, before moving to Syracuse, New York in 1952 where he still lives. Rogers learned to carve from his father who was a carpenter and his first carvings were inspired by dreams and the animals he saw in rural Lafayette County. In discussing the ideas for his carvings, he explains: "Horses, dogs, snakes, different little things like that. It come easy to me to make them. Sometimes I dream about something or another. I wake up and I think about it. I draw an outline, and then I go back to sleep. I remember it when I get up." Rogers also carves human figures that he bases upon people he has met or seen in his travels.

Collections: Mississippi State Historical Museum, Jackson, Mississippi; Smith-Robertson Museum, Jackson, Mississippi; University Museums, The University of Mississippi, University, Mississippi; private collections.

Quote in above passage from an interview of the artist by Bill Ferris, Director of the Center for the Study of Southern Culture, in December, 1988 in Oxford, Mississippi.

BERT SAMPLES

Bertram Samples was born in 1955 in Houston, Texas. Samples draws upon the richness of universal myth for his sources of inspiration in his work. A student of John Biggers, Samples studied the impact of Africa upon African-American culture while an undergraduate at Texas Southern, and incorporated this knowledge into his own painting. Later study with Kermit Oliver, another Texas Southern graduate, enabled Samples to refine his technique and explore even further the relationship of myths to man. As chief preparator at the Museum of Fine Arts, Houston, Samples finds that being surrounded by art is inspiring and challenging and encourages him to define his own vision even more carefully. Growing up in Houston with its blend of blues, folk rhythms, and big city raw energy has given Samples an interesting perspective on the interface of African and American traditions in the Southwest.

Education: University of Houston, M.F.A., 1983; Texas Southern University, Houston, B.F.A., 1978; Artist in

Residence, The Glassell School of Art, Museum of Fine Arts, Houston, 1984-85; CORE Program, The Glassell School of Art, Museum of Fine Arts, Houston, 1983-84.

Professional Experience: Chief Preparator, Museum of Fine Arts, Houston, 1985-present; Teaching Fellow, 1982-83.

One-Person Exhibitions: Texas Southern University Art Center, 1978.

Group Exhibitions: *Core B Artist-in-Residence Exhibition*, The Glassell School of Art, Museum of Fine Arts, Houston, 1984; *Sounds in Stairwells*, University of Houston (performance), 1983; *amaalsbrientgh*, Studio One, Houston, 1983; *Eleven Artists*, Sarah Campbell Blaffer Gallery, University of Houston, 1983; *Six From Houston*, Foster Gallery, Louisiana State University, Baton Rouge, 1982; *The Prophet Toots in the Shadow of My Mind*, Lawndale Annex of the University of Houston (performance), 1982; *Miniature Art From Texas*, Gallery 101, University of Wisconsin, River Falls, 1982; *Other Realities*, Contemporary Arts Museum, Houston (performance), 1981; *Exchanges*, Maryland Institute College of Fine Arts (tour), 1981; *Amarillo Competition*, Amarillo Art Center 1979.

Collections: Texas Southern University, Houston; Sam Houston State University, Huntsville, Texas; private collections.

CHARLES SEARLES

Charles Searles was born in 1937 in Philadelphia where he lived until moving to New York City in 1978. He became interested in African art in the 1960s after discovering the African art collections of the University of Pennsylvania. He made this discovery after going into the University Museum one afternoon while job hunting. Searles remembers, ". . . (I) was walking through these rooms and came upon a room of African art that stopped me right in my tracks." He began going back to the Museum to study the collection and began buying books from the Museum store. This awareness of African art

and culture became a strong influence in the development of his work. As a student, he says, he was interested in ". . .incorporating mask ideas in my paintings." He also made sculpture out of found pieces of rusty metal, cutting them out and assembling them, seeking to create work with "an African feeling." When he received a graduation fellowship for travel in 1972, he chose to go to Africa, visiting Nigeria, Ghana, and Morocco. In a 1986 interview, Searles described the impact of this African trip: "What really hit me was that the art was in the people. The way the people carried themselves, dressed, decorated their houses became the art to me, like a living art."[1] He was also struck by the patterns of African dress: "In the Western style of dress, we see a print shirt against plaid or plain, but in Africa it was checks against stripes against polka dots. That became a major awareness for me, so that when I got back, I began to paint things combining patterns together."[2] In the late 1970s Searles began creating brightly colored wooden sculpture. In describing his sculpture Searles says:

> . . . I use flat, bent and curved and cut out forms that are painted and assembled to become three-dimensional. The combination of curved surfaces, flat planes and high-energy color is my 'formula.' My works have strong cross-cultural references. . . . They often feel like animal forms, masks, or figures, and feel very much alive. The curves and cut out surfaces activate the space through and around the sculptures, negative space becomes positive. A sense of humor, which I enjoy, is also felt in some of the pieces. My work is serious fun.

Education: Pennsylvania Academy of Fine Arts, Philadelphia, graduated 1972; also studied at University of Pennsylvania, Philadelphia.

Professional Organizations: Recherché (African-American artist group in Philadelphia), member from 1983 to 1987.

Professional Experience: Instructor of Drawing, University of the Arts, Philadelphia (formerly Philadelphia College of Art), 1973 to present; artist-in-residence, The Montclair Art Museum, Montclair, New Jersey, July 1989; visiting artist, City College of the City University of New York, New York City, April 1989; Instructor, The Brooklyn Museum Art School, 1984-1985.

Travel: Nigeria, 1977, 1972; Haiti, 1974; Ghana, Morocco, 1972.

Honors and Awards: "CAPS" Fellowship (Creative Artists Project Services), New York City, 1981; National Endowment for the Arts Fellowship, 1979; Certificate of Recognition, FESTAC '77, Lagos, Nigeria, 1977; Ware Memorial Travelling Scholarship, Pennsylvania Academy of Fine Arts, 1972; Cresson Memorial Travelling Scholarship, Pennsylvania Academy of Fine Arts, 1971.

One-Person Exhibitions: Sande Webster Gallery, Phila-delphia, 1988, 1986, 1983; Peale Gallery, Pennsylvania Academy of Fine Arts, Philadelphia, 1982; Landmark Gallery, New York City, 1981; Howard University, Wash-ington, D.C., 1974; Philadelphia Museum of Art, Philadelphia, 1973.

Group Exhibitions: *Masks: Cultural and Contemporary*, Afro-American Historical and Cultural Museum, Phila-dephia, 1989; *Divergencies* (2-artist exhibition), The Montclair Art Museum, Montclair, New Jersey, 1989; *Six Contemporary Sculptors*, Montclair State College, Montclair, New Jersey, 1988; *Art from the African Diaspora*, Aljira Center, Newark, New Jersey, 1988; *Made in Philadelphia 7*, Institute of Contemporary Art, Univer-sity of Pennsylvania, Philadelphia, 1987; *The Recherché/ Den Flexible International Exchange Exhibition* (USA/ Denmark), The Port of History Museum, Philadelphia, 1987 and Charlottenborg Museum, Copenhagen, Den-mark, 1986; *CAPS Fellowship Exhibition*, Arnot Art Museum, Elmira, New York, 1981; *Afro-American Abstrac-tion*, circulated by The Art Museum Association, 1982, (exhibition first organized in 1980 for P.S. 1, Long Island City, New York and then shown again at the Everson Museum, Syracuse, New York in 1981); *FESTAC '77*, National Theatre Gallery, Lagos, Nigeria, 1977; *Jubilee*, Museum of Fine Arts, Boston, 1975; *Contemporary Black Artists in America*, Whitney Museum of American Art, New York City, 1971; *New Black Artists*, The Brooklyn Museum, Brooklyn, 1969 (tour).

Commissions: *Cultural Harmony*, 4 interior wall sculptures for Dempsey Multi-Service Center, New York City, 1989; *Triumph*, interior hanging sculpture for Philadelphia Health Center 6, 1988; *Form and Rhythm*, interior wall sculpture, Amtrak train station, Newark, New Jersey, 1983; *Looking Ahead*, interior wall sculpture, West Oak Lane Branch Public Library, Philadelphia, 1983; *Celebration*, interior mural for Wiliam J. Green Federal Building, Philadelphia, 1976 (commissioned by the General Services Administration).

Collections: Alvin Ailey American Dance Company, New York City; CIBA GIGY Corporation, New York City; First Pennsylvania Bank, Philadelphia; Gallery of Art, Howard University, Washington, D.C.; The Montclair Art Museum, Montclair, New Jersey; Museum of the National Center of Afro-American Artists, Inc., Boston; National Museum of American Art, Smithsonian Institution, Washington, D. C.; Philadelphia Museum of Art ; private collections.

1 Barbara Binkley, "African awareness motivates artist Charles Searles," *Reading Eagle*, Reading, Pennsylvania, February 16, 1986, B-24.

2 *Ibid.*

All other quotes in above passage from telephone conversations held with the artist in June, 1989.

GEORGE SMITH

George Smith was born in 1941 in Buffalo, New York. As a sculptor, he has been influenced by the simple strength and monumentality of African architecture. His series of works which investigate the cosmology of the Dogon people are a result of his study of this group as well as his self-imposed challenge to define a personal creation of form that marries his own vision with the emblematic aspects of the Dogon toguna, or men's house. As a teacher, Smith is interested in inspiring his students to find their own philosophy, as well as the technical expertise to realize their visions. As designer of the *mbari* structure for this exhibition, Smith assumes a double identity as blacksmith and architect, two critical figures in African culture.

Education: Hunter College, New York City, M.A., 1972; San Francisco Art Institute, B.F.A., 1969.

Professional Organizations: Advisory Board of Diverse Works Gallery, Inc., Houston.

Professional Experience: Associate Professor, Rice Univer-sity, 1981-present; Associate Professor, State University of New York (SUNY) at Buffalo, 1981; Assistant Professor, SUNY at Buffalo, 1975-81; Visiting Assistant Professor, SUNY at Buffalo, 1972-75; Teaching Assistantship, Hunter College, 1970-72.

Travel: Africa, Europe, Mexico and Central America.

Honors and Awards: Artist-in-Residence Fellowship at Yaddo, Saratoga Springs, New York, 1989, 1986; Creative Artist Public Service Fellowship, Cultural Arts Council of Houston, 1985; Rice University Summer Research Grant (for continued investigation of architectural sculpture projects), 1985; Rice University Research Grant (to investigate polyhedral forms in architectural sculpture), 1981-82; National Endowment for the Arts Planning Grant for Architectural Sculpture and Earthworks (continuation of "Journey to Dogon" project), 1980-81; University of Buffalo Foundation Institutional Funds Grant, "Urban Architectural Sculpture", 1978; National Endowment for the Arts Grant for travel in Africa Research Foundation, Grant-in-Aid, metal sculpture fabrication research, 1974; Creative Artist Public Service Grant for Sculpture, New York State Council on the Arts, 1973; SUNY Research Foundation Grant-in-Aid, metal sculpture fabrication research, 1971; John Simon Guggenheim Fellowship, 1971; Scholarship in Sculpture, San Francisco Art Institute, 1964-69.

One-Person Exhibitions: *George Smith, New Works*, Sewall Art Gallery, Rice University, Houston, 1983; *Architectural Sculpture by George Smith*, The Studio Museum in Harlem, New York City, 1980; Exhibition completed as artist-in-residence, Hobart School of Welding and Technology, Troy, Ohio, 1974; Solo Exhibition, Everson Museum of Art, Syracuse, 1973; Solo Exhibition, Everson Museum of Art, Syracuse, 1972; Solo Exhibition, Reese Palley Gallery, New York City, 1970.

Group Exhibitions: *Traditions and Transformations: Contemporary Afro-American Sculpture*, The Bronx Museum of the Arts, New York City, 1989; Faculty Exhibition, Sewall Gallery, Rice University, Houston, 1986; *Contemporary Sculpture*, The Studio Museum in Harlem, 1986; *Artists at Hunter*, Hunter College, New York City, 1986; *Sculpture '86*, site project, Houston, 1986; Graham Gallery, Houston, 1985; *Art in Public Places*, Diverse Works, Inc., Houston, 1984; Environmental Sculpture Project for the Houston International Festival, 1984; *Cliff, Water and Sky*, site-specific project for the 3rd Annual Texas Sculpture Symposium, Austin, Texas, 1983; Architectural Earthwork Sculpture Project for the 13th Annual Atlanta Arts Festival, 1983; *Ritual and Myth: A Survey of African-American Art*, The Studio Museum in Harlem, New York City, 1982; CAPS Sculpture Exhibition, Arnot Museum of Art, Elmira, New York, 1981; Hartwick College of Art Gallery, Oenonta, New York, 1981; 11th International Sculpture Conference, Washington, D.C. and Baltimore, 1980-81; Environmental Sculpture Installation, Herbert F. Johnson Museum of Art, Ithaca, New York, 1979, Architectural Sculpture Project, Art Park, Lewiston, New York, 1976; *Contemporary American Artists*, Arnot Museum of Art, Elmira, New York, 1973; *Enviro Vision*,

New York Cultural Center, 1973; *Two Generations of Black Art*, Newark Museum, New Jersey, 1973; *Three Environmental Sculptors*, Rutgers University, New Jersey, 1971; *Contemporary Black American Artists*, Hudson River Museum, Yonkers, New York, 1970; Sculpture Biennial, Whitney Museum of American Art, New York City, 1970; *New Perspectives in Black Art*, Oakland Museum of Art, Oakland, California, 1968.

Commissions: Sculpture Commission for the United States Olympic Festival '86, Houston, 1986; Permanent sculpture for the Niagara Frontier Transit Authority (NFTA), Utica Station, Buffalo, New York, 1984; Permanent sculpture for the Metropolitan Atlanta Rapid Transit Authority (MARTA) for the Lindbergh Center Station, 1981-82; Department of Cultural Affairs, Atlanta, 1981-82; Architectural Earthwork Commission, Virginia Commonwealth University, Richmond, Virginia, 1980; Westheimer Presbyterian Church, Buffalo, New York, 1980.

Collections: Everson Museum of Art, Syracuse; Harlem Art Collection, State Office Building of New York, New York City; Newark Museum of Art, Newark, New Jersey; Studio Museum in Harlem, New York City.

ROBERT ST. BRICE

Robert St. Brice was born in Petionville, Haiti in 1898 and died in Port-au-Prince, Haiti in 1973. After moving to Port-au-Prince, he met the American painter Alex John who encouraged him to paint. In 1949 he was introduced to Le Centre d'Art. As a vodun priest, his paintings are of

an inner vision and are spiritual and expressive. Painting for him was a mystical act to convey his religious beliefs. His organic images, which appear to be in a state of transformation, are not strongly outlined, often dissolving into the background. Sometimes the mysterious shapes have features such as eyes and mouth. The eyes, like those of snakes, allude to vodun. The evocative forms represent spiritual presences.

One-Person Exhibitions: Le Centre d'Art, Port-au-Prince, Haiti, 1968; New York City, 1960; Musée d'Art Haitien du Collège St. Pierre, Port-au-Prince, Haiti.

Group Exhibitions: Musée du Panthéon National, Port-au-Prince, Haiti, 1989; *Where Art is Joy: Forty Years of Haitian Art*, Museum of Art, Fort Lauderdale, Florida, 1989; Davenport Art Gallery, Iowa, 1985, 1983-84, 1974, *The Art of Haiti*, 1969; *Under the Spell: The Art of Haiti*, The Chicago Public Library Cultural Center, 1983; *Haitian Art*, The Brooklyn Museum, New York, 1978 (tour); *The World of Haitian Painting From the Collection of Claude Auguste Douyon*, Smithsonian Institution Traveling Exhibition Service (S.I.T.E.S.), Washington, D.C., 1978; *The Naive Tradition: Haiti: The Flagg Tanning Corporation Collection*, Milwaukee Art Center, Wisconsin, 1974; *Haitian Painting: The Naive Tradition*, The American Federation of Arts, New York City, 1973 (tour); *Popular Painting From Haiti from the Collection of Kurt Bachmann*, Hayward Gallery, London, 1969 (tour); *Artists of the Western Hemisphere: Art of Haiti and Jamaica*, Center for Inter-American Relations, New York City, 1968; *20th Century Latin American Naive Art*, La Jolla Museum of Contemporary Art, California, 1964; *Das Naive Bild der Welt*, Staatliche Kunsthalle, Baden-Baden, Germany, 1961 (tour).

Collections: Le Centre d'Art, Port-au-Prince, Haiti; Davenport Museum of Art, Iowa; The Flagg Collection, Milwaukee, Wisconsin; Musée d'Art Haitien du Collège St. Pierre, Port-au-Prince, Haiti; New Orleans Museum of Art, Perry E.H. Smith Collection; The Selden Rodman Collection of Popular Art, Ramapo College, Mahwah, New Jersey; private collections.

RENEE STOUT

Renée Stout was born in 1958 in Junction City, Kansas where her father was stationed in the army. When she was one her family returned to their hometown of Pittsburgh where she lived until moving to Washington, D.C. in 1985. Her move to D.C. as well as an earlier stay in Boston (late 1984-1985) led to changes in her work. During her six months as artist-in-residence at Northeastern University in Boston she gradually turned from painting to sculpture. As she explains, "I began letting go of painting. (My) work started to go into box forms." Stout was also influenced by her reaction to Boston which she found to be an impersonal and unfriendly city. These feelings were reflected in her work which became darker and more introspective. The move to D.C. intensified these changes. D.C. seemed to her as impersonal a city as Boston and she continued to turn inward in her work. "More of what was inside me began coming out," she explains. Stout's deep interest in the spiritual also led her to explore the world of spiritualists, palm readers, and folk medicine practitioners that she discovered in D.C. In Pittsburgh she had known of only one house where a spiritualist lived. She remembers asking people about the woman but no one knew much about her. Stout was intrigued by the mystery. "What stimulates my imagination," she says, "is not actually knowing. Because there is a mystery, there are no rules

set, I am free to use my own imagination." Her explorations into the world of spiritualists and "root" stores led to an interest in the vodun religion, which, in turn, led her to African art and culture. She became very interested in African art, attracted by its spiritual nature and sense of mystery, and began reading such books as Robert Farris Thompson's *Flash of the Spirit*. She began creating assemblages from found objects that were much more "African" than any of the boxes or constructions she had made previously. Her interest in the spiritual attracted her to Native American Indian culture as well. "I'm attracted to spiritual societies . . . it (spirituality) seems like a means of survival in a world that you can't always understand." The past also fascinates Stout and is ever present in her pieces: "The past always comes into my work." Because her family history is not well documented, much of her past is a mystery to her. "I am obsessed about knowing about my own past," she explains. She often incorporates old sepia photographs into her work (as in *Fetish #2*), as references to the past, "almost as if trying to create a past for myself."

Education: Carnegie-Mellon University, Pittsburgh, B.F.A., 1980.

Professional Organizations: VISIONS (Pittsburgh-based art group).

Honors and Awards: Afro-American Master Artists in Residency Program, Northeastern University, Boston, 6-month residency, 1984-85.

One-Person Exhibitions: Chapel Gallery, Mount Vernon College, Washington, D.C., 1987.

Group Exhibitions: *New Directions*, Marie Martin Gallery, Washington, D.C., 1988; Carlow College, Pittsburgh, 1987; Bloomers Gallery, Pittsburgh, 1987; *The Sixth Annual Atlanta Life Insurance Company Juried Art Exhibition*, Atlanta, 1986; California State University, California, Pennsylvania, 1986; *Black Creativity*, Museum of Science and Industry, Chicago, 1985; Massachusetts College of Art, Boston, 1985; Fitchburg State College, Fitchburg, Massachusetts, 1985; The Paul Robeson Cultural Center, Pennsylvania State University, State College, 1984, 1982; The Joan Velar Gallery, Carnegie-Mellon University, Pittsburgh, 1984; Duquesne University, Pittsburgh, 1981.

Collections: Allegheny Community College, Pittsburgh; Columbia Hospital, Pittsburgh; Coraopolis Health Center, Pittsburgh; Dallas Museum of Art, Dallas; private collections.

Quotes in above passage from telephone conversations held with the artist in June and July, 1989.

MATTHEW THOMAS

Matthew Thomas was born in 1943 in San Antonio, Texas and educated primarily in California. His art is derived from the earth. His regular and geometricized forms take their inspiration from North African architectural forms, while the surface of his paintings has a patinization much like figures of ancestral sculpture which have, through the course of time, been the subject of a number of libation offerings. Thomas' works have a similar sense of tactile richness. A student of world religions, Thomas regards sacred rituals as practiced by various peoples of the earth — Native America, Africa, and Asia, in particular — as converging in one path which leads to God, the Great Spirit. As he stated in a recent interview, his challenge is to reveal through the art the cultural motifs and traditions which cut across cultural boundaries. Upon his burlap-covered plywood, the artist applies acrylic mixed with clay, which yields a work that ages and changes much like the earth itself. Thomas' studies and explorations of martial arts, yoga, African history, and East Indian and Native American social customs are simply further manifestations of his inquiries into world cultures which are part of his art.

Education: Chouinard School of Fine Arts, Los Angeles, 1965-67; Honolulu Academy of Arts, Honolulu, Hawaii, 1963-64; San Fernando Valley College, Van Nuys, California, 1961-63.

Travel: Asia, Africa, and Europe.

Honors and Awards: *Art in Public Building Program*,

Commission for San Francisco Federal Building, 1988; *Artists in Social Institutions: Sharing art with acutely to terminally ill children*, California Arts Council Grant, Children's Hospital of Los Angeles, 1986-87, 1984-85; Artist-in-Residence, Dorland Mountain Colony, Temecula, California, 1986; California Arts Council for establishing multicultural visual arts programs in 12 Los Angeles Libraries, 1983-84, 1982-83.

One-Person Exhibitions: *Matthew Thomas: Recent Paintings & Installation*, Los Angeles Artcore, 1986; *Selected Works*, Los Angeles Southwest College Art Gallery, 1983; *Oranges and Sardines*, Los Angeles, 1982; *Construction Painter*, Municipal Art Gallery, Los Angeles, 1980; *The Yoga of Painting*, The Gallery, Los Angeles, 1975;

Group Exhibition: *Los Angeles Collects*, Museum of African-American Art, Los Angeles, 1987; *Options in Painting*, Masa College Art Gallery, San Diego, CA; *Dimensions II*, Los Angeles County Museum of Art, 1987; *Continuity & Change: Emerging Afro-American Artists*, California Afro-American Museum, 1986; *Only L.A. Contemporary Variations*, Los Angeles, CA, 1986; *Art Passages*, Brockman Gallery, 1986; *Atelier VI & VII*, Self Help Graphics, 1985; *A Broad Spectrum: Contemporary Los Angeles Painters and Sculptors*, Los Angeles, 1984; *Two Natures: Maren Hassinger: Sculpture, Matthew Thomas: Painting*, Van Nuys, CA, 1983; *Other Things That Artists Make*, Municipal Art Gallery, Barnsdall Park, 1979; *West Coast Black Artists*, Brand Library Art Gallery, Glendale, CA, 1976.

Collections: Private Collections.

BILL TRAYLOR

Bill Traylor was born a slave near Benton, Alabama in 1854 on the plantation of George Traylor. After emancipation he remained there as a farm hand until he was eighty-four years old. He then moved to Montgomery and, in 1939, suddenly began to draw. In the daytime he sat on the sidewalk drawing and at night he slept in a funeral parlor. On whatever paper or cardboard he could find, Traylor began drawing simple geometric forms, filled with color and made into animal or human forms or story-telling compositions. The images derived from experiences in Traylor's life. His spontaneous works are known for their imaginative and lyrical quality. With the simplest of materials, the artist created a fresh and uncomplicated personal vision. Traylor died in 1947 in Montgomery, Alabama.

One-Person Exhibitions: Hirschl & Adler Modern, New York City, 1989, 1986; Luise Ross Gallery, New York City, 1988-89, 1985-86; *Bill Traylor Drawings From the Collection of Joseph H. Wilkinson and an Anonymous Chicago Collector*, Randolf Gallery of The Chicago Library Cultural Center, 1988 (tour); Acme Art Gallery, San Francisco, 1984; Hill Gallery, Birmingham, Michigan, 1983; Gasperi Gallery, New Orleans, 1983; Mississippi Museum of Art, Jackson, 1983; Karen Lennox Gallery, Chicago, 1982; Arkansas Art Center, Little Rock, 1982 (tour); Montgomery Museum of Fine Arts, Alabama, 1982; Hammer and Hammer Gallery, Chicago, 1982; *Bill Traylor (1854-1947) People, Animals, Events 1939-42*, Vanderwoude Tananbaum Gallery, New York City, 1982; R.H. Oosterom Gallery, New York City, 1979; Fieldston School, New York City, 1941; New South Art Center, Montgomery, Alabama, 1940.

Group Exhibitions: *Black Folk Art by Minnie Evans and Bill Traylor*, African American Museum, Hempstead, Long Island, 1989; *What is Contemporary Art?*, Rooseum, Malmo, Sweden, 1989; Luise Ross Gallery, New York City, 1987-88; *The Art of Black America in Japan*, Terada Warehouse, Tokyo, Japan, 1987 (tour); *Since the Harlem Renaissance: 50 Years of Afro-American Art*, The Center Gallery, Bucknell University, Lewisburg, Pennsylvania, 1984 (tour); Seton Hall University Museum, South Orange, New Jersey, 1985; Columbia Museum of Art, South Carolina, 1985; Fleisher Gallery, Philadelphia, *Major Black Folk Artists*, 1984, 1982; University of New Orleans, 1984; Hammer and Hammer Gallery, Chicago, 1983; *Artists on the Black Experience*, University of Illinois, Chicago, 1983; High Museum of Art, Atlanta, 1983; *Black Folk Art in America 1930-1980*, Corcoran Gallery of Art, Washington, D.C., 1982 (tour); *The Black Presence in the American Revolution . . . The Continuing Revolution*, City College of New York, 1982; *Southern Works on Paper 1900-1950*.

Southern Arts Federation, Atlanta, 1982; R.H. Oosterom Gallery, New York City, 1979.

Collections: Abby Aldrich Rockefeller Folk Art Center, Williamsburg, Virginia; Arkansas Arts Center, Little Rock; Evans-Tibbs Collection, Washington, D.C.; High Museum of Art, Atlanta; The Menil Collection, Houston; Montgomery Museum of Fine Arts, Alabama; Museum of American Folk Art, New York City; National Museum of American Art, Smithsonian Institution, Washington, D.C.; New Jersey State Museum, Trenton; Newark Museum, New Jersey; Schomburg Center for Research in Black Culture, The New York Public Library, Art & Artifacts Division, New York City; private collections.

OSMOND WATSON

Osmond Watson was born in 1934 in Kingston, Jamaica where he currently lives. As a child he attended art classes at the Institute of Jamaica's Junior Centre in Kingston (1948-52). He pursued further art studies at the Jamaica School of Art, Kingston (1952-58) and St. Martin's School of Art in London, England (1962-65). While in

London Watson spent a great deal of time studying the African art collections of the British Museum. As Watson later recalled, ". . . The British Museum became my real place of study with its wealth of African sculpture, the most important part of my heritage." Watson, who is both a painter and a sculptor, feels that his carvings convey his ideas more clearly because, as he explains, ". . . I (have) had no training in this field, therefore I have no influences to shed. My paintings are due to my training and I am still in the process of unlearning the many 'isms' I have picked up along the way."

Honors and Awards: Silver Musgrave Medal, Institute of Jamaica, 1972; First Prize/painting, 1972, 1969, 1959, Annual National Exhibition, National Gallery of Jamaica; Gold medal/sculpture, painting, and drawing, 1971, Gold medal/sculpture, 1969, and Bronze medal/painting, 1968, National Festival Exhibition, sponsored by the Jamaican Cultural Development Commission.

One-Person Exhibitions: The Art Gallery, Institute of Jamaica, Kingston, 1972; Hills Galleries, Kingston, 1966, 1961, 1960, 1959.

Group Exhibitions: Annual National Exhibition, National Gallery of Jamaica, Kingston, 1986-1982, 1980, 1977; *Jamaican Art: 1922-1982*, an exhibition organized by the National Gallery of Jamaica and circulated by the Smithsonian Institution Traveling Exhibition Service (SITES), 1983-85; *Five Centuries: Art in Jamaica Since the Discovery*, National Gallery of Jamaica, Kingston, 1976; *Ten Jamaican Sculptors*, Commonwealth Institute, London, England and National Gallery of Jamaica, Kingston, 1975; Carifesta Exhibition, Guyana, 1972; Eleventh Biennial, São Paulo, Brazil, 1971; *Three Decades of Jamaican Painting*, Commonwealth Institute, London, England, 1971; *Jamaican Art Since the Thirties*, Spelman College, Atlanta, 1969; Museum of the National Center of Afro-American Artists, Inc., Boston, 1969; *Art of Jamaica*, Kaiser Center Gallery, Oakland, California, 1964; *Face of Jamaica*, an exhibition organized by the Institute of Jamaica that traveled to London, England, 1964 and Germany (to several cities including Freiburg, Munich, Dusseldorf, Frankfurt, Berlin), 1963; Spanish Biennial, Cuba, 1953.

Collections: Casa de las Americas, Havana, Cuba; National Gallery of Jamaica, Kingston; Olympia International Art Centre, Kingston; private collections.

Quotes in above passage are from Alex Gradussov, "Osmond Watson talks to Alex Gradussov," *Jamaica Journal*, Vol. 3, No. 3 (Sept. 1969).

WILLARD "THE TEXAS KID" WATSON

Willard "The Texas Kid" Watson was born in Caddo Parish, Louisiana in 1921. The seventh of eleven children, Watson grew up as the child of poor sharecroppers who worked on a plantation near Powhatan. Accompanying his mother to the creek almost daily on fishing excursions, it was Watson's job to watch for snakes and frighten them away. In this natural environment, he became sensitive to nature and began to collect tree roots and limbs, take them home and carve figures which he saw in them. Moving to Dallas at age seven, Watson grew up familiar with the Deep Ellum section and worked as a plumber, carpenter, tailor, electrician, and auto mechanic. He began doing his yard sculptures in 1975 and has created fantastic works of installation ranging from a "live" volcano to a Boot Hill burial. Watson's work has been written about frequently, and his home was recently featured in David Byrne's *True Stories*.

Group Exhibitions: *Black History/Black Vision: The Visionary Image in Texas*, Archer M. Huntington Art Gallery, The University of Texas at Austin (tour), 1989; *Ramblin On My Mind: Black Folk Art of the Southwest*, Museum of Afro-American Life and Culture, Dallas, 1988 (tour); *SHOWDOWN: Perspectives on the Southwest*, organized by Robinson Gallery, Houston (tour), 1983; *2nd Annual Wild West Show*, Alberta College of Art, Canada; *The Eyes of Texas*, University of Houston, 1980; *Rooms*, D.W. Co-op Gallery, Dallas, 1979; *Clothes & Portraits*, D. W. Co-op Gallery, Dallas, 1976.

Collections: Dallas Museum of Art; private collections.

DEREK WEBSTER

Derek Webster was born in 1934 in the Republic of Honduras and raised in Belize. He decided to move to Chicago in 1964 after visiting his sister who was living there. Webster, who has never studied art, was inspired to begin making his sculptures in 1979 as decoration for the yard of his new home on the south side of Chicago. In a 1982 interview he described the inspiration for his work: "Since we got this house I always think in my mind to how things different from what I see. So since we get this house I decide to decorate the yard. . . . I like to see things look different from what I see. So that's how I come to do it. I just decided to go and start and get scraps of woods from out the garbage can and go and work on things in the yard, decorate the yard." The response from passersby was very positive: "Well, everybody like it, both black and white. Some people was passing . . . and some people turn around in the car and tell me congratulations. . . . They like it, everybody told me they like it. They told me, 'You're doing a wonderful job. I really like your yard.'"

Group Exhibitions: *Past Perfect/Future Indicative*, Hyde Park Art Center, Chicago, 1989; *Four Black Folk Artists of Chicago*, DuSable Museum of African-American History, Inc., Chicago, 1984; *Intuitive Art*, Art Center of Battle Creek, Michigan, 1984; Paul Waggoner Gallery, Chicago, 1984, 1983, 1982, 1981.

Collections: DuSable Museum of African-American History, Inc., Chicago; private collections.

Quotes in above passage are from Patrick Clinton, "Chi Lives: how Derek Webster became an artist," The Chicago *Reader*, January 15, 1982, p. 7.

HALE WOODRUFF

Hale A. Woodruff was born in Cairo, Illinois in 1900. In 1927 he left for Paris where he studied with Henry O. Tanner and simultaneously absorbed much of the interest in Cubism which occupied many French artists at the time. At Atlanta University he initiated annual art shows for artists. These ran until 1970 and provided the major showcase in the South where African-American artists could display and assess their talent. Known for the monumental mural style, Woodruff studied during the summer of 1936 with the Mexican muralist Diego Rivera. With artist Romare Bearden, Woodruff founded the organization "Spiral," a black artists' cooperative in the mid-sixties. Woodruff died in 1980.

Education: Herron Art Institute, Indianapolis; the Fogg Art Museum, Harvard University; Academie Scandinave and Academie Moderne in Paris. Studied with Diego Rivera in Mexico, Henry O. Tanner in Paris.

Professional Organizations: Society of Mural Painters; New Jersey Society of Artists; Committee on Art Education, Museum of Modern Art; New York State Council on the Arts; "Spiral" (with Romare Bearden).

Professional Experience: Professor, Art Department, Atlanta University, 1931-1945; Professor of Art Education, New York University, 1947-1968.

Travel: Europe, Africa and Mexico.

Honors and Awards: Honorary Doctorate, Morgan State College, Baltimore, 1968; Great Teacher Award, New York University, 1966; Purchase Prize, Atlanta University, 1951; Rosenwald Fellowship, 1943-45; Bronze Medal, Harmon Foundation, 1926; Honorable Mention, Harmon Foundation; First Prize, High Museum, Atlanta; 2nd and 3rd Awards, Diamond Jubilee Exposition, Chicago.

One-Person Exhibitions: *Ancestral Memory*, The Studio Museum in Harlem, 1976; International Print Society, New York City; Bertha Schaefer Gallery, New York City; State Museum of North Carolina, Raleigh; University of North Carolina, Chapel Hill; University of Southern Illinois; Hampton Institute; University of Michigan; Tuskegee Institute, Alabama; Kansas City Art Institute.

Group Exhibitions: *Hidden Heritage*, Bellevue Art Museum and the Art Museum Association of America (tour), 1985; *Two Centuries of Black American Art*, Los Angeles County Museum of Art (tour), 1976; Newark Museum, 1971; New York University, 1967; Los Angeles County Museum of Art, 1967; San Diego Art Museum, 1967; Museum of Fine Arts, Boston, 1967; Howard University Gallery of Art, Washington, D.C., 1967; New York University, 1967; City College of New York, 1967; Bertha Schaefer Gallery, New York, 1958; University of North Carolina, 1955; Atlanta University, 1951; Grace Horne Galleries, Boston, 1944; American Negro Exposition, Chicago, 1940; Baltimore Museum, 1939; High Museum, Atlanta 1935, 1938; Ferargil Gallery, 1931; Pacquereau Gallery, France; Downtown Gallery, New York, 1929, 1931; Texas Centennial Exhibition, Dallas, 1936; Harmon Foundation, 1935, 1933, 1931, 1928-29; Art Institute of Chicago, 1927; John Herron Art Institute, Indianapolis, 1923-24, 1926.

Collections: Newark Museum, New Jersey; IBM Corporation, New York City; Atlanta University, Georgia; Howard University, Washington, D.C.; Spelman College, Atlanta; New York University; Lincoln University, Pennsylvania; Harmon Foundation, Talladega College, Alabama; Golden State Mutual Life Insurance Company, Los Angeles; Texas Southern University, Houston; Johnson Publishing Company, Chicago.

ROOSEVELT (RIP) WOODS, JR.

Rip Woods was born in 1933 in Idabel, Oklahoma and grew up in Phoenix, Arizona where he currently lives. In high school Woods developed an awareness of African art through the teaching of his art instructor, Eugene Grigsby, a former student of Hale Woodruff. Grigsby, who later become a colleague of Woods at Arizona State University, continued over the years to play a pivotal role in bringing African art to Arizona. As Woods explains, "The major part of my life has been spent in Arizona where the abundance of art from ancestral Africa is as scarce as rainfall. However, much is changing in making heritage work available, thanks to the trailblazing efforts of Dr. Eugene Grigsby, mentor, and Professor Emeritus, Arizona State University." In 1977 Woods traveled to Africa to participate in FESTAC, the pan-African arts festival held in Lagos, Nigeria. This experience reinforced his understanding of African art and its mystique and intensified his interest in making images dealing with the art of Africa. He became curious about masks, "what they are, what they do," and began to explore the idea of masks in his work. "While the sources of inspiration for my masks are African art," Woods explains, " I invent the function of my masks. . . . (Their) function comes from my response/reaction to the function and mystique of the African mask. . . . The magic of (my) mask is personal." Woods also incorporates animal imagery in his paintings and

drawings. He describes these animals (the ram, the cow, the snake, the goat) as ". . ..cross-references to western folklore and African folklore." In discussing his work, Woods says, "It's about the mystique. . . . I've had an opportunity to respond to a form of magic and, in my response, recreate my own form of magic."

Education: Arizona State University, Tempe, M.A. (1958), B.S. (1956).

Professional Organizations: ABC (Artists from the Black Community), an organization of artists from throughout Arizona that sponsors group exhibitions (founded in 1980 by Eugene Grigsby).

Professional Experience: Professor of Painting and Drawing, Arizona State University, Tempe, 1965 to present; Assistant Professor of Painting and Drawing, Colorado College, Colorado Springs, 1967 (summer); Instructor, Phoenix College, 1962 (summer).

Travel: Nigeria, 1977.

Honors and Awards: Sabbaticals awarded by Arizona State University in 1986, 1980, 1972; faculty grants from Arizona State University awarded in 1979, 1973, 1968.

Group Exhibitions: *Four from ASU*, Phoenix College, Phoenix, 1989; Old Dominion University, Norfolk, Virginia, 1989; *Artists from the Black Community/ USA*, Arizona Bank, Phoenix, 1988; *Visual Heritage*, Benedict College, Columbia, South Carolina, 1987; Udinotti Gallery, San Francisco and Venice, California, and Phoenix since 1987; *Artists Select: Contemporary Perspectives by Afro-American Artists*, Arizona State University Art Museum, Tempe, 1986; School of Art Faculty Exhibition, Arizona State University Art Museum, Tempe, 1981; *FESTAC '77*, Lagos, Nigeria, 1977; *Arizona's Outlook*, Tucson Museum of Art, 1976; *Southwestern Invitational*, Yuma Arts Center, Yuma, Arizona, 1975, 1973, 1972, 1970, 1969, 1967, 1966; *74th Western Annual*, The Denver Art Museum, Denver, 1973; Phoenix Art Museum, Phoenix, mid-1960s.

Commissions: mosaic floor piece and wall mural, Greyhound Corporation, Phoenix, 1970s; wall mural (multi-media), National Housing Industries, Phoenix, c. 1970.

Collections: Arizona State University Art Museum, Tempe; Phoenix Art Museum, Phoenix; Southeast Arkansas Arts and Science Center, Pine Bluff; University of Montana, Missoula; Yuma Arts Center, Yuma, Arizona; private collections.

Quotes in above passage from telephone conversations held with the artist in June and July, 1989.

SELECTED BIBLIOGRAPHY

Aden, Alonzo. *Exhibition of Fine Arts Production by American Negros.* Dallas, Texas, 1936.

African-American Artists 1880-1987: Selections from the Evans-Tibbs Collection. Washington, D.C.: Smithsonian Institution Traveling Exhibition Service, 1989.

AfriCobra II. New York: The Studio Museum in Harlem, 1971.

Another Face of the Diamond: Pathways Through the Black Altantic South. New York: INTAR Latin American Gallery, 1988.

Apraxine, Pierre. *Haitian Painting: The Naive Tradition.* New York: American Federation of Arts, 1973.

ART/artifact. New York: The Center for African Art, 1988.

The Art of Haiti. [Davenport, Iowa: Davenport Municipal Art Gallery], 1969.

Artists of the Western Hemisphere: Art of Haiti and Jamaica. New York: Center for Inter-American Relations, 1968.

Baking in the Sun: Visionary Images from the South. Lafayette: University Art Museum, University of Southwestern Louisiana, 1987.

Berry, Mary Frances and John Blassingame. *Long Memory: The Black Experience in America.* New York: Oxford University Press, 1982.

Biggers, John. *Ananse, the Web of Life in Africa.* Austin: University of Texas Press, 1962.

Biggers, John and Carroll Simms. *Black Art in Houston, The Texas Southern University Experience.* College Station and London: Texas A & M University Press, 1978.

Bill Traylor 1854-1947. New York: Hirschl & Adler Modern, 1988.

Bill Traylor Drawings From the Collection of Joseph H. Wilkinson and an Anonymous Chicago Collector, Chicago: Chicago Office of Fine Arts, 1988.

Binkley, Barbara. "African awareness motivates artist Charles Searles." *Reading Eagle,* February 16, 1986.

Black Artists: Two Generations. [Newark]: Newark Museum, 1971.

Bontemps, Arna Alexander and Jacqueline Fonvielle-Bontemps. *Forever Free: Art by African-American Women 1862-1980.* Alexandria, Virginia: Stephenson, Inc., 1980.

Boxer, David. *Fifteen Intuitives.* Kingston: National Gallery of Jamaica, 1987.

Boxer, David. *Jamaican Art, 1922-1982.* Washington, D.C.: Smithsonian Institution Traveling Exhibition Service, 1983.

Boxer, David and Rex Nettleford. *The Intuitive Eye.* Kingston: National Gallery of Jamaica, 1979.

Britton, Crystal, ed. *Selected Essays: Art & Artists from the Harlem Renaissance to the 1980's.* Atlanta: National Black Arts Festival, 1988.

Caribbean Festival Arts. St. Louis: The Saint Louis Art Museum, 1988.

Clinton, Patrick. "Chi Lives: how Derek Webster became an artist." The Chicago *Reader,* January 15, 1982.

Cole, Herbert M. *Mbari: Art and Life Among the Owerri Igbo.* Bloomington, Indiana: Indiana University Press, 1982.

Das Naive Bild der Welt. Baden-Baden: Die Kunsthalle, 1961.

De Lusthof der Naieven. Rotterdam: Gemeentedrukkerij, 1964.

Dover, Cedric. *American Negro Art.* Greenwich, Connecticut: New York Graphic Society, 1969.

Driskell, David C. *African Art, The Fisk University Collection.* Nashville, Tennessee: Fisk University, 1970.

Driskell, David C. *Amistad II: Afro-American Art.* Nashville: Department of Art, Fisk University, 1975.

Driskell, David C. *Hidden Heritage: Afro-American Art, 1800-1950.* Bellevue, Washington: Bellevue Art Museum and The Art Museum Association of America, 1985.

Driskell, David C. *Two Centuries of Black American Art.* Los Angeles and New York: Los Angeles County Museum of Art and Alfred A. Knopf, 1976.

Driskell, David C. and Earl J. Hooks. *The Afro-American Collection, Fisk University.* Nashville: Department of Art, Fisk University, 1976.

The Evolution of Afro-American Artists, 1800-1950. New York: City University of New York, 1967.

Exhibition of Productions by Negro Artists. [New York]: The Harmon Foundation, 1933.

Fax, Elton. *Seventeen Black Artists.* New York: Dodd, Mead and Company, 1971.

Fax, Elton. *West Africa Vignettes.* New York: American Society of African Culture, 1960.

Ferris, William, ed. *Afro-American Folk Arts and Crafts.* Jackson, Mississippi and London: University Press of Mississippi, 1983.

Ferris, William and Charles R. Wilson, ed. *Encyclopedia of Southern Culture.* Chapel Hill: University of North Carolina Press, 1989.

48th Fine Arts Festival: Benjamin Jones. Nashville: Fisk University, 1977.

Gaither, Edmund Barry. *Massachusetts Masters: Afro-American Artists.* [Boston]: Museum of Fine Arts, Boston in cooperation with the Museum of the National Center of Afro-American Artists, 1988.

Goldwater, Robert J. *Primitivism in Modern Painting.* New York: Harper, 1938.

Gradussov, Alex. "Osmond Watson talks to Alex Gradussov." *Jamaica Journal.* vol. 3, no. 3, September 1969.

Gulf-Caribbean Art Exhibition. [Houston: Museum of Fine Arts, Houston, 1956].

Gumbo Ya-ya: A Collection of Louisiana Folk Tales. [New Orleans]: Pelican Publishing Company, 1987.

Haiti: art naif art vaudon. Paris: Galeries Nationales du Grand Palais, 1988.

Haitian Popular Paintings Presented by Le Centre d'Art, Port-au-Prince, Haiti. New York: American British Art Center, 1947.

Hammond, Leslie King. *Ritual and Myth: A Survey of African American Art.* New York: The Studio Museum in Harlem, 1982.

Harlem Renaissance/Art of Black America. New York: Harry N. Abrams, Inc., 1987.

Hoffman, L.G. *Haitian Art: The Legend and Legacy of the Naive Tradition.* Davenport: Davenport Art Gallery, 1985.

Huggins, Nathan. *The Harlem Renaissance.* New York: Oxford University Press, 1971.

Huggins, Nathan., ed. "Visual Arts: To Celebrate Blackness," *Voices From the Harlem Renaissance.* New York: Oxford University Press, 1976.

Igoe, Lynn M. *Two-Hundred-and-Fifty Years of Afro-American Art: An Annotated Bibliography.* New York: R.R. Bowker, 1981.

Introspectives: Contemporary Art by Americans and Brazilians of African Descent. Los Angeles: The California Afro-American Museum, 1989.

Kahan, Mitchell D. *Heavenly Visions: The Art of Minnie Evans.* Raleigh: North Carolina Museum of Art, 1986.

Kingsley, April. *Afro-American Abstraction.* San Francisco: The Art Museum Association, 1982.

Kirschenbaum, Blossom S. "Nancy Elizabeth Prophet, Sculptor." *SAGE: A Scholarly Journal on Black Women.* vol. IV, no. 1, Spring 1987.

Knokke-le Zoute, Albert Plage, and Casino Communal. *Les peintures naif du douanier Rousseau a nos jours.* Bruxelles: Editions de la connaissance, 1958.

Kunst aus Haiti: Sammlung Kurt Bachmann, New York. Dortmund: Museum am Ostwall, 1969.

LaDuke, Betty. "The Grande Dame of Afro-American Art: Lois Mailou Jones." *SAGE: A Scholarly Journal on Black Women.* vol. IV, no. 1, Spring 1987.

Lewis, David Levering. *When Harlem Was In Vogue.* New York: Knopf, 1981. Reprint: New York: Vintage Books, 1982.

Livingston, Jane and John Beardsley. *Black Folk Art in America, 1930-1980.* Jackson: University Press of Mississippi

and the Center for the Study of Southern Culture, 1982.

Locke, Alain L. *Negro Art: Past and Present.* Washington, D.C.: Associates in Negro Folk Education, 1936.

Locke, Alain L., ed. *The Negro in Art.* Washington, D.C.: Associates in Negro Folk Education, 1940. Reprint: Washington, D.C.: Hacker Art Books, 1968.

Locke, Alain L., ed. *The New Negro: An Interpretation.* New York: Albert and Charles Boni, 1925. Reprint: Boston: Atheneum Press, 1968.

Long, Richard. *Highlights from The Atlanta University Collection of Afro-American Art.* Atlanta: The High Museum of Art, 1973.

Magiciens de la terre. Paris: Editions du Centre Pompidou, 1989.

Montgomery, Evangeline J. *Sargent Johnson: Retrospective.* Oakland: The Oakland Museum, 1971.

Morris, Randall. "Georges Liautaud." *Black Art,* vol. no. 4 (1981): 29-43.

Morris, Shari Cavin. "Bessie Harvey: The Spirit in the Wood." *The Clarion* 12 (Spring/Summer 1987): 44-49.

Morrison, Keith. *Art in Washington and Its Afro-American Presence: 1940-1970.* Washington, D.C.: Washington Project for the Arts, 1985.

Naive Painters of Latin America. [Durham, North Carolina]: The Department of Art and The Duke University Student Union, [1962].

The Naive Tradition: Haiti: The Flagg Tanning Corporation Collection. Milwaukee: Milwaukee Art Center, 1974.

The Negro Artist Comes of Age: A National Survey of Contemporary American Artists. [Albany]: Albany Institute of History and Art, [1945].

Negro Artists: An Illustrated Review of Their Achievements. New York: The Harmon Foundation, 1935.

New Black Artists. New York: 1969.

19 schilders uit Haiti. [Amsterdam]: Stedelijk Museum, 1950.

Paint by Mr. Amos Ferguson. Hartford: Wadsworth Atheneum, 1984.

Painting in the South: 1564-1980. Richmond: Virginia Museum, 1983.

Paintings from Le Centre d'Art, Port-au-Prince, Haiti. New York: American British Art Center, 1946.

Perry, Regenia. *What it is: Black American Folk Art from the collection of Regenia Perry.* Richmond: Anderson Gallery, Virginia Commonwealth University, 1982.

Popular Paintings from Haiti From the Collection of Kurt Bachmann. London: Arts Council of Great Britain, 1969.

Porter, James A. *Modern Negro Art.* New York: Dryden Press, 1943.

Poupeye-Rammelaere, Veerle. "The Rainbow Valley: The Life and Work of Brother Everald Brown." *Jamaica Journal.* vol. 21, no. 2, May — July, 1988.

Powell, Richard J. *African and Afro-American Art: Call and Response.* Chicago: Field Museum of Natural History, 1984.

Primitive Artists of the Americas in Celebration of Pan American Week. Washington, D.C.: Pan American Union, 1963.

Retrospective Exhibition, Paintings by Aaron Douglas. Nashville: Fisk University, 1971.

Rodman, Selden. *Where Art is Joy: Haitian Art: The First Forty Years.* New York: Ruggles de Latour, 1988.

Rodman, Selden and Candice Russell. *Where Art is Joy: Forty Years of Haitian Art.* Fort Lauderdale: Museum of Art, 1989.

Sims, Lowery S. *Bill Traylor (1854-1947): People, Animals, Events 1939-42.* New York: Vanderwoude Tananbaum, 1982.

Since the Harlem Renaissance/ 50 Years of Afro-American Art. Lewisburg, Pennsylvania: The Center Gallery of Bucknell University, 1985.

Stebich, Ute. *Haitian Art.* Brooklyn: The Brooklyn Museum, 1978.

Stewart, Jeffrey, ed. *The Critical Temper of Alain Locke: A Selection of His Essays on Art and Culture.* New York and London: Garland, 1983.

Thompson, Robert Farris. *Flash of the Spirit: African and Afro-American Art and Philosophy.* New York: Random House, 1983.

Thompson, Robert Farris. *Soundings: An Exhibition of Sculpture by Ed Love.* Washington, D.C.: Gallery of Art, Howard University, 1986.

Thompson, Robert Farris and Joseph Cornet. *The Four Moments of the Sun: Kongo Art in Two Worlds.* Washington, D.C.: National Gallery of Art, 1981.

Tradition and Conflict: Images of a Turbulent Decade, 1963-1973. New York: The Studio Museum in Harlem, 1985.

Under the Spell: The Art of Haiti. Chicago: Chicago Council on Fine Arts, 1983.

Vlach, John M. *The Afro-American Tradition in Decorative Arts.* Cleveland: The Cleveland Museum of Art, 1978.

Wardlaw, Alvia. *John Biggers: Bridges.* Los Angeles: California Museum of Afro-American History and Culture, 1983.

Werke und Werkstatt Naiver Kunst. [Recklinghausen]: Ruhrfestspiele Recklinghausen, 1971.

William Edmondson: A Retrospective. Nashville: Tennessee State Museum, 1981.

Willis, Wilda Logan. *A Guide to the Alain L. Locke Papers.* Washington, D.C.: Moorland-Spingarn Research Center, Howard University, 1985.

INDEX

PHOTO CREDITS

Allen, Jules, 266; Apfelbaum, Ben, 270; Blackwell, Ben, courtesy of San Francisco Museum of Modern Art, 146; Cavin-Morris Gallery, New York City, 285; Clockman, Lee, DMA, 179; Cohen, Mitchell, courtesy of Davenport Museum of Art, Iowa, 261, 264; Cooper, Christie, 205; Dahl-Wolfe, Louise, gift of the artist, courtesy of Cheekwood Fine Arts Center, Nashville, 268; Davis, Griffith J., courtesy of Hale Woodruff Papers, The Amistad Research Center at Tulane University, New Orleans, 297; Davis, Pat, 282; Eells, P. Richard, courtesy of The Flagg Collection, Milwaukee, 238, 239; Evans-Tibbs Collection, Washington, D.C., 142; Fatherree, M. Lee, Collection of The Oakland Museum, lent by the M.H. de Young Memorial Museum, 150; Felgar, J., 196; Fernandez, Antonio A., DMA, 193, 254; Ferris, William, courtesy of University of Mississippi Archives and Special Collections, University, 288; Finch, Michael Alonzo, 284; Fisk University Library, Special Collections, Nashville, 267; Gainsforth, Stan, 189; Gips, Glen, 288; Gore, Arnold, courtesy of The Flagg Collection, Milwaukee, 258; Gordon, Ron, ©1989, 271; Grant, Jarvis, c 1989, 188, 292; Grant, Jarvis, 6, 194, 255; Grigsby, William, courtesy of Cavin-Morris Gallery, New York City, 278; Hill, Jackson, courtesy of The Aaron Douglas Collection, The Amistad Research Center at Tulane University, New Orleans, 160; Hudnall, Earlie, Jr., DMA, 196, 240; Hudnall, Earlie, Jr., The Museum of Fine Arts, Houston, Museum purchase with funds provided by Texas Eastern Corporation, 248, 249; Hudnall, Earlie, Jr., 200, 262, 286; Jenkins, Tom, DMA, courtesy of University Museums, University of Mississippi, 157, 168, 176; Jenkins, Tom, DMA, Cover, frontispiece, 4, 5, 9, 151, 152, 153, 154, 155, 156, 159, 162, 166, 167, 168, 169, 171, 173, 174, 175, 177, 178, 179, 180, 181, 183, 184, 185, 186, 187, 188, 190, 198, 199, 201, 202, 203, 204, 207, 208, 209, 210, 211, 212, 214, 215, 216, 217, 218, 219, 220, 221, 222, 223, 225, 226, 227, 228, 229, 230, 231, 235, 236, 240, 241, 243, 245, 246, 247, 252, 256, 257, 260, 277, 290, 296 ; Johnson, Lynn, 269; Le Centre d'Art, Port-au-Prince, Haiti, 264, 291; Lindgren, Scott, 195; Lopisi, Joseph, 276; Love, Ed, 279; Monteaux, Michel, DMA, 172; Morgan, Ruth, 283; Mussa, Mansa K., 273; National Museum of American Art, Smithsonian Institution, Washington, D.C., gift of the Harmon Foundation, 147; National Gallery of Jamaica, Kingston, 281, 282, 295; National Archives, Washington, D.C. (photo no. 200S-HNE-20-27), 271; Oberli, Andreas, 265, 276; Okazak, Cary, 250, 251; Perry, Regenia, 278; Photo, courtesy of Alleyne R. Booker and Bobbye M. Booker, Ph.D., 287; Photo, courtesy of Virgil Young, 250; Photo, courtesy of Joseph H. Wilkinson, 294; Photo, courtesy of Matthew Thomas, 293; Polazolo, C., 197; Robinson, Rudolph, 237; Ross, Joanne, DMA, 206, 213; Sassoonian, Manu, courtesy of Luise Ross Gallery, New York City, 154; Schomburg Center for Research in Black Culture, The New York Public Library, Astor, Lenox, and Tilden Foundations, and the Harmon Foundation, National Archives, Washington, D.C., 272; Scurlock Studio©, 218, 274; Searles, Charles, 197; Space, Kenneth, courtesy of Schomburg Center for Research in Black Culture, The New York Public Library, Astor, Lenox and Tilden Foundations and National Archives, Washington, D.C., 286; Spicer, Kathleen, 289; Starr, Nina Howell, ©1962, courtesy of Photo Researchers, Inc., New York City, 269; Stevens, Jane, DMA, 284, 296; Sullivan, Lester, courtesy of The Aaron Douglas Collection, The Amistad Research Center at Tulane University, New Orleans, 161; Szaszfai, Joseph, courtesy of Wadsworth Atheneum, Hartford, The Ella Gallup Sumner and Mary Catlin Sumner Collection, c Wadsworth Atheneum, 182, 232; University Media Systems, Arizona State University, 224, 225; Van Vechten, Carl, courtesy of Rex Madsen-Billy Daniels Collection, The Amistad Research Center at Tulane University, New Orleans, 260; Watkins, Arlette A., 281; Wiley, Herb, Collection of The Newark Museum, New Jersey, Purchase 1985 Metropolitan Life Grant for Minority Visual Arts and The Members' Fund, 253; Wiley, Herb, 221; Wilson, Ellen Page, ©1989, courtesy of Cavin-Morris Gallery, New York City, 176, 244; Wilson, Ellen Page, ©1986, courtesy of Cavin-Morris Gallery, New York City, 185; Williams, A. R., courtesy of Selden Rodman from the publication *Where Art is Joy: Forty Years of Haitian Art*, 262; Woods, Deedee, 165, 298;